# A CATALOGUE OF THE
# EARLIER ITALIAN
# PAINTINGS
## IN THE
## ASHMOLEAN MUSEUM

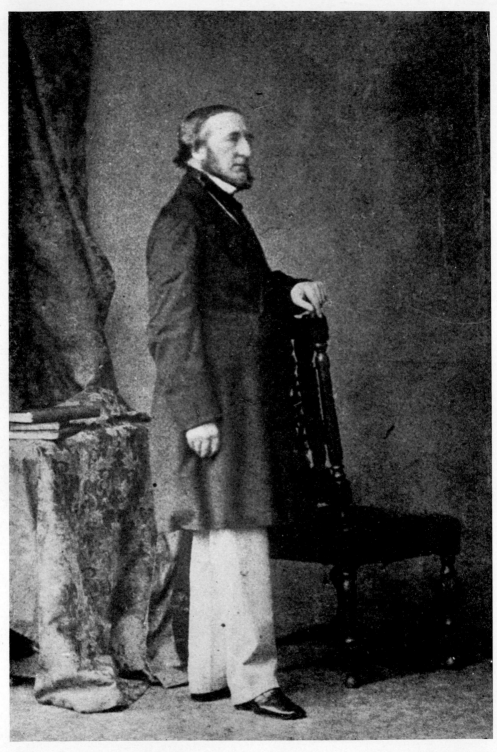

William Thomas Horner Fox-Strangways, 4th Earl of Ilchester, from a photograph in the possession of the Dowager Viscountess Wimborne

# A CATALOGUE OF THE
# EARLIER ITALIAN
# PAINTINGS
## IN THE
## ASHMOLEAN MUSEUM

COMPILED BY

CHRISTOPHER LLOYD

OXFORD
AT THE CLARENDON PRESS
1977

*Oxford University Press, Walton Street, Oxford* OX2 6DP

OXFORD LONDON GLASGOW NEW YORK
TORONTO MELBOURNE WELLINGTON CAPE TOWN
IBADAN NAIROBI DAR ES SALAAM LUSAKA ADDIS ABABA
KUALA LUMPUR SINGAPORE JAKARTA HONG KONG TOKYO
DELHI BOMBAY CALCUTTA MADRAS KARACHI

ISBN 0 19 817342 3

*Printed in Great Britain*
*at the University Press, Oxford*
*by Vivian Ridler*
*Printer to the University*

# PREFACE

THE present catalogue includes those paintings in the Ashmolean Museum painted by Italian artists born between the years 1260 and 1560. It therefore comprises paintings dating from between 1300 and 1600. There is also a small section devoted to the collection of icons. As such this volume is the first in a series of critical catalogues which will incorporate all the paintings from the various schools represented in the collection. The boundaries imposed upon this first volume have been chosen for reasons of containment rather than in support of any theoretical subdivision created by art historians. The entries are the first attempt to examine the earlier Italian paintings in the Ashmolean Museum in detail and so supplement and considerably enlarge upon those found in the preliminary catalogues of paintings published under the aegis of Sir Karl Parker in 1951 and 1961. Each painting has been freshly examined in the light of the most recent literature. The bibliographies have been brought up to date and are intended to be as complete as possible. Measurements have been checked and the condition of each work carefully considered, although in most cases without recourse to scientific aids. Brief biographies of each artist have been given, but no attempt has been made to emulate the biographical accounts provided by the compilers of the various catalogues of the collections in the National Gallery, London. Verbal descriptions of compositions have been omitted as each painting is reproduced. Although colour is occasionally referred to in the commentaries, detailed notations of colour for each painting have been omitted. A concordance of previous attributions used by the Museum in Guides and Summary Catalogues has been attached at the end before the Indexes.

A catalogue is an instrument for further research. It is therefore hoped that the basic information about each picture set out below will assist scholars in their research and that the opinions or statements made in the commentaries will not hinder or mislead them. In the process of assembling so much detailed information about a variety of pictures the compiler of a catalogue is dependent upon the kindnesses of innumerable people. First and foremost I owe a large debt to Mr. James Byam Shaw, who not only supervised my work on this catalogue at the thesis stage, but also aided and encouraged the undertaking at every turn. His profound knowledge of the collection has been invaluable and on the personal side his

generosity and patience inexhaustible. Secondly, my work benefited immeasurably from a year's study in Italy based in Florence at Villa I Tatti. I am extremely grateful to the President and Fellows of Harvard University for my election to a Fellowship for the academic year 1972–3 and to the Visitors of the Ashmolean Museum for allowing me a year's leave of absence. Thirdly, I have received a great deal of help from my colleagues in the Department of Western Art in the Ashmolean Museum. It is true to say that without their support this catalogue would never have been completed. Other members of the Museum staff have also given generously of their time and skills, particularly the Librarian in the Department of Western Art, Mrs. Constance Gunn, her successor Miss Margaret Miller, Mr. Michael Dudley, who took nearly all of the photographs reproduced here, Col. E. R. M. Bowerman, who made drawings of the heraldic devices found on the backs of many of the paintings, and also the staff of the Museum workshop, Mr. Hayes, Mr. Samuels, and Mr. Neave.

Most of the research for this catalogue has been undertaken in the Departmental Library in the Ashmolean Museum and also in the Bodleian Library, both of which in their separate ways are superbly well equipped for the task in hand. I am also grateful to Mr. Cecil Gould for granting me permission to use the National Gallery Library when books or catalogues were unobtainable elsewhere and to the staff of the Biblioteca Berenson at Villa I Tatti and the Kunsthistorisches Institut in Florence. I have used the Witt Library regularly where I have received the friendly assistance of Mr. Rupert Hodge, and similarly I have been well served by members of Sotheby's and Christie, Manson & Wood's, as well as by the firm of P. & D. Colnaghi & Co. Ltd. The notes and information recorded over a period of time in the Departmental files by C. F. Bell, T. Borenius, Mr. John Woodward, Mr. Ian Robertson, and Mr. Gerald Taylor have been a further valuable source of information.

Beyond this it is a pleasure to recall the help I have received from such distinguished authorities as Dr. Federico Zeri, Mr. Everett Fahy, and Dr. Miklòs Boskovits. I have pestered innumerable people with my inquiries and requests for points of information while writing the entries for this catalogue and I gratefully acknowledge the assistance of the following: Dr. Jaynie Anderson, Mr. Hugh Brigstocke, Professor Ellen Callman, Professor Eugene Carrol, Dr. Marco Chiarini, Mr. John Christian, Mr. John Hargrave, Professor Janet Cox Rearick Hitchcock, Dr. Christian von Holst, M. Michel Laclotte, Dr. Karla Langedijk, Mr. Herbert Lank, Mr. Michael Maclagan, Professor Ulrich Middeldorf,

Dottoressa Luisa Vertova Nicolson, Dr. Valentino Pace, Professor
Terisio Pignatti, Dr. Olga Pujmanova, Sir John Pope-Hennessy, Mr.
Stephen Rees-Jones, Professor Roger Rearick, Professor Giles Robertson,
Mr. Francis Russell, and Professor Sir Ellis Waterhouse. In particular, I
would like to emphasize the kindness of my colleague Hugh Macandrew,
who read a draft of my manuscript with great care and interest; his close
criticism of the draft was salutary and deeply appreciated. Specific
acknowledgements to these and many other scholars and specialists have
been made in the commentaries. It should be stressed, however, that all the
conclusions are my own and that no one else is to blame for any indiscre-
tions or mistakes that may have occurred. The icons were all inspected
by the late Professor David Talbot Rice, but prior to my work on this
catalogue. The opinions accredited to this scholar in the appropriate
section below are based upon notes found in the departmental files. Miss
Camilla Powell was kind enough to undertake the checking of certain
facts during the course of writing, and the typing of the manuscript was
ably and patiently undertaken by Miss Violet Legg, Miss Noelle Brown,
and Mrs. Lea Briggs.

The Introduction to this catalogue is in the main devoted to the Hon.
W. T. H. Fox-Strangways and his part in the rediscovery of earlier
Italian painting at the beginning of the nineteenth century. For informa-
tion regarding the family and for permission to reproduce the presumed
photographic portrait of Fox-Strangways which serves as the frontis-
piece, I am beholden to the Dowager Viscountess Wimborne. I am also
particularly grateful to Mr. Anthony Burnett-Brown for allowing me to
quote so liberally from the family correspondence of Henry Fox-Talbot
which is still at Lacock Abbey in Wiltshire. Miss Janet Burnett-Brown
very kindly transported suitcases full of letters from Lacock to Oxford,
thus saving me the trouble of several journeys. To read through the Fox-
Talbot correspondence provided me with a marvellous insight into this
charming and gifted family. The passage quoted in the Introduction from
Lady Callcott's unpublished Journal has been done so by kind permission
of the owner of that particular volume, Mrs. Nancy Strode. My interest
in nineteenth-century taste for Italian art has been kindled by attending
the lectures of Professor Francis Haskell in Oxford and I have also bene-
fited enormously from numerous conversations with him on this subject.

# CONTENTS

# ABBREVIATIONS USED IN THE TEXT

| | |
|---|---|
| *Annual Report* | *Ashmolean Museum. Report of the Visitors*, 1888– . |
| Berenson | B. Berenson |
| —— 1910 | *North Italian Painters of the Renaissance*, London, 1910. |
| —— 1911 | *The Central Italian Painters of the Renaissance*, 2nd edn., London, 1911. |
| —— 1911 Venetian | *The Venetian Painters of the Renaissance*, 3rd edn., London, 1911. |
| —— 1912 | *The Florentine Painters of the Renaissance*, 3rd edn., London, 1912. |
| —— 1932 | *Italian Pictures of the Renaissance*, Oxford, 1932. |
| —— 1936 | *Pitture italiane del Rinascimento*, Milan, 1936. |
| —— 1957 | *Italian Pictures of the Renaissance. Venetian School*, 2 vols., London, 1957. |
| —— 1963 | *Italian Pictures of the Renaissance. Florentine School*, 2 vols., London, 1963. |
| —— 1968 | *Italian Pictures of the Renaissance. Central Italian and North Italian Schools*, 3 vols., London, 1968. |
| Crowe and Cavalcaselle | J. A. Crowe and G. B. Cavalcaselle |
| *History* | *A History of Painting in Italy*, 3 vols., London, 1864–6; 2nd edn., 6 vols., London, 1903–14, vols. i–iv ed. R. Langton Douglas, vols. v–vi ed. T. Borenius. |
| *History North Italy* | *A History of Painting in North Italy*, 2 vols., London, 1871; 2nd edn., 3 vols., ed. T. Borenius, London, 1912. |
| Offner, *Corpus* | R. Offner, *A Critical and Historical Corpus of Florentine Painting*, section III, New York, 1930–58, vols. i–viii in parts; section IV, New York, 1960– , vols. i–v in parts with K. Steinweg. |
| Schubring, *Cassoni* | P. Schubring, *Cassoni. Truhen und Truhenbilder der italienischen Frührenaissance*, 2 vols., Leipzig, 1915; *Supplement*, Leipzig, 1923. |
| Thieme-Becker, *Lexikon* | *Allgemeines Lexikon der bildenden Künstler von der Antike bis zur Gegenwart*, ed. U. Thieme and F. Becker, 37 vols., Leipzig, 1907–50. |

Van Marle, *Development*      R. Van Marle, *The Development of the Italian Schools of Painting*, 19 vols., The Hague, 1923–38.

Vasari      G. Vasari, *Le vite de' più eccellenti pittori scultori ed architettori*, ed. G. Milanesi, 9 vols., Florence, 1878–85.

Venturi, *Storia*      A. Venturi, *Storia dell'arte italiana*, 11 vols., Milan, 1901–40, from vol. vii. in parts.

Waagen, *Treasures*      G. F. Waagen, *Treasures of Art in Great Britain*, 3 vols., London, 1854.

# EXPLANATIONS

Attribution     (a) *attributed to* implies that final confirmation is needed before the attribution of a picture to a specific painter can be wholly accepted.

(b) *ascribed to* implies even less confidence in an attribution and that a suitable alternative has not been found.

(c) *studio of* means that a painting was executed in a painter's studio usually on his design and probably under his direction.

(d) *follower of* indicates a connection in style, or merely a resemblance of style, between the named master and an anonymous painter.

(e) *copy after* or *after* is self-explanatory. The nature of the copy is defined in the commentary.

Measurements    in centimetres throughout, height preceding width. The measurements taken are those of the paint surface, but the size of the panel is also recorded where necessary.

Medium     except where otherwise stated the medium in all cases is tempera or a mixture of oil and tempera.

Condition     detailed descriptions have been provided on the basis of visual inspection. Only the *Tallard Madonna* attributed to Giorgione and the *Portrait of Giovanni de' Medici* by Bronzino have been subjected to technical examination.

Supports     except in the case of the triptych painted in the studio of Angelico, no attempt has been made to determine the type of wood used for each panel. Details of relining of canvases and cradling of panels have been given.

Right and left    these refer to the spectator's right and left unless the context implies the contrary.

Numbering     in contrast with some earlier Museum catalogues, inventory numbers have been used instead of separate catalogue numbers. The paintings are arranged in alphabetical order according to artist.

Labels     three distinctive hands recur on labels on the backs of panels from the collection of the Hon. W. T. H. Fox-Strangways:

1. an eighteenth-century hand discussed in the Introduction (p. xxiii) and reproduced in fig. 2. These labels are numbered and usually accompanied by a second number brushed on to the back of the panel in brown stain. This second number is placed between two dots and often coincides with that on the label. Most of the labels inscribed by this hand have attributions.

2. a nineteenth-century hand writing in Italian, but not necessarily that of an Italian. An example is reproduced in fig. 3. This hand is found on labels on the back of only a few panels from the collection. The labels have attributions and information regarding the provenance of the panel.

3. the collector's own label usually inscribed with his name and a number. Occasionally on a separate label he supplied a title or comments on the condition, but rarely is there an attribution recorded by his own hand.

# INTRODUCTION

A LARGE number of the paintings included in this catalogue were presented to Oxford University in 1850 by the Hon. W. T. H. Fox-Strangways, later the 4th Earl of Ilchester. The gift comprised forty-one pictures, but this figure by no means represented the whole of his collection, nor, indeed, the full extent of his generosity, for in 1828, and again in 1834, Fox-Strangways had already made donations to his former Oxford college, Christ Church. In addition, he retained a small number of paintings, recorded in a private catalogue of 1883, in the family house at Abbotsbury in Dorset, which was destroyed by fire in 1913 together with the contents. His complete collection amounted to approximately one hundred paintings, and nearly half of these can be ranked as primitives, that is paintings dating from before 1500. Several are of high quality and of major importance. From those now in the Gallery at Christ Church, the triptych painted in the workshop of Duccio (Byam Shaw, No. 3), the fragment of *Four Musical Angels* (Byam Shaw, No. 5), possibly from an altar-piece by the young Orcagna, the two panels of *Sibyls* (Byam Shaw, Nos. 35 and 36), painted in the studio of Botticelli with the assistance of the young Filippino Lippi, and the *Virgin and Child with Angels* (Byam Shaw, No. 33), from the school of Piero della Francesca, are among the most notable, while from the pictures in the Ashmolean, the *Crucifixion and Lamentation* by Barna da Siena, the *Annunciation*, close in style to the Master of the Bambino Vispo, the *Meeting at the Golden Gate* by Filippo Lippi, and *The Hunt* by Uccello, are equally distinguished. As in every collection of Italian paintings formed during the course of the eighteenth and the nineteenth centuries, a sediment of old copies, imitations, and icons of fairly recent origin was present, but the over-all quality of the group of pictures in Oxford reflects well upon the artistic judgement of the collector and earns Fox-Strangways a leading place in the early history of English connoisseurship of Italian primitive painting. He belongs, in fact, to that distinguished coterie which includes William Roscoe, the Revd. John Sanford, the Revd. Walter Davenport-Bromley, James Dennistoun, and Thomas Gambier-Parry. An engraving, which forms part of a series dedicated to various connoisseurs known in Florence at the beginning of the nineteenth century, is here reproduced (fig. 1) to serve as testimony to his standing amongst his contemporaries.[1]

William Thomas Horner Fox-Strangways was born in 1795, the first

[1] The series of thirteen engravings, twelve of which are dedicated to various connoisseurs,

son by the second wife of the 2nd Earl of Ilchester. He was educated at Westminster and Christ Church, where he matriculated in 1813. He succeeded his half-brother as 4th Earl of Ilchester in 1858, one year after his marriage to Sophia Penelope, the second daughter of Sir Robert Sheffield, and he died without issue in 1865. After coming down from Oxford, Fox-Strangways elected to enter the Diplomatic Service, primarily to escape from the demands of an active social life in England, which, even during his youthful years, he found distasteful, but also because he was almost totally devoid of political ambition and felt that such a failing would not be so readily observed in a career pursued largely overseas. As he wrote in an undated letter to his nephew, Henry Fox-Talbot, 'I prefer the beauties of Riva and the Lago di Garda to the hustings of Chippenham or any other'. He was posted as attaché to St. Petersburg (1819), Constantinople (1820), Naples (1822), and The Hague (1824). The three years from 1825 until 1828 were spent as Secretary of Legation in Florence and he held the same post in Naples from 1828 to 1832, and again in Turin for the duration of 1832, after which he held no further posts in Italy. Subsequently Fox-Strangways served as Secretary to the Embassy in Vienna from 1832 to 1835, as Under-Secretary of State for Foreign Affairs to Palmerston from 1835 to 1840 in Lord Melbourne's second government, and finally, from 1840 to 1849, as Minister Plenipotentiary to the Diet of the German Confederacy at Frankfurt. In that year, he resigned from the Diplomatic Service and retired from public life.

Italian painting was not a consuming interest for Fox-Strangways. From his earliest years, he had a penchant for the period of history which he described in an early letter as 'falsely called dark and barbarous ages or more properly middle ages'.[1] Inspired by the medieval buildings at Abbotsbury, he spent much of his youth composing romances in the style of the Troubadours, translating ancient Breton lays, inspecting

is contained in a portfolio of prints and drawings bequeathed by the Revd. Robert Finch to the Taylor Institution in 1830, and transferred to the Ashmolean in 1971 (inv. 1971. 85). The publishers of the series were Niccolò Pagni and Luigi Bardi.

Not all of the forty-one pictures presented to the Ashmolean Museum in 1850 are included in the present catalogue. A *Landscape* by Johann Melchior Roos (1659–1731) will be catalogued elsewhere and a small panel of *St. Mary Magdalen*, perhaps after Bartolommeo Schidone (?), will be discussed in the catalogue of the later Italian paintings in the Ashmolean Museum. Three of the pictures which formed part of the gift are now missing—*Head*, described as 'after Correggio', *S. Rosa*, described as 'after Carlo Dolci', and a *Virgin and Child*, described as 'Byzantine'. One other picture, a two-sided early Byzantine panel, with the *Annunciation* on the recto and the *Four Evangelists* on the verso, will be found catalogued below in the appropriate section.

[1] B.M. Add. MSS. 51367 (Holland House Papers), f. 1, letter dated 1 Feb. 1812.

medieval seals, and discussing the beauties of Gothic architecture. This natural sympathy for the past, however, remained subservient throughout his life to a more ardent interest in horticulture, which, as his obituary in the *Gentleman's Magazine* reminds us, won him a considerable reputation.[1] Today the garden at Abbotsbury and the grounds of the Ilchester family seat at Melbury, also in Dorset, bear witness to the extent of his passion for horticulture. His niece, Caroline, Lady Valletort, later Lady Mount Edgcumbe, remarked epigramatically of her uncle in a letter of 10 February 1835, that he 'likes flowers better then men and stones better than flowers'. Of Fox-Strangways's geological researches, there are four papers published in the *Transactions of the Geological Society*, between 1821 and 1824. It seems, in fact, to have been these contributions to geological studies that aided his election to Fellow of the Royal Society in 1821, at the age of twenty-six, when he was described in his certificate of candidature as 'a Gentleman well acquainted with several Branches of Science and Literature'.[2] He wrote to his sister Lady Elizabeth Feilding from Naples on 26 November 1822:

Some think I am absorbed in botany and accordingly stuff letters as full of vegetables as an Herbal. Others think I am always in the depths of the earth and lament my devotion to unprofitable spurs and barren rocks and at the same time suppose they can only amuse me when they have scraped up materials for a couple of Geological pages or an account of some natural wonder. . . . All this will do very well for a time but there must be an end. In the meantime I remain very contentedly where I am because though the chances of direct advantage are not great, yet the indirect advantages are sufficient to make it worthwhile. Naples alone, perhaps would scarcely justify such views, but my eye includes the rest of Italy in the distance.

It was not long before his eye fell upon Italian art. 'The Great Gallery here', he writes to his aunt, Lady Susan O'Brien, in 1825, 'is the principal attraction in Florence. I go there often. It contains everything and so arranged that you can visit any part of it separately, and go every day.'[3]

[1] *Gentleman's Magazine*, xviii (March 1865), 368. See further J. Britten and G. S. Boulger, *A Biographical Index of British and Irish Botanists* (London, 1907), p. 63.

[2] Mr. N. H. Robinson, the Librarian of The Royal Society, kindly sent a copy of the certificate of candidature and a list of Fox-Strangways's geological publications, which were principally devoted to Russian geological research, based on studies made when he was in St. Petersburg where he had been resident since 1817. Fox-Strangways's profound interest in Slavonic culture is not only reflected in the course of his career in the Diplomatic Service and his entanglement in Polish affairs, but also in his generous bequest of £1,000 to the Taylor Institution in Oxford, adjacent to the Ashmolean Museum, for 'the encouragement of the study of Polish and other Slavonic languages and their literature and history' (for which see Sir Charles Firth, *Modern Languages at Oxford 1724–1929* (Oxford, 1929), pp. 57–8).

[3] B.M. Add. MSS. 51352 (Holland House Papers), f. 136, letter dated 12 June 1825.

It is reasonable to assume that Fox-Strangways had seen the collection of pictures bequeathed by General Guise to Christ Church in 1765, and had examined the collection formed by his brother-in-law, the 3rd Marquess of Lansdowne, but the years in Italy, beginning with his appointment to Naples in 1822, enabled him to review the whole development of Italian painting at first hand. His approach was neither academic nor literary. Almost certainly, he had no specific notions of art-historical theory, and showed no inclination to formulate a carefully worded brief for the defence of his appreciation of early Italian painting. Rather, his knowledge was cumulative and his enthusiasms untrammelled by preconceptions. Thus, on leaving Italy on official leave, he could remark in a letter of 19 April 1827, 'I had my head full of pictures before I crossed the Alps but now I have quite forgotten them'. None the less, a series of family letters from the years 1824 to 1829, mainly addressed to his nephew, Henry Fox-Talbot (1800–77), a pioneer in photography and the owner of Lacock Abbey, is packed with references to dealers and days spent 'picture-hunting', even, on occasions, to the exclusion of botanical matters. The passages quoted here are intended merely to illuminate the nature of Fox-Strangways's appreciation of Italian painting.[1]

Unlike most of the dilettantes of his day, Fox-Strangways was not a keen admirer of either the Bolognese or of the Venetian schools. In a letter to Fox-Talbot, dated 26 September and postmarked 1826, he wrote,

For the number and the merit that certainly must be among them somewhere I never saw such uninteresting pictures as those of the Scuola Bolognese in general with some splendid exceptions. There is so much confusion in their pictures it makes me doubly value the simplicity and severity of the Florentines.

Almost one month later, in an undated letter postmarked 21 October 1826, he wrote of Venetian painting, 'Venetian pictures are too much alike to please me and being mostly painted for furniture pictures, they are of such shapes and proportions as they were intended for cornices, ceilings, over doors, etc. that they seldom look well out of the place they were painted for'. Both judgements are reflected in the character of the collection, which comprised works almost solely of the Tuscan school and mainly panels of small proportions from dismembered altar-pieces.

In common with many of his contemporaries, however, Fox-Strangways was an admirer of Raphael and Correggio, but he did not harbour an uncritical bias towards either painter. On seeing 'the famous Tempi Madonna' by Raphael, he pronounced it, in a letter of 17 August 1826,

---

[1] Transcriptions of the more important letters containing references to dealers and copyists will be found in *Italian Studies*, xxx (1975), 42–68.

'positively ugly'. Yet, later in the same year, while visiting Dresden, he described the Sistine Madonna as 'the finest picture I ever saw'.[1] This ambivalence also characterized his appreciation of Correggio, to whose 'charms' he was 'quite alive'.[2] If Dresden's distinguished holding of paintings by Correggio 'rather disappointed' him,[3] it was, nevertheless, his avowed intention to 'have a copy by [Trajan] Wallis of all Correggio's pictures' (letter dated 5 February, most probably written in 1827).

Regrettably for the Ashmolean, perhaps, Fox-Strangways never completely overcame his instinctive dislike of Venetian painting. In an undated letter postmarked 21 October 1826, he wrote:

I never thought much of Tintoret and Giorgione till I came to Venice. I think the Flora at Florence must be a Giorgione. What laborious workmen the Venetians were, what acres of canvas P. Veronese, Palma and Tintoretto covered. Half a dozen names are all you ever have for what it seems would acquire the labour of 50 οἷοι νῦν βροτοί εἰσι.[4]

He was, however, suspicious of the number of paintings masquerading under the name of Titian, for when he was looking at the collection of a certain Marchesa Grimaldi in Florence, he records, in a letter to Lady Elizabeth Feilding, dated 6 June, most probably written in 1826, that 'there are 3 Graces which if they had Titian's heads would I am sure fetch *mints*. It is not certain it is a Titian, but I think it a capital Padovanino who came very near to Titian in figures but fell short in heads'. In Milan, too, the frequent attributions to Leonardo da Vinci also aroused his suspicions. As he remarked in a letter of 15 October 1827, 'Every old yellow gipsy is a Luino, the great man of Milan after Leonardo and who I really believe painted half the Leonardos'. By 11 January 1828 his admiration for Bernardino Luini had increased to the point where he preferred a painting apparently by him to one purporting to be by Leonardo. Surprisingly, Tuscan painting does not seem to have aroused in him the same desire for close stylistic analysis, for Fox-Strangways's preference was undoubtedly for the painters of that school. His interest lay not only in the primitives, but also in early seventeenth-century painters such as Matteo Rosselli, Jacopo da Empoli, and Lodovico Cigoli. There are several references to a

---

[1] B.M. Add. MSS. 51352 (Holland House Papers), f. 145, letter dated 3 Dec. 1826, addressed to Lady Susan O'Brien.

[2] B.M. Add. MSS. 52152 (Holland House Papers), f. 149, letter dated 24 Nov. 1843 from Frankfurt.

[3] B.M. Add. MSS. 51352 (Holland House Papers), f. 145, letter dated 3 Dec. 1826, addressed to Lady Susan O'Brien.

[4] Homer, *Iliad*, v. 304. In Pope's translation, 'Such men as live in these degenerate days'. Professor Martin Robertson kindly identified the source of the quotation.

painting of *Ugolino* by Giacomo Ligozzi in the Palazzo Gondi-Cerretani, which, in a letter postmarked 22 February 1828, he described as 'one of the most original of paintings'. Yet regardless of his considerable knowledge of seventeenth-century Florentine painting, Fox-Strangways derived greatest pleasure from looking at the earlier painters of the Florentine school. He wrote to Henry Fox-Talbot on 25 March 1828: 'There is now a lovely picture of M. Albertinelli to be sold framed and cleaned for 50 louis, after the Salutation in the Gallery, the finest I ever saw. I would rather have it than all C. Dolcis.'

During the course of 1825–6, acquisitiveness became allied to inquisitiveness and by 17 August 1826, Fox-Strangways was aware that 'with a little money and knowledge I am sure a very tolerable collection might be made now'. A few days later, on 25 August, he wrote to Henry Fox-Talbot: 'I wish you had staid. I have got deeper in the picture dealing line than ever. That is I have bought nothing but only feel tempted.' In the letter dated 5 February, most probably written in 1827, his intentions are stated more clearly. 'If I had capital I would lay out £5000 sterling in pictures and make a perfect historical collection from Cimabue to Mengs and sell it for double to the National Gallery for they by [*sic*] nothing. The outlay would hardly be felt as a good collection can only be picked up by degrees.' The distinction between the various types of collection that could be formed is of interest and is defined more precisely in a passage in another letter written in Genoa on 25 October 1827:

I met Mr. Irvine at Milan. He told me, or rather agreed with me, that two most useful sorts of collections were wanting in England and might be made at no great expense and within small compasses to size and numbers. One is that of oil sketches and studies if not of every master of note at least of every school.... The other sort of collection is that of Gothic and Greek paintings beginning as high up as you can get them and ending with Giotto, Perugino, Francia, Giambellino etc. Two such collections with one specimen of each school in its maturity would be a gallery for a king. It would be the skeleton of a collection of any size.

The purpose of the collection eventually formed by Fox-Strangways is clear from this passage and in the letter dated 5 February 1827(?), he declares to Fox-Talbot, 'I am making a collection of Giottos etc.'. Just over a year later, on 25 March 1828, he writes, 'My picture gallery increases. Where on earth shall I put them all I don't know.'

Unfortunately, there are no certain references to specific purchases in the same series of letters, and Fox-Strangways's prime concern in his family correspondence is to give a general description of the art market in

Italy as he found it—the number and diversity of pictures, the unparalleled opportunities for the discerning collector, the fluctuating prices and the names of dealers, the predicament of Italian families forced to disgorge their collections through financial duress, and the failure of the British government to form a collection for a National Gallery in propitious times. These are the recurring themes in the letters. Only one piece of evidence survives for the actual formation of his collection. This is a bill of lading dated 21 January 1830, addressed to Fox-Strangways from the firm of Woodburn & Bros.[1]

London
21st January 1830

Sir,

I beg to acknowledge the receipt of your favour of the / 30th inst.[?] and in answer have to inform you I have / again examined the Pictures contained in the cases from / Italy. They are 32 in number, 12 of which have suffered / from the Sea Water, as follows:

Bronzino 1. Head of a Young Gentleman, suffered very much.
Starini—2. Triumph of Purity—damaged near the Bottom.
A. Botticelli[2] 3. Magdalen—suffered much.
Cigoli—4. St. Francis on his Knees.
A. Pollaiolo 5. Painting on both sides—nearly destroyed.
      Do. 6. St. John—suffered very much.
            7. Portrait of an Artist with Bronze figures.
Cigoli—8. One of the Heads of a Frate.
F. Granacci 9. S. Francis
      Do. 10. S. Antonio
      Do. 11. An Angel
      Do. 12. Martyrdom of S. Catherine.

The 5 last Pictures appeared to have been much in / sea water, and the surface so chilled that the subjects are / difficult to distinguish. I am in hopes by a little / proper treatment to bring them all into good order. The other 20 will require to be washed and varnished, and I should be glad / of your permission to remove them, together with the / Books and Cabinets to your House in Burlington St / as soon as we have them ready. The only packet of Books / which has sustained damage is the work on Etruscan Vases / contained in the Case WF No. 1. The others appear to have escaped unhurt.

We have received no tidings of the Case belonging to you. / We forwarded the Bill of Lading to our agent in the City / and I have no doubt. We shall be informed whenever / the vessel arrives.

[1] B.M. Add. MSS. 51367 (Holland House Papers), f. 103.
[2] Crossed through.

My brother William is, at present doubtful whether / he shall see Naples, or travel Northward this present year.

<div style="text-align: center;">

I remain Sir,

very respectfully your Obliged

Humble Servant,

Allen Woodburn for self / and Brothers

</div>

Four of the pictures listed in this bill of lading can be identified from amongst those presented to Christ Church in 1834 and the rest from amongst those in the gift of 1850 to the University.[1] By the time he made the gift of 1850, Fox-Strangways appears to have become confused about the nature of these last acquisitions. A statement made to the Revd. Dr. Henry Wellesley when proposing the gift of 1850 is otherwise difficult to explain.

As I hear from various quarters that the picture gallery at Oxford is now finished, and in a state to receive works of art to which it is destined, I should feel greatly obliged to you if you could let me know whether the Trustees would accept from me the present of a few works of the very Old Masters, somewhat similar to those which I formerly gave to Christ Church? They were bought at Rome some years later than the others and comprise works of rather a different style and school, but of the same age.[2]

In fact the gifts are complementary and the bill of lading shows that some of the pictures intended for Christ Church, together with others ultimately destined for the University, were bought and dispatched at the same time, and not on separate dates. The reason for this vagueness may be partially explained by the fact that he had the pictures 'slightly touched and put in order by Woodburn when they first came over, since when they had been lying in a case in Lansdowne House . . .'.[3]

All the available evidence shows, then, that Fox-Strangways formed his collection between the years 1827 and 1832, when he left the peninsula for the last time. He does not appear to have added to his collection after leaving Italy, either by attendance in the saleroom or by private purchase. We have seen above that Fox-Strangways was an ardent admirer of

---

[1] Nos. 1, 6, 8, 10, and 11 are identifiable with pictures in the Ashmolean (see below, pp. 39, 37 and 87). Nos. 3, 4, 5, 7, 9, and 12 are at Christ Church (Byam Shaw, Nos. 47, 68, 41, 60, and 77 respectively). No. 2 in the bill of lading has not been identified.

[2] The letter is transcribed in full by F. Herrmann, *The English as Collectors. A Documentary Chrestomathy* (London, 1972), Letter I, pp. 300–1. The same author transcribes three other letters addressed to the Revd. Dr. Henry Wellesley from Fox-Strangways preserved in the archives of the Department of Western Art, Ashmolean Museum.

[3] Herrmann, loc. cit.

Tuscan primitive painting and panels belonging to this school dominate the collection. Twenty-one of these, now divided between the Gallery at Christ Church and the Ashmolean, have important evidence on their backs as to their provenance. Each has a label inscribed and numbered by an eighteenth-century hand and in nearly every case the number on the label is concurrent with a second number brushed on to the back of the panel itself in brown stain (fig. 2). One such label occurs on the reverse of *S. John the Baptist* at Christ Church (Byam Shaw, No. 4). It is inscribed *S. Giovanni di Bufalmaco No. 10.* The picture was engraved by Matteo Carboni for the first volume of *L'Etruria pittrice* published in 1791, where in the accompanying text it is stated: 'Il Quadro che si esibisce, è uno dei componenti la bellissima Serie storica de' Pittori Toscani, raccolta con gran diligenza e spesa dal Sig. Vincenzio Gotti, Pittor Fiorentino, e dei monumenti dell'arte sua profondissimo conoscitore.'[1] In the *Supplemento alle serie dei trecento elogi e ritratti degli uomini i più illustri in pittura, scultura e architettura,* published in 1776, Gotti is described as the pupil of Agostino Veracini and is praised mainly for his restoration of old paintings.[2] A further, and in the present circumstances the most tantalizing, piece of information about Gotti is given in the fifth edition (1790) of Gaetano Cambiagi's *Guida al forestiero per osservare con metodo le purità e bellezze della città di Firenze,* who writes, 'E volgendo dipoi per la via di Gualfondo, è quivi da vedersi la Getterià delle Campane, e altri lavori di bronzo del Sig. Moreni; come pure lo studio di Pittura del Sig. Vincenzio Gotti, quivi vicino ripieno di belle, e rare pitture, de la quali ne fu stampato un Catalogo. . . .[3] The catalogue of Gotti's collection has not been traced, but the fact that many of the labels numbered and inscribed as in fig. 2 are of the Tuscan school does suggest that Fox-Strangways may have acquired, either directly or indirectly, all, or part of, Gotti's once celebrated collection.

As a diplomat posted to Italy, Fox-Strangways was ideally placed to form a collection of Italian paintings. Availability and accessibility were the main advantages. Indeed, many of the most distinguished collectors of the early part of the nineteenth century were diplomats—François

---

[1] M. Lastri, *L'Etruria pittrice ovvero storia della pittura toscana dedotto dai suoi monumenti che si esibiscono in stampa dal secolo X fino al presente* i, (Florence, 1791), No. V.

[2] G. Cambiagi, *Supplemento alla serie dei trecento elogi e ritratti degli uomini i più illustri in pittura, scultora e architettura o sia abecedario pittorico dall'origine delle belle arti a tutto l'anno MDCCLXXV* (Florence, 1776), col. 1433.

[3] pp. 245–6. G. Previtali, *La fortuna dei primitivi dal Vasari ai Neoclassici* (Turin, 1964), p. 187, n. i, cites a reference to Gotti in the first edition of Artaud de Montor, *Considérations sur l'état de la peinture dans les trois siècles qui ont précédé Raphael* (Paris, 1808), p. 21, but the writer has been unable to trace a first edition of this work and the reference does not recur in the second (1811) and third editions (1843).

Caçault, Cardinal Fesch, Artaud de Montor, and Georg August Kestner. Almost four years after leaving Italy, Fox-Strangways wrote to Lady Augusta Fox, the wife of the 4th Lord Holland, who was Secretary of Legation in Florence from 1839 to 1846, 'Do you ever deal with Nocchi the printseller who used to be my guide and ferret into all the old houses and corners in Florence?'[1] By good fortune, we do have an independent eye-witness account of his 'picture-hunting' activities. This is provided by Lady Callcott, the wife of the painter Sir Augustus Wall Callcott and a distinguished authority on Italian painting in her own right, who kept a detailed Journal of her honeymoon in 1827–8, which was spent travelling in the Netherlands, Germany, and Italy. She records of a day in Florence:

Wednesday, 2nd 1827 went at 11 o'clock with Mr. Strangways (having paid Bardi for the Campo Santo) to see pictures. We visited several houses on this side of the water and found absolutely nothing but works of secondary masters, copies of damaged things. At the King of Bavaria's brokers indeed there were some true and good ancient pictures especially some portraits of the earliest— two especially I think by Botticelli & one profile by the same that is beautiful: also a good head of Masaccio and in one of the houses in the Piazza Vecchio di S. M. Novella we saw Ligozzi's *Ugolino* a picture full of terrible and true expression. We then crossed the bridge to Botticelli's picture shop. Again a heap of rubbish, a few things of the old Florentines but asking enormous prices for them and claiming to *restaurare* them. Thence to the Printsellers in the Via dello Studio where I bought the Almanac of Saints and then home.[2]

On several other occasions during their stay in Florence the Callcotts met Fox-Strangways either at dealers or in the galleries.

In the house at Abbotsbury, with its commanding view over the sea, Fox-Strangways surrounded himself with the prizes of his years of service in Italy. His garden contained the plants, shrubs, and flowers that he had collected from such leading Italian botanists as Domenico Viviani (1772–1840), Antonio Bertolini (1775–1869), Giuseppe Raddi (1770–1829), and Michele Tenore (1780–1861), while the interior of the house is fleetingly described by his niece, in a letter of 16 December 1831.

We have had nothing but storms since we came here, & the sea finer than I ever happen to have seen it here before. . . . The house is as comfortable as possible, with a pianoforte, and portfolios full of Italian drawings and prints— over my chimney piece is an extremely pretty slight sketch in black and white

[1] B.M. Add. MSS. 52152 (Holland House Papers), f. 81, letter dated 10 Dec. 1841. Giovanui Battista Nocchi was an engraver and print-seller. L. Biadi, *Notizie inedite della vita d'Andrea del Sarto*, 2nd edn. (Florence, 1831), p. 148, n. 7, records that Nocchi's shop was in the Piazza S. Trinita.

[2] 'Journal', vol. 5, f. 89. (Unpublished: quoted by kind permission of the owner.)

on coloured paper by Kirkup; Uncle William sent it over lately, and all I can find out about it is that it is called 'La Bella dormente'—I suppose one of his numerous *admirations*.

Three other collectors, whose pictures have greatly enhanced the quality of the collection of early Italian paintings in the Ashmolean, should be discussed. Charles Drury Edward Fortnum (1820–99) formed an extensive collection of bronzes, sculpture, majolica, and finger-rings, parts of which had been on loan to the Museum since 1888, and all of which was subsequently bequeathed. In 1894 he had also generously made an endowment of £10,000 for the extension of the Galleries. He was famed for his knowledge of Italian sculpture and ceramics, and his most important publications were devoted to the last-named subject. Having emigrated to Australia in 1840, Fortnum returned to this country in 1845 and during the following years, through his friendship with Sir J. C. Robinson, he became intimately involved with the affairs of the South Kensington Museum. Only six small paintings were included in the bequest of 1899, but each was of high quality. The overt decorativeness of the *S. Catherine of Alexandria* by Vittorio Crivelli, the suppleness of line and the even modelling of the *Virgin and Child* by Pintoricchio, the jewel-like sparkle in the landscape of the small panel of *S. Jerome* ascribed to Giovanni Bellini, and the meticulous characterization of the figures on the *Entombment* by the Master of San Martino alla Palma are all stylistic characteristics applicable to his other interests, particularly his love of bronzes. A more detailed account of Fortnum's collecting habits rightly belongs to the introduction of a *Catalogue of Sculpture in the Ashmolean Museum* or a *Catalogue of Majolica in the Ashmolean Museum*.

James Reddie Anderson (1850–1907) had a small but prestigious collection of ten pictures which came to the Ashmolean Museum in two parts, the first presented by his widow in 1913, and the second presented by his daughters in memory of their father in 1947. Among these are eight pictures by Italian painters, including the *Virgin and Child* by a close follower of Giotto, the *Baptism of Christ* by Giovanni di Paolo, the *Consecration of S. Eligius* by a close follower of Altichiero, but also the important *Christ before Pilate* by the Master of the Bielefeld Altar. Anderson came to Oxford from Glasgow. He matriculated in 1870 at the age of twenty and took his B.A. in 1874. He was an undergraduate at Balliol when Ruskin became the first Slade Professor of Fine Art in Oxford and almost certainly attended his lectures. He seems to have been deeply influenced by Ruskin and played a leading part in the building of Hinksey Road for which Ruskin exhorted him to 'Make what recruits you can to

the theory that one's chief exercise ought to be in useful work, not in cricket or rowing merely'.[1] He then collaborated with Ruskin on a study of the *Life of S. George* painted by Carpaccio in the church of S. Giorgio degli Schiavone, Venice, which was published as part of *S. Mark's Rest* in 1879. Later in his life Anderson went to live in the Lake District, but whether or not this represents the continuing influence of Ruskin is not known.[2]

The Italian paintings from the collection of Sir William James Farrer (1822–1911), bequeathed by his son Gaspard through the National Art-Collections Fund in 1946, together with other parts of the Farrer family collections, are five in number, and mainly good examples of the Venetian school. These include the gentle *Virgin and Child* by Bartolomeo Montagna, the two roundels also by Montagna, which were originally inserted into the front of a *cassone*, the *Portrait of a Young Man with a Skull* by Bernardino Licinio, and the vigorous *Resurrection of Christ*, painted by Jacopo Tintoretto with workshop assistance.

The names of other benefactors are best listed in chronological order: George Fairholme (1846), John Bayley (1849), Chambers Hall (1855), the Revd. Greville Chester (1864 and 1892), John Chambers (1897), Henry Pfungst (1903), Ingram Bywater (1915), Thomas Watson Jackson (1915), G. Gidley Robinson (1921), Mrs. W. F. R. Weldon (1926), Sir Arthur Evans (1929 and 1941), Dr. Arthur Waters (1937), C. J. Longman (1938), Miss Mabel Price (1939), Miss Emily G. Kemp (1940), Harold Bompas (1941), the Revd. F. M. T. Palgrave and Miss Annora Palgrave (1941), F. P. M. Schiller (1946), Henry Harris (1950), Mrs. Henry Medlicott (1950), Percy Moore Turner (1951), Francis Falconer Madan (1957 and 1962), A. G. B. Russell (1958), Thomas Balston (1968), Sir John Beazley (1971), and Professor Martin Robertson (1971).

It should not be forgotten that the National Art-Collections Fund has presented a number of important early Italian paintings to the Museum, including the famous *Forest Fire* by Piero di Cosimo (1933), the *Virgin and Child* by Andrea Vanni (1942), *Christ Carrying the Cross* by Bartolomeo Montagna (1955), and the *Adoration of the Shepherds*, previously ascribed to Pellegrino Tibaldi and to Giovanni Demio (1937).

In addition to these donations and bequests, various purchases have also been made, many of them during the Keepership of Sir Karl Parker

[1] *The Works of John Ruskin*, Library Edn., ed. E. T. Cook and A. Wedderburn, vol. xxxvii (London, 1909), p. 735, letter from Ruskin to Anderson dated 25 Feb. 1874 (present whereabouts unknown).

[2] For Ruskin and Anderson see *The Brantwood Diary of John Ruskin*, ed. Helen Gill Viljoen (Yale University Press, 1971), pp. 559–60.

(1934–62). These include some outstanding examples of Venetian painting —the *Tallard Madonna*, attributed to Giorgione, the *Holy Family with S. George*, an early work by Paolo Veronese, and *Christ Disputing in the Temple*, an early work by Jacopo Bassano. More recent purchases catalogued below include the *Allegory of the Immaculate Conception* by Vasari and the *modello* by Naldini for a lost altar-piece of *Christ in Glory with SS. Agnes and Helena*, once in the church of S. Maria del Carmine, Florence.

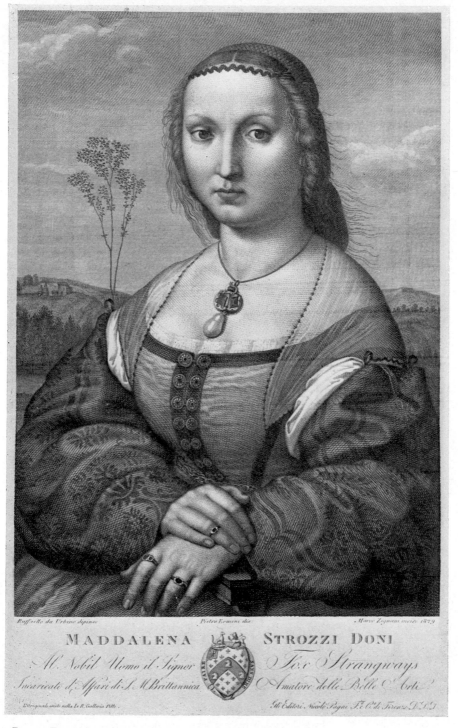

Raffaello da Urbino dipinse        Pietro Ermini dis.                    Marco Zignani incise 1829

MADDALENA        STROZZI DONI

Al Nobil Uomo il Signor        Fox Strangways

Incaricato d'Affari di S. M. Brittannica        Amatore delle Belle Arti

L'Originale esiste nella R. Galleria Pitti .        Gli Editori Nicolò Pagni F. e C.ᵢ di Firenze V.L.D.

FIG. 1. Engraving by Marco Zignani of the *Portrait of Maddalena Strozzi* after Raphael

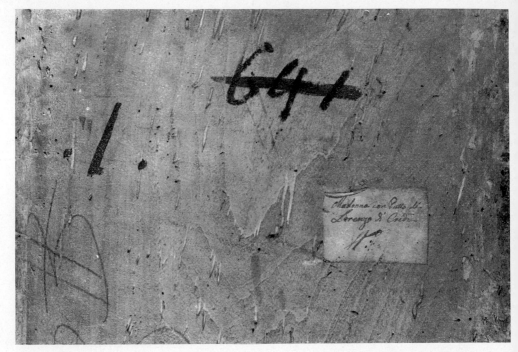

FIG. 2. Reverse of *Virgin and Child* by Lorenzo di Credi (see below, 74)

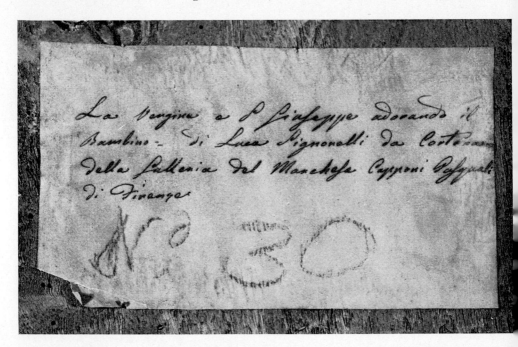

FIG. 3. Reverse of *The Holy Family*, copy after Fra Bartolommeo (see below, 17)

# CATALOGUE

## PART 1. ITALIAN SCHOOLS

ALTICHIERO               documented between 1369 and 1384

Veronese school. He also painted extensively in Padua. Most of his extant work is in fresco, and only one panel, a triptych in a private collection in America, has so far been convincingly attributed to him. A painter named Jacopo Avanzi appears to have collaborated with him. Altichiero's style is marked by the influence of Giotto, Orcagna, and Giusto de'Menabuoi. The frescoes in the Oratorio di S. Giorgio, Padua, may be considered his masterpiece.

### FOLLOWER OF ALTICHIERO

A732    THE CONSECRATION OF S. ELIGIUS          **Pl. 1**

Wood. 48·7× 67 (trefoil arched top, bowed).

Condition: good. The figures are particularly well preserved, apart from some damage to the arm of the acolyte on the bishop's left. There is an area of restoration above the left window of the chapel extending to the top of the panel, and also inwards for 20 cm. on a line with the top of the window. The panel is slightly damaged at the edges. The architectural motifs of the inside of the building are in excellent condition.

Presented by the daughters of J. R. Anderson, 1947.

Literature: *Annual Report*, 1947, 38 repr.; F. Bologna, *Opere d'arte nel Salernitano dal XII al XVIII* (Naples, 1955), p. 37; R. Longhi, 'Due pannelli del seguito di Altichiero', *Paragone*, 107 (1958), 64–5; F. Zeri, 'Altri due scomparti veronesi della fine del '300', *Paragone*, 107 (1958), 65–6 repr.

Three other panels of similar dimensions and with trefoil arched tops are related to No. A732. Longhi first published *The Birth of S. Eligius* (present whereabouts unknown), and *S. Eligius Performing a Miracle* (private collection). Dr. Federico Zeri then added the scene of *S. Eligius' Mother Foretold of her Son's Future Fame* (Philadelphia, Johnson Collection).[1] No. A732 appears to be the best preserved of these panels, which were most probably placed in the predella of an altar-piece. An alternative location would be as part of a series of scenes flanking a full-length figure of the saint.

Sir Karl Parker wrote in the *Annual Report* of 1947 that No. A732 is 'evidently by a North Italian painter (probably Veronese or Paduan) from the immediate circle of Altichiero da Zevio or Jacopo Avanzo'. Although it is not listed under the name of Tomaso da Modena in any of the editions of the Lists, Berenson once attributed the panel to that master.[2] More recently, Longhi and Zeri have both supported Parker's judgement. Professor Ferdinando Bologna originally suggested that No. A732 was by the hand responsible for the frescoes illustrating scenes from the life of Ladislas I of Hungary in the church of S. Maria Incoronata (Cappella del Crocifisso), Naples, but in a more recent discussion of these frescoes, he does not mention the panel in Oxford.[3]

Parker, Longhi, and Zeri erroneously identified the saint as S. Nicholas. Dr. Georg Kaftal (verbal communication) has proposed an identification with S. Eligius, the patron saint of goldsmiths. A scene that might have been included in the series, therefore, is the making of the golden saddle for Clovis.[4]

REFERENCES I. Inv. 3024, 51×68·3. B. Sweeny, *John G. Johnson Collection. Catalogue of Italian Paintings* (Philadelphia, 1966), p. 79. 2. Letter of 23 Aug. 1948 from Nicky Mariano. 3. F. Bologna, *I pittori alla corte angioina di Napoli 1266–1414* (Rome, 1969), pp. 346–9 where the frescoes are reproduced Pl. VIII, 6–17. In support of the attribution to a follower of Altichiero Mr. Robin Simon of Nottingham University has suggested that the depiction of the façade shown on the panel *S. Eligius Performing a Miracle* (repr. R. Longhi, 'Due pannelli del seguito di Altichiero', *Paragone*, 107 (1958), fig. 17) is dependent upon the façade of the Basilica di S. Antonio, Padua. 4. G. Kaftal, *Iconography of the Saints in Central and South Italian Schools of Painting* (Florence, 1965), pp. 375–80, No. 121.

## ANDREA DI BARTOLO                          active 1389, died 1428

Sienese school. He was the son of the painter Bartolo di Fredi. There are several signed works, but none is dated. The chronology of the *œuvre* is based on Andrea di Bartolo's stylistic development, which extends from the immediate influence of Bartolo di Fredi at the beginning of his career to that of Taddeo di Bartolo at a later date. There is an extensive *œuvre*, implying a large workshop in which a son, Giorgio, may have played an important part. Andrea di Bartolo was also actively employed in Sienese public life.

### A75  S. LUCY (PANEL FROM AN ALTAR-PIECE)                    Pl. 2
Wood. 63·5×20·5 (arched).

Condition: good. Cleaned in 1917. The figure is well preserved, although both the eyes are slightly worn. 4·5 cm. of the top of the original panel has broken off and been renewed. So too has the frame, but the shape of the cinquefoil arch is authentic.

Fox-Strangways Gift, 1850.

Literature: Berenson, 1911, 257: 1932, 9: 1936, 8: 1968, 7; F. Zeri, 'Appunti sul Lindenau-Museum di Altenburg', *Bollettino d'arte*, 49 (1964), 47 repr.

The outline of the figure is incised.

The present attribution, which first occurs in the 1932 edition of Berenson's Lists replacing an earlier attribution to Taddeo di Bartolo (1911), has been generally accepted. Five other panels, of approximately the same dimensions, with similarly shaped cinquefoil frames and identical halo patterns, were published and reproduced by Dr. Federico Zeri. They are: *S. Catherine of Alexandria* (Altenburg, Lindenau-Museum),[1] *S. Blaise* (Oslo, National Gallery),[2] *S. Benedict* (Berlin, formerly de Burlet collection, present whereabouts unknown) and *SS. Margaret* and *Cecilia* (both Paris, private collection). These panels, together with No. A75, were most probably placed, one above the other, in the pilasters of an altar-piece. No part of the main section of the altar-piece has yet been identified.

REFERENCES: 1. Inv. 66, 59·4×20·8. R. Oertel, *Frühe italienische Malerei in Altenburg* (Berlin, 1961), p. 88. 2. Inv. 1935, 59·5×19·5. The compiler is grateful to Dr. Leif Østby for this information.

## ANDREA DEL BRESCIANINO                    active 1507, last mentioned 1525

Sienese school. His real name was Andrea del Giovannantonio di Tommaso Piccinelli and he was of Brescian origin. He is recorded in Siena and Florence and was possibly a pupil of Girolamo del Pacchia, although he was more profoundly influenced by Beccafumi, Fra Bartolommeo, Raphael, and Andrea del Sarto. He collaborated extensively with his brother Raffaello and the distinction between the two hands is by no means clear. There are three important altar-pieces still extant in Siena.

## ATTRIBUTED TO ANDREA DEL BRESCIANINO

A370  PORTRAIT OF A YOUNG WOMAN                    **Pl. 3**

Wood. 58·3×45.

On the back inscribed in ink *Del Andrea del Sarto*. There is also a wax impression of a seal.[1]

Condition: fair. Cleaned and restored in 1973. The lower part of the right sleeve is modern, as this area appears to have been left unfinished. There are several small repairs on the face, specifically below the mouth, along the right side of the jaw, and also in the neck. The facial features, however, are comparatively well preserved. Worm holes have been filled

in, but there is still a prominent craquelure. The background has been strengthened throughout and an area of damage in the centre at the top edge has been repaired.

Bequeathed to the University by the Revd. Robert Finch, 1830. Transferred to the Ashmolean Museum, 1921, from the Taylor Institution.

Literature: *Annual Report*, 1921, 24.

The name of Andrea del Brescianino was first suggested in connection with No. A370 by Professor Sir Ellis Waterhouse, who inspected the portrait before cleaning and drew attention to the fact that there are several known variants.[2] Recent cleaning has revealed the true quality of the panel, which, although damaged, has passages of good quality such as the facial features and the hand holding the book. Only its present condition precludes No. A370 from being placed alongside the *Portrait of a Young Woman* in the National Gallery, Rome,[3] which is a remarkably fine example of the charm and delicacy that Andrea and Raffaello del Brescianino could bring to portraiture.

REFERENCES: 1. The seal is that of a branch of the Finch family. Compare J.-B. Rietstap, *General Illustrated Armorial*, 3rd edn., ii (Lyons, 1953-4), pl. CCCXXV, Row 2, No. 2 from the left. It is most probably the personal seal of the Revd. Robert Finch, but his pedigree has never been properly established (E. Nitchie, *The Reverend Colonel Finch* (New York, 1940), pp. 20-1 and the photograph of his tomb repr. opp. p. 64). I am grateful to Mr. Michael Maclagan for examining a photograph of the seal. 2. Formerly Berlin, Schweitzer collection, repr. Berenson (1968), iii, pl. 1571, of which there is a replica in the Musée Fesch, Ajaccio (inv. 205); formerly Northwick collection (*Catalogue of the Collection of Pictures at Northwick Park* (London, 1921), p. 9, No. 14); Colum Crichton-Stuart collection, formerly Lansdowne collection (G. E. Ambrose, *Catalogue of the Collection of Pictures belonging to the Marquess of Lansdowne, K.G., at Lansdowne House, London, and Bowood, Wilts.* (London, 1897), p. 98, No. 35), as Andrea del Sarto; formerly Heseltine collection (*Ten More Little Pictures in the Collection of J. P. H.* (privately printed, London, 1909), No. 9 repr.) as Salaino; also, another variant was in the Marczell von Nemes sale, Amsterdam, Nov. 1928, lot 25, bt. in and subsequently sold in Munich 16 June 1931, lot 28, and offered for sale again by Julius Böhler, Munich, 1-2 June 1937, lot 655. 3. Inv. 1778. N. di Carpegna, *Catalogue of the National Gallery. Barberini Palace, Rome* (Rome, 1964), pp. 11-12, repr. fig. 67. There is a better reproduction in Berenson, 1968, iii. 1570.

## FRA ANGELICO                                   active 1417, died 1455

Florentine School. Guido di Piero, known as Fra Giovanni da Fiesole, and also as Il Beato Angelico. He was first described as a friar in 1423, when he was attached to the Dominican friary at Fiesole, where he became Prior in 1450. There are a large number of autograph works, but many aspects of their chronological arrangement are still disputed. He also carried out important commissions in Cortona, Orvieto, and Rome, where he

died. A large number of assistants were active in his workshop, the most illustrious being Benozzo Gozzoli, Zanobi Strozzi, and Domenico di Michelino. His style was influenced by Lorenzo Monaco, Lorenzo Ghiberti, and Masaccio.

## STUDIO OF FRA ANGELICO

A77 A TRIPTYCH: VIRGIN AND CHILD ADORED BY ANGELS AND A DOMINICAN MONK (CENTRE PANEL); S. PETER (LEFT WING) AND S. PAUL (RIGHT WING) **Pls. 4–7**

Wood. Centre panel, 41 × 26·8 (arched); 46·0 × 31·6 (including frame); left wing, 44·9 × 16·3; right wing, 44·8 × 15·2.

Inscribed on the scroll, DISCITE AME QUIA MITIS SUM SUM . . . (Matthew 11: 29).

On the back, a label inscribed by an eighteenth-century hand, *Tabernacolo di Fra Gio / vanni Angelico di Sto. / Marco . . . / No. 26.* The number *.26.* also occurs and another number (*.3.*) has been crossed through. In addition, there is a Fox-Strangways label (*No. 6*).

Condition: fairly good. Cleaned in 1947. The centre panel is apparently quite well preserved, although there is retouching on the Virgin's drapery and on the draperies of the two angels on the left above the kneeling Dominican. Some small damages to the angels in the foreground, where the panel is rubbed, have been made good. The facial features of the figures on the lateral panels are badly worn and have been slightly re-touched. These two figures might have suffered from overcleaning at some time in the past. Their draperies are better preserved.

Fox-Strangways Gift, 1850.

Literature: R. Langton Douglas, *Fra Angelico* (London, 1900), p. 39; Crowe and Cavalcaselle, *History*, 2nd edn., iv (1911), 93, n. 2; Van Marle, *Development*, x (1928), 161 repr.; Berenson, 1936, 19: 1963, 14; L. Ragghianti Collobi, 'Studi angelichiani', *Critica d'arte*, N.S. 2 (1955), 40; J. Pope-Hennessy, *Fra Angelico*, 2nd edn. (London, 1974), p. 230 repr.

The triptych was carefully examined by Mr. F. S. Walker of the Research Laboratory for Archaeology and the History of Art, Oxford, in 1972.[1] The panels are all of poplar wood, but the side panels appear to have been cut down to their present shape only comparatively recently, perhaps during the last half of the eighteenth century. The shutters do not close properly, although this may be due to bowing or to the reframing of the centre panel. The hinges have been renewed. On this evidence alone it cannot be positively asserted that the triptych has been made up, but it

seems likely that the two side panels were either added or adapted in some way at a later date. The backs of all three panels are painted to simulate porphyry.

There are minor *pentimenti* in several of the figures on the centre panel (for example, at the Virgin's right hand).

Regardless of the observations made above, to the effect that No. A77 may have been made up, there is little doubt in the compiler's mind that the same hand was responsible for all three panels. The condition of the two lateral panels might tempt one to ascribe them to a different hand, but any such conclusion would be unjustified.

Langton Douglas in his monograph, and again later in the second edition of Crowe and Cavalcaselle, and Van Marle, attributed No. A77 to an anonymous follower of Angelico. More recently, Dottoressa Licia Ragghianti Collobi has suggested that the painter whom Sir John Pope-Hennessy designated as the Master of Cell 36 in San Marco was responsible for the triptych in Oxford. Michel Laclotte (verbal communication) is of the opinion that the triptych was painted by Angelico himself.

The present writer finds that there are greater similarities between the style of No. A77 and the painter of Cell No. 31 in San Marco, an attribution with which Pope-Hennessy concurs.[2] This anonymous follower of Angelico also painted the five following cells in the monastery and may have assisted the master on the predella of the San Marco altar-piece, although this is far less certain.[3]

The figures of the saints on the side panels of No. A77 are derivative.[4]

REFERENCES: 1. The findings are reported in a letter of 28 Feb. 1972. 2. J. Pope-Hennessy, *Fra Angelico*, 2nd edn. (London, 1974), p. 208. 3. Pope-Hennessy, op. cit., pp. 199–202. Compare, in particular, the figures on the left of the scene of *The Burial of SS. Cosmas and Damian* (Pope-Hennessy, pl. 63). 4. Compare the characterization of the same saints in the pilasters of the *Deposition* (Florence, Museo di San Marco), formerly in the church of S. Trinita, Florence, repr. F. Schottmüller, *Fra Angelico da Fiesole. Klassiker der Kunst* (Stuttgart and Leipzig, 1911), p. 59.

## FOLLOWER OF FRA ANGELICO

A78   THE ANNUNCIATION                                    Pl. 8

Wood. 22·2 × 18·7 (slightly bowed).

On the back a label inscribed by an eighteenth-century hand: *La: Annunziata di | Fra Giovanni Angeli | co* . . . . The number *.62.* occurs together with a Fox-Strangways label (*No. 7*). There is also an old inscription on the back of the panel, *di mano da fra . . . angelico.*

Condition: fair. Cleaned in 1952. A fine vertical split to the left of the line of trees depicted on the left side extends half-way down the panel.

Fox-Strangways Gift, 1850.

Literature: Crowe and Cavalcaselle, *History*, 2nd edn., iv (1911), 92, n. 2; Van Marle, *Development*, x (1928), 479–80 repr.; J. R. Spencer, 'Spatial Imagery of the Annunciation in Fifteenth Century Florence', *Art Bulletin*, 37 (1955), 276 repr.; L. Ragghianti Collobi, 'Studi angelichiani', *Critica d'arte*, N.S. 2 (1955), 47, n. 10 (incorrectly described as in the collection at Christ Church, Oxford); A. Neumeyer, 'The Lanckoronski Annunciation in the M. H. de Young Memorial Museum', *Art Quarterly*, 28 (1965), 13 repr.

There are many incised lines in the architecture.

No. A78 was tentatively attributed to Benozzo Gozzoli by Langton Douglas in the second edition of Crowe and Cavalcaselle, but Van Marle was of the opinion that this small panel might be an early work by Pesellino. Neither of these attributions can be maintained today. The weaknesses apparent in the handling of the perspective and the drawing of the architecture suggest that the painter was only a minor follower of Angelico, perhaps indirectly acquainted with the master's style through the influence of an intermediary, such as the assistant who was employed on the predella of *The Coronation of the Virgin* in the Louvre.[1]

The panel was cited by Professor John Spencer and Dr. Alfred Neumeyer in recent discussions on the treatment of the theme of the Annunciation in Florentine painting during the opening decades of the fifteenth century. Together with other more famous representations, including that by Domenico Veneziano (Cambridge, Fitzwilliam Museum) and that formerly in the Lanckoronski collection (San Francisco, de Young Memorial Museum), it has been argued that No. A78 distantly reflects the composition of a lost *Annunciation* by Masaccio, once in the church of S. Niccolò oltr'Arno, Florence, and described in some detail by Vasari (ii. 290). A more immediate prototype for the composition of No. A78, however, is, as Dottoressa Licia Ragghianti Collobi first pointed out, the *Annunciation* in the Museo di San Marco, Florence, which is one of the thirty-five scenes, mainly illustrating the life of Christ, painted to decorate the doors of the silver chest in the church of SS. Annunziata in Florence.[2]

The triangular patterns visible on both sides and along the lower edge may be the marks of an elaborate quatrefoil frame. They are not evident along the top edge of the panel, either because of cutting, or because of over-painting.

REFERENCES: 1. J. Pope-Hennessy, *Fra Angelico*, 2nd edn. (London, 1974), pp. 215–16.

The predella scenes are reproduced by the same author in his article 'The Early Style of Domenico Veneziano', *Burlington Magazine*, 93 (1951), 216–23, figs. 12–15. 2. Repr. after cleaning by M. Salmi, *Mostra dell'Angelico. Catalogo* (Rome, 1955), pl. LIV.

## APOLLONIO DI GIOVANNI      1415 or 1417–1465
## MARCO DEL BUONO GIAMBERTI      1403–1489

Florentine school. These two painters were partners in the running of a workshop which was in operation by 1446 and specialized in painting *cassoni*. Their output was considerable and Apollonio also painted miniatures. The style of Marco del Buono has yet to be defined. Although older than Apollonio, he need not necessarily have played a more important role in the running of the workshop. His son Antonio was a painter and was made Apollonio's heir. The influence of the International Gothic style is evident in Apollonio's early works, but later he became interested in adopting a more advanced style derived in the main from Domenico Veneziano.

## STUDIO OF APOLLONIO DI GIOVANNI AND MARCO DEL BUONO GIAMBERTI

A90   ASSASSINATION AND FUNERAL OF JULIUS CAESAR (*CASSONE PANEL*)      **Pls. 9–11**

Wood. 38·5 × 134·5.

Inscribed above the key figures, APPOLLO, CESARE, CHASCHA, BRUTO.

On the back a Fox-Strangways label (*No. 3*) and the title of the panel inscribed by his own hand, *Life and Death of Caesar*. An earlier hand has inscribed two other labels, the first, *Etruria Pittrice No. 85* (apart from the number 85, which has been filled in, this label is printed) and below that the second, *No. 85 | Spinello Aretino | Discepolo di Jacopo | di Casentino | 1328+1410*. The following numbers also occur: *.24.*, *119.*, and *580*, all drawn in brown stain with the brush, the last two crossed through.

Condition: fair. There is pitting top centre caused by the keys of the *cassone*. Flaking has occurred at both ends. There is a certain amount of surface dirt. The faces of the figures in the centre are badly damaged, but the faces of all the other figures are comparatively unharmed.

Fox-Strangways Gift, 1850.

Literature: Schubring, *Cassoni*, i (1915), 306, No. 366; R. Offner, *Italian Primitives at Yale University* (New Haven, 1927), p. 30 repr. (detail); Van Marle, *Development*, x (1928), 550; Berenson, 1932, 347: 1936, 283: 1963, 18; W. Stechow, 'Marco del Buono and Apollonio di Giovanni, Cassone Painters', *Bulletin of the Allen Memorial Art Museum, Oberlin College*, I

(1944), 17; E. Gombrich, 'Apollonio di Giovanni: A Florentine cassone workshop seen through the eyes of a humanist poet', *Journal of the Warburg and Courtauld Institutes*, 18 (1955), 21 and 25 repr., reprinted in *Norm and Form* (London, 1966), pp. 16 and 19 repr.; E. Callmann, *Apollonio di Giovanni* (Oxford, 1974), p. 47, n. 44, and pp. 74–5, Cat. no. 56 repr.

There are incised lines in the architecture.

No. A90 was attributed to Jacopo Sellaio by Schubring, by Berenson to the Master of the Jarves Cassoni, and by Offner to the Virgil Master, before the true identification of the workshop run by Apollonio di Giovanni and Marco del Buono was established firstly by Professor Wolfgang Stechow and then by Professor Sir Ernst Gombrich.

No. A90 clearly reflects the style of the miniatures in the Virgil manuscript in the Biblioteca Riccardiana, Florence,[1] which is the starting-point for the reconstruction of Apollonio's *œuvre*. The miniatures are in his mature style and No. A90 may therefore be reasonably dated *c.* 1455–60. Dr. Ellen Callmann regards the figures on No. A90 as having been painted by Apollonio himself with the background filled in by assistants. One other workshop variation of the *Assassination and Funeral of Julius Caesar* is known.[2]

Plutarch's account of Caesar's death (*Lives*, lxii–lxviii) seems to have been followed on No. A90. On the extreme left Caesar is seen making a sacrifice to Apollo in order to ascertain whether the omens are favourable for his visit to the Senate. Left of centre he is seen making his way to the Forum and in front of the Pantheon[3] is handed the message of warning from Artemidorus, a teacher of philosophy. Right of centre the murder of Caesar is depicted in the Senate, and on the extreme right in front of Trajan's Column his body is burnt on the funeral pyre. Above the wall in the background on the right is Caesar's spirit, which was to trouble Brutus at Philippi.

Gombrich suggests that the figure standing to the right of the pyre feeding the flames with faggots may be derived from an antique figure on the Meleager sarcophagus from the Villa Albani.[4] The same writer makes the point that the subject-matter of the panel—the failure of a proud mortal to pay heed to warning—would not have been without political significance for whichever Florentine family the *cassone* was painted.[5]

REFERENCES: 1. Biblioteca Riccardiana, MS. 492. See E. Callmann, *Apollonio di Giovanni* (Oxford, 1974), pp. 55–6, Cat. no. 7 repr. 2. Callmann, op. cit., p. 75, No. 57 repr. (present whereabouts unknown), who also lists two other later versions (p. 47, n. 44). 3. The view of the Pantheon is not strictly accurate. The inscription along the

pediment has been omitted together with several of the columns supporting the portico. Furthermore, the architectural order of the capitals is Ionic and not Corinthian, as should be the case. Cf. E. Nash, *Pictorial Dictionary of Ancient Rome*, ii (London, 1962), figs. 895–900. 4. For the Meleager sarcophagus see E. Gombrich, 'A Classical Quotation in Michael Angelo's "Sacrifice of Noah"', *Journal of the Warburg Institute*, 1 (1937), 69 repr. pl. 8b. 5. E. Gombrich, 'Apollonio di Giovanni: A Florentine caissone workshop seen through the eyes of a humanist poet; *Journal of the Warburg and Courtauld Institutes*, 18 (1955), 29, n. 2; reprinted *Norm and Form* (London, 1966), p. 142, n. 42. Also Callmann, op. cit., p. 47.

### A92 THE RAPE OF THE SABINES (?) (FRAGMENT FROM A *CASSONE*)
**Pl. 12**

Wood. 38·2 × 60·3.

On the back a label inscribed by Fox-Strangways: *Damaged picture, unknown Master.*

Condition: poor. Cleaned and restored 1953–4. The panel is damaged throughout and extensively retouched, but some traces of original paint do remain on most of the figures. The faces of those on the right have suffered most and are mainly repainted. Similarly, the draperies of the figures on the left, where the faces are comparatively well preserved, have been repainted. The quality of the panel, particularly the vividness of the colours (blues, reds, pink, white, and yellow), is by no means totally lost. The green on the hedge above the wall on the left has darkened.

Fox-Strangways Gift, 1850.

Literature: R. Offner, *Italian Primitives at Yale University* (New Haven, 1927), p. 30 repr. (detail); Van Marle, *Development*, x (1928), 550; Berenson, 1932, 347: 1936, 283: 1963, 18; E. Gombrich, 'Apollonio di Giovanni: A Florentine cassone workshop seen through the eyes of a humanist poet', *Journal of the Warburg and Courtauld Institutes*, 18 (1955), 27–8 repr., reprinted in *Norm and Form* (London, 1966), 21–2 repr.; B. Anderson, 'A Cassone Puzzle Reconstructed', *Museum Studies. The Art Institute of Chicago*, 5 (1970), 23 and 26 repr.; E. Callmann, *Apollonio di Giovanni* (Oxford, 1974), p. 41, n. 14, pp. 60, 71, and 72, Cat. no. 47 repr.

The panel has been trimmed on all sides and almost certainly cut on the left.

Offner classified No. A92 as by the Virgil Master, Berenson as by the Master of the Jarves Cassoni. Van Marle followed Offner. There is no mention of No. A92 in Schubring's corpus.

Professor Sir Ernst Gombrich identified the subject of No. A92 as the *Entertainment of the Sabines*, the literary source for which is Livy, *Ab Urbe Condita*, i. 9. Another panel, identified by Gombrich as the *Rape of the*

*Sabines* (National Gallery of Scotland), which has also been trimmed and shows signs of having been cut on the right, has been discussed in connection with No. A92.[1] Gombrich proposed that these two fragments were originally united to form one panel showing the complete narrative of the *Rape of the Sabines*. Owing to basic differences in format this cannot have been the case.[2] More recently, it has been suggested by Dr. Barbara Anderson that they formed the end-pieces or *testate* of a *cassone*, and that a panel in Chicago (The Art Institute), which, in her opinion, represents the *Reconciliation of the Sabines*, was placed in the front of the *cassone*. Dr. Ellen Callman argues that the correct title of the panel in Chicago is not the *Reconciliation of the Sabines*, but the *Continence of Scipio*[3] and suggests very plausibly that both the panels in Oxford and Edinburgh are fragments from the right-hand ends of two separate *cassoni* fronts. No. A92 need not necessarily represent an incident from the story of the Romans and the Sabines, although from the nature of the composition and the gesture of the figure on the right, possibly intended for Romulus, it seems fairly likely. Stylistically, No. A92 belongs to the fifth decade.

REFERENCES: 1. Inv. 1974, 38·8 × 61·7. *National Gallery of Scotland: Catalogue of Paintings and Sculpture* (Edinburgh, 1957), pp. 91–2 as Florentine school, fifteenth century. E. Callmann, *Apollonio di Giovanni* (Oxford, 1974), pp. 71–2, Cat. no. 46 repr. 2. The panel in Edinburgh has a join approximately 3 cm. from the lower edge, which is not evident along the panel in Oxford. Even more significant is the fact that when due allowance is made for cutting and the loss of a middle section of some 10 cm. or so, the two panels do not form a continuous scene. (Letters from Mr. Hugh Brigstocke of the National Gallery of Scotland dated 16 and 17 July 1968.) 3. Inv. 33. 1036, 40·1 × 136·3. *Paintings in the Art Institute of Chicago* (Haarlem, 1961), p. 225, as Italian school, sixteenth century, entitled *The Betrothal and Wedding Dance*. Callmann, op. cit., p. 73, Cat. no. 50.

## ANONYMOUS ARETINE SCHOOL (?) 1480–1500

### A734 THE CRUCIFIXION WITH SS. BERNARDINO OF SIENA AND LAWRENCE Pl. 13

Wood. 38·2 × 26·8.

On the back a label inscribed by a nineteenth-century hand *1331 Pollajuolo*. This is stuck over an older inscription to *Angelico*, which has been inscribed on the panel.

Condition: fair. There is a vertical split on the right, extending the height of the panel. The figures are well preserved, apart from slight rubbing in the haloes.

Presented by the daughters of J. R. Anderson, 1947.

Literature: *Annual Report*, 1947, 39.

The underdrawing and several minor *pentimenti* in the figure of Christ are clearly visible. The beams of the cross are marked by incised lines, which extend to the edges of the panel. The mottled appearance of the paint surface, particularly in the sky and foreground, is due to the fact that the paint has been thinly applied in these areas.

The proposal that No. A734 was executed by a painter from the Aretine school was made by Dr. Federico Zeri (written communication).[1] Comparison with the frescoed *Crucifixion with SS. Francis, Clare, John Evangelist, James, and Benedict* by Bartolomeo della Gatta, in the Duomo, San Sepolcro, shows that the painter of No. A734 was subject to that master's influence, and this, to some extent, confirms Zeri's hypothesis.

In the *Annual Report* of 1947, Sir Karl Parker described No. A734 as 'a work of real distinction and beauty', although he was of the opinion that the painter was 'of no very high order'. The original quality of the panel is still evident in the drawing of the figures. A notable feature is the abundant use of gold heightening in the landscape, in both the foreground and the middle distance, as well as on the book held by S. Bernardino and on the front of S. Lawrence's vestments. The gold appears to have been applied with short, hurried strokes drawn with the finest of brushes. This technique suggests the hand of a miniaturist, an observation supported by the delicate decoration along the edges of S. Lawrence's drapery and by the system of highlighting on the faces of both the saints.

In the 1961 edition of the Ashmolean catalogue, reference was made to a painting of the *Crucifixion with SS. Jerome and Francis*, formerly in the Severino Spinelli collection, Florence. Dr. Zeri has confirmed that this is not by the same hand as No. A734.[2]

REFERENCES: 1. Letter of 5 Oct. 1970. 2. This panel was apparently sold by the Galleria Pesaro, Florence, in 1928, and is now in the possession of Dr. Alberto Saibene, Milan.

## BACCHIACCA                                    1495–1557

Florentine school. His real name was Francesco d'Ubertino, called Il Bacchiacca. He was a pupil of Perugino and of Franciabigio. In Florence he was frequently employed by the Medici. He also worked in Rome. There are several portraits by his hand, but many of his religious compositions are derived from Andrea del Sarto, Raphael, Leonardo, and Michelangelo. Later he adopted the Mannerist tendencies of Pontormo and Rosso.

## ATTRIBUTED TO BACCHIACCA

A67 THE HOLY FAMILY (known as *Il Silenzio*), after Michelangelo

**Pl. 14**

The book held in the Virgin's right hand is inscribed:

*VERITAS DE | TERRA ORTA | EST ET IUS | TITIA DE | COGLO PRO | SPEXIT.*

Slate (cradled). 52·5 × 41·2.

A label with the following inscription by a nineteenth-century hand was once on the back:[1] *Il presente quadro dipinto in | lavagna esprimente il Sogno di | Michelagnolo che dicessi dipinto | da Michelagnolo stesso e sempre | estito fino da anni dargento a | questa parte nella Nobil . . . | Ganucci il quale e sempre pas | sato di essendosi sempre risiutati di Venderlo | . Ma da mesi diretto a questa parte-(?)-volonta testamentaria | del desunto Marchese Ganucci fatto presso e nelle Manis delle di lui Figlie Eredi Illustrissima Signora . . . besia Galli | , e Illustrissima Signora Marchesa Guadagni | le quali si determinanoro di far | ne l'o . . . Vendita.*

    *Il detto quadro sono di opinione che | lia dipinto dal risetto Michelagnolo | in Siggⁱ. Benvenuti, B . . . nol: e Illmᵒ. Sigᵉ. Antonio Monsalvi.*

Condition: poor. The surface is badly worn throughout with a considerable amount of retouching on the flesh parts. There is a vertical crack in the paint surface, extending the height of the picture through the centre of the Virgin's body. There is further retouching in this area.

Collection: Ganucci, Florence.[2]

Bequeathed by George Fairholme, 1846.

Literature: J. C. Robinson, *A Critical Account of the Drawings by Michel Angelo and Raffaello in the University Galleries, Oxford* (Oxford, 1870), p. 100, No. 88; H. Thode, *Michelangelo: Kritische Untersuchungen über seine Werke*, ii (Berlin, 1908), 436; H. Thode, *Michelangelo und das Ende der Renaissance*, iii, pt. 2 (Berlin, 1912), 558; F. Saxl, 'Veritas Filia Temporis', in *Essays Presented to Ernst Cassirer* (Oxford, 1936), p. 217.

The text of the inscription on the book is Psalm 85: 12.

    No. A67 is one of numerous variants of Michelangelo's famous composition of the Holy Family, known as *Il Silenzio*, which was engraved in 1561 by Giulio Bonasone. Thode listed a number of copies based on Michelangelo's composition and further versions are recorded by Mr. Cecil Gould in his National Gallery catalogue.[3] The original drawing for the composition by Michelangelo is in the possession of the Duke of

Portland and was first published by Gould.[4] Professor Charles de Tolnay suggests a date *c.* 1538–40 for the drawing, that is during the period of Michelangelo's friendship with Vittoria Colonna, for whom the drawing might well have been made.[5] The iconography of the composition has been discussed by Saxl, de Tolnay,[6] and Firestone.[7] According to Saxl, the Virgin is shown lifting the transparent veil draped over the body of Christ, whose birth into this world represents the presence of Truth on earth. The Virgin's gesture, therefore, symbolizes the revelation of Truth to all who recognize the Christ Child as the Saviour.

There is no landscape background in Michelangelo's original composition, and Bonasone only introduces a glimpse of landscape in the background on the right of his engraving.[8] As far as the present writer is aware, no other extant copy or variant of this famous composition has a complete landscape as on No. A67.

Robinson ascribed No. A67 to Marcello Venusti. In the compiler's opinion, the distinctive palette (light green, ice blue, orange, and carmine), the treatment of the landscape, the handling of the draperies, and the modelling of the silver-grey flesh parts, in addition to the facial type of the Virgin, betray the hand of Bacchiacca.[9] Even though No. A67 is somewhat damaged the personal characteristics of Bacchiacca's style are still clearly recognizable.

REFERENCES: 1. A garbled transcription of this label is in the Departmental files. 2. Reference may be made to L. Ginori Conti, *I palazzi di Firenze*, i (Florence, 1972), 265–6. 3. H. Thode, *Michelangelo: Kritische Untersuchungen über seine Werke*, ii (Berlin, 1908), 434–9, and by the same author, *Michelangelo und das Ende der Renaissance*, iii, pt. 2 (Berlin, 1912), 558–60. Also C. Gould, *National Gallery Catalogues. The Sixteenth-Century Italian Schools (excluding the Venetian)* (London, 1962), pp. 101–2. The most important variants are reproduced as follows: Vienna, Kunsthistoriches Museum, inv. 303, by Venturi, *Storia*, ix, pt. 6 (1933), fig. 269 as by Venusti; Dresden, inv. 73. by Thode, op. cit. (1912), on 559; London, National Gallery, inv. 1227, by C. de Tolnay, *Michelangelo: V. The Final Period* (Princeton, 1960), pl. 310. The important version in Leipzig, inv. 271, signed *Marcellus Venusto* and dated 1563 is repr. by G. Firestone, 'The Sleeping Christ Child in the Renaissance', *Marsyas*, 2 (1942), 44–62, fig. 26. 4. C. Gould, 'Some Addenda to Michelangelo Studies', *Burlington Magazine*, 93 (1951), 279–81, fig. 1. 5. de Tolnay, op. cit., pp. 193–4, Cat. no. 196. 6. de Tolnay, op. cit., p. 65. 7. Firestone, loc. cit. 8. Repr. de Tolnay, op. cit., pl. 309. 9. Compare the works reproduced by L. Nikolenko, *Francesco Ubertini Called Il Bacchiacca* (New York, 1966), figs. 36, 35, and 51, which are respectively the *Baptism of Christ* at Vassar College, Poughkeepsie, New York, *The Deposition*, in the Uffizi, and the *S. John the Baptist in the Wilderness* in the Kunsthalle, Bremen. Bacchiacca also made a copy after Michelangelo's *Doni Tondo*, for which see Nikolenko, op. cit., p. 54, fig. 58 where again the background of the original is replaced by a landscape.

# BARNA DI SIENA

active during the first half of
the fourteenth century

Sienese school. Lack of documents and the conflicting evidence of the secondary sources has complicated the identification of this painter. His main work is the series of frescoes of scenes from the Life of Christ in the Collegiata at San Gimignano. These show the influence of Simone Martini and of Pietro Lorenzetti, while some of the compositions are derived from the *Maestà* by Duccio. He may have been the pupil of Memmo di Filipuccio, the father of Lippo Memmi. The attribution of panels to Barna is still disputed.

## ATTRIBUTED TO BARNA DA SIENA

A73 THE CRUCIFIXION AND LAMENTATION                     **Pl. 15**
(RIGHT WING OF A DIPTYCH)

Wood. 47·3 × 32·9; 52·7 × 38·3 (including frame).

On the back a label inscribed by an eighteenth-century hand: *Un Crocifisso a Santi / di Simone Memmi*. The number *.27.* occurs.

Condition: very good. Cleaned in 1949. Apart from some local damages, No. A73 is remarkably well preserved for a panel of this date. The Virgin's mantle appears to have been repainted, likewise the hand and forearm of the mourner seated at the head of Christ. There are small retouches on the draperies of most of the other figures. The gold background is intact, apart from a scratch to the right of Christ's loin-cloth. The figures of Christ and of S. John, and the head of S. Peter, are in excellent condition.

Fox-Strangways Gift, 1850.

Literature: Waagen, *Treasures*, iii. 53; Crowe and Cavalcaselle, *History*, 2nd edn., iii (1908), 68, n. 1.; W. Suida, 'Trecento-Studien', *Monatshefte für Kunstwissenschaft*, 7 (1914), 4; R. Van Marle, 'Unknown Paintings by Simone Martini and his followers—II', *Apollo*, 4 (1926), 214 repr.; E. Sandberg-Vavalà, *La croce dipinta italiana e l'iconografia della passione* (Verona, 1929), p. 462, No. 70; C. Weigelt, 'Minor Simonesque Masters', *Apollo*, 14 (1931), 12 n.; Berenson, 1932, 41: 1936, 35; 1968, 26 repr.; R. Offner, 'The Straus Collection Goes to Texas. Comments on its more important aspects', *Art News*, 44 (1945), 17; J. Pope-Hennessy, 'Barna, the Pseudo-Barna and Giovanni d'Asciano', *Burlington Magazine*, 88 (1946), 36; M. Meiss, *Painting in Florence and Siena after the Black Death* (Princeton, 1951), p. 21 n. 27; M. Meiss, 'Nuovo dipinti e vecchio problemi', *Rivista d'arte*, 30 (1955), 142–4 (incorrectly designated as Fitzwilliam Museum, Cambridge); F. Zeri, 'La riapertura della Alte Pinakothek di Monaco', *Paragone*, 95 (1957), 66; C. Volpe, 'Precisazioni sul "Barna" e sul "Maestro

di Palazzo Veneziano" ', *Arte antica e moderna*, 10 (1960), 152–3 repr.; E. Carli, 'Ancora dei Memmi a San Gimignano', *Paragone*, 159 (1963), 35; S. Delogu Ventroni, *Barna de Siena* (Pisa, 1972), pp. 52–4 and 64–5, Cat. no. 28.

Nearly all the outlines of the figures have been incised. The paint has not been filled in at the fingertips of S. Peter's right hand.

Offner first observed that No. A73 was the right wing of a diptych, the left wing of which is a panel of the *Annunciation*, now in Berlin-Dahlem (Staatliche Museen).[1]

Waagen ascribed No. A73 to Simone Martini. The attribution to Barna, first tentatively suggested by Langton Douglas in the second edition of Crowe and Cavalcaselle, and again later by Suida, has recently been upheld by Professor Carlo Volpe and by Dottoressa Sebastiana Delogu Ventroni. Other scholars have suggested the Master of the Straus Madonna (Weigelt and Offner), Lippo Memmi (Van Marle), and Giovanni d'Asciano (Sir John Pope-Hennessy). Both Professor Millard Meiss and Dr. Federico Zeri have independently favoured an attribution to an anonymous follower of Barna, whom they call the Master of the Ashmolean Crucifixion.

Comparison with the frescoes at San Gimignano, however, suggests that the attribution to Barna is the most valid in the present state of knowledge. The scenes of *The Agony in the Garden*, *The Way to Calvary*, *The Betrayal of Christ*, and *The Cruxifixion*, which can all safely be regarded as Barna's own work as opposed to that of his assistant Giovanni d'Asciano, reveal striking similarities in the drawing of the features and the treatment of the draperies.[2] The compiler would also maintain that the compelling power with which the two scenes are handled on No. A73 is not at all unworthy of the painter of the large fresco of the *Crucifixion* at San Gimignano, which is the climax of the series and the fresco with which the panel in Oxford has most in common. Although Volpe has argued in favour of a date *c.* 1330 for the frescoes in the Collegiata, they are normally dated in the fifth decade, and regarded as Barna's last work. No. A73 is surely close in date to these frescoes.

There is, therefore, good reason for including No. A73 among a small group of paintings, which is now generally regarded as representative of Barna's work on panel. The group includes: *S. Agnes* (Worcester, Art Museum),[3] *Mystic Marriage of S. Catherine* (Boston, Museum of Fine Arts),[4] *Virgin and Child* (Kress collection),[5] *Christ Carrying the Cross* (New York, Frick collection),[6] and the *Two Hermit Saints* (Altenburg, Lindenau-Museum),[7] to which *Christ Blessing* (Douai, Musée) is related.[8]

The iconography of No. A73 is unique and no other representations which combine Christ on the Cross with the Lamentation are known. The combining of these two scenes serves to emphasize the symbolic significance of the death of Christ in place of mere narrative.

Certain aspects of the composition recall the scene of the *Entombment* from Simone Martini's Passion polyptych, specifically the anguished pose of S. John and the female mourners in the foreground.[9] The positioning of one of these mourners with her back turned towards the spectator is a motif used by Giotto in his scene of the *Lamentation* in the Arena Chapel at Padua and also by Pietro Lorenzetti on the panel of the *Obsequies of Santa Umiltà* in the Uffizi.[10] Evelyn Sandberg-Vavalà suggested that the figure on the left of the Cross was S. Nicodemus, but this must surely be S. Peter. Five Holy Women are depicted around Christ's body. On a scriptural basis there should only be four Marys, but Mary Magdalen occasionally occurs twice in some compositions, and the figure on the extreme right of No. A73 is probably intended as a second representation of this figure.[11] None the less, both Matthew and Mark refer to other women besides the four Marys witnessing the Crucifixion, and in Italian painting the number of attendant female figures at the Lamentation is often unlimited.

REFERENCES: 1. Inv. 1142, 53 × 38·5. *Beschreibendes Verzeichnis der Gemälde im Kaiser-Friedrich-Museum* (Berlin, 1931), pp. 446–7. Both panels are reproduced together by Berenson, 1968, ii, pls. 336–7. A detailed description of the physical appearance of the panel in Berlin was kindly provided by Professor Robert Oertel (letter of 13 May 1969), to whom the compiler is indebted. Both No. A73 and the panel in Berlin have been covered on the back with a layer of *gesso*, which has been painted to simulate porphyry. The format and framework of the panels are identical, likewise the punching. 2. The whole series is reproduced by O. Nygren, *Barna da Siena. Monografi över en Fresk* (Helsinki, 1963); also by S. L. Faison, 'Barna and Bartolo di Fredi', *Art Bulletin*, 14 (1932), 285–96, figs. 6, 5, 10, 30 respectively, with details of the *Crucifixion*, figs. 15 and 16. J. Pope-Hennessy, 'Barna, the Pseudo-Barna and Giovanni d'Asciano', *Burlington Magazine*, 87 (1946), 36, attributes *The Agony in the Garden* to Giovanni d'Asciano. 3. Inv. 1923. 35. 4. Inv. 15. 1145. *Summary Catalogue of European Paintings in Oil, Tempera and Pastel* (Boston, 1955), p. 2. 5. K 459. F. R. Shapley, *Paintings from the Samuel H. Kress Collection. Italian Schools XIII–XV Century* (London, 1966), p. 50, fig. 128. 6. Inv. 27. 1. *The Frick Collection. An Illustrated Catalogue*, ii (New York, 1968), 189–92 repr. 7. Inv. 44 and 45; R. Oertel, *Frühe italienische Malerei in Altenburg* (Berlin, 1961), pp. 75–6, repr, pls. 10a and b. 8. See M. Laclotte, *De Giotto à Bellini* (Paris, 1956), p. 2, No. 2, repr. pl. 1. Also see G. Coor, 'Two unknown Paintings by the Master of the Glorification of S. Thomas and Some Closely Related Works', *Pantheon*, 19 (1961), 127, where the panel at Douai is reproduced (figs. 1–3) alongside the *Two Hermit Saints* at Altenburg. 9. G. Paccagnini, *Simone Martini* (Milan, 1955), pp. 110–21, fig. 30. 10. For the pagan prototype of this figure see A. Bush-Brown, 'Giotto: Two Problems in the Origin of his Style', *Art*

*Bulletin*, 34 (1952), 45. 11. For the number of Marys present at the Crucifixion, see F. L. Cross, *Oxford Dictionary of the Christian Church* (Oxford, 1958), pp. 870-1. See further E. Hennecke, *New Testament Apocrypha*, ed. W. Schneemelcher, Eng. edn., i (London, 1963), *The Relatives of Jesus*, pp. 426-7. For an extended discussion on the dramatis personae of the scenes of the Entombment, Deposition, Descent from the Cross, and Pietà, see K. Birkmeyer, 'The Pietà from San Remigio', *Gazette des beaux-arts*, 60 (1962), 459-80. Birkmeyer points out that the Mary Magdalen occurs twice on the San Remigio *Pietà* in the Uffizi (inv. 454). Also compare the account of the Crucifixion in the *Meditationes Vitae Christi*, ed. I. Ragusa and R. B. Green (Princeton, 1961), pp. 335, 342, and 344-5, which was a popular source for painters of this period.

## BARTOLOMEO DEGLI ERRI    born shortly before 1430, still alive 1479

Modenese school. He was born into a family of painters and worked together with his brother, Agnolo, in partnership with another Modenese family headed by Antonio and Francesco Azzi. The Erri brothers painted in a provincial style, dependent upon the Lombard and Ferrarese schools, but the distant influence of Piero della Francesca is detectable. There are documented works by both Agnolo and Bartolomeo and so a firm basis for the separation of their hands does exist.

A93   S. VINCENT FERRER PREACHING BEFORE A POPE (PANEL FROM AN ALTAR-PIECE)    Pl. 16

Wood (cradled). 62·2 × 61·7.

Condition: poor. Cleaned in 1957. The surface is worn throughout. The panel is damaged at the edges. There is heavy repainting, particularly in the foreground along a vertical split in the middle of the panel. Several other splits can be made out. Much of the retouching in the architecture has not been properly toned in. Some of the faces are quite well preserved.

Provenance: S. Domenico, Modena (the old church was demolished in 1708, see Commentary below).

Fox-Strangways Gift, 1850.

Exhibited: London, New Gallery, *Exhibition of Venetian Art* (1894-5) (3).

Literature: Crowe and Cavalcaselle, *History North Italy*, i (1871), 113: 2nd edn., i (1912), 114; C. J. Ffoulkes, 'L'esposizione dell' arte veneta a Londra', *Archivio storico dell'arte*, Ser. 2, i (1895), 70 and 247; G. Gronau, 'Correspondance d'Angleterre. L'Art vénitien à Londres, à propos de l'Exposition de la New Gallery—1', *Gazette des beaux-arts*, Ser. 3, 13 (1895), 166-7; G. Gronau, 'Litteraturbericht: Venetian art', *Reportorium für Kunstwissenschaft*, 19 (1896), 137-8; B. Berenson, *The Study and Criticism of Italian Art* (London, 1903), p. 118 n.; W. Suida, 'Studien zur lombardischen

Malerei des XV. Jahrhunderts', *Monatshefte für Kunstwissenschaft*, 2 (1909), 484–6 repr.; L. Testi, *La storia della pittura veneziana*, ii (Bergamo, 1915), 272–4; B. Berenson, 'Nine Pictures in Search of an Attribution', in *Three Essays in Method* (Oxford, 1927), pp. 10–11 repr.; W. Suida, 'Einige italienische Gemälde im Landesmuseum zu Brünn', *Belvedere*, 8 (1929), 256; Berenson, 1932, 377: 1936, 324: 1968, 280; C. Ragghianti, 'Sul problema Erri–D. Morone', *Critica d'arte*, 4 (1939), Notizie e Lettere, i–v; A. M. Chiodi, 'Bartolomeo degli Erri e i polittici domenicani', *Commentari*, 2 (1951), 17 repr.; R. Brenzoni, *Domenico Morone* (Florence, 1956), p. 42.

There are many incised lines in the architecture.

Chiodi, with acknowledgement to Professor Carlo Ragghianti, discovered that No. A93, together with twelve other panels illustrating scenes from the life of S. Vincent Ferrer (Vienna, Kunsthistorisches Museum),[1] once formed part of an altar-piece dedicated to the saint in the old church of S. Domenico, Modena. The central panel, a whole-length image of the saint, immediately beneath which No. A93 was placed, is still in Modena (Seminario Arcivescovile).[2] The panels in Vienna were evenly distributed around the central panel, two rows of three on each side.[3]

Earlier writers had attributed No. A93 variously: Crowe and Cavalcaselle to the workshop of Jacopo Bellini and the compiler of the catalogue of the exhibition of Venetian art held at the New Gallery in London in 1894–5 to Jacopo Bellini himself; Gronau (1895–6) to the school of Verona; Suida, in the first place (1909) to the Master of the St. Thomas Legend, whom he defined as a Lombard follower of Vincenzo Foppa, and in the second place (1929) to the school of Modena; and Testi to the school of Verona, *c.* 1470. The attribution of the panel to Morone or his school, so elaborately championed by Berenson and even retained in the 1968 edition of the Lists, was supported by Ffoulkes, and also by Borenius in the second edition of Crowe and Cavalcaselle. Brenzoni listed No. A93 as 'attributed to Domenico Morone', leaving the problem open for further consideration. Prior to Chiodi's article, Venturi[4] had suggested the name of Agnolo degli Erri in connection with the series of related panels in Vienna, but was apparently unaware of No. A93. Ragghianti regarded the altar-piece as the joint work of Agnolo and Bartolomeo degli Erri, while Chiodi, after close scrutiny of the documents, attributed it to Bartolomeo alone.

The S. Vincent Ferrer altar-piece formed a series with three others formerly in the old church of S. Domenico in Modena. These were dedi-

cated to SS. Peter Martyr, Thomas Aquinas, and Dominic—the main saints of the Dominican Order. The altar-piece dedicated to S. Peter Martyr has been identified with one in Parma (Pinacoteca), signed and dated *Simon Lamberti mutineus 1450*.[5] The other two—or the surviving fragments from them[6]—were, like the S. Vincent Ferrer altar-piece, at one time ascribed to Domenico Morone. On the basis of the documentary evidence which exists for the one surviving panel from the altar-piece dedicated to S. Dominic, however, all three altar-pieces can now be firmly attributed to Bartolomeo degli Erri.[7]

Chiodi showed that structural alterations were made to the old church of S. Domenico towards the middle of the fifteenth century. The execution of the altar-pieces was probably connected with this undertaking and, indeed, in his Lives of Garofalo and Girolamo da Carpi Vasari briefly refers to them (vi. 481). Vedriani, writing in 1762, informs us where the four altar-pieces were originally positioned in the church, which had been demolished in 1708 and then rebuilt according to its present design.[8] The altar-pieces were presumably removed from the church on that occasion and perhaps dispersed shortly afterwards. Tiraboschi gives brief details of the temporary whereabouts of the S. Peter Martyr altar-piece, but makes no mention of that dedicated to S. Vincent Ferrer.[9]

There has been some discussion concerning the location of the scenes shown on the panels from the S. Vincent Ferrer altar-piece, particularly with reference to No. A93. Earlier writers identified the church as Veronese and searched for incidents in the saint's life to suit that particular location.[10] Ragghianti, however, realizing that No. A93 might be by a Modenese painter, suggested an identification with the façade of the old church of S. Domenico in Modena.[11]

S. Vincent Ferrer was born *c.* 1350 and died in 1419. He joined the Dominican Order in 1367 and was canonized by Calixtus III in 1455. Since a Pope is present on No. A93 (on the balcony at the left), it might well be supposed that the scene, although transferred to a Modenese setting, records a specific incident in the life of the saint, such as that mentioned tangentially by Ffoulkes, who referred to the occasion when S. Vincent Ferrer addressed the anti-Pope Benedict XIII and Ferdinand of Aragon at Tortosa in Spain.[12] In a more general context, however, the scene is presumably intended to illustrate S. Vincent Ferrer's widespread fame as a preacher, and his success at converting the Jews and the Moors.

Ragghianti tentatively dated all four altar-pieces between 1450 and 1470. Chiodi favoured some time between 1474, the date of the final payments

for the S. Domenico altar-piece, and 1479 when Bartolomeo drew up
his will.

REFERENCES: 1. Inv. 6691–702, each 61 × 34. *Katalog der Gemäldegalerie*, i (Vienna, 1965),
pp. 49–50. All the panels in Vienna are reproduced by A. Venturi, *Studi dal vero* (Milan,
1927), figs. 81–92, pp. 137–54. 2. The panel measures 130× 57. Repr. A. M. Chiodi,
'Bartolomeo degli Erri e i polittici domenicani', *Commentari*, ii (1951), pl. VI, fig. 32.
3. There is a photo-montage in Chiodi, op. cit., fig. VII, fig. 33. The reconstruction is
based on the chronological arrangement of the scenes. 4. Venturi, op. cit., pp. 137–54.
5. Inv. 499. A. O. Quintavalle, *La Regia Galleria di Parma* (Rome, 1939), pp. 15–19.
6. The most recent discussion of the panels from the S. Thomas Aquinas altar-piece is
by F. R. Shapley, *Paintings from the Samuel H. Kress Collection. Italian Schools XV–XVI
Century* (London, 1968), pp. 9–10. Only one panel from the S. Dominic altar-piece has
so far been identified, *S. Dominic Reviving Napoleone Orsini from the Dead*, now in the
Metropolitan Museum, New York (inv. 22. 60. 59) for which see H. B.Wehle, *A Catalogue
of Italian, Spanish and Byzantine Paintings* (New York, 1940), pp. 133–4. 7. The document
commissioning the altar-piece dedicated to S. Dominic from Bartolomeo degli Erri
was first published by A. Venturi, 'I pittori degli Erri o del R', *Archivio storico dell'arte*, 7
(1894), 140–1, Doc. LII. Bartolomeo is specifically cited as the painter of the altar-piece,
although Agnolo also signed the contract, and indeed received payments, presumably as
Bartolomeo's partner. 8. L. Vedriani, *Raccolta de'pittori, scultori, ed architetti modonesi
più celebri* (Modena, 1662), pp. 23–4. 9. G. Tiraboschi, *Notizie de' pittori, scultori, incisori,
e architetti di Modena* (Modena, 1786), pp. 133–4. 10. C. J. Ffoulkes, 'L'esposizione dell'arte
veneta a Londra', *Archivio storico dell'arte*, Ser. 2, i (1895), 247, argued in favour of an
identification with the anti-Pope John XXIII, who travelled through Verona in 1414
on his way to the League of Constance. G. Gronau, 'Litteraturbericht: Venetian Art',
*Reportorium für Kunstwissenschaft*, 19 (1896), 137–8, associated the Pope with Eugenius IV,
drawing attention to an incident which took place in Verona in 1441 when the figure of
Christ appeared in a mandorla on the façade of the church of S. Giorgetto (later S. Pietro
Martire) during a sermon preached by a Dominican monk on behalf of the League
between the Pope ,Venice, Florence, and Genoa. The figure of Christ in a mandorla,
however, is a specific attribute of S. Vincent Ferrer, who had already been dead for several
years by 1441. 11. We do not know what the façade of the old church of S. Domenico
looked like, but for general points of similarity with Modenese architecture compare the
façade of the Duomo in Modena, repr. A. C. Quintavalle, *La Cattedrale di Modena*, ii
(Modena, 1964), pl. 2. 12. This incident is recorded in the *Acta Sanctorum*, Aprilis i
(Antwerp, 1675), p. 482. 16. Also see H. Fages, *Histoire de saint Vincent Ferrier*, ii (Paris,
1901), 42–50, and M. Gorce, *Saint Vincent Ferrier*, 2nd edn. (Paris, 1933), pp. 128–9.

# FRA BARTOLOMMEO                                        1472–1517

Florentine school. His real name was Baccio di Paolo del Fattorino, known as Baccio
della Porta and later as Fra Bartolommeo. Most of his work was executed in Florence,
but he was also active in Volterra, Pistoia, Lucca, and Venice. He became a monk in 1500
and apparently did not paint again until *c.* 1504. From 1509 he ran an active studio for
three years with his former partner, Mariotto Albertinelli. He was most probably the

pupil of Cosimo Rosselli, but was more profoundly influenced by Leonardo da Vinci, Piero di Cosimo, and Domenico Ghirlandaio.

## COPY AFTER FRA BARTOLOMMEO

A104   THE HOLY FAMILY                                              **Pl. 17**

Wood. 86·3 (round, slightly bowed).

On the back a label inscribed by a nineteenth-century hand: *La Vergine e S. Giuseppe adorando il | Bambino di Luca Signorelli da Cortona | della Galleria del Marchese Capponi Pasquali | di Firenze.*[1] On a separate label inscribed by the same hand *No. 38.*

Condition: poor. There are small paint losses above the Virgin's head and in the lower part of Her drapery. The paint surface is rather dirty, and covered with a thick layer of varnish. The pigments are very dry.

Collections: Capponi-Pasquali, Florence.

Fox-Strangways Gift, 1850.

Literature: Crowe and Cavalcaselle, *History*, iii (1866), 35: 2nd edn., v (1914), 121; H. Ulmann, 'Piero di Cosimo', *Jahrbuch der Königlich Preussischen Kunstsammlungen*, 17 (1896), 132, n. 5; B. Degenhart, 'Die Schüler des Lorenzo di Credi', *Münchner Jahrbuch der bildenden Kunst*, N.F. 9 (1932), 157; E. Fahy, 'The Earliest Works of Fra Bartolommeo', *Art Bulletin*, 51 (1969), 142–3, n. 7.

As Ullmann was the first to observe, No. A104 is an exact copy, although somewhat smaller in size, after the *tondo* of *The Holy Family* in the Borghese Gallery, Rome, which is now widely accepted as an early work by Fra Bartolommeo (*c.* 1495).[2] Mr. Everett Fahy has drawn attention to another painting (present whereabouts unknown), which is a close variant of this picture.[3]

   No. A104 was almost certainly painted towards the middle of the sixteenth century. The old attribution to Signorelli, recorded by a nineteenth-century hand on the label on the back of the panel (see above), is not without interest, since the hard, sombre tone of the primary colours and the dry pigmentation are characteristic of many panels painted by Signorelli. Crowe and Cavalcaselle observed, however, that the style of No. A104 is more reminiscent of Piero di Cosimo.

REFERENCES: 1. Repr. fig. 3. Two members of the Pasquali family married into the Capponi family: Elisabetta (b. 1561), daughter of Girolamo Capponi (1531–86), married Cosimo di Andrea Pasquali in 1582 and Elisabetta (1729–1800), daughter of Lorenzo Capponi (1684–1757), married Cosimo di Francesco Pasquali in 1747 (see P. Litta,

*Celebri famiglie italiane* (Milan, 1870–1), Capponi Family pls. XVII and IX. There are three panels in the National Gallery, London, from the Palazzo Capponi (see M. Davies, *National Gallery Catalogues. The Earlier Italian Schools*, 2nd edn. (London, 1961), pp. 287–8 (inv. 1124), and pp. 341–2 (inv. 1106 and 1381). Following an inscription on the back of inv. 1124, Sir Martin Davies tentatively identifies the owner of the panels in London with Marchese Francesco Pier Maria Capponi (1688–1753). For the Pasquali family see L. Ginori, *I palazzi di Firenze nella storia e nell' arte*, i. (Florence, 1972), p. 271, No. 31. The marriage between Cosimo di Francesco Pasquali and Elisabetta was childless and the Pasquali family name was conjoined with that of the Capponi on Cosimo's death. 2. Inv. 439, 112 cm. in diameter. P. della Pergola, *Galleria Borghese: I dipinti*, ii (Rome, 1959), 16–17, No. 13 repr. Repr. in colour in R. Longhi, 'Precisioni nelle Gallerie italiane. La Galleria Borghese', *Opere complete*, ii (Florence, 1967), pl. XXIV. 3. E. Fahy, 'The Earliest Works of Fra Bartolommeo', *Art Bulletin*, 51 (1969), 142–3, n. 7 (formerly Wilson collection, Florence, and then Carmichael collection, Leghorn).

## MARCO BASAITI
active *c.* 1470, still active 1530

Venetian school. He was most probably the pupil of Alvise Vivarini, but Giovanni Bellini, Carpaccio, and Cima da Conegliano were also important formative influences. At a later stage Basaiti began to paint in the manner of Giorgione. There are several signed pictures by him, some of them dated.

## ATTRIBUTED TO MARCO BASAITI

A735 HEAD OF THE VIRGIN (FRAGMENT) **Pls. 18–19**

Wood. 24·2 × 18·5.

On the back an old attribution to *Cima da Conegliano* and the remnants of a wax impression of a seal.

Condition: poor. Cleaned and restored in 1959 when the damage at the right side of the panel, mainly to the Virgin's mantle, was restored and the heavy craquelure filled in. Two fine cracks in the paint surface extend vertically through the Virgin's face, one touching the left edge of the mouth and the other just to the right of the chin. There is retouching in these areas.

Presented by the daughters of J. R. Anderson, 1947.

Literature: *Annual Report*, 1957, 38; F. Heinemann, *Giovanni Bellini e i belliniani*, i (Venice, n.d.), p. 139, No. 322 repr.; *I Pittori bergamaschi dal XIII al XIX secolo. Il Cinquecento* i (Bergamo, 1975), p. 138, No. 65 repr. (before cleaning).

No. A735 is a fragment of a larger panel. Heinemann surmised that originally the fragment was part of the scene of an *Annunciation*. Much of

the original quality of No. A735 was lost in restoration and a true appreciation of the panel can be gained only by reference to the photograph taken before restoration in 1959 (Pl. 18).

In the *Annual Report* of 1947 Sir Karl Parker ascribed No. A735 to Previtali and that attribution was accepted by Heinemann and more recently by Dotterassa Chiappini in the publication *I Pittori bergamaschi*. The attribution to Basaiti, tentatively proposed in the last two editions of the Ashmolean Catalogue, is preferable. Comparison may be made with the *Virgin and Child* in London (National Gallery)[1] and the panel of the same subject in the Pinacoteca Vaticana, Rome,[2] both signed works. The colour harmonies on No. A735 (light blue in the lining of the drapery on the left, white in the head-dress, blue and green in the drapery on the right) are strikingly reminiscent of Alvise Vivarini by whom Basaiti was certainly influenced. The bland flesh tones and the round, almost tubular, features are wholly characteristic.

REFERENCES: 1. Inv. 2499. M. Davies, *National Gallery Catalogues. The Earlier Italian Schools*, 2nd edn. (London, 1961), pp. 47–8 repr. 2. Repr. Monsignor E. Francia, *Pinacoteca Vaticana* (Milan, 1960), pl. 161 in colour.

# JACOPO BASSANO                              active 1534, died 1592

Venetian school. Jacopo da Ponte, called Bassano. He began in his father's workshop, but was also the pupil of Bonifazio Veronese. Northern, Central Italian, and Emilian influences can be detected in his work. At a later date, towards 1565, he specialized in genre scenes or pastoral interpretations of religious subjects. Four of his sons carried on the Bassanesque tradition after their father's death.

## A771   CHRIST DISPUTING WITH THE DOCTORS IN THE TEMPLE
**Pl. 20**

Canvas (relined). 116 × 174.

Condition: fair. Cleaned in 1949. There are a number of small retouches and areas of paint loss. The surface is also considerably worn. However, the original quality is by no means completely lost.

Collections: Sir John Oxenden, Broome Park, Dene, Kent (by whom bt. for £250 at an auction held in London at The Banqueting Hall, 2 June 1684, lot 123);[1] thence by direct inheritance to Sir Henry-Chudleigh Oxenden, 8th Bt. (Christie's, 6 July 1839, lot 62 as Pordenone—bt. in); Lady Capel Cure, *née* Dixwell-Oxenden (Christie's, 20 Nov. 1931, lot 15—bt. C. E. Blunt); Christopher Blunt, by whom sold (anonymously) Christie's, 10 Dec. 1948, lot 145.

Purchased 1949.

Literature: Lady Victoria Manners, 'The Oxenden Collection III', *Connoisseur*, 43 (1915), 206–7 repr.; W. Arslan, 'Contributo a Jacopo Bassano', *Pinacoteca*, 1 (1929), 186 and 188 repr.; W. Arslan, *I Bassano* (Bologna, 1931), 58–9 and 190 repr.; Berenson, 1932, 57: 1936, 49: 1957, 19 repr.; S. Bettini, *L'arte di Jacopo Bassano* (Bologna, 1933), pp. 36 and 155; R. Longhi, 'Calepino veneziano XIV', Suggerimento per Jacopo Bassano, *Arte veneta*, 2 (1948), 46; *Annual Report*, 1949, 46 repr.; H. D. Gronau, 'Pitture veneziana in Inghilterra', *Arte veneta*, 3 (1949), 183; R. Pallucchini, 'Commento alla mostra di Jacopo Bassano', *Arte veneta*, 11 (1957), 100–1; P. Zampetti, *Catalogo della Mostra Jacopo Bassano* (Venice, 1957), p. xxv repr.; P. Zampetti, *Jacopo Bassano* (Rome, 1958), p. 22; E. Arslan, *I Bassano*, i (Milan, 1960), pp. 46–8 and 173 repr.; A. Ballarin, 'Jacopo Bassano e lo studio di Raffaello e dei Salviati', *Arte veneta*, 21 (1967), 77; S. J. Freedberg, *Painting in Italy 1500–1600* (Harmondsworth, 1971), p. 371.

The attribution to Jacopo Bassano was first proposed by Lady Victoria Manners in 1915 and has since been unanimously accepted. No. A771 is an early work, usually dated sometime between the altar-piece of the *Virgin and Child with SS. John the Baptist and Zeno* (Borso del Grappa, dated 1538) and the altar-piece of *S. Anne Enthroned with the Young Virgin and SS. Jerome and Francis* (Venice, Accademia, formerly Asolo and Sossano (Vicenza), signed and dated 1541). A number of other works were painted between these altar-pieces, among them *Supper at Emmaus* (Cittadella), *Lamentation* (San Luca di Crosara (Vicenza)), *Adoration of the Magi* (Burghley House, Exeter collection), and the altar-piece of *S. Ursula between SS. Valentine and Joseph* (Mussolente). Both Arslan (1931 and 1960) and Professor Sergio Bettini attempted to date No. A771 slightly earlier, 1537/8, and indeed when he first published the picture Arslan (1929) even suggested 1536/7. Longhi indicated a date of 1539, while Professor Rodolfo Pallucchini (1957) posited 1540/1, bringing No. A771, together with the Mussolente altar-piece with which it is so closely related in style, near to the ex-Sossano altar-piece of 1541. Dr. Alessandro Ballarin implies a date of 1539/40, and Professor Sydney Freedberg has recently suggested c. 1540.

The juxtaposition of the warm tones of colour in the draperies certainly suggests the influence of Bonifazio, but the cool Alpine tones in the landscape and the firm outlines of the solidly formed figures suggest, as Pallucchini was the first to observe, that Bonifazio's influence has here

been replaced by that of Pordenone.² The greater mastery of form, the wider range of characterization, and the successful handling of a more complex composition foreshadow some of the outstanding achievements of the fifth decade.

No. A771 is a thoroughly eclectic work and reflects a host of different compositions. The subject of *Christ Disputing with the Doctors* was often depicted in North Italian painting at the beginning of the cinquecento, specifically in Lombardy, but also in Emilia and then slightly later in Venice. Bassano, however, does not seem to have drawn upon any of these earlier compositions. Indeed, his visual sources appear to have been more widespread. Thus he makes reference to Dürer in the architectural setting (woodcut, *Christ Disputing with the Doctors*, from the *Life of the Virgin*);³ to Pordenone in the pose of the Doctors (the *Dispute of S. Catherine* in S. Maria di Campagna, Piacenza);⁴ to Giorgione in the figure shouting abuse beside the left-hand pillar (*Christ Carrying the Cross* in the Scuola di S. Rocco, Venice);⁵ to Titian in the pose of Christ (*S. Peter Enthroned Adored by Pope Alexander VI and Jacopo Pesaro*, Antwerp, Musée des Beaux-Arts);⁶ to Sebastiano del Piombo for the raised dais on which Christ sits (*Judgement of Solomon*, Banks collection, Kingston Lacey, Dorset).⁷ Finally, the elegant pose of the doctor seated in the right foreground with his back turned towards the spectator is amost certainly derived, either directly or indirectly, from the antique.⁸

REFERENCES: 1. As stated by E. K. Waterhouse, 'A Note on British Collecting of Italian Pictures in the later Seventeenth Century', *Burlington Magazine*, 102 (1960), 54. Sir John Oxenden's purchase of No. 48 at The Banqueting Hall is specifically recorded in the *Seventh Report of the Royal Commission on Historical Manuscripts. Appendix.* (London, 1879), MSS. of Sir Harry Verney, p. 481b, letter dated 5 June 1684. Oxenden apparently bought a number of other pictures at the same sale. Professor Sir Ellis Waterhouse was the first to trace the provenance of No. A771 in full (letter of 20 Feb. 1949). 2. Crowe and Cavalcaselle, *History North Italy*, ii (1871), 249, write of Pordenone's 'uncontrollable habit of putting matronly shape into posture and introducing affected gracefulness into gesture'; an apt description of the figures on No. A771. 3. See C. Gould, 'On Dürer's Graphic and Italian Painting', *Gazette des beaux-arts*, 75 (1970), 104–6, fig. A4, without reference to No. A771. 4. J. Schulz, 'Pordonone's Cupolas', *Studies in Renaissance and Baroque Art presented to Anthony Blunt on his Sixtieth Birthday* (London, 1967), pl. x, fig. 4. 5. T. Pignatti, *Giorgione* (Venice, 1969), pl. 116. 6. H. E. Wethey, *The Paintings of Titian*, i *The Religious Paintings* (London, 1969), pl. 144. Professor Francis Haskell has suggested that the pose of Christ may equally well have been inspired by the figure of the Proconsul in Raphael's tapestry of the *Blinding of Elymas*, the cartoon for which is repr. by J. Shearman, *Raphael's Cartoons in the Collection of Her Majesty the Queen and the Tapestries for the Sistine Chapel*, (London, 1972), pl. 26. 7. Pignatti, op. cit., pl. 190. 8. Compare the sarcophagi with reliefs of Tritons and Nereids in the Vincenzo Giustiniani collection, repr. *Galleria Giustiniana del*

*Marchese Vincenzo Giustiniani*, ii (Rome, 1631), pls. 102 and 144. Vincenzo Giustiniani formed his collection at the beginning of the seventeenth century, but it is possible that many of the pieces had been excavated earlier.

## COPY AFTER JACOPO BASSANO

A905 THE ANNUNCIATION TO THE SHEPHERDS       **Pl. 21**

Canvas (relined). 131 × 97·5.

Condition: good.

Presented by F. F. Madan, 1957.

Literature: *Annual Report*, 1957, 49; E. Arslan, *I Bassano*, i (Milan, 1960), p. 359.

No. A905 is a copy after an important composition devised by Jacopo Bassano towards the end of the sixth decade of the sixteenth century. The primary version is now thought to be the painting in the Kress collection (Washington, National Gallery).[1] Several replicas and, according to Professor Roger Rearick (verbal communication), over thirty copies of the composition are known. Arslan, who regarded the painting of the *Annunciation to the Shepherds* in Rome (Accademia di S. Luca) as the primary version, described No. A905 as a 'discreta copia di un seguace (con propri accenti)'. An attribution to Francesco Bassano was first tentatively proposed on acquisition in 1957.

The compiler regards No. A905 as a late copy, probably dating from the seventeenth century and, judging from the style and tonality, possibly painted by a Lombard artist.[2] That Bassano's composition retained its popularity is attested by the repetition of the main motifs on a majolica plate of a *Pastoral Scene* manufactured in Siena and painted by Ferdinando Maria Campani (1702–71).[3]

REFERENCES: 1. K 258. F. R. Shapley, *Paintings from the Samuel H. Kress Collection. Italian Schools XVI–XVIII Century* (London, 1973), pp. 45–6 repr. 2. It should be remembered that a version of Bassano's *Annunciation to the Shepherds* was in Milan in the seventeenth century; see A. Falchetti, *La Pinacoteca Ambrosiana* (Vicenza, 1969), p. 261. 3. A plate of this design is in the collection of majolica belonging to the Ashmolean Museum (Fortnum collection, inv. C 415).

## LEANDRO BASSANO       1557–1622

Venetian school. Leandro da Ponte, the third surviving son of Jacopo Bassano, of whom he was a pupil and assistant. Shortly after 1582 Leandro moved to Venice where he was employed in the Palazzo Ducale. He was renowned as a portrait painter. Of all

the sons of Jacopo Bassano, Leandro's style is the most individual. There are several signed works.

### A445 PORTRAIT OF A PROCURATOR OF S. MARK    Pl. 22

Canvas (relined). 113·9× 101.

On the back a wax impression of a seal now indecipherable.

Exhibited: London, Hayward Gallery, *Andrea Palladio*, 1975 (235).

Condition: fair. There has been some rubbing of the surface, mainly at the edges. The flesh parts, the robe and the foreground are well preserved.

Purchased 1935.

Literature: *Annual Report*, 1935, 25 repr.; *Apollo*, 22 (1935), 179 repr.; Berenson, 1957, 23; E. Arslan, *I Bassano*, i (Milan, 1960), 243 and 266 repr.

No. A445 was first attributed to Leandro Bassano on acquisition. Arslan proposed a date of *c.* 1590, during the time when the painter was in Venice and shortly before he received the honour of a knighthood for his services to the state. On the basis of the style of the hair and beard a date towards the end of the last decade of the sixteenth century may be preferred.[1]

No. A445 is a characteristic work, dependent not only on the official portraits painted by Tintoretto, but also on those painted by Northern painters working in Tintoretto's workshop.

The sitter has been identified as Paolo Nani (1552–1608) on the authority of Fabio Mauroner,[2] but a posthumous portrait bust of Paolo on the Nani monument in S. Giobbe, Venice, bears only a slight resemblance to the sitter shown on No. A445.[3] Other clues as to his identity are lacking. No insignia are visible. The garment worn by the sitter is the Ducale, the official procuratorial robe, but one that was also used by those holding other offices of state.[4] The harbour in the background cannot be specifically located, although in the *Annual Report* of 1935 Sir Karl Parker described the subject 'as displaying credentials as the Venetian envoy to some Dalmatian trading centre (?Zara)'. The fortifications, in fact, do not represent those of Zara,[5] but they may well be those of the island of Zante.[6]

REFERENCES: 1. Notes on the costume and *coiffure* were kindly supplied by Mrs. Stella Newton and by Miss Jane Bridgeman (letter of 21 Oct. 1971). 2. Letter of 4 Nov. 1938. 3. A line engraving of the monument in S. Giobbe by C. Simonetti may be found in E. A. Cicogna, *Delle iscrizioni veneziane*, vi (Venice, 1842), opp. p. 940. Biographical details of Paolo are given by Cicogna on pp. 546–7. Paolo Nani was made a Procurator of S. Mark in 1573. For the insignia of the Nani family, see D. C. Freschot, *La nobilità veneta o sia tutte le famiglie patrizie con le figure de' suoi scudi e arme*, 2nd edn. (Venice, 1707), between

pp. 384–5. 4. See the engraving in Freschot, op. cit., repr. at the end after p. 448. For a discussion of the Ducale see C. Vecellio, *Degli abiti antichi et moderni di diversi parti del mondo* (Venice, 1590) Book i, 104. 5. For Zara see A. De Benvenuti, *Zara nella cinta delle sue fortificazioni* (Milan, 1940), and by the same author, *Storia di Zara del 1409 al 1797* (Milan, 1944). The fortifications as they were in the sixteenth century are repr. in the earlier publication, figs. 1 to 4, and discussed in the text, pp. 60–1. Certain members of the Nani family other than Paolo did hold appointments on the island of Zara. 6. Paolo Nani is credited by Sansovino (*Venetia città nobilissima et singolare*, i (Venice, 1663), 216) with the capture of the island of Zante from the Turks in 1571. There are, however, only similarities of a very general nature between the fortifications depicted on No. A445 and those shown in nineteenth-century topographical engravings of Zante and the compiler has failed to trace earlier representations.

# GIOVANNI BELLINI
born shortly after 1430/1
died 1516

Venetian school. Also called Giambellino. Giovanni was the son of Jacopo Bellini and in all probability the younger brother of Gentile. He was influenced at an early stage by his brother-in-law, Andrea Mantegna, and later by Antonello da Messina, who was in Venice in 1475/6. The chronology of his earlier work is much discussed, as there are no firmly documented pictures before the end of the seventh decade. He had a large number of assistants and followers who painted many variants of his compositions. Titian and Giorgione were his foremost pupils.

## ASCRIBED TO GIOVANNI BELLINI

A302   S. JEROME READING IN A LANDSCAPE                    **Pl. 23**

Wood. 27× 22.

Condition: good. The flesh parts are slightly rubbed. A scratch in the paint surface extends from the right-hand page of the book over the top of the saint's legs. The landscape is extremely well preserved. There are minor damages in the sky on the right.

Fortnum Bequest, 1899.[1]

Exhibited: London, Royal Academy, *Exhibition of the Works of the Old Masters*, 1872 (246). London, Royal Academy, *Italian Art and Britain*, 1960 (317).

Literature: *Annual Report*, 1899, 7 and 21; Crowe and Cavalcaselle, *History North Italy*, 2nd edn., i (1912), 273, n. repr.; Berenson, 1932, 72: 1936, 62: 1957, 33; Van Marle, *Development*, xvii (1935), 267; L. Dussler, *Giovanni Bellini* (Vienna, 1949), p. 72; R. Pallucchini, *Catalogo della Mostra Giovanni Bellini* (Venice, 1949), p. 139; J. Byam Shaw, 'A Giovanni Bellini at Bristol', *Burlington Magazine*, 94 (1952), 158;

R. Pallucchini, 'La pittura veneta alla mostra "Italian Art and Britain":
appunte e proposte', in *Eberhard Haufstaengel zum 75 Geburtstag* (Munich,
1961), p. 73; F. Heinemann, *Giovanni Bellini e i belliniani*, i (Venice, n.d.),
p. 66, No. 224a repr.; G. Robertson, *Giovanni Bellini* (Oxford, 1968),
p. 77.

The attribution of No. A302 to Giovanni Bellini first occurs in Berenson's
Lists (1932) and was upheld by Van Marle and by Professor Rodolfo
Pallucchini (1949 and 1961). Borenius, in the second edition of Crowe
and Cavalcaselle, had already proposed the name of Basaiti and later
Heinemann suggested that of Previtali as alternative attributions. Dr.
Luitpold Dussler and Professor Giles Robertson have also rejected the
attribution to Giovanni Bellini, while Mr. James Byam Shaw has ex-
pressed doubts as to its validity. Robertson (written communication)[2]
has recently proposed the name of Jacometto Veneziano in connection
with No. A302. Jacometto was a portrait painter of some importance
in the Veneto frequently mentioned by the Anonimo Morelliano and
there described as a miniaturist.[3] Only a much damaged panel of the *Virgin
and Child* in Ravenna (Accademia delle Belle Arti), first published by
Robertson,[4] can be cited here as an example of Jacometto's style of religious
painting, but, owing to its damaged condition, comparison with No. A302
is hardly conclusive.

The composition of No. A302 is usually described as Bellinesque.
Robertson, for instance, regards No. A302 as a studio version of a lost
original by Bellini dating from the eighth decade. In fact, neither the early
composition of the subject in Birmingham (Barber Institute),[5] nor the
later composition used for the group of pictures depicting *S. Jerome
Reading* (London, National Gallery; Florence, formerly Contini Bonacossi
collection; Washington, National Gallery, Kress collection)[6] are strictly
comparable with that of No. A302. Closer to No. A302 than any of these
is a panel in the Thyssen collection, Lugano, ascribed by Berenson to
Benedetto Diana.[7]

A drawing of *S. Jerome* (Berlin–Dahlem, Kupferstichkabinett), al-
though not preparatory to the picture in Oxford, should be considered,
since the figure corresponds almost exactly with that on No. A302.[8] Von
Hadeln's attribution[9] of the Berlin drawing to Carpaccio has not been
widely accepted. The Tietzes[10] favoured an attribution to Giovanni
Bellini, while Dr. Jan Lauts[11] assigned the drawing to a follower of
Carpaccio, Professor Terisio Pignatti[12] to the circle of Giovanni Bellini,
and Dr. Lionello Puppi[13] to Speranza. If the drawing in Berlin is by

Carpaccio, as the compiler is inclined to believe, it can only be concluded that the prototype for No. A302 was painted by Carpaccio. Whether Carpaccio devised the composition himself, or in turn derived it from Bellini, remains to be resolved.

Mr. Francis Russell (verbal communication) has pointed out that the landscape on the right of No. A302 is also found faithfully recorded on the S. Jerome in a Landscape (Boston, Museum of Fine Arts) by Jacopo da Valenzia.[14]

In view of the fact that much of the discussion about No. A302 is still so inconclusive, it seems desirable to retain some connection with the name of Giovanni Bellini, even if it serves only to draw attention to the particularly high quality of this small panel.

REFERENCES: 1. It is recorded in C. D. E. Fortnum's manuscript catalogue in the Ashmolean (Vol. IV, f. 83, No. 1) that No. A302 was bought in Florence in 1864, ascribed to Basaiti. 2. Letters of 20 Dec. 1969 and 7 Jan. 1970. The compiler is extremely grateful to Professor Robertson for discussing the attribution at some length and for so kindly making available photographic material for purposes of comparison. 3. For a convenient summary of the activity of Jacometto Veneziano see M. Canova, La miniatura veneta del rinascimento 1450–1500 (Venice, 1969), pp. 111–12, with further references. 4. G. Robertson, 'A Madonna by Jacometto Veneziano', Burlington Magazine, 95 (1953), 208. 5. Repr. G. Robertson, Giovanni Bellini (Oxford, 1968), pl. IIa. 6. Repr. G. Gronau, Giovanni Bellini. Klassiker der Kunst (Stuttgart, 1930), pp. 83 and 82 respectively. The painting in Washington is repr. Robertson, op. cit., pl. LVIIIb. 7. The Thyssen–Bornemisza Collection, ed. R. Heinemann, i. (Castagnola, 1969), 242, No. 222, repr. ii, pl. 229. 8. Inv. 5065. Pen and ink heightened with body colour on faded blue paper, 138 × 142 mm. 9. D. F. von Hadeln, Venezianische Zeichnungen des Quattrocento (Berlin, 1925), p. 53, pl. 24. 10. H. and E. Tietze, The Drawings of the Venetian Painters (New York, 1944), pp. 82–3, No. 288. 11. J. Lauts, Carpaccio (London, 1962), p. 280, No. 62 with further references. 12. T. Pignatti, review of J. Lauts, Carpaccio, Paintings and Drawings (London, 1962), Master Drawings, i. No. 4 (1963), 48. 13. L. Puppi, 'Giovanni Speranza', Rivista dell' Istituto Nazionale d'Archeologia e Storia dell' Arte, N.S. 11 and 12 (1963), 389 and 416, n. 51. 14. Inv. 26.141. Summary Catalogue of European Paintings in Oil, Tempera and Pastel (Boston, 1955), p. 3, attributed to Lazzaro Bastiani. The picture is repr. K. Clark, Landscape into Art (London, 1949), pl. 43, incorrectly located as in Bologna, Pinacoteca.

# BICCI DI LORENZO                                         1373–1452

Florentine school. Painter, architect, and sculptor. Both his father, Lorenzo di Bicci, and his son, Neri di Bicci, were painters. Bicci di Lorenzo's early style was inherited from his father, but this trecentist manner soon gave way to the more sophisticated International Gothic style exemplified in Florence by Lorenzo Monaco and Gentile da Fabriano. His output was large. There is circumstantial evidence that Masaccio was for a short time apprenticed in his workshop.

A89  S. NICHOLAS OF BARI REBUKING THE STORM (PREDELLA PANEL
     FROM AN ALTAR-PIECE)                                       Pl. 24

Wood. 29 × 59.

On the back an old attribution to *Giotto*, a Fox-Strangways label (un-numbered) and a second label in his hand inscribed *A Storm*. The number *.16.* also occurs.

Condition: good. Cleaned in 1946.

Fox-Strangways Gift, 1850.

Literature: Van Marle, *Development*, ix (1927), 16–18 repr.; Berenson, 1932, 85: 1936, 73: 1963, 30; F. Zeri, 'Una precisazione su Bicci di Lorenzo', *Paragone*, 105 (1958), 70 repr.; W. Cohn, 'Maestri sconosciuti del Quattrocento fiorentino II. Stefano d'Antonio', *Bollettino d'arte*, 44 (1959), 62; L. Baldass, 'Toskanische Gemälde des internationalen Stiles in der Wiener Galerie', in *Eberhard Haufstaengel zum 75 Geburtstag* (Munich, 1961). pp. 35–6; R. Longhi, 'Il tramonto della pittura medioevale nell' Italia del Nord' (1935–6), in *Opere Complete*, vi (Florence, 1973), 126; R. Fremantle, *Florentine Gothic Painters* (London, 1975), p. 478 rep. There is a minor *pentimento* in the figure at the stern of the boat.

The attribution first occurs in Van Marle, who pointed out that No. A89 once formed part of the predella of an altar-piece painted by Bicci di Lorenzo for the church of S. Niccolò in Cafaggio, Florence.[1] Dr. Federico Zeri has made a convincing reconstruction of the altar-piece. The central panel of the *Virgin and Child with Four Angels*, dated 1433, is now in the Pinacoteca at Parma.[2] An old inscription on the back of this panel confirms the original location. The lateral panels are now in Grottaferrata (Museo della Badia, *SS. Benedict and Nicholas of Bari*) and New York (formerly Robert Lehman collection, *SS. John the Baptist and John the Evangelist*).[3] The predella of the altar-piece comprised panels illustrating scenes from the life of S. Nicholas. Five such panels, including No. A89, have so far been connected with the predella. Two (*S. Nicholas Resuscitating Three Youths* and *S. Nicholas Providing Dowries*) are in the Metropolitan Museum, New York.[4] The fourth (*Pilgrims at the Shrine of S. Nicholas*) in the Wawel Museum, Cracow,[5] and the fifth (*The Birth of S. Nicholas*), recently exhibited at the Heim Gallery in London and Paris,[6] have been found since the publication of Zeri's article.[7]

Cohn produced documentary evidence to the effect that the altar-piece was appraised by Fra Angelico and Rossello di Jacopo Franchi in 1435 and that an assistant Stefano d'Antonio (1405–83) helped Bicci di Lorenzo in

the execution. Cohn contended that Stefano d'Antonio painted the side panel of *SS. Benedict and Nicholas* at Grottaferrata and the predella panel of *S. Nicholas Resuscitating Three Youths* in the Metropolitan Museum, New York. On the grounds of style, however, No. A89 can be attributed to Bicci di Lorenzo alone.

It has often been observed that both the composition and, to a lesser extent, the style of this altar-piece are derived from the Quaratesi polyptych painted by Gentile da Fabriano for S. Niccolò oltr'Arno, Florence, in 1425.[8] The predella panels from Bicci di Lorenzo's altar-piece appear to have been set originally in quatrefoil frames,[9] but the sequence of the scenes was almost certainly the same as that on the Quaratesi polyptych and only minor alterations were made to the compositions devised by Gentile da Fabriano.

A panel painted by Lorenzo Monaco depicting the same miracle as that shown on No. A89 is in the Accademia, Florence.[10]

The literary source for these scenes from the life of S. Nicholas of Bari is the *Golden Legend of Jacobus de Voragine*.[11]

REFERENCES: 1. G. Richa, *Notizie istoriche delle chiese fiorentine*, vii (Florence, 1758), 35, describes the altar-piece and attributes it to Lorenzo di Niccolò. Richa mistakenly identified the second saint on the lateral panel formerly in the Lehman collection as S. Matthew. No mention is made of a predella and this may possibly have been removed by 1758. The church of S. Niccolò in Cafaggio was destroyed in 1787. See W. and E. Paatz, *Die Kirchen von Florenz*, iv (Frankfurt-am-Main, 1952), 387–91. 2. Inv. 456, 161 × 81. A. O. Quintavalle, *La Regia Galleria di Parma* (Rome, 1939), pp. 167–8. 3. Both the side-panels measure 115 × 75. The three main panels of the altar-piece are repr. together by F. Zeri, 'Una precisazione su Bicci di Lorenzo', *Paragone*, 105 (1958), fig. 44, and in Berenson, 1963, pl. 506. 4. Inv. 16. 121, 30·4 × 56·5 : inv. 88. 3. 89, 30·5 × 56·5 respectively. F. Zeri and E. Gardner, *Italian Paintings. A Catalogue of the Collection of the Metropolitan Museum of Art. Florentine School* (New York, 1971), pp. 69–72. 5. Inv. 17, 31·5 × 37. See *La Peinture italienne des XIV et XV siècles. Exposition des Musées et des collections polonaises* (Cracow, 1961), No. 26, pp. 48–9 repr. 6. Heim Gallery, London, Summer Exhibition, 1967, Cat. No. 1 repr. and Galerie Heim, Paris, *Le Choix de l'amateur* (1974), Cat. No. 5 repr. in colour. 7. In his original reconstruction Zeri included a panel of *S. Nicholas Performing a Miracle* in a private collection in New York (repr. Zeri, op. cit., fig. 48). This panel measures 25 × 21 and Zeri argued that the scene was divided between two panels. No mention of this panel is made in Zeri's *Catalogue of the Florentine Paintings in the Metropolitan Museum, New York*, and in a letter to the compiler, dated 12 Feb. 1972, he declares that the panel belongs to the predella of a different altar-piece. 8. The whole of the Quaratesi polyptych is repr. by Berenson (1968), ii, pl. 533. The influence of Gentile da Fabriano on Bicci di Lorenzo may have been transmitted initially through Arcangelo di Cola with whom Bicci worked (1421–2) in the church of S. Lucia de'Magnoli, Florence (U. Procacci, 'Il soggiorno fiorentino di Arcangiolo di Cola', *Rivista d'arte*, 11 (1929), 119–27). 9. The marks of quatrefoil frames are clearly visible on the two panels

in the Metropolitan Museum. The panels at Cracow and at the Heim Gallery, London, are possibly still in their original quatrefoil frames. 10. Inv. 8615. Repr. Berenson, 1963, pl. 465. 11. *The Golden Legend of Jacobus de Voraigne*, ed. G. Ryan and H. Ripperger (New York, 1948), pp. 16–24.

## BONIFAZIO DE'PITATI                                          1487–1553

Venetian school. Although born in Verona, Bonifazio was active mainly in Venice. He was apparently the pupil of Palma Vecchio and was further influenced by Giorgione and Titian. There is a variety of dated works. Together with members of his workshop, he was responsible for decorating various rooms in the Palazzo Camerlenghi, Venice, and this was his most extensive undertaking.

### A451a   MOSES BROUGHT BEFORE PHAROAH'S DAUGHTER       Pl. 25

Canvas laid on wood. 27·2× 80·7.

On the back a wax impression of a seal, showing two hands clasped in amity couped at the wrist above a coat of arms dimidiated; on the dexter side, quartered, with two lions passant (?) and two eagles displayed, and on the sinister side a lion rampant between three scrolls.

Condition: fair. Restored in 1963. The surface is slightly rubbed throughout. Several small blisters (e.g. in the dress of Pharoah's daughter and on the male figure seated on the left) have been relaid.

Collections: Capt. James W. St. L. Wheble, Bulmershe Court, Berkshire; Revd. E. Moodie, Hove.[1]

Purchased 1936.

Exhibited: Birmingham, *Italian Art from the 13th Century to the 17th Century*, 1955 (15).

Literature: *Annual Report*, 1936, 29; Berenson, 1957, 43.

### A730   THE TRIAL OF MOSES                                    Pl. 26

Canvas laid on panel. 27·4× 96·9.

On the back the remnants of a number of wax impressions of seals.

Condition: fair. Restored in 1963 when small blisters were relaid (e.g. in the sky top left and on the knee of the second male figure from the right). The surface is lightly rubbed throughout with some small retouches.

Collections: F. P. M. Schiller, by whom bequeathed, 1946.

Literature: *Annual Report*, 1946, 28; Berenson, 1957, 43.

Both Nos. A451a and A730 were acquired as works by Bonifazio de'Pitati.

It was stated in the *Annual Reports* of 1936 and 1946 that these two panels, now reunited in Oxford, were in some way related to two panels of vertical format of allegorical figures representing *Summer* and *Autumn* now belonging to Mrs. Carmen Gronau.[2] The evidence for this particular connection is tentative,[3] but it is certainly possible that the two allegorical figures could have flanked one or other of the panels in Oxford.[4]

The subject of No. A451a was frequently depicted in Bonifazio's workshop. Ridolfi records three versions still in private collections in Venice in the seventeenth century,[5] and the following versions are extant today: Milan, Brera;[6] Florence, Pitti Palace;[7] Dresden, Gemäldegalerie;[8] Rome, Palazzo Chigi; Sydney, Art Gallery of New South Wales.[9] No. A451a is most closely related in size and composition to the versions in Florence and Sydney.

There is no biblical authority for the subject of No. A730 and the incident is only recorded in Jewish sources.[10] The earliest visual representations of the episode are possibly those occurring in manuscripts of the *Speculum Humanae Salvationis* (1324).[11] As in the case of No. A451a, other versions of the subject were painted in the workshop of Bonifazio.[12]

REFERENCES: 1. This is the provenance given by Horace Buttery, from whom No. A451a was bought, on an invoice dated 28 Mar. 1936. 2. Measuring 12 × 25·3 and 12 × 26·7 respectively. These figures were also originally painted on canvas and subsequently laid on panel. The compiler is indebted to Mrs. Carmen Gronau for photographs of the two paintings in her collection and for sending details of size and provenance. 3. In a letter of 13 Mar. 1936 Horace Buttery states that the wax impression of a seal that occurs on the back of No. A451a also occurred on the back of one or other of the two panels with allegorical subjects. There is no sign of such a seal today (letter of 24 Feb. 1969 written on behalf of Mrs. C. Gronau). 4. Compare Berenson, 1957, pls. 1150-1. 5. C. Ridolfi, *Le maraviglie dell' arte*, i, ed. D. F. von Hadeln (Berlin, 1914), 289. 6. Inv. 144. Repr. D. Westphal, *Bonifazio Veronese* (Munich, 1931), pl. XVII, fig. 32. 7. Inv. 161. Repr. Westphal. op. cit., pl. XV, fig. 29. 8. Inv. 208. Exhibited *Venezianische Malerei 15. bis 18. Jahrhundert* (Dresden, 1968), pp. 42-3, No. 16 repr. 9. Inv. 1149. Previously in the Salting collection. Mrs. Renée Free kindly sent photographs of the panel before and after cleaning together with details (letter of 14 Dec. 1971). 10. L. Réau, *Iconographie de l'art chrétien*, ii, pt. 1 (Paris, 1956), 182-3. For details see L. Ginzberg, *The Legends of the Jews*, ii (Philadelphia, 1910), 272-5, and v. 402. Also J. Lutz and P. Perdrizet, *Speculum Humanae Salvationis*, i (Mulhouse, 1907), Commentary, p. 199. 11. Lutz and Perdrizet, op. cit., i. 24, Ch. XI, illustrated ii, pl. 22, left, from a manuscript now in Munich (Clm. 146) dating from the mid fourteenth century. Another occurs in the dismembered manuscript published by M. R. James and B. Berenson, *Speculum Humanae Salvationis* (Oxford, 1926), Ch. XI, ill. 3 painted in Florence towards the end of the fourteenth century. 12. See T. Borenius, 'Michele da Verona', *Burlington Magazine*, 39 (1921), 4, pl. B.

A914 THE JUDGEMENT OF SOLOMON **Pl. 27**

Wood. 27·5 × 86·5.

Condition: poor. Restored in 1963. The surface is worn throughout and damaged by blistering. The faces have been retouched.

Collections: Susan, Duchess of Somerset (d. 1936), wife of the 15th Duke of Somerset (Foster's, 14 Oct. 1936, lot 193); A. G. B. Russell.

Bequeathed by A. G. B. Russell, 1958.

Literature: *Annual Report*, 1958, 48.

No. A914 passed through the saleroom in 1936 with an attribution to Andrea Schiavone, but on acquisition one to Bonifazio de'Pitati was rightly preferred. The panel was most probably used as an over-door.

## SANDRO BOTTICELLI 1444/5-1510

Florentine school. His real name was Alessandro di Filipepi, called Botticelli. He was active mainly in Florence, but he painted three frescoes in the Sistine Chapel in Rome (1481/2). There is only one signed work, the *Mystic Nativity* in the National Gallery, London, which is dated 1500, but both the character of his style and its development are fairly well established. He was the pupil of Filippo Lippi and his work also shows the influence of Verrocchio and the Pollaiuoli. Filippino Lippi was his most distinguished pupil. Botticelli was often employed by the Medici family, for whom he painted the *Birth of Venus* and the *Primavera*, as well as making a series of drawings illustrating Landino's *Commentary* to Dante's *Divina Commedia*.

## STUDIO OF BOTTICELLI

A413 VIRGIN AND CHILD **Pl. 28**

Wood. 88 × 57·9.

Condition: fair. There are some minor paint losses along cracks in the surface above the head of the Virgin, in Her tresses, and near the Child's feet. There is also retouching along a split, which extends the height of the panel and passes through the back of the Virgin's neck and the little finger of the Child's right hand. The lower edge of the panel is damaged.

Collections: John Ruskin (Sotheby's, 20 May 1931, lot 122 repr.).[1]

Presented by the National Art-Collections Fund, 1932.

Literature: *Annual Report*, 1932, 22; *National Art-Collections Fund Report*, 1932, p. 30 repr.; C. B. and G. Mandel, *L'opera completa del Botticelli*,

(Milan, 1967), pp. 102–3, No. 110 (incorrectly described as in the collection of a certain H. T. G.).

There is a *pentimento* at the Virgin's right shoulder.

No. A413 is one of a number of studio variants ultimately derived from Botticelli's early painting of the *Virgin and Child with the Young S. John* in the Louvre.[2] Here the figure of the Young S. John has been omitted and the background considerably altered. In his National Gallery catalogue, the late Sir Martin Davies compiled an exhaustive list of other studio variants, together with a further list of panels from Botticelli's workshop with similar, or related, compositions.[3]

No. A413 is rather crudely painted, but was once in Ruskin's collection and is therefore of some historical significance in that Ruskin's appreciation of Botticelli's work was an important contributory factor in the modern reassessment of this painter.[4]

REFERENCES: 1. It is stated in the sale catalogue that No. A413 was discovered by C. Fairfax Murray in Florence in 1877 and that the discovery was reported to Ruskin in a letter dated 1 Nov. 1877. The compiler has been unable to trace this letter. 2. W. Bode, *Botticelli. Klassiker der Kunst* (Stuttgart, 1926), p. 11. 3. M. Davies, *National Gallery Catalogues. The Earlier Italian Schools*, 2nd edn. (London, 1961), pp. 111–12. 4. See M. Levey, 'Botticelli and Nineteenth-Century England', *Journal of the Warburg and Courtauld Institutes*, 23 (1960), 291–306.

# FRANCESCO BOTTICINI                         1446/7–1497

Florentine school. His real name was Francesco di Giovanni and he is only referred to once in a document as Botticini. He began in the workshop of Neri di Bicci, but remained there for only nine months. His early style was based on that of Cosimo Rosselli and of Andrea del Castagno and, at a later stage, he was influenced by Verrocchio, Botticelli, and the Pollaiuoli. The only extant documented work was actually completed by his son, Raffaello. There is, therefore, no firm basis for the development of his style, but several altar-pieces are widely acknowledged to be by him.

## ATTRIBUTED TO FRANCESCO BOTTICINI

A85  S. JOHN THE BAPTIST                      **Pl. 29**

Wood (cradled). 152·5 × 68·5.

Inscribed on the scroll ECCE (AG)NUS (DEI).

Condition: poor. Long vertical splits in the centre of the panel and also on each side of the figure, particularly in the lower half, are clearly visible

in the reproduction. There has been considerable paint loss in these areas. The features appear to have been slightly retouched. The paint surface is dirty and obscured by old varnish.

Fox-Strangways Gift, 1850.

Literature: Crowe and Cavalcaselle, *History*, iii, German edn. (Leipzig, 1870), 138; Van Marle, *Development*, xii (1931), 271; E. Möller, 'Salvestro di Jacopo Pollaiuolo dipintore', *Old Master Drawings*, 10 (1935), 20.

The panel illustrates a quotation from Matthew 3: 10.

In earlier editions of the Ashmolean catalogue No. A85 was ascribed to Antonio and Piero Pollaiuolo. This was first denied by Jordan, the editor of the German edition of Crowe and Cavalcaselle, and again later by Möller. Van Marle classified No. A85 as school of Botticelli. The present attribution is due to Mr. Everett Fahy.[1]

A panel of S. Vincent Ferrer in the Accademia, Florence, ascribed by Van Marle to Botticini, is similar in style and there are also analogies in the treatment of the landscape.[2] Several other representations of S. John the Baptist illustrating the same text as that used for No. A85 are known.[3] Dr. Miklòs Boskovits has argued that the pose and characterization of the Saint were inspired by Botticelli's treatment of the Baptist on the altarpiece painted for the church of S. Barnabà, Florence.[4] In fact, the pose is closer to that of the Baptist on Botticelli's altar-piece formerly in the Bardi chapel, S. Spirito, Florence, a documented work of 1485.[5] Stylistically, however, No. A85 owes more to the Pollaiuoli, and it is pertinent to recall, even if no definite connection can be posited, that Vasari describes a lost painting of S. John the Baptist by Antonio Pollaiuolo, which was once in the Palazzo Signoria.[6] The influence of the Pollaiuoli in No. A85 is most apparent in the treatment of the draperies.

REFERENCES: 1. Letter of 27 Jan. 1969. 2. Inv. 3455. Van Marle. *Development*, xiii (1931), 416, n. 1. U. Procacci, *The Gallery of the Academy of Florence*, 2nd edn. (Rome, 1951), p. 46 as 'manner of Francesco Botticini'. 3. M. Boskovits, *Tuscan Paintings of the Early Renaissance* (Budapest, 1969), pls. 42–3. 4. Boskovits, ibid. Repr. by Berenson, 1963, ii, pl. 1085. 5. Now in Berlin-Dahlem (Staatliche Museen, inv. 106). Repr. by Van Marle, *Development*, xii (1931), fig. 84. 6. Vasari, iii. 293. An old label, now destroyed, once on the back of No. A85 apparently drew attention to this passage in Vasari. The wording of the label is known from a copy made by Borenius for the Departmental files. A. Sabatini, *Antonio e Piero del Pollaiolo* (Florence, 1944), p. 87 tentatively associates a drawing in the Uffizi (inv. 357E) with the lost painting by Pollaiuolo, but this does not appear to have been accepted by other writers. There is no resemblance between the Baptist in the drawing and the figure on No. A85. For further discussion and a reproduction of the drawing, see S. Ortolani, *Il Pollaiuolo* (Milan, 1948), pp. 209–10, repr. pl. 98.

# AGNOLO BRONZINO                                    1503–1572

Florentine school. Painter and poet. His real name was Agnolo di Cosimo, called Bronzino. Vasari says that he was the pupil of Raffaellino del Garbo and then of Pontormo with whom he collaborated. He worked mainly in Florence, often for the Medici family, particularly after the marriage of Cosimo I and Eleanora of Toledo in 1539. He also worked in Pesaro, Urbino, Rome, and Pisa. Bronzino was a friend of Vasari and a founder member of the Accademia del Disegno in 1562/3.

A105   PORTRAIT OF GIOVANNI DE'MEDICI (1543–62)       **Pls. 30–2**

Wood. 66·2 × 52·8 (slightly bowed).

On the back a label inscribed by a nineteenth-century hand: *Ritra(tto) di Garzia de' Medici di Angiolo Allori / esist(ente) di nella Galleria dei Conti Guidi di Firenze.* On the back of each of the eight panels set into the frame there are the remnants of wax impressions of seals, but none is completely preserved. The most that can be made out is a helm affronté above a shield enclosing three crosses, containing two fishes naiant head to tail, in chief a label of four pieces.[1]

Condition: fair. Cleaned in 1934. There is considerable retouching in the background. The features are slightly rubbed and both cheeks have been damaged by blistering. Two vertical cracks in the paint surface on the right side of the panel can be made out in the reproduction. The crack nearest the right edge extends the height of the panel. The medallions in the frame are all slightly rubbed and the two upper panels on either side have several small repairs. The lower panel on the left side is false, having been added in 1951.

Fox-Strangways Gift, 1850.

Exhibited: Leeds, *National Exhibition of Works of Art*, 1868 (295).

Literature: H. Schulze, *Die Werke Angelo Bronzinos* (Strasbourg, 1911), p. xxv; A. McComb, *Agnolo Bronzino* (Cambridge, Mass., 1928), p. 116, No. 30 repr.; L. Venturi, *Pitture italiane in America* (Milan, 1931), CCCXLVII; Berenson, 1932, 116: 1936, 100: 1963, 43 repr.; Venturi, *Storia*, ix, pt. 6 (1933), 73, n.; L. Becherucci, *Manieristi toscani* (Bergamo, 1944), p. 49; L. Becherucci, *Bronzino* (Florence, 1949), n.p. [pp. 4–5] repr.; D. Heikamp, 'Agnolo Bronzinos Kinderbildnisse aus dem Jahre 1551', *Mitteilungen des Kunsthistorischen Institutes in Florenz*, 7 (1953–6), 136 repr.; L. Becherucci, 'Per un ritratto del Bronzino', *Studi in onore di Matteo Marangoni* (Florence, 1957), p. 202; A. Emiliani, *Il Bronzino* (Milan, 1960), pp. 72, 92, and pl. 76; F. Cappi Bentivegna *Abbigliamento e costume nella pittura*

*italiana. I. Rinascimento* (Rome, 1961), p. 252, No. 356 repr.; J. Pope-Hennessy, *The Portrait in the Renaissance* (London, 1966), pp. 184–5 repr.; K. Langedijk, *De Portretten van de Medici tot omstreeks 1600* (Amsterdam, 1968), pp. 94 and 150, n. 58; E. Baccheschi *L'opera completa del Bronzino* (Milan, 1973), p. 99, No. 86.

X-ray photographs of No. A105 were taken in 1969, but the results produced no new evidence.

C. F. Bell first observed that a similar portrait of Giovanni de' Medici painted by Bronzino most probably in the same year as No. A105, but with important iconographical differences, is in the Lansdowne collection at Bowood.[2]

Berenson recorded No. A105 as a copy after a lost portrait by Bronzino in the 1932 and 1936 editions of the Lists, but in the most recent edition (1963) the portrait is regarded as autograph. McComb tentatively sought an attribution to Francesco Salviati, but this has received no support. No. A105 has been accepted as autograph by all other writers.

There has been much discussion regarding the identity of the sitter on No. A105 and until the publication of Dr. Detlef Heikamp's article in 1955 most writers, with the exception of Dottoressa Luisa Becherucci (1944 and 1949), accepted the traditional identification of the sitter as Don Garzia (1547–62), the third son of Cosimo I and Eleanora of Toledo, as inscribed on the label on the back of the panel. Becherucci correctly suggested that the sitter was Giovanni de' Medici, the second son of Cosimo I and Eleanora of Toledo. Heikamp, with the aid of a portrait drawing in the Uffizi showing four of the Medici children grouped together, their likenesses copied from independent portraits painted by Bronzino, has solved many of the problems of identification.[3] Further evidence is not lacking and it can now be claimed beyond any reasonable doubt that the sitter on No. A105 is Giovanni de' Medici.[4] The drawing published by Heikamp, although a copy, is inscribed with the date 1551, which must surely refer to those portraits of the Medici children commissioned from Bronzino in the correspondence of that year and later recorded in the Medici inventories.[5] Professor Sir Ellis Waterhouse (written communication)[6] first pointed out that the likeness of Giovanni in the drawing in the Uffizi was copied not from No. A105 as Heikamp asserted, but from the portrait in the Lansdowne collection, where the sitter is shown with a similar fringe hair-style and holds a Greek text in his right hand.[7] The most likely explanation for the iconographical differences

between the two portraits lies in the fact that the portrait at Bowood was most probably intended as a gift for the Pope.[8] Giovanni de' Medici was destined for the Church from birth, no doubt in an attempt to revive the memory of his illustrious forebear and namesake, Leo X. Giovanni never took Holy Orders, but he was made deacon in 1550 and was, none the less, made a Cardinal by Pius IV in 1560[9] when only seventeen, and Archbishop of Pisa in 1561.[10]

There is a considerable literary tradition about the relationship between Giovanni and his brother Garzia, which developed out of what appeared to contemporaries to be the strange circumstances of their deaths.[11]

A bust-length portrait of Giovanni de' Medici, weaker in execution than No. A105, is in the Museum of Art, Toledo.[12]

The frame of No. A105 should be noted. Mr. James Byam Shaw has observed that it was probably originally transferred from another picture forming part of that section of the Fox-Strangways collection now at Christ Church.[13] No. A105 was apparently surrounded by the present frame in 1891,[14] removed from it in 1910,[15] and only reunited with it in 1951.[16] The frame is undoubtedly contemporary with the portrait. A painting of the *Holy Family* in the collection of Sir Harold Acton in Florence (Villa La Pietra) is surrounded by a similar frame which is believed to have been designed by Vasari.[17] A convincing attribution for the *putti* and other allegorical figures painted *en grisaille* in the medallions has not yet been made and the specific allegorical significance of these panels, if indeed any is intended, has not been explained. It should be observed, however, that the quality of the seven original medallions is high.[18]

REFERENCES: 1. This does not appear to be the seal of any branch of the Guidi family. 2. Notes in the Departmental files. Bell made this observation in 1925. For the portrait in the Lansdowne collection see G. Ambrose, *Catalogue of the Collection of Pictures belonging to the Marquess of Lansdowne, K.G., at Lansdowne House, London, and Bowood, Wilts.* (London, 1897), p. 9, No. 105. The measurements are 72·4×59 cm. Mrs. Jameson, *Companion to the Most Celebrated Private Galleries of Art in London* (London, 1844), p. 299, first identified the sitter on the portrait at Bowood as Giovanni de' Medici. Previously it was Lot 21 of Lord Vernon's sale (Christie's, 16 Apr. 1831), described as 'Portrait of Pope Leo X when a Boy with a Book in his Hand, in an embroidered dress', bt. Lord Lansdowne £34. 13s. 0d. The portrait was seen at Bowood by G. F. Waagen, *Treasures*, iii. 160. It is now in poor condition, but was once of fine quality. The compiler is grateful to the Marquess of Lansdowne for allowing him to inspect the panel. 3. Inv. 1494S. Repr. D. Heikamp, 'Agnolo Bronzinos Kinderbildnisse aus dem Jahre 1551', *Mitteilungen des Kunsthistorischen Institutes in Florenz*, 7 (1953–6), 134, fig. 1. 4. The supplementary evidence is as follows; a miniature in the Museo Medici, Florence, one of a series painted in the studio of Bronzino inscribed GIOVANNI DI COSIMO MEDICI

CARDINALE, repr. G. Pieraccini, *La stirpe de' Medici di Cafaggiolo*, ii (Florence, 1924), pl. XLVIII, fig. LV, where a double portrait of Giovanni and Garzia attributed to Vasari and apparently in the Palazzo Vecchio is also repr. (fig. LVI); a three-quarter-length portrait, in cardinal's robes, perhaps seventeenth century, in the Galleria Corsi, Florence (inv. 130) inscribed GIOV. MED.; the engraving by Adriaen Haelwegh in the series *Chronologica series simulacrorum regiae familiae mediceae centum* published by Francesco Allegrini in 1761, inscribed JOHANNES AB ETRURIA / COSMI I : MAG : DUCIS ETRURIAE FILIUS / S : R : ECC : DIACONUS CARDINALIS. Professor Janet Cox Rearick Hitchcock kindly informed the compiler that there is documentary evidence to show that the face of S. John the Baptist on the picture in the Borghese Gallery, Rome (repr. A Emiliani, *Il Bronzino* (Milan, 1960), pl. 70), is a likeness of Giovanni de' Medici. Professor Hitchcock intends to publish the relevant document in the near future. 5. For the letters see Heikamp op. cit., 137–8. For the references to the portraits in the inventory of 1553, see C. Conti, *La prima reggia di Cosimo I de' Medici* (Florence, 1893), p. 139. An inventory dated 1560 with other references to portraits of the children of Cosimo I and Eleanora of Toledo has recently been published by J. Beck, 'Bronzino nell' inventario mediceo del 1560', *Antichità viva*, 11 (1972), 10–12. 6. Letter of 2 Feb. 1956. 7. The book on the portrait at Bowood is inscribed with the opening passage from the oration addressed *To Nicholas* by Isocrates (*Isocrate: Discours*, ed. G. Mathieu and E. Brémond, ii (Paris, 1938), pp. 97–8). Isocrates was an author well known to the humanists and by the sixteenth century his writings often formed the basis of treatises addressed to rulers. For the textual history of the oration *To Nicholas* in the Renaissance see R. R. Bolgar, *The Classical Heritage and its Beneficiaries* (Cambridge, 1954), pp. 478 and 516–18. The identification was made by Professor Hugh Lloyd-Jones. The inscription does not occur on No. A105. 8. Pieraccini, op. cit., pp. 108 and 116. 9. For an eyewitness account of his arrival in Rome, see the description in two letters written by Vasari to Antonio de' Nobili and Vincenzo Borghini in Florence, both dated 29 Mar. 1560 (K. Frey, *Der literarische Nachlass Giorgio Vasaris*, i. (Munich, 1923), 550–1, letter ccxcix and 553–4, letter ccc). 10. Biographical details are given by Pieraccini, op. cit., pp. 105–19. Also see N. Zuchelli, *Cronotassi dei Vescovi e Arcivescovi di Pisa* (Pisa, 1907), pp. 182–7, No. LXVII. 11. G. E. Saltini, *Tragedie medicee domestiche (1557–87)* (Florence, 1898), pp. 112–77. Saltini omits to mention the poem entitled 'Garzia' in Samuel Rogers's *Italy* (*The Poetical Works of Samuel Rogers* (London, 1875), pp. 265–8), which was completed by 1834. 12. Inv. 51. 305, on panel, measuring 46×30. The compiler is grateful to Dr. R. M. Riefstahl for sending this information. Judging from the photograph, the portrait in Toledo is weaker than both the portraits in Oxford and at Bowood, and may therefore have been painted by an assistant, possibly at the same sitting. The sitter is of the same age and apparently wearing the same chemise. The portrait in Toledo was formerly in the collections of Baron Lazzaroni, Paris, and Lawrence P. Fisher, Detroit. 13. J. Byam Shaw, *Paintings by Old Masters at Christ Church, Oxford* (London, 1967), p. 61, No. 65. 14. *A Provisional Catalogue of the Paintings Exhibited in the University Galleries, Oxford* (Oxford, 1891), pp. 22–3, No. 30. 15. *Annual Report*, 1910, 23. 16. *Annual Report*, 1951, 44–5. 17. Repr. *Mostra del Cinquecento toscano in Palazzo Strozzi* (Florence, 1940), Sala XI, p. 88, No. 12, pl. 41. 18. The upper panels on both sides and the two panels set into the bottom part of the frame are painted in greeny-blue monochrome. The rest are in brown monochrome.

## AFTER BRONZINO

A672 BUST-LENGTH PORTRAIT OF AN UNKNOWN WOMAN Pl. 33

Wood. 45·5 × 35·5.

Condition: poor. There is a vertical split in the panel just to the right of centre. The surface is covered by a thick layer of old varnish.

Bequeathed by Sir Arthur Evans, 1941.

No. A672 appears to be an eighteenth-century imitation of a portrait by Bronzino, possibly copied from an engraving. No exact prototype has been traced.[1] The features are surely the same as those of the *Portrait of a Woman* in the Sabauda Gallery, Turin, which has sometimes been erroneously identified as a likeness of Eleonora of Toledo.[2]

REFERENCES: 1. The portrait of Laudomia de' Medici, the second wife of Piero Strozzi, which is included in the series engraved by F. Allegrini, *Chronologica series simulacrorum regiae familiae mediceae centum* (Florence, 1761), may have been the source, although the correspondence is by no means exact. 2. N. Gabrielli, *Galleria Sabauda. Maestri italiani* (Turin, 1971), pp. 82–3, Cat. no. 122, fig. 103.

## AFTER BRONZINO

A520C PORTRAIT OF ELEANORA OF TOLEDO WITH A VIEW
OF FLORENCE BEHIND Pl. 34

Wood. 104·2 × 85·2.

Condition: fair.

Collections: C. J. Longman.

Bequeathed by Mrs. H. A. Longman, 1938.

No. A520c is no more than a nineteenth-century pastiche of a famous composition by Bronzino, namely the *Portrait of Eleanora of Toledo*, of which a much discussed variant is in the National Gallery, Washington.[1] The pose has been slightly changed and so have the details of the embroidery on the dress. The view of Florence in the background on the right is an interpolation, and the fact that the figure has been reversed suggests that the portrait was copied from an engraving.

REFERENCES: 1. K 2068. F. R. Shapley, *Paintings from the Samuel H. Kress Collection. Italian Schools XVI–XVIII Century* (London, 1973), pp. 15–16 repr.

## BARTOLOMEO CAPORALI
active 1442,
last mentioned 1503

Umbrian school. His real name was Bartolomeo di Segnolo, called Caporali. The formative influences on his style were Benozzo Gozzoli, Fra Angelico and, more distantly,

Domenico Veneziano. He collaborated with Bonfigli on an altar-piece for the church of S. Domenico, Perugia. Often works painted by Caporali are mistakenly attributed to Bonfigli. Caporali's style appears to have developed little and he held a number of important positions in public life.

## ATTRIBUTED TO BARTOLOMEO CAPORALI

A803    CHRIST AS THE MAN OF SORROWS            **Pl. 35**

Wood. 16 (round, irregular edge).

On the back a label inscribed by a nineteenth-century hand: *Dip ad olio in ta | vola sec XVI rap | Ecce Homo stema del Monte di Pietà | M° 0.24.XO. .24. | lot 19(4?) Piot 653 | Bonnat 11-11-94 | L. Bartolini.*

Condition: fair. The panel is damaged at the edges and the surface is rather disfigured by a heavy craquelure. There is some retouching above and to the left of the loin-cloth.

Bequeathed by Percy Moore Turner, 1951.

Literature: *Annual Report*, 1951, 52 repr.

No. A803 has almost certainly been cut from the central panel of the predella of an altar-piece.

     At the time of acquisition No. A803 was attributed to Benedetto Bonfigli by Evelyn Sandberg-Vavalà.[1] The present attribution to Caporali was first suggested by Mr. Francis Russell (verbal communication), who has compared No. A803 with the following works: the pinnacle panels of the *Annunciation*, which formed part of an altar-piece painted in 1467 in collaboration with Bonfigli for the church of S. Domenico in Perugia (Perugia, Galleria Nazionale dell' Umbria);[2] the figures in the quatrefoils beneath the detached fresco of *Christ and the Virgin in Glory*, painted in 1468 for the monastery of S. Giuliana, Perugia (Perugia, Galleria Nazionale dell' Umbria);[3] and the *Angels with Instruments of the Passion* (Perugia, Galleria Nazionale dell' Umbria), which are the only remaining fragments of an altar-piece painted in 1477 for the Duomo in Perugia.[4] On the basis of these comparisons a date of 1470-5 may be the most acceptable for No. A803, at which time Caporali was still deeply influenced by Bonfigli. None the less, the bunching of the drapery, the relationship of eye to nose, the articulation of the wrists, the drawing of the locks of Christ's hair, and the crisp modelling of the light all point in this instance to Caporali's hand.

     Dr. Federico Zeri (written communication) has also independently suggested the name of Caporali in connection with No. A803.[5]

REFERENCES: 1. As stated in the *Annual Report*, 1951, 52. 2. Inv. 142. Repr. S. Lothrop 'Bartolomeo Caporali', *Memoirs of the Academy in Rome*, i (Bergamo, 1917), pl. 21, and Berenson, 1968, ii, pls. 681–2. 3. Inv. 166. Repr. Lothrop, op. cit., pls. 28–9, with a detail of S. Giuliana on pl. 28, fig. 2. 4. Inv. 160–3. Repr. Lothrop, op. cit., pl. 38. 5. Letter, 5 Oct. 1970.

# GIOVAN FRANCESCO CAROTO                    *c.* 1480–1555

Veronese school. He was the pupil of Liberale da Verona, but looked for inspiration towards Mantegna, Raphael, and Giulio Romano, as well as towards the leading Emilian and Lombard painters. Although there are several signed and dated works, the tendency to quote from other painters makes the chronology of his other works difficult to establish. Caroto worked mainly in Verona, but also in Milan and Casale. His brother, Giovanni Caroto, was also a painter.

A783   THE CRUCIFIXION WITH THE VIRGIN MARY AND
S. JOHN                                                          **Pl. 36**

Wood. 45·5 × 33·9.

Signed at the bottom of the cross, G. F. CHAROTUS PING.

On the back a label now badly faded, but, as far as it can be made out, recording the rudimentary facts about Giovan Francesco Caroto's life and possibly written by George Richmond (see Collections below).

Condition: poor. The paint-surface is badly worn throughout, with extensive retouching in the sky, on the Cross, and in the foreground. Some original paint is left on the figures.

Collections: George Richmond (Christie's, 1 May 1897, lot 37, bt. Julia Robinson, granddaughter of George Richmond); thence by direct inheritance to Mrs. H. F. Medlicott, the daughter of Julia Robinson.

Bequeathed by Mrs. H. F. Medlicott, 1950.

Exhibited: London, Royal Academy, *Exhibition of Works by the Old Masters*, 1884 (261).

Literature: *Annual Report*, 1950, 42; Berenson, 1968, 79.

No. A783 was described by Sir Karl Parker in the *Annual Report* of 1950 as an early work by Caroto reflecting 'the influence of Mantegna and the proximity of Montagna'. In fact, the treatment of the landscape with the precipitous mountains and the dramatic movements of the clouds across the sky, together with the impassioned gestures of the figures, recall the restless world of Liberale da Verona.[1] In as much as Liberale da Verona was a formative influence on Caroto, No. A783 can safely be regarded as

a work of his early maturity. The three predella panels from a lost altarpiece with scenes from the *Death of the Virgin*, now divided between the Art Museum, Princeton University, and the collection of Mr. P. M. R. Pouncey, London, are possibly close in date.[2]

REFERENCES: 1. Cf., e.g. the miniature by Liberale da Verona in the Biblioteca Comunale, Siena (inv. x. 11. 3.) painted in 1471. Repr. Carlo del Bravo, *Liberale da Verona* (Florence, 1967), pl. CIII. There is a better reproduction in E. Fahy, 'Some notes on the Stratonice Master', *Paragone*, 197 (1966), fig. 12. 2. See Carlo del Bravo, 'Per Giovan Francesco Caroto', *Paragone*, 173 (1964), figs. 2–4, who suggests a date *c.* 1510. The whole predella is repr. by M. T. Franco Fiorio, *Giovan Francesco Caroto* (Verona, 1971), fig. 20; for catalogue entries of the individual predella panels see pp. 84 and 88, Cat. nos. 15 and 25.

## ATTRIBUTED TO GIOVAN FRANCESCO CAROTO

A347   THE LAMENTATION WITH A BENEDICTINE DONOR        **Pl. 37**

Linen (relaid on canvas). 40·5 × 55·3.

A label on the stretcher inscribed by Charlotte Bywater, wife of Ingram Bywater, reads *Bernardo Parenzano | Signed picture by him in | Gallery of Modena | Bought at Christie's July 1897 from the sale of | Mr. Boyce.*

Condition: poor. Cleaned in 1958. The surface is badly worn throughout and the paint is now very thin in places. There are several small retouches on the figures.

Collections: G. P. Boyce (Christie's, 1 July 1897, lot 340, as Fimarose, bt. Ingram Bywater for 3 gns.).

Bequeathed by Ingram Bywater, 1915.

Literature: *Annual Report*, 1915, 14; Berenson, 1932, 377: 1936, 324: 1968, 280.

An attribution to Bernardo Parentino, first adopted when No. A347 was in the Bywater collection, was accepted on acquisition and repeated in most of the earlier editions of the Ashmolean catalogue. Berenson ascribed No. A347 to Domenico Morone. Neither attribution can be substantiated today. The style of No. A347, however, is certainly Veronese, although there is a pronounced influence, particularly in the figure of Christ, of the Ferrarese school. Professor Sir Ellis Waterhouse (verbal communication) has suggested that an attribution to Giovan Francesco Caroto is worth consideration. The figure of the Magdalen on the right of the composition and the highlights on all the draperies are indeed strikingly reminiscent of Caroto, although the treatment of the desolate landscape and the

skeletal figure of the Dead Christ are not quite so characteristic of that master. Professor Carlo del Bravo has recently emphasized the influence of the Ferrarese school on the development of Caroto's style. A date of 1510–15 might be tentatively suggested for No. A347, that is at about the time of the altar-piece in S. Giorgio in Braida, Verona, where similarities can be found in the scenes of the predella.[1]

REFERENCE: 1. Carlo del Bravo, 'Per Giovan Francesco Caroto', *Paragone*, 173 (1964), 3–16, particularly 7–8, figs., 7, 8, and 9.

## BALDASSARE CARRARI

first documented in 1486,
died 1515/16

Romagnole school. The real name was Baldassare di Matteo, called Carrari and known as il Giovane. He was active at Forlì and also at Ravenna where many of his works are still to be found. Carrari's style is derivative, the most notable sources being Niccolò Rondinelli and Marco Palmezzano.

## ATTRIBUTED TO BALDASSARE CARRARI

A711   PORTRAIT OF AN UNKNOWN WOMAN                    **Pl. 38**

Wood. 50·4 × 35·2.

Condition: fair. A large area of damage extends down the right side of the face, over the chin and into the neck. The right eye has for the most part been repainted. The landscape is intact, but the drapery has been fairly heavily retouched.

Bequeathed by Miss E. G. Kemp, 1940, but did not enter the collection until 1945.

Exhibited: London, Burlington Fine Arts Club, *Pictures of the Umbrian School*, 1910 (11).

Literature: *Annual Report*, 1945, 18 repr.

The old attribution to Giovanni Santi, which was tentatively accepted at the time of acquisition, first occurs in the catalogue of the Umbrian exhibition held at the Burlington Fine Arts Club in 1910. In the *Annual Report* of 1945 Sir Karl Parker, who was not totally convinced by the attribution to Santi, did nevertheless favour an attribution to the school of Urbino, on the basis of the combination of Flemish and Umbrian

elements in the style, notably the drawing of the hands and the treatment of the landscape.

Sir John Pope-Hennessy (verbal communication) has recently proposed the name of Baldassare Carrari. Comparison with the figures on the *Coronation of the Virgin* (Forlì, Pinacoteca),[1] signed and dated 1512, reveals a number of similarities, particularly in the stiffness of the pose and the drawing of the rather wooden features. Comparison may also be made with the altar-piece of the *Visitation* (Forlì, S. Mercuriale), where the female attendant positioned behind the pillar to the left of the main figures is strikingly similar in type to the sitter on No. A711.[2]

REFERENCES: 1. Repr. Berenson, 1957, pl. 397. Also see C. Gnudi and L. Becherucci, *Mostra di Melozzo e del Quattrocento Romagnolo*, (Forlì, 1938), pp. 122–3, No. 111, repr. pl. 77. 2. Repr. Gnudi and Becherucci, op. cit., pp. 123–4, No. 118, pl. 77.

## NADDO CECCARELLI　　　　documented 1347

Sienese school. He was a pupil of Lippo Memmi. There is only one signed and dated work and his *œuvre* is small.

## ASCRIBED TO NADDO CECCARELLI

### A1062　VIRGIN AND CHILD　　　　Pl. 39

Wood. Painted surface 15·8× 11·2; Size of panel 17·7× 13·1 (including frame).

On the back inscribed in ink *Sienese | 100/- | Rome 95* (?).

Condition: fair. There is a certain amount of ingrained surface dirt. There is some damage bottom left.

Bequeathed by Sir John Beazley, 1971.

There is a *pentimento* above the Virgin's right shoulder.

The ascription to Naddo Ceccarelli is based upon comparison with the *Virgin and Child*, formerly in the Cook collection,[1] but is advanced here with little confidence. If No. A1062 is by Ceccarelli it is most likely an early work,[2] but the compiler is not wholly satisfied that the panel dates from the fourteenth century. Both the style and the composition appear to be an amalgam of motifs taken from Lippo Memmi and Naddo Ceccarelli. The affinities with the Sienese school are undeniable, but the technique (there is a great deal of scraping with a stilus over the Child's drapery), the shallowness of the punching, and such factors as the light weight of the wood and the character of the decoration on the back of the panel suggest that the painter may possibly be a later imitator.

REFERENCES: 1. Repr. Berenson, 1968, ii, pl. 320. 2. Inv. 115. See C. Brandi, *La Regia Pinacoteca di Siena* (Rome, 1933), pp. 54–5. There is a better reproduction in Berenson, 1968, ii, pl. 319. For a recent article on Naddo Ceccarelli and an attempt to establish the evolution of his style see C. de Benedictis, 'Naddo Ceccarelli', *Commentari*, xxv (1974), 139–54.

## ANONYMOUS CREMONESE SCHOOL (?)  1570–1590

### A863a  PORTRAIT OF A MUSICIAN  Pl. 40

Canvas (relined). 68·5 × 56·5.

Condition: poor. The surface was once extensively repainted and some of this repaint is still apparent in the drapery, particularly on the shoulders and the sleeves.[1] The face and the hands are in a far better state, apart from small repaints. Further damage to the surface may have been caused by relining. There is a horizontal crease approximately 11 cm. from the lower edge and two abrasions that may be burns above and below the cuff of the sitter's right sleeve. The colours have darkened and the textural qualities of the draperies have been almost completely lost. Cleaned some-time before 1952.

Collections: Giacomo Stradivari, Cremona; J. B. Vuillaume, Paris; W. H., A. F., and A. E. Hill, London.

Presented by W. E. Hill & Sons Ltd., 1952.

Literature: W. H., A. F., and A. E. Hill, *Antonio Stradivari* (London, 1902), Ch. XII pp. 279–85 repr.: 2nd edn. (London, 1909), pp. 294–300 repr.; H. F. Redlich, 'Monteverdi', in *Die Musik in Geschichte und Gegenwart*, ed. F. Blume, 9 (Kassel–Basel–London–New York, 1961), repr. pl. 32, fig. 1.

According to Lady Huggins, who was invited to contribute to the mono-graph on Antonio Stradivari written by W. H., A. F., and A. E. Hill, the sitter is shown holding a viola da gamba, possibly of Brescian workman-ship, and in the left background there is an alto-viol with bow. The bows of both viols are apparently pre-Corellian. The cartellino in the foreground inscribed with musical notation and a text is now too rubbed to be clearly identifiable, even by musicologists.

The traditional identification of the sitter with Antonio Stradivari (1644–1737) was rightly dismissed by Lady Huggins on chronological grounds. The same writer proposed an identification with the young Claudio Monteverdi (1567–1643) as an alternative and this has gained some currency. Dr. H. F. Redlich, for instance, reproduces No. A863a as a

presumed portrait of Monteverdi. The only extant authentic likeness of Monteverdi shows him at a far more advanced age. This is the portrait painted by Bernardo Strozzi and seen by Boschini in Venice, of which there is a copy in the Tiroler Landesmuseum Ferdinandeum, Innsbruck.[2] This portrait was engraved for the *Fiori poetici raccolti da G. B. Marinoni*, published in Venice in 1644. Marinoni was a pupil of Monteverdi and the engraving confirms the identification of the original portrait by Strozzi. Even allowing for the considerable difference in age, it is hardly possible that No. A863a is a portrait of the same person.[3]

On a strictly iconographical basis the sitter shown on No. A863a is neither a composer nor an instrument-maker, but, rather, an able performer on stringed instruments.[4] It is, of course, possible that the sitter combined the talents of composing and playing, or of instrument-making and playing. Monteverdi was renowned as a composer, but not as a performer on stringed instruments. On the other hand, Gasparo da Salò (1540–1609) was an instrument-maker with a reputation as a brilliant performer and, inasmuch as the instruments shown in the background of the portrait in Oxford are of the type made by Gasparo da Salò, an identification with this Brescian instrument-maker is worth further consideration.[5]

No. A863a appears to be Cremonese, having stylistic features in common with portraits by the Campi family. The quality of the portrait is not sufficient to support an attribution either to Bernardino or Giulio Campi. A *Portrait of a Man* in the Pinacoteca, Cremona, which Dr. Alfredo Puerari compares with the manner of Cristoforo Magnani, is similar.[6] The drawing of the facial features and particularly of the fingers is strikingly close to No. A863a.

Lady Huggins suggested a date *c.* 1590 for the portrait now in Oxford. On the evidence of the costume Mrs. Stella Mary Newton (written communication) states that No. A863a is unlikely to have been painted before 1600.[7] On grounds of style, however, No. A863a could have been painted between 1570 and 1590.

REFERENCES: 1. For a reproduction of the portrait before cleaning see W. H., A. F., and A. E. Hill, *Antonio Stradivari* (London, 1902), opp. p. 284, and 2nd edn. (London, 1909), opp. p. 296. 2. Inv. 503. See L. Mortari, *Bernardo Strozzi* (Rome, 1966), pp. 66–7, 82, and 139, repr. fig. 436. For the passage in M. Boschini see *La carta del navegar pitoresco* (Venice, 1660), ed. A. Pallucchini (Venice–Rome, 1966), p. 397 and n., where the portrait in Innsbruck is described as 'probably a copy'. 3. The engraving is repr. by Hill, op. cit., fig. 68, in both editions. 4. Compare the iconography of the so-called *Portrait of a Musician* in the National Gallery, London (inv. 2511), attributed to the North Italian School, for which see C. Gould, *National Gallery Catalogues. The Sixteenth-Century Italian*

*Schools (excluding the Venetian)* (London, 1962), p. 124, repr. *Plates* (London, 1964), p. 153, where the sitter is shown holding a pair of compasses. It is significant that Strozzi painted Monteverdi with his hands resting on a score. 5. On Gasparo da Salò see G. Livi, *I liutai bresciani* (Milan, 1896), Ch. V, pp. 39–54, supplemented by A. M. Mucchi, 'Paralipomeni su Gasparo da Salò', *Miscellanea Salodiense* (1937), pp. 337–54. The Hill Collection of musical instruments in the Ashmolean Museum has some fine examples of Gasparo da Salò's workmanship, for which see D. Boyden, *Catalogue of the Hill Collection of Musical Instruments in the Ashmolean Museum, Oxford* (London, 1969), Nos. 2, 9, and 12. 6. A. Puerari, *La Pinacoteca di Cremona* (Cremona, 1951), p. 105, No. 155 repr. 7. Letter of 21 Dec. 1973.

# CARLO CRIVELLI                                active 1457, died 1494/5

Venetian school. He was the son of a painter Jacopo Crivelli; his younger brother, Vittorio, also painted. He had left Venice for Dalmatia by 1465 and after 1469 he was active mainly in the Marches, where he executed a number of magnificent polyptychs. His early works reveal the influence of Antonio Vivarini, Jacopo Bellini, and Mantegna. His mature style is characterized by expressive drawing and a fine technique.

**A314   S. JOHN THE BAPTIST (PANEL FROM AN ALTAR-PIECE)   Pl. 41**

Wood. Original painted surface approximately 67·5 × 33 (formerly arched, see Condition below). Size of panel, 72·7 × 39.

Condition: good. Cleaned and restored in 1970. A narrow strip in the middle of the panel, which includes the whole of the face, the neck, the chest, and part of the left forearm and hand, is original and well preserved. The background, as seen in old reproductions, had been extensively repainted.[1] This has now been removed and the area filled in with a neutral ground. Traces of the original background are just visible above the right shoulder and around the head. The panel is rectangular, but the composition was originally arched with the paint surface probably not extending to the top edge of the panel.

Presented by Henry Pfungst, 1903.

Literature: Berenson, 1932, 164: 1936, 140: 1957, 70; Van Marle, *Development*, xviii (1936), 84–5, n.; P. Zampetti, *Carlo Crivelli nelle Marche* (Urbino, 1952), p. 64; F. Zeri, 'Cinque schede per Carlo Crivelli', *Arte antica e moderna*, 13/16 (1961), 172–3 repr.; P. Zampetti, *Catalogo. Mostra Carlo Crivelli e i Crivelleschi* (Venice, 1961), p. 101; A. Bovero, *Tutta la pittura del Crivelli* (Milan, 1961), p. 88 repr.; P. Zampetti, *Paintings from the Marches. Gentile to Raphael*, Eng. edn. (London, 1971), p. 180.

Van Marle and at first Berenson (1932) both favoured an attribution to Vittorio Crivelli for No. A314. Later, Berenson (1936, 1957) regarded the

panel as autograph in part. More recently, Professor Pietro Zampetti, Dr. Federico Zeri, and Dottoressa Anna Bovero have upheld the attribution to Carlo Crivelli, although neither Zampetti nor Zeri completely rule out the possibility of some studio participation. Since cleaning something of the true quality of the original has been revealed and an attribution to Carlo Crivelli alone now seems perfectly tenable.

Zeri has published three other panels which once belonged to the same polyptych as No. A314: S. Lorenzo (Lugano, Thyssen collection),[2] S. Augustine (Utrecht, Archiepiscopal Museum),[3] and A Bishop Saint (Tokyo, National Museum).[4] The halo patterns and the treatment of the decorative backgrounds on all these panels are similar, but the difference in height between No. A314 and the others can be accounted for, as Zeri reasonably assumed, by the fact that No. A314 has been cut at the bottom. The figure was originally a whole length, balancing the Bishop Saint now in Tokyo.

Zeri tentatively associated these four panels with an altar-piece evidently commissioned from Crivelli for the church of S. Lorenzo, Castel San Pietro (Palmiano), recorded in a document of 1487 (16 July), but of which there is no other record.[5]

REFERENCES: 1. P. Zampetti, Carlo Crivelli (Milan, 1961), fig. 119. 2. Facing right, 58×35. See The Thyssen-Bornemisza Collection, ed. R. Heinemann (Castagnola, 1969), i. 90–1, No. 81, repr. ii, pl. 231. 3. Facing left, 57×38. Repr. Zampetti, op. cit., pl. 122. 4. Inv. P. 322, facing left, 141×40. Repr. Zampetti, op. cit., fig. 120. A better repr. in H. Sasaki in Bulletin annuel du Musée National d'Art Occidental, i (Tokyo, 1967), 63–4. 5. For a transcription see Zampetti, op. cit., p. 107.

## VITTORIO CRIVELLI                    first mentioned 1465,
                                        died 1501/2

Venetian school. He was the son of a painter Jacopo Crivelli and the younger brother of Carlo Crivelli. Early works, possibly painted while still in Venice, reveal the influence of Antonio Vivarini, but his mature style is derived from that of his brother, whom he followed to Dalmatia and then to the Marches, where he was mainly active after 1481.

A301    S. CATHERINE OF ALEXANDRIA (PANEL FROM AN ALTAR-PIECE)
                                        Pl. 42

Wood. Painted surface 72·5 × 41 (arched). Size of panel 73·7 × 41 (slightly bowed).

Condition: excellent. Cleaned in 1969. The gold background is slightly worn above the saint's right shoulder. There are some small retouches in the background, on the forehead, and across the knuckles of the right hand.

Collections: Alessandro Castellani (Rome, Hoffman's, 29 Mar. 1884, lot 1092, bt. C. D. E. Fortnum); Miss Mary Fortnum, the buyer's cousin, who became his second wife in 1891.[1]

Fortnum Bequest, 1899.

Exhibited: London, Royal Academy, *Exhibition of Works by the Old Masters, Winter Exhibition*, 1885 (216).

Literature: G. Mc.N. Rushforth, *Carlo Crivelli* (London, 1900), p. 96; Crowe and Cavalcaselle, *History North Italy*, 2nd edn., i (1912), 98, n. 4; B. Geiger, in Thieme–Becker, *Lexikon*, viii (1913), 137; L. Testi, *La Storia della pittura veneziana*, ii (Bergamo, 1915), 688; C. Drey, *Carlo Crivelli und seine Schule* (Munich, 1927), p. 158; Berenson, 1932, 164; 1936, 141; 1957, 72; Van Marle, *Development*, xviii (1936), 84–5 n.; F. Zeri, 'Appunti nell' Ermitage e nel Museo Pusckin', *Bollettino d'arte*, 46 (1961), 236, n. 45; P. Zampetti, *Paintings from the Marches. Gentile to Raphael*, Eng. edn. (London, 1971), p. 186. S. di Provvido, *La pittura di Vittore Crivelli* (L'Aquila, 1972), pp. 178–84 repr.

At the time of the Castellani sale in Rome in 1884 and subsequently when in the collection of C. D. E. Fortnum, No. A301 was attributed to Carlo Crivelli.[2] Rushforth was the first to reject this attribution in favour of one to Vittorio Crivelli. The appearance of the panel has been considerably improved since cleaning in 1969.

Dr. Federico Zeri has suggested that No. A301 comes from the upper tier of the same altar-piece as a half-length panel of *S. Anthony of Padua* (formerly Englewood, New Jersey, Dan Fellows Platt collection)[3] and from which one whole-length panel, *S. John the Baptist* (Camden, New Jersey, W. S. Serri collection),[4] from the lower tier has survived. Forming part of the upper tier, together with the *S. Anthony of Padua* and No. A301, was a *S. Jerome* (Cambridge, Mass., Fogg Art Museum).[5]

Dottoressa Sandra di Provvido has tentatively proposed that these panels once belonged to the same polyptych as that from which a number of other parts are preserved in the Fitzwilliam Museum, Cambridge.[6]

REFERENCES: 1. Against the entry in Fortnum's manuscript catalogue in the Ashmolean Museum is written 'given by my dear wife Mary, 1891' (IV. 90, No. 27). The catalogue of the Castellani sale in the Victoria and Albert Museum, which is inscribed with some of the buyers' names, records that Fortnum was the buyer at the sale in Rome, but when exhibited at the Royal Academy in 1885, No. A301 was lent by Miss Mary Fortnum. 2. For the reference to Fortnum's manuscript catalogue see note 1 above. 3. Facing right, 73·66×40·64. Repr. S. di Provvido, *La pittura di Vittore Crivelli* (L'Aquila, 1972), pp. 178–84, pl. 51. 4. Facing right, 140·9×45·7. Repr. Provvido, op. cit., pp. 178–84, pl. 50. 5. Inv. 1920. 18. Facing left, 75·9×38·3. Repr. Provvido, op. cit., pp. 178–84, pl. 52.

6. Inv. 1060. See J. W. Goodison and G. Robertson, *Fitzwilliam Museum Cambridge. Catalogue of Paintings*, ii. *Italian Schools* (Cambridge, 1967), pp. 42–4. Also Provvido, op. cit., pp. 172–7.

## DOSSO DOSSI                                      active 1512, died 1542

Ferrarese school. His real name was Giovanni di Luteri, called Dosso. Dosso Dossi is an eighteenth-century appellation. The profound influence of Giorgione and Titian points to a Venetian training, but the more distant influence of Raphael is also apparent. He was in the service of Alfonso and Ercole d'Este and, together with his brother Battista, ran an active studio in Ferrara. His treatment of iconography and the emphasis on the pastoral were of some significance for the development of Italian painting.

## ATTRIBUTED TO DOSSO DOSSI

### A886   PORTRAIT OF A YOUNG MAN HOLDING A DOG
### AND A CAT                                         **Pls. 43–4**

Wood. 27·8 × 24·9.

Condition: fair. Restored in 1956. The background is completely re-painted and several paint losses on the right side of the face, particularly on the cheek, have been made good. Original paint remains on the turban, on the left side of the face, and in the neck. Below that point the original paint surface is intact. For a photograph of the painting before restoration, see **pl. 43.**

Purchased 1956.

Exhibited: London, P. & D. Colnaghi & Co. Ltd., *Old Master Paintings*, 1956(6).

Literature: *Annual Report*, 1956, 52–3 repr.; L. Puppi, The Literature of Art, 'A monograph on Dosso Dossi', review of A. Mezzetti, *Il Dosso e Battista Ferraresi* (Milan, 1965), *Burlington Magazine*, 110 (1968), 361 repr.

Sir Karl Parker, in a masterly discussion of No. A886 in the *Annual Report* of 1956, ascribed the portrait to 'a Venetian artist of the early 16th Century under the influence of Giorgione (?Domenico Mancini)'. Parker drew attention to four portraits attributed by Wilde to an anony-mous Venetian painter of the early sixteenth century designated as the Master of the Self-Portraits with reference to Domenico Mancini. The four portraits are *Portrait of a Young Man* (Leningrad, Hermitage), *Portrait of a Young Man with a Lute* (Vienna, Kunsthistorisches Museum), *Portrait of a Man with Gloves* (Munich, Alte Pinakothek), and the portrait entitled

*Il Bravo* (Vienna, Kunsthistorisches Museum).[1] All these portraits, like No. A886, reveal the profound influence of Giorgione, but, as Sir Karl Parker observed, the most telling comparison for the portrait in Oxford is with the *Portrait of a Young Man with a Lute* at Vienna, 'not only on account of its withdrawn gaze and similar expression, but also for the curious disregard that it shows for the compositional limits of the panel'.

Dr. Lionello Puppi, however, has recently suggested that No. A886 belongs to a late Giorgionesque phase in the development of Dosso Dossi, *c.* 1535–40. Puppi singles out for comparison two paintings: *Circe* (Kress collection)[2] for its tonality and dense impasto and an *Allegory* (Moscow, Pushkin Museum)[3] for the similarity of the turbaned figure on the left. No. A886 is most reminiscent of Dosso in the hard-green tonality of the drapery with the sharply lit collar, in the half-open mouth of the sitter, and in the bravura with which the animals are painted in the foreground.

As Parker observed, the iconography of No. A886 is unusual. The presence of a cat and dog in the same representation usually symbolizes the incompatibility of certain personal characteristics.[4] Parker suggested that since the sitter on No. A886 appears to be holding the animals securely under each arm, a reconciliation of two conflicting aspects within his personality might be implied Again, this rather obscure and highly personal approach to iconography is typical of Dosso Dossi.

REFERENCES: 1. J. Wilde, 'Die Probleme um Domenico Mancini', *Jahrbuch der Kunsthistorischen Sammlungen in Wien*, N.F. 7 (1933), 113–27, repr. figs. 93, pl. IX, 95, and pl. X respectively. 2. K 1323. F. R. Shapley, *Paintings from the Samuel H. Kress Collection. Italian Schools XV–XVI Century* (London, 1968), p. 73 repr. Also see F. Gibbons, *Dosso and Battista Dossi. Court Painters at Ferrara* (Princeton, 1968), pp. 215–16, No. 80 repr. 3. Repr. F. Gibbons and L. Puppi, 'Dipinti inediti o poco noti di Dosso e Battista Dossi: con qualche nuova ipotesi', *Arte antica e moderna*, 8 (1965), 317, repr. 132d. 4. As in C. Ripa, *Iconologia* (Padua, 1611), pp. 101–2.

## ANONYMOUS FERRARESE SCHOOL 1510–1520

### A335   THE REST ON THE FLIGHT INTO EGYPT   Pl. 45

Wood 51·8 × 37·8.

On the back two numbers 27 and 17 drawn with the brush in brown and red stains respectively There are also wax impressions of two unidentifiable seals. The first is only partly decipherable (a crest showing a stag's head with a branch held in the mouth and the number 90 impressed in the

wax outside the crest); the second shows the head of a Roman emperor in profile contained in a circle

Condition: fair. Cleaned and restored in 1970. There is a horizontal split in the panel, approximately 5 cm. from the top, extending from the left across half the width of the panel. There is some flaking top right on a line with the split and some slight retouching on the figures, for example on Joseph's head and on the back of his right hand and above the Angel's right knee.

Collections: Melzi d'Eril, Milan;[1] Lochis, Bergamo;[2] J. R. Anderson.[3]

Anderson Gift, 1913.

Literature: *Annual Report*, 1913, 13–14; T. Borenius, 'The Anderson Gift to The Ashmolean Museum, Oxford', *Burlington Magazine*, 25 (1914), 326 repr.; F. Gibbons, *Dosso and Battista Dossi. Court Painters at Ferrara* (Princeton, 1968), p. 258, Cat. no. 171 repr.

When No. A335 formed part of the Lochis collection, it was thought to have been painted by Lodovico Mazzolino. Borenius published the panel as a work by either Battista Dossi himself or else by a 'different artistic personality in the neighbourhood of the Dossi'. Dr. Felton Gibbons rightly denies that No. A335 has any connection with Battista Dossi, preferring an attribution to an anonymous painter of the Ferrarese school influenced by L'Ortolano, and suggesting that the panel 'may be an early work of Niccolò Pisano'. The present writer can find few connections with this last-named painter and has succeeded in finding only one other painting that resembles No. A335 in style and which may well be by the same hand. This is *The Agony in the Garden* (Ferrara, Pinacoteca), ascribed by Professor Giuliano Frabetti to a follower of Ortolano.[4]

As Borenius first observed, the iconography of No. A335 is rare. The source is the *Apocryphal Gospel of the Pseudo-Matthew*, chs. xx–xxi, where Christ bids the palm tree to give forth of the fruit of its branches and of the water from beneath its roots. The stream is visible in the foreground on A335, but the main incident depicted here is the removal of one of the branches ('. . . I give thee this privilege, that one of thy branches shall be taken by my angels and planted in my Father's garden. And henceforth all who win contests shall be told that they have won the palm of victory. An angel came and took a branch and flew away with it').[5] Another representation of *The Rest on the Flight into Egypt*, which includes related incidents described in the *Apocryphal Gospel of the Pseudo-Matthew*, is in the collection of Lord Faringdon, Buscot Park, Berkshire.[6]

Dr. Felton Gibbons entitled No. A335 *The Journey to Bethlehem*, but, as the Child can be made out in the Virgin's arms in the background on the right, this cannot be correct. Nevertheless, the absence of Christ in the foreground of the picture is not easily explained.

REFERENCES: 1. A catalogue of the Melzi d'Eril collection, dating from the early decades of the nineteenth century, is published as an appendix to G. Carotti, *Capi d'arte appartenenti a S. E. La duchessa Joséphine Melzi d'Eril-Barbò* (Bergamo, 1901). The picture in Oxford is probably No. 222 (p. 191) attributed to 'scuola antica'. The Melzi d'Eril collection was formed by Conte Giacomo (1720–1802), after whose death it was inherited by his nephews, Giovanni, Francesco, and Luigi. On the death of Francesco in 1832 there were three minor heirs, Lodovico, Giovanni, and Barberina, and in 1835 the collection was again divided. Some pictures appear to have been sold after that date. Presumably No. A335 was one of these. For the Melzi d'Eril Collection in general and for No. A335 in particular see G. Melzi d'Eril, *La Galleria Melzi e il Collezionismo milanese del tardo settecento* (Milan, 1973), p. 164. In 1835 No. A335 was granted to Lodovico (No. 27 of his inventory). 2. *La Pinacoteca e la Villa Lochis alla Crocetta di Mozzo*, 2nd edn. (Bergamo, 1858), p. 112, No. CCX recorded size 51×38; attributed to Lodovico Mazzolino. 3. Apparently acquired by J. R. Anderson from Pinti, who had purchased No. A335 from the Lochis collection (letter from Mrs. J. R. Anderson, 12 Feb. 1913). 4. G. Frabetti, *L'Ortolano* (Ferrara, 1966), pp. 47–8, No. 14, repr. pl. 40a. 5. M. R. James, *The Apocryphal New Testament* (Oxford, 1955), p. 75. 6. *The Faringdon Collection, Buscot Park* (National Trust Publications, 1964), pp. 22–3. Repr. *I Pittori bergamaschi dal XIII al XIX secolo. Il Cinquecento* i. (Bergamo, 1975), 156 No. 3, for text see p. 137 No. 53. The incidents described in the *Apocryphal Gospel of the Pseudo-Matthew* are often depicted by Northern artists (for example, in works by Patinir, Schongauer, and Grien), but only rarely in Italy. An incomplete list is given by L. Réau, *Iconographie de l'art chrétien*, ii, pt. 2 (Paris, 1957), 279–80.

## FRANCESCO BIANCHI FERRARI     active 1481, died 1510

Modenese school. Painter and goldsmith. His *œuvre* is small, but there are enough works to show that his style was an amalgam of those adopted by the main exponents of the schools of Bologna and Ferrara. Traditionally, he is described as the first master of Correggio.

## ATTRIBUTED TO FRANCESCO BIANCHI FERRARI

A733    ARION RIDING ON A DOLPHIN        **Pl. 46**

Wood (cradled). 68·1 × 53·7.

Condition: poor. Restored in 1961 and again in 1966 when the panel was planed down and cradled. There is retouching along a vertical split to the left of centre extending the height of the panel with several more retouches on the body of Arion. The landscape is slightly rubbed.

Presented by the daughters of J. R. Anderson, 1947.

Literature: *Annual Report*, 1947, 38–9; L Baldass, 'Die Tat des Giorgione', *Jahrbuch der kunsthistorischen Sammlungen in Wien*, N.F. 15 (1955), 141–3 repr.; R. Longhi, *Officina ferrarese*, 'Note breve agli ampliamenti', edn. *Opere complete*, v (Florence, 1956), 170, n. 8 (incorrectly identified as lot 81 in the Chillingworth sale held in Lucerne in 1922), and 'Nuovi ampliamenti', p. 186 repr.; Berenson, 1957, 114; E. Grassi, 'Profilo storico dello pittore modenese Francesco Bianchi Ferrari', *Parma nell'arte*, ii (1970), 72.

According to the *Annual Report* of 1947, the traditional attribution of No. A733 was to Jacopo de' Barbari. In Berenson's Venetian Lists of 1957 No. A733 is recorded as a work by Gerolamo Mocetto. Baldass found reason to suggest an attribution to the school of Carpaccio, but Longhi indicated that a painter of Emilian origin was more appropriate, initially (1940) proposing Lorenzo Costa and later (1940–55) revising his opinion in favour of an attribution to Francesco Bianchi Ferrari. This last proposition is accepted by Dottoressa Emy Grassi who implies a date of c. 1490–1505.

Both the drawing of the figure of Arion on No. A733, when compared with the *putti* on the altar-piece in S. Pietro, Modena,[1] and the similarities in the technique, particularly the rendering of the landscape and the method of highlighting, when compared with the *Agony in the Garden* (Rome, Galleria Nazionale),[2] may be adduced as evidence in support of the attribution to Bianchi Ferrari.

It was stated in the *Annual Report* of 1947 that a panel representing the *Judgement of Paris*, now in the Museum of Fine Arts, Boston, is by the same hand as No. A735.[3] To this may be added a panel of *Orpheus* formerly in the Lanckoronski collection, Vienna.[4]

Arion (fl. 628–625 B.C.) was a poet born at Methymna in Lesbos. According to legend he was thrown overboard by sailors in a storm and was carried to Corinth on the back of a dolphin. Much of his life was spent at the court of Periander at Corinth. His work, none of which survives in its original form, was important for the development of the dithyramb.

The story of Arion is first related by Herodotus (*History*, i. (ed. Rawlinson, London, 1858), 169–72 I. chs. 23–4), on whose rendering Ovid (*Fasti*, i. (ed. Sir J. G. Frazer, London, 1929), 56–61, II. 79–118) was dependent. Antique prototypes show him as a young man,[5] but, as Frazer pointed out in his commentary to the *Fasti*, Pausanius (*Description*

*of Greece*, i. (ed. Sir J. G. Frazer, London, 1898), 176, III. 25. 5) had seen small boys riding on dolphins off the coast of Greece. The depiction of the vessel in the background on the right of No. A733 leaves no doubt that the figure is intended for Arion. Yet there is a visual connection, perhaps an intentional one, with representations of Amor, who was often depicted riding on a dolphin in Renaissance art.[6]

REFERENCES: 1. Repr. Berenson, ii, 1968, pl. 756, but also by A. Venturi, 'Il Maestro del Correggio', *L'Arte*, i (1898), pl. II, opp. 282, with a detail of the *putti* on pl. III, opp. 284. For a repr. of the altar-piece after cleaning see *Arte in Emilia*, I (1960–1), 54–6, Cat. no. 25, pls., 38–9. 2. Inv. 21. Repr. Venturi, op. cit., opp. 280. Also see *Catalogo della Esposizione della pittura ferrarese del Rinascimento* (Ferrara, 1933), p. 118, No. 142. 3. Inv. 44. 659. *Summary Catalogue of European Paintings* (Boston, 1955), p. 67, as school of Verona. Repr. Schubring, *Cassoni* (1923), 6, No. 956, pl. XXIII as Michele da Verona. 4. Repr. Schubring, *Cassoni*, i. 393, No. 765 repr. ii, pl. CLXII. 5. As on the coinage of Tarentum for which see B. V. Head, *Historia Numorum*, 2nd edn. (Oxford, 1911), pp. 53–69, and of Methymna for which see W. Wroth, *A Catalogue of the Greek Coins in the British Museum. Catalogue of the Greek Coins of Troas, Aeolis, and Lesbos* (London, 1894), pls. XXXVI, 15, and XXXVII, 4 and 8. 6. See, for example, two majolica plates in the Victoria and Albert Museum of about the same date as No. A733. These are reproduced by B. Rackham, *Victoria and Albert Museum. Catalogue of Italian Maiolica* (London, 1940), Nos. 527 and 532, pls. 82 and 83. For references to young boys carried by dolphins in classical literature as collected by Renaissance writers, see E. Wind, 'Raphael: the Dead Child on a Dolphin', *The Times Literary Supplement*, 23 Oct. 1963, 874.

## CAMILLO FILIPPI  first mentioned 1523, died 1574

Ferrarese school. He was the son of Sebastiano da Lendinara, a painter, and was himself a father of two painters, Cesare and Sebastiano (known as Il Bastianino). This family workshop was often employed by the Este court. Camillo worked as an assistant to the Dossi and was further influenced by Garofalo and Gerolamo da Carpi, with whom he also collaborated on occasions. His style resembles most closely that of Battista Dossi.

### A678  THE ADORATION OF THE SHEPHERDS  Pl. 47

Wood. 67·5 × 41 (arched).

On the back drawn with the brush in brown stain *No. 191* (top), *Rafaelino del Garbo* (centre), and *MAr°·PSB* (?) (bottom). Also a wax impression of a seal no longer decipherable except for a coronet at the top of the crest.

Condition: good. Cleaned in 1967. There is an area of damage to the left of God the Father. There is a minor blemish to the right of the waist

of the shepherd pointing to the sky, above the head of the kneeling shepherd in the foreground. A thin split in the panel extending from the lower edge to the Child's head is visible in reproductions.

Presented by Mr. Harold Bompas, 1941.

Literature: *Annual Report*, 1941, 17; A. Mezzetti, *Il Dosso e Battista ferraresi* (Milan, 1965), pp. 105 and 117, Cat. nos. 132 and 181; F. Gibbons, *Dosso and Battista Dossi. Court Painters at Ferrara* (Princeton, 1968), p. 234, Cat. no. 113.

No. A678 was attributed to Battista Dossi at the time of acquisition. Dottoressa Amalia Mezzetti argued in favour of a painter from the circle of Gerolamo da Carpi, whose influence is indeed apparent in the figure of the Virgin. The more convincing attribution to Camillo Filippi was first proposed by Dr. Felton Gibbons who, following Mezzetti, also demonstrated that the composition is derived from an *Adoration of the Shepherds* by Battista Dossi now in the Residenzgalerie, Salzburg.[1] Here the painter has added the pointing shepherd on the left, altered the background on the right and placed God the Father at the very top of the composition, incorporating an Angel and several more *putti*. The poses of the two shepherds on the left have also been changed, as have details in the landscape.

The attribution to Camillo Filippi is almost certainly correct. The facial types, the dramatic gestures, the flat clinging draperies—all closely modelled on Battista Dossi—can be found on other paintings ascribed to him.[2] Recent cleaning has revealed the ravishingly fresh colouring, which older authorities often remarked upon as one of the more distinctive features of this painter's style.[3]

No. A678 may be an early work by Camillo Filippi executed while he was still working under the aegis of the Dossi.

REFERENCES: 1. Inv. 1844. See A. Mezzetti, *Il Dosso e Battista ferraresi* (Milan, 1965), p. 117, Cat. no. 181 and F. Gibbons, *Dosso and Battista Dossi. Court Painters at Ferrara* (Princeton, 1968), pp. 233–4, Cat. no. 113 repr. fig. 125. 2. Compare the Virgin on No. A678 with the same figure on the *Annunciation* (Ferrara, S. Maria in Vado, repr. F. Arcangeli, *Il Bastianino* (Milan, 1963), pl. 24a) and the profile of the shepherd with his arms crossed on his chest on the left of No. A678 with the figure of S. George (?) on the ruined *Resurrection of Christ* (Ferrara, Pinacoteca, repr. Arcangeli, op. cit., pl. 1). The handling of the draperies and the somewhat topply stances of the figures are closely matched on the *Baptism of Christ* (Rovigo, Accademia dei Concordi), repr. Gibbons, op. cit., fig. 219, a painting discussed in greater detail by Mezzetti, op. cit., p. 116, Cat. no. 177. 3. G. Baruffaldi, *Vite de' pittori e scultori ferraresi*, i (Ferrara, 1844), 439, and see C. Cittadella, *Catalogo istorico de' pittori e scultori ferraresi e delle opere loro*, ii (Ferrara, 1782), 115.

ANONYMOUS FLORENTINE SCHOOL 1420–1430

A80 THE ANNUNCIATION **Pl. 48**

Wood. 64·6 × 47·5 (slightly bowed).

On the back, a label inscribed by an eighteenth-century hand, *Madonna con Angiol | di Maniera Antichi di | Peselo Pe | selli | No. 22.* The number *.22.* occurs with the number *82* crossed through.

Condition: very good. Cleaned in 1951. There is some damage at the edges caused by an old frame. The faces are slightly worn, but retouching is minimal.

Fox-Strangways Gift, 1850.

Literature: Waagen, *Treasures*, iii. 53; Berenson, 1932, 458: 1936, 393: 1968, 4; M. Salmi, 'Aggiunte al Tre e al Quattrocento fiorentino', *Rivista d'arte*, 16 (1934), 182–3 repr.; J. Pope-Hennessy, *Sassetta* (London, 1939), pp. 202–3, n. 133: C. Volpe, 'Per Pietro di Giovanni d'Ambrogio', *Paragone*, 75 (1956), 55.

Many of the outlines of the figures have been incised; likewise, many of the lines in the architecture.

Sir John Pope-Hennessy was the first to observe that No. A80 is by the same hand as *S. George Killing the Dragon* in Melbourne (National Gallery, Victoria), incorrectly attributed by Van Marle to Domenico di Bartolo.[1]

First mentioned by Waagen as a work by Benozzo Gozzoli, listed by Berenson as by Pietro di Giovanni d'Ambrogi and then attributed by Professor Mario Salmi to Dello Delli, No. A80 has also been ascribed by Sir John Pope-Hennessy to a Florentine pupil of Uccello and by Professor Carlo Volpe to a Sienese painter close to Pietro di Giovanni d'Ambrogi. More recently, Sir John Pope-Hennessy (written communication) has revised his attribution in favour of an artist of Lombard origin, whose style shows affinities with Michelino da Besozzo,[2] whereas Dr. Federico Zeri is of the opinion that the panel is Florentine by a hand closely related to that of the Maestro del 1419.[3] Dr. Carl Huter (verbal communication) first posited a connection with the Master of the Bambino Vispo, a painter thought by many scholars to have been of Spanish extraction, but who carried out important commissions in Florence.[4] The compiler does not believe that No. A80 is by the Master of the Bambino Vispo himself, but the similarities that do exist between No. A80 and that master, such as the treatment of the facial features, the handling of the draperies, and the iconography, suggest that the painter of the panels in

Oxford and Melbourne was formed in a similar environment. The proximity of the style of these two panels to the work of other painters active in Valencia during this period, such as Pedro Nicolau, Marzal de Sas, and the anonymous painter of the Bonifazio-Ferrer retable, reinforces this hypothesis.[5]

It remains, however, a firm possibility that No. A80 was painted in Florence. There was a great deal of close contact between Florentine and Spanish painters during the opening decades of the fifteenth century,[6] and until the nature of these contacts is properly examined, the retention of an attribution to the Florentine school seems justified.

The dispatch of the Archangel Gabriel by God the Father, seen in the upper part of No. A80, is rarely depicted in Italian painting. Giotto does include the scene on the central arch in the Scrovegni Chapel in Padua, but only in Arezzo does it recur later with any frequency.[7] The source for the charge to Gabriel is the *Meditationes Vitae Christi*.[8]

REFERENCES: 1. Inv. 2124/4. See U. Hoff, *National Gallery of Victoria. European Paintings before Eighteen Hundred* (Victoria, 1967), pp. 3–4 repr. 2. Letter of 14 Jan. 1969. 3. Letter of 25 Feb. 1969. The name-piece is now in the Cleveland Museum of Art, for which see E. Pillsbury, *Florentine Art in Cleveland Collections. Florence and the Arts. Five Centuries of Patronage* (Cleveland Museum of Art, 1971), Cat. No. 3 repr. 4. For useful summaries of the discussion so far see C. Volpe 'Per il completamento dell' altare di San Lorenzo del Maestro del Bambino Vispo', *Mittelungen des Kunsthistorischen Institutes in Florenz*, 17 (1973), 346–60, and J. van Waadenoijen, 'A Proposal for Starnina: exit the Maestro del Bambino Vispo', *Burlington Magazine*, 116 (1974), 82–91. The last writer argues in favour of identifying the Master of the Bambino Vispo with Starnina, but this identification has been contested by M. Boskovits, 'Il Maestro del Bambino Vispo: Gherardo Starnina o Miguel Alcañiz?, *Paragone*, 307 (1975), 3–15. 5. See C. M. Kauffmann, 'The Altar-Piece of St. George from Valencia', *Victoria and Albert Museum Yearbook*, ii (1970), 65–100, and the catalogue of the exhibition held in Madrid in 1973, *El Siglo XV Valenciano* (Madrid, 1973), which has much useful illustrative material. 6. See generally on this point, A. de Bosque, *Artistes italiens en Espagne du 14ième siècle aux rois catholiques* (Paris, 1965), pp. 57–74. 7. M. J. Zucker, 'Parri Spinelli's Lost Annunciation to the Virgin and other Aretine Annunciations of the Fourteenth and Fifteenth Centuries', *Art Bulletin*, lvii (1975), 190–5. 8. *Meditations on the Life of Christ. An Illustrated Manuscript of the Fourteenth Century*, eds. I. Ragusa and R. Green (Princeton, 1961), pp. 15–16.

## ANONYMOUS FLORENTINE SCHOOL 1430–1450

A334   DAVID REPROVED BY NATHAN                                    Pl. 49

Wood. 36·6 × 38·7.

On the back the number *540* drawn in brown stain with the brush. There is also an old attribution to Masaccio.

Condition: poor. Cleaned in 1946. The paint surface is rubbed and scratched throughout and the panel is damaged along the right and lower edges.

Anderson Gift, 1913.[1]

Literature: *Annual Report*, 1913, 13; T. Borenius, 'The Anderson Gift to The Ashmolean Museum, Oxford', *Burlington Magazine*, 25 (1914), 325–6; Berenson, 1932, 342: 1936, 279: 1963, 88; V. Giovannozzi, 'Note su Giovanni di Francesco', *Rivista d'arte*, 16 (1934), 361 repr.

There are incised lines in the architecture. The original location of a panel of this size and subject is uncertain.

The text is 2 Samuel 12:1–15.

Berenson attributed No. A334 to the Master of the Carrand Triptych (now identified as Giovanni di Francesco). This attribution was convincingly rejected by Dottoressa Vera Giovannozzi, who, following the suggestion first made by Borenius to the effect that No. A334 was by an unknown follower of Masolino, compared the panel with the frescoes in the apse of the Collegiata in Castiglione d'Olona, illustrating scenes from the lives of SS. Stephen and Lawrence.[2] The majority of these frescoes were painted by Paolo Schiavo with the aid of assistants.[3]

The figures and the architectural framework on No. A334 are crudely painted and the perspective is also rather clumsily handled. At best, therefore, the painter of No. A334 may have been a minor assistant in Schiavo's workshop; at worst, a distant follower of limited ability.

REFERENCES: 1. Stated in a letter of 12 Feb. 1913 from Mrs. J. R. Anderson to have been bought from Pinti in London in 187–. 2. For reproductions of the frescoes before cleaning, see M. Salmi, 'Gli affreschi nella Collegiata di Castiglione d'Olona-II', *Dedalo*, 9 (1928–9), 3–30. 3. See R. Longhi, 'Ricerchi su Giovanni di Francesco', *Opera completa*, iv (1968), 23–4.

## ANONYMOUS FLORENTINE SCHOOL          1450–1460

### A91  A TOURNAMENT (CASSONE PANEL)                    Pl. 50

Wood. 44·2 × 164·5.

On the back a Fox-Strangways label (*No. 4*). The number *.23.* occurs with *566* crossed through.

Condition: poor. There is pitting top centre caused by the keys of the *cassone*, but the panel is also badly scratched elsewhere. The faces are somewhat rubbed throughout, but those at the extreme right are

better preserved. The sky is repainted. The green used in the trees has darkened.

Fox-Strangways Gift, 1850.

Literature: Schubring, *Cassoni*, i (1915), 257, No. 149 (with inaccurate measurements); Berenson, 1936, 283: 1963, 18 repr.; E. Callmann, *Apollonio di Giovanni* (Oxford, 1974), p. 86, Appendix III.

No. A91 was first published by Schubring as a work by an anonymous Florentine painter *c.* 1450. Berenson lists and reproduces the panel as from the workshop of Apollonio di Giovanni, which is unconvincing and has been rejected by Dr. Ellen Callmann.

Another *cassone* panel, illustrating the history of Coriolanus and formerly in the collection of Sir Thomas Merton, may have been painted by the same workshop as No. A91.[1] Judging from the stylistic evidence presented by these two panels, this workshop stood in close relation to that of the Master of the Battle of Anghiari.[2]

REFERENCES: 1. A. Scharf, *A Catalogue of Pictures and Drawings from the Collection of Sir Thomas Merton, F.R.S.* (London, 1950), p. 20, No. VI. Note the motif of the falling horse left of centre, which occurs on both of these panels. 2. For the name-piece see Schubring, *Cassoni*, i (1915), 243, Nos. 103–4 repr. ii, pl. XVIII.

## ANONYMOUS FLORENTINE SCHOOL 1490–1500

### A338 CHRIST IN THE TOMB SUPPORTED BY THE VIRGIN (PREDELLA PANEL FROM AN ALTAR-PIECE) Pl. 51

Wood. Painted surface, 22·0 × 42·7 (rounded at both ends). Size of panel, 26·9 × 50. There is a gold border of 2·5 around the composition, but this does not extend to the edges of the panel.

Condition: fair. The blue of the Virgin's drapery has darkened. There is considerable surface dirt, but retouching is minimal.

Collections: Berenson, Florence.

Presented anonymously by Bernard Berenson, 1913.

Literature: Berenson, 1912, 127 (?): 1932, 478: 1936, 410: 1963, 187; *Annual Report*, 1913, 14; J. Shearman, *Andrea del Sarto*, ii (Oxford, 1965), 195, Cat. no. 1.

No. A338 is most probably the central panel of a predella.

Dr. John Shearman has tentatively suggested that a panel of *SS. Thomas Aquinas, Peter and Dominic*, formerly in the Kaufmann collection, Berlin,

is from the same predella and was presumably placed to the left of No. A338.[1]

Berenson proposed an attribution to Raffaellino del Garbo for No. A338. Shearman, while for the related panel advancing an attribution to the young Andrea del Sarto, whom he believes to have been employed in Raffaellino del Garbo's workshop, appears to retain an attribution to Raffaellino himself for No. A338. Mr. Everett Fahy (written communication) has proposed an attribution to Francesco Granacci.[2] The compiler finds this last suggestion the most persuasive,[3] but only the discovery of other panels from the same predella would allow confirmation. The positioning of the Virgin on the front edge of the tomb is unusual. She is normally shown supporting the body of Christ from behind, or from the side, often accompanied by S. John.

REFERENCES: 1. J. Shearman, *Andrea del Sarto*, i (Oxford, 1965), 17 and pl. 1 (b), and ii, 195, Cat. no. 1. 2. Letter of 15 May 1969. 3. Allowing for a slight difference in date, the technique and drawing of No. A338 are quite closely matched on the predella panel of the same subject by Granacci in the Stibbert Museum, Florence, for which see Christian von Holst, *Francesco Granacci* (Munich, 1974), p. 152, Cat. no. 35, repr. figs. 59 and 62.

## ANONYMOUS FLORENTINE SCHOOL           1580–1590

### A70   PORTRAIT OF BACCIO ORLANDINI (1520–1598)           **Pl. 52**
Wood. 115 × 87·6.

The paper held in the sitter's right hand is inscribed '*Al Illre Sre Baccio Orlandini Am | Baste di Toschana Alle | Corte Catolicha e | Are di portogallo | Da lāno 1575 Alāno 1580*.

Condition: fair. The background is encrusted with old varnish and dirt. The face and the hands appear to be well preserved beneath a thick layer of varnish.

Presented by John Bayley, 1849.

Baccio Orlandini was the son of Piero di Bartolommeo Orlandini. He was made a senator in 1573 and, as recorded on the document held by the sitter, he was ambassador to the court of Philip II of Spain and Portugal from 1575 to 1580, in addition to serving as commissioner for Cortona, Pistoia, and Pisa.[1]

The style is somewhat reminiscent of Santo di Tito, but until the portrait is cleaned it is impossible to make a definite attribution.

REFERENCE: 1. G. M. Mecatti, *Storia genealogica della nobilità, e cittadinanza di Firenze*

(Naples, 1754), pt. II, *Notizie istorico-genealogiche appartenenti alla nobiltà fiorentina parte seconda che contiene il senatorista o sia la serie de' senatori fiorentini*, pp. 131 and 199; and for the family as a whole, p. 80.

## FRANCESCO DE' FRANCESCHI

first mentioned 1445,
still active 1456

Venetian school. An important altar-piece, now dismembered but previously bearing his signature with the date 1447, is in the Museo Civico, Padua. The existing *œuvre* is small and contains many *membra disiecta*. He was, apparently, a follower of Michele Giambono. Jacopo Bellini, Antonio Vivarini and Tuscan painters, such as Filippo Lippi, Masolino, and Uccello, who all worked briefly in the Veneto, also influenced the development of his style.

### A86   S. CATHERINE OF ALEXANDRIA (PANEL FROM AN ALTAR-PIECE)
**Pl. 53**

Wood (cradled). 92·8 × 33·6 (arched).

Condition: poor. Cleaned in 1948 when extensive repaint was removed.[1] The gold background is badly rubbed and abraded, particularly near the edges. There is a vertical split in the panel passing through the Saint's body to the left of centre, along which there is still considerable retouching. The flesh parts are comparatively well preserved.

Fox-Strangways Gift, 1850.

Literature: see No. A87 below.

### A87   S. MARY MAGDALEN (PANEL FROM AN ALTAR-PIECE)   **Pl. 54**

Wood (cradled). 93 × 35 (arched).

Condition: poor and slightly worse than No. A86. Cleaned in 1948.[2] The gold background is badly rubbed and abraded. There are several vertical splits in the panel with extensive retouching in the drapery. What original paint does remain in the drapery is badly worn. The flesh parts are comparatively well preserved.

Fox-Strangways Gift, 1850.

Literature: Berenson, 1932, 599: 1936, 516: 1957, 79; E. Sandberg-Vavalà, 'Additions to Francesco de' Franceschi', *Burlington Magazine*, 76 (1940), 155–6 repr.; C. Volpe, 'Donato Bragadin. Ultimo Gotico', *Arte veneta*, 9 (1955), 22–3 repr.

There can be little doubt that Nos. A86 and A87 once belonged to the same unidentified altar-piece. No other related panels have yet been found.

In the earlier editions of Berenson's Lists (1932 and 1936) an attribution to Antonio Vivarini and Giovanni d'Alemagna was posited. Evelyn Sandberg-Vavalà proposed the name of Francesco de 'Franceschi and this was accepted by Berenson for the Lists of 1957. Professor Carlo Volpe suggested the name of Donato Bragadin and proposed a date towards the beginning of the seventh decade of the fifteenth century. Volpe's attribution is not acceptable on two grounds. Firstly, the triptych in the Metropolitan Museum, New York, has recently been shown by Dr. Federico Zeri to be a signed work by Donato de' Bardi, a Ligurian painter, and not by Donato Bragadin as Volpe supposed.[3] Secondly, Nos. A86 and A87 do not match the style of the one signed work by Donato Bragadin, *Lion of S. Mark between SS. Jerome and Augustine*, in the Palazzo Ducale, Venice, which is also dated 1459.[4]

Sandberg-Vavalà's attribution of Nos. A86 and A87 to Francesco de' Franceschi still seems to be the most convincing. Comparison with the saints from the dismembered altar-piece at Padua amply bears this out,[5] as does comparison with the *Virgin and Child* in the Ca d'Oro, Venice,[6] and the panels from another dismembered altar-piece now in Budapest.[7] The colours—azure, cherry-red, green, and gold—are strikingly reminiscent of Antonio Vivarini, with whom, according to Professor Rodolfo Pallucchini, Francesco de' Franceschi may have collaborated.[8]

Nos. A86 and A87 were once of fine quality.

REFERENCES: 1. For the condition before cleaning see the reproductions used by E. Sandberg-Vavalà, 'Additions to Francesco de'Franceschi', *Burlington Magazine*, 76 (1940), pl. 1. 2. See note 1 above. 3. Kress collection, K 1101. F. R. Shapley, *Paintings from the Samuel H. Kress Collection. Italian Schools XV–XVI Century* (London, 1968), p. 29, and by the same author *Paintings from the Samuel H. Kress Collection. Italian Schools XVI–XVIII Century* (London, 1973), Addenda to Vol. 2, p. 389. 4. Repr. C. Volpe, 'Donato Bragadin. Ultimo Gotico', *Arte veneta*, 9 (1955), figs. 23–4. 5. See L. Grossato, *Il Museo Civico di Padua. Dipinti e sculture dal XIV al XIX secolo* (Venice, 1957), pp. 57–60 repr. Some of these panels are also repr. by Berenson, 1957, pls. 48 and 50–2. 6. Repr. Berenson, 1957, pl. 56. 7. Inv. 1111–14. A. Pigler, *Katalog der Galerie Alter Meister* (Budapest, 1968), pp. 239–40. Repr. in the exhibition catalogue *Venezianische Malerei 15. bis. 18. Jahrhundert* (Dresden, 1968), pp. 58–9, Nos. 42 a–d. 8. R. Pallucchini, *I Vivarini* (Venice, n.d.), pp. 30 and 103, Cat. no. 56.

# FRANCESCO FRANCIA c. 1450, died 1517/18

Bolognese school. Francesco di Marco di Giacomo Raibolini, called Francia. He was apprenticed to a goldsmith before becoming a painter. His early pictorial style owes much to the Ferrarese school and in Bologna itself he worked in close proximity with Lorenzo

Costa. Later, his style gravitated towards that of Perugino and Raphael. He had many pupils and imitators among whom may be counted his son Giacomo.

## AFTER FRANCESCO FRANCIA

A419a    VIRGIN AND CHILD WITH THE YOUNG S. JOHN      **Pl. 55**

Wood (two horizontal battens have been inserted into the panel at the back). 47 × 37·2.

On the back the number *284* occurs drawn in brown stain with the brush. There is a wax impression of a seal identified as that of Don Luis-Francisco de la Cerda y Aragón.[1] Three labels also occur, inscribed *Taylor-reframe, Friend of Lady Monteagle*[2] and *20713* respectively.

Condition: fair. There is a vertical split in the panel right of centre, along which there is heavy retouching. This split does not extend all the way downwards as it might appear in the reproduction, but for 2 or 3 cm. in the centre runs parallel with a second split extending upwards from the lower edge. The surface is covered with a thick layer of varnish, beneath which retouching is discernible on the face of the Christ Child and on the figure of S. John the Baptist. The landscape on the right appears to have been repainted.

Collections: Don Luis-Francisco de la Cerda y Aragón (fl. 1688). Next recorded in the collection of Sir Henry Taylor (1800–86) and thence by direct inheritance to Miss I. A. Taylor.

Bequeathed by Miss I. A. Taylor to the Bodleian Library, 1930, and transferred to the Ashmolean, 1932.[3]

No. A419a was described in the donor's will as 'Holy Family, Replica of Francia, (probably by a pupil)'. The true quality of No. A419a is concealed beneath an unsightly layer of old varnish, but, none the less, certain passages suggest that when freed from this and from various retouches the panel may well emerge as a work of some interest. The Virgin's face, parts of her drapery, and the figure of the Christ Child have been ably painted. The relationship between the Christ Child and S. John is reminiscent of the composition ascribed to a close follower of Francia on a panel of the *Virgin and Child with the Young S. John* in the Pinacoteca Nazionale, Parma,[4] but no exact prototype of the composition on No. A419a has been traced.

REFERENCES: 1. Don Luis-Francisco de la Cerda y Aragón, Marqués de Cogolludo, was the eldest son of Don Juan-Francisco de la Cerda y Enríquez de Ribera and of Doña Catalina de Aragón y Cardona. He married Doña María de las Nieves Téllez-Girón y

Sandoval, a descendant of the fifth Duques of Osuna. He was the last of his line and on his death his family name was joined to that of Fernández Cordoba. The identification was made by Mr. Dalmiro de la Válgoma, secretary of the Spanish Royal Academy of History, who also supplied biographical details (letter of 30 Apr. 1974 from Dr. Xavier de Salas). 2. Explained by the fact that Sir Henry Taylor (see Collections above) married Theodosia Alice Spring Rice, the daughter of Thomas Spring Rice, the 1st Lord Monteagle. 3. *Annual Report*, 1932, 25. 4. Repr. Venturi, *Storia*, ix, pt. 3 (1914), fig. 722.

# FRANCIABIGIO
*c.* 1482/3–1525

Florentine school. His real name was Francesco di Cristofano, called Franciabigio. He was the son of Cristofano di Francesco d'Antonio da Milano. The influence of Albertinelli, together with that of Piero di Cosimo, Fra Bartolommeo, and Andrea del Sarto, was clearly an important factor in the development of Franciabigio's style. He collaborated with Andrea del Sarto in the cloisters of SS. Annunziata, Florence, and later in the Chiostro degli Scalzi.

## A342  S. NICOLAS OF TOLENTINO PERFORMING A MIRACLE (PREDELLA PANEL FROM AN ALTAR-PIECE) Pl. 56

Wood. 18·5 × 24·5.

On the back there are several faint inscriptions, now illegible, and two mutilated wax impressions of seals. Another wax impression, still intact, shows a coat of arms *barre ondulée*, which bears a striking, although not exact, resemblance to the arms of the Florentine branch of the Tempi family.[1]

Condition: poor. The panel is damaged at the edges, particularly on the left, and badly rubbed throughout. There are a number of small disfigurements and some retouches on the figures.

Collections: Tempi, Florence;[2] Revd. J. Sanford[3] (Christie's 9 Mar. 1839, lot 38); T. W. Jackson, Fellow of Worcester College, Oxford.

Presented by the legatees of T. W. Jackson, 1915.

Literature: Berenson, 1912, 135: 1932, 210: 1936, 181; T. Borenius, 'A Little Known Collection at Oxford—II', *Burlington Magazine*, 27 (1915), 72–7 repr.; *Annual Report*, 1915, 12; Venturi, *Storia*, ix, pt. 1 (1925), 452 n.; F. Sricchia Santoro, 'Per il Franciabigio', *Paragone*, 163 (1963), 12–13 repr.; C. Rosini, 'La donazione Salmi nel Museo del Arezzo', *Bollettino d'arte*, 49 (1964), 419; J. Shearman, *Andrea del Sarto*, i (Oxford, 1965), 25, n. 3; M. Laskin, 'Franciabigio's Altarpiece of S. Nicholas of Tolentino in Santo Spirito, Florence', *Festschrift Ulrich Middeldorf*, i (Berlin, 1968), 276–80 repr.; A. Parronchi, 'L'altare di San Nicola da Tolentino del

Franciabigio', *Commentari*, 22 (1971), 24–35 repr.; S. R. McKillop, *Franciabigio* (University of California Press, 1974), pp. 53 and 150–2, Cat. no. 22 repr.

No. A342 was first attributed to Franciabigio by Berenson. Borenius identified the panel as part of the predella of a dismembered altar-piece dedicated to S. Nicholas of Tolentino and placed in the third chapel of the right aisle in the church of S. Spirito, Florence. The tripartite architectural scheme of the altar-piece is described in some detail by Vasari in his Life of Franciabigio (v. 191). A marble altar-piece, together with two *Angels* in the smaller lateral arches and the *tondi* above with the *Annunciation* have recently been rediscovered by Dr. Alessandro Parronchi in a room in the monastery of S. Spirito.[4] The wooden statue of S. Nicholas of Tolentino,[5] executed, according to Vasari (vii. 488), by Nanni Unghero (Giovanni d'Alesso d'Antonio) after a terracotta *modello* by Jacopo Sansovino and originally placed in the central arch, together with a second pair of *Angels*, which were reasonably thought to have been placed in the lateral arches of the original complex,[6] remain in the chapel today.

In addition to No. A342, two other parts of the predella have been published by Dr. Myron Laskin: *Canonisation of S. Nicholas of Tolentino* (Dublin, National Gallery of Ireland)[7] and a double panel representing *Two Miracles of S. Nicholas of Tolentino* (Arezzo, Museo).[8] Parronchi added *The Obsequies of S. Nicholas of Tolentino* (Rome, private collection),[9] which, owing to its size, was most probably placed in the middle of the predella. Parronchi places the two scenes in Arezzo on the left and the panels in Oxford and Dublin on the right. The same writer also suggested that an allegorical figure of *Charity* (Florence, private collection)[10] was originally found under the pilaster on the right, but this is not convincing.[11]

A design for an altar-piece in the Louvre[12] has been connected since Vasari's day with the altar-piece in S. Spirito. Parronchi retains Vasari's attribution of the drawing to Franciabigio, but Dr. John Shearman[13] has argued that the design may well be by Andrea Sansovino, or by his pupil, Jacopo, arguing that this preliminary study, drawn *c.* 1505/6, is for a sculpted altar-piece without painted elements and is in this respect similar to that executed by Andrea Sansovino in the Corbinelli chapel, also in S. Spirito. If this is correct, then the style of the wooden statue of S. Nicholas of Tolentino, based according to Vasari on the terracotta *modello* by Jacopo Sansovino, should, and to a certain extent does, reflect the style of Jacopo Sansovino's early work before his departure for Rome in 1506. For some unexplained reason, therefore, the design of the altar-

piece was substantially altered, and painted figures introduced into the schema. It is not known exactly when Franciabigio was commissioned to execute the painted parts, although Parronchi has established a *terminus ante quem* of 1513.[14]

REFERENCES: 1. J. B. Rietstap, *General Illustrated Armorial*, vi, 3rd edn. (Lyon, 1954), pl. XII. 2. As stated in the Sanford sale catalogue, Christie's, 9 Mar. 1839, lot 38. 3. First observed by J. Shearman, *Andrea del Sarto*, i (Oxford, 1965), 25, n. 3. 4. A. Parronchi, 'L'altare di San Nicola da Tolentino del Franciabigio', *Commentari*, 22 (1971), 24–6, gives a detailed account of the history of the chapel and the altar-piece, supplemented by newly discovered documentation. See also W. and E. Paatz, *Die Kirchen von Florenz*, v (Frankfurt am Main, 1953), 155, to which should be added the reference in R. Borghini, *Il Riposo* (Florence, 1730), pp. 359–60. 5. Repr. L. Pittoni, *Jacopo Sansovino* (Venice, 1909), fig. 9. 6. Repr. F. Sricchia Santoro, 'Per il Franciabigio', *Paragone*, 163 (1963), figs. 14–15. S. R. McKillop, *Franciabigio* (University of California Press, 1974), pp. 147–50, Cat. no. 21 repr. figs. 62 and 64. In the light of Parronchi's recent discovery the status of the pair of *Angels* remaining in the chapel is uncertain. They are of larger dimensions but carry the saint's attributes. A preparatory study for the *Angel* under the left arch in the chapel is in Rome, Gabinetto Nazionale delle Stampe (inv. 124941), first published by A. Forlani, *I disegni italiani del Cinquecento* (Venice, 1962), pp. 182–3, repr. pl. 42, and also discussed by McKillop, op. cit., pp. 178–9 repr. fig. 63. Dr. McKillop (op. cit., p. 174 repr. figs. 65–6) includes in her discussion a drawing in Berlin-Dahlem (inv. 5194), which she regards as a preparatory study for the *Angels*. The connection, however, is extremely tenuous, as the author admits. 7. Inv. 1290, 18 × 26. Repr. M. Laskin, 'Franciabigio's Altar-piece of S. Nicholas of Tolentino in Santo Spirito, Florence', *Festschrift Ulrich Middeldorf*, ii (Berlin, 1968), pl. CXXIX, no. 1. Also see *National Gallery of Ireland. Catalogue of the Paintings* (Dublin, 1971), p. 42 and more recently McKillop, op. cit., pp. 152–3, Cat. no. 23 repr. fig. 70. The panel, as pointed out by Laskin, was lot 27 of the Sanford sale at Christie's, 9 Mar. 1839. Mr. Michael Wynne has kindly confirmed (letter of 30 Dec. 1971) that in so far as the wax impression on the back of the panel in Dublin is decipherable, it would appear to resemble that on the back of No. A342. 8. Inv. 13, 18 × 55·5. Repr. Laskin, loc. cit., pl. CXXX, No. 3. McKillop, op. cit., p. 153, Cat. no. 24 repr. fig. 71. 9. Measuring 21·5 × 43. Repr. Parronchi, loc. cit., fig. 7. 10. Measuring 19·5 × 20·5. Repr. Parronchi, loc. cit., fig. 9. 11. A photo-montage of the proposed reconstruction is repr. by Parronchi, loc. cit., fig. 12. Laskin, loc. cit., 277, records that Professor Sir Ellis Waterhouse observed that lot 113 of the Sanford sale came from the same altar-piece, but fetched half the price of either of the two other lots in the sale. This missing panel was probably placed under one of the pilasters of the altar-piece and thus weakens Parronchi's argument in favour of the panel with the allegorical figure of *Charity*. 12. Cabinet des Dessins, inv. 1202. Repr. Parronchi, loc. cit., fig. 11, and discussed at length by McKillop, op. cit., pp. 232–4, repr. fig. 67 (as Jacopo Sansovino). 13. Shearman, op. cit., p. 25, n. 4. 14. Parronchi, loc. cit., 24–5. This is the year in which the chapel passed temporarily into the hands of the monastery of S. Spirito on the death of its possessor, Fra Niccolao di Giovanni di Lapo Bicchielli, who was a member of the community and had set up the altar-piece in the chapel. Sricchia Santoro, loc. cit., 12 and 21, n. 19 reported the year of Fra Niccolao's death as 1518. On grounds of style S. Freedberg, *Painting of the High Renaissance in Rome and Florence*, i (Cambridge, Mass.,

1961), 478 and 589, had suggested a date c. 1517–18 and U. Procacci, *La donazione Salmi nel Museo di Arezzo* (Arezzo, 1963), p. 13, c. 1516–18. McKillop, (op. cit., pp. 147–9, Cat. no. 21), opines 'late 1516 or 1517'.

## GEROLAMO DA SANTACROCE

active 1503
last mentioned 1556

Venetian school. He was of Bergamask origin, but is recorded in Gentile Bellini's studio for the first time in 1503. He himself ran a large family workshop, which specialized in painting copies, or variants, of works executed by leading Venetian painters, such as Giovanni Bellini, Titian, Lotto, and Cima da Conegliano. At its most personal his style approaches that of Francesco Bissolo.

### A292   THE ANNUNCIATION                                     Pl. 57

Wood. 50·4 × 69·5.

Condition: good. There is damage at the edges of the panel particularly along the bottom and top right, in addition to some movement of the panel in the centre on the right.

Bequeathed by John D. Chambers, 1897.

Literature: *Annual Report*, 1897, 13; F. Heinemann, *Giovanni Bellini e i belliniani*, i (Venice, n.d.), 166, No. 513.

The composition of No. A292 is derived from the *Annunciation* painted by Cima da Conegliano in 1495 for the Cappella Zeno in the church of S. Maria de' Crocicchieri (Oratorio di Padri Crociferi, later the church of the Gesuiti), Venice, and now in the Hermitage Museum, Leningrad.[1] Originally, the *Annunciation* was the centre of a triptych apparently flanked by two saints.[2]

On No. A292 the composition has been slightly altered by the omission of certain details from the interior and by simplifying the landscape in the background. The composition has also been given a horizontal axis, whereby the elegance of Cima's slender figures so successfully emphasized by the vertical axis, has been lost.

No. A292 is a good example of Gerolamo's limited abilities. Dr. Fritz Heinemann suggests a date c. 1530–40.

REFERENCES: 1. Exhibited *Mostra Cima da Conegliano* (Treviso, 1962), pp. 23–4, No. 23, fig. 28. There is detailed discussion and some comment on the origin and influence of the composition in V. Lasareff, 'Opere nuovo e poco note di Cima da Conegliano', *Arte veneta*, 11 (1957), 41–6 repr. 2. Sometimes identified with the *SS. Mark* and *Sebastian* in the National Gallery (inv. 4945 and 4946), for which see M. Davies, *National Gallery Catalogues. The Earlier Italian Schools*, 2nd edn. (London, 1961), pp. 147–8.

# DOMENICO GHIRLANDAIO 1448/9–1494

Florentine school. His full name was Domenico di Tomaso Curradi di Doffo Bigordi, called Ghirlandaio. He also worked in Pistoia, Pisa, Volterra, and Rome. There are important fresco cycles in S. Trinita, Florence, and in S. Maria Novella, Florence. Domenico was supposedly the pupil of Alessio Baldovinetti, but Antonio Pollaiuolo and the Verrocchio workshop appear to have been more important influences at the outset. The Portinari altar-piece, painted by Hugo van der Goes and set up in Florence in 1483, was another important factor in the development of his style. His brothers Davide and Benedetto, and his brother-in-law, Sebastiano Mainardi, were almost certainly active in Domenico's workshop.

## ATTRIBUTED TO DOMENICO GHIRLANDAIO

### A83  PORTRAIT OF A YOUNG MAN                                    Pl. 58

Wood. 39 × 27·7 (slightly bowed).

On the back a label inscribed by an eighteenth-century hand, *Testa di Giovine | di Maniera di Ma | saccio No* . . . . The number *.28.* occurs.

Condition: fair. Cleaned in 1946. The eyes are slightly rubbed and there are some slight scratches across the face. Small cracks are visible in the cap and the drapery. The landscape is well preserved. Fox-Strangways Gift, 1850.

Exhibited: London, Royal Academy, 1962. *Primitives to Picasso* (31).

Literature: Waagen, *Treasures*, iii. 53; Crowe and Cavalcaselle, *History*, iii (1866), 536, n. 3: 2nd edn., iv (1911), 63; A. Woltmann and K. Woermann, *History of Painting*, Eng. edn. (London, 1887), p. 512; C. Ricci, *Pintoricchio*, Eng. edn. (London, 1902), pp. 72 and 237; C. Ricci, *Pintoricchio*, It. edn. (Perugia, 1915), p. 30, n. 1; Van Marle, *Development*, xiii (1931), 216: xiv (1933), 249; M. Salmi, *Masaccio* (Paris, 1935), p. 114; Berenson, 1936, 295: 1968, 345; E. Carli, *Il Pintoricchio* (Milan, 1960), p. 18.

While Woltmann and Woermann suggested the name of Granacci, Ricci (1902) ascribed No. A83 to an anonymous Umbro-Tuscan painter possibly identifiable with one of Pintoricchio's assistants in the Borgia Apartments in the Vatican. Van Marle (1933) and Berenson posited an attribution to Pintoricchio himself. Professor Enzo Carli, by inference, accepts the attribution to Pintoricchio. Salmi, following an earlier suggestion by Van Marle (1931), ascribed No. A83 to Sebastiano Mainardi. Comparison with the *Portrait of a Young Man* at Dresden[1] and with the *Portrait of a Young Man* formerly in the Kress collection (Washington, National Gallery of Art),[2] both widely accepted works by Pintoricchio, shows that No. A83 is by a

different hand, although there is a superficial resemblance in the handling of the composition and in the treatment of the landscape.

The more convincing attribution to Domenico Ghirlandaio, first made by Waagen and by Crowe and Cavalcaselle, has recently been reaffirmed by Mr. Everett Fahy, who proposes a date *c.* 1475.[3] In support of this attribution attention may be drawn to the fresco of the *Obsequies of S. Fina* at S. Gimignano, dated 1475, where many of the male onlookers are characterized in the same manner as the sitter in No. A83.[4] Furthermore, the technique, particularly the delicate application of the flesh tones with finely hatched brush-strokes over the grey-green ground, is common to other portraits painted by Ghirlandaio.[5]

REFERENCES: 1. Inv. 41. Repr. E. Carli, *Il Pintoricchio* (Milan, 1960), pl. 16. Also *Picture Gallery Dresden. Old Masters* (Dresden, 1962), p. 80. 2. Inv. 405. Repr. Carli, op. cit., pl. 17. Also see *National Gallery of Art. Summary Catalogue of European Paintings and Sculpture* (Washington, D.C., 1965), p. 103. 3. Letter of 27 Jan. 1969. Fahy regards the presumed *Portrait of Clarice de' Medici* in the National Gallery of Ireland, Dublin, as of the same date, for which see *National Gallery of Ireland. Catalogue of the Paintings* (Dublin, 1971), 47, with a repr. in the volume of *Illustrations* accompanying the 1963 *Concise Catalogue of the Oil Paintings in the National Gallery of Ireland*. For a photograph and details of this portrait the compiler is grateful to Mr. James White. 4. J. Lauts, *Domenico Ghirlandaio* (Vienna, 1943,) pls. 12–14. 5. For the flesh tones compare the *Portrait of Giovanna Tornabuonai*, repr. Lauts, op. cit., pl. 103, and in colour, in *The Thyssen-Bornemisza Collection* ed. R. Heinemann, ii (Castagnola, 1969), pl. 220.

## GIORGIONE                                    active 1504, died 1510

Venetian school. The real name was Giorgio da Castelfranco, called Giorgione, or in Venetian dialect, Zorzon. He also worked in his native town of Castelfranco. The number of autograph works is disputed. Giorgione's style and his technique of painting, derived in the main from Giovanni Bellini, was of undoubted significance for Italian painting in general and for the Venetian school in particular: likewise his treatment of subject-matter. The formative influences may not have been restricted solely to the Veneto, as knowledge of Northern art, as well as of Central Italian painting, both transmitted by prints, is clearly evident. He may also have had first-hand acquaintance with the work of painters belonging to the Emilian school. Giorgione's reputation was such that Baldassare Castiglione in his *The Courtier*, published in 1524, placed the artist alongside Leonardo da Vinci, Mantegna, Raphael, and Michelangelo.

## ATTRIBUTED TO GIORGIONE

A777   VIRGIN AND CHILD WITH A VIEW OF VENICE BEHIND
       ('THE TALLARD MADONNA')                          Pl. 59

Wood. 76·6 × 60·2.

Condition: fair. Minor repairs have been made in several areas (the Virgin's face and neck, the upper part of Her body, the legs of the Child and in the sky). There is a thin vertical crack in the paint surface passing through the Virgin's veil towards the back of Her head and a second vertical crack, less noticeable, slightly to the right where there has been some retouching. There are no major areas of damage or of restoration. There is considerable wear to the Child's head, to the Virgin's drapery on the right, and along the decorated borders. No. A777 was subjected to a technical examination in 1969.[1] This showed that the flatness of the Virgin's drapery on the right is due to the attrition of a final layer of paint. A red glaze, usually made up with an oil resin and thus soluble, was probably used to render the folds in this part of the drapery or, alternatively, another solution often used by Venetian painters of the cinquecento, known as 'Dragon's Blood', could have been used in the glaze. This glaze could have easily deteriorated in the same way as varnish and so have been removed when it became unsightly or damaged. Similarly, the apparent lack of modelling in the face is due to the Venetian technique of using a thin creamy *gesso* as a base for the pink flesh tones, which becomes transparent in the course of time. The curious treatment of the water lapping at the Piazetta is due neither to damage nor to restoration and, although still open to various interpretations, is best described as unfinished.[2] It is unlikely that the painter originally intended to leave this passage as it is seen today.

Collections: Marie-Joseph, 13th Duc de Tallard (1683–1755) (Tallard sale, Remy & Glomy, Paris, 22 Mar. 1756, lot. 88, bt. Bernard).[3] Next recorded in the collection of the 6th Earl of Cathcart (Christie's, 13 May 1949, lot 119, bt. P. & D. Colnaghi & Co. Ltd.).

Purchased 1949.

Exhibited: Brussels, Palais des Beaux-Arts, *Peinture vénétienne*, 1953 (39); Paris, Orangerie, *Chefs d'oeuvre vénétiens*, 1954 (22); Venice, *Mostra Giorgione e i giorgioneschi*, 1955 (10).

Literature: A. N. Dézallier d'Argenville, *Voyage pittoresque de Paris*, 2nd edn. (Paris, 1762), p. 214; *Annual Report*, 1949, 43–5; H. D. Gronau, 'Pitture veneziane in Inghilterra', *Arte veneta*, 3 (1949), 183; R. Pallucchini, 'Un nuovo Giorgione a Oxford', *Arte veneta*, 3 (1949), 178–80 repr.; A. Morassi, 'The Ashmolean "Madonna Reading" and Giorgione's Chronology', *Burlington Magazine*, 93 (1951), 212–16 repr.; B. Berenson, 'Notes on Giorgione', *Arte veneta*, 8 (1954), 146–52 repr.; L. Venturi, *Giorgione* (Rome, 1954), pp. 42–3 and 66 repr.; L. Baldass, 'Die Tat des

Giorgione', *Jahrbuch der kunsthistorischen Sammlungen in Wien* N.F. 15 (1955), 123–6, n. 26; G. Castelfranco, 'Note su Giorgione', *Bollettino d'arte*, 40 (1955), 306; L. Colletti, *Tutta la Pittura di Giorgione* (Milan, 1955), p. 53 repr.; A. Morassi, 'Un disegno e un dipinto sconosciuti di Giorgione', *Emporium* 121 (1955), 151–4 repr.; R. Pallucchini, 'Guida alla mostra del Giorgione', *Le arti*, N.S. 3 (1955), 3 repr.; P. Della Pergola, *Giorgione* (Milan, 1955), p. 36 repr.; T. Pignatti, *Giorgione* (Milan, 1955), pp. 60–4; G. Robertson, 'The Giorgione Exhibition in Venice', *Burlington Magazine*, 97 (1955), 275; F. R. Shapley, ' "The Holy Family" by Giorgione', *Art Quarterly*, 18 (1955), 383–9 repr.; P. Zampetti, 'Postille alla mostra di Giorgione', *Arte veneta*, 9 (1955), 59; P. Zampetti, *Mostra di Giorgione e i giorgioneschi* (Venice, 1955), pp. 20–2, No. 10 repr.; Berenson, 1957, 55 repr.; R. Salvini, 'Giorgione: un ritratto e molti problemi', *Pantheon*, 19 (1961), 230; F. Heinemann, *Giovanni Bellini e i belliniani*, i (Venice, n.d.), p. 116, No. 184 repr.; L. Baldass–G. Heinz, *Giorgione* (Vienna–Munich, 1964), p. 117: Eng. edn. 1965, p. 119; V. Lilli and P. Zampetti, *L'Opera completa di Giorgione* (Milan, 1968), p. 89 No. 11 repr.; T. Pignatti, *Giorgione* (Venice, 1969), pp. 64 and 104, No. 17 repr.; R. Pallucchini, *Tiziano*, i (Florence, 1969), 6; S. J. Freedberg, *Painting in Italy 1500 to 1600* (Harmondsworth, 1971), p. 91; J. Wilde, *Venetian Art from Bellini to Titian* (Oxford, 1974), pp. 85–6; G. Tschmelitsch, *Zorzo, gennant Giorgione* (Vienna, 1975), pp. 94–5.

There is a minor pentimento at the child's right heel.

X-ray photographs of No. A777 were taken in 1950. These revealed that changes in the course of execution were minimal and were, in fact, limited to the position of the cushion at the Child's feet. They do not clarify the problem of the background on the left.

No. A777 has frequently been discussed in the recent literature on Giorgione and has become the subject of controversy. The panel was first attributed to Giorgione in the eighteenth century by Dézallier d'Argenville when in the collection of the Duc de Tallard, but by the time it is next recorded, at auction in London in 1949, an attribution to Cariani was preferred. Sir Karl Parker, with the support of Mr. James Byam Shaw, reaffirmed the attribution to Giorgione in a brilliant exposition in the *Annual Report* of 1949. Most writers mentioned in the Literature above have supported Parker's reaffirmation. Of the dissenters, Berenson's attribution (1954 and 1957) of No. A777 to Cariani, together with the *Sacra Conversazione* in the Accademia, Venice,[4] on comparison with the *Virgin and Child in a Landscape* in Leningrad[5]—a perfect demonstra-

tion of the shortcomings of the Morellian method—is difficult to uphold in the light of that painter's pedestrian and somewhat provincial abilities. Dr. Fritz Heinmann's attribution to Rocco Marconi deserves little support. Dr. Günther Heinz makes no alternative attribution, whereas Baldass and Mrs. F. R. Shapley argue in favour of an unidentified follower of Giorgione. Professor Sydney Freedberg has proposed the name of Sebastiano del Piombo with a date *c.* 1506–7. Such an attribution for No. A777 is unconvincing and, in the present state of knowledge, it is difficult to interpret an ascription to this or any other follower of Giorgione, given the fact that the technique of the panel in Oxford is so close to Giorgione himself in every respect. An attribution to Giorgione is therefore still the most acceptable. Venturi is exceptional in that, while accepting the attribution to Giorgione, he indicated that the lower half of the panel might be assigned to a collaborator, but it should be firmly stated that No. A777 is manifestly the work of a single painter.

The dating of No. A777 has promoted further discussion. Sir Karl Parker, Sir Philip Hendy (written communication),[6] Gronau, Professor Pietro Zampetti, Venturi, and Professor Giles Robertson regard the panel in Oxford as an early work dating, with narrow degrees of variance, from between the years 1500 and 1504. These same writers all associate No. A777 with a group of paintings at one time referred to as the 'Allendale group', supposedly painted before the Castelfranco altar-piece and comprising the *Holy Family* (Washington, National Gallery of Art, Kress collection, ex-Benson collection), the *Adoration of the Shepherds* (Washington, National Gallery of Art, Kress collection, ex-Allendale collection), and the *Adoration of Kings* (London, National Gallery).[7] Recently, however, the stylistic homogeneity of the 'Allendale group' has been doubted, thus allowing Professor Antonio Morassi, Dottoressa Paolo Della Pergola and Professor Terisio Pignatti (1969) to place No. A777 among the mature works. More specifically, Morassi suggests 1507–8, Della Pergola 1508, Pignatti *c.* 1508, while Professor Rodolfo Pallucchini (1969) implies a date of 1505–10. To this end Vasari's analysis of Giorgione's 'seconda maniera' (iv. 92–3) has often been quoted in confirmation. As regards a secure date for No. A777, the external evidence provided by the view of Venice in the background, which has provoked much discussion owing to the painter's failure to give a topographically accurate rendering of the scene, is inconclusive. The margin of time for the rebuilding of the Campanile and for the erection of the Torre dell' Orologio is virtually equal to the span of Giorgione's own working life.[8]

The composition is derived essentially from Giovanni Bellini,[9] but specific prototypes of the Virgin reading to the Child, or of the Child reading with the Virgin looking on, are found in the work of Carpaccio, Palma Vecchio, and Cima da Conegliano.[10] On many Venetian panels of the Virgin and Child the figures are frequently posed against a landscape, but, as far as the compiler is aware, there is no precedent in Venetian painting for the topographical emphasis given to the background of No. A777.

REFERENCES: 1. The examination was carried out by Mr. Stephen Rees Jones of the Courtauld Institute, London. His findings are reported in a letter of 20 Mar. 1970. 2. L. Baldass, 'Die Tat des Giorgione', *Jahrbuch der kunsthistorischen Sammlungen in Wien* N.F. 15 (1955), 124, n. 26, suggested that the dark outlines silhouetted against the Piazzetta were the prows of gondolas. 3. Lot 88 reads: 'Le Giorgion, la Vierge assise lisant; l' Enfant Jésus est devant elle. Dans le fond, on aperçoit la Place de S. Marc de Venise'. The reference to the sale catalogue was first quoted by G. Richter, *Giorgio da Castelfranco* (Chicago, 1937), p. 334. Richter, however, did not notice that the size of the panel is given in the Corrigenda at the back of the catalogue, *p. 51 line 14: après cet article, mettez la mesure du Tableau, qui est de 29 de haut, sur 23 ponces de large*. These measurements coincide with those of No A777. M. de Bernard, the buyer, of No A777, bought over fifty lots in the sale and appears to have been a dealer, unless he can be identified with the Abbé Bernard mentioned by C. Blanc, *Le Trésor de la curiosité*, i (Paris, 1857), p. l, as one of the main buyers at the Crozat sale of 1741. 4. Inv. 70. Repr. B. Berenson, 'Notes on Giorgione', *Arte veneta*, 8 (1954), fig. 152. 5. Inv. 185. Repr. Berenson, loc. cit., fig. 156. 6. Letter of 29 Aug. 1950. 7. This grouping is first mentioned in the literature on Giorgione by G. Gronau, 'Kritische Studien zu Giorgione', *Reportorium für Kunstwissenschaft*, 31 (1908), 508–9. For convenient reproductions see T. Pignatti, *Giorgione* (Venice, 1969), pls. 8, 35, and 22 respectively. 8. The view of Venice can only be described as an artist's impression of the Molo and the adjacent buildings. On the left is the Campanile with the Mint immediately beneath. To the right of the Campanile is the Torre dell'Orologio with a side view of the façade of S. Mark's adjacent. In the foreground is the Palazzo Ducale with two of the cupolas of S. Mark's rising above the roof. The bell chamber of the Campanile, originally in the shape of a cusp and made of wood, was struck by lightning and burnt in 1489. On No. A777 the temporary *loggia campaneria* with a flat roof is shown, as on the *Death of Adonis* by Sebastiano del Piombo in the Uffizi, Florence (repr. R. Pallucchini, *Sebastian Viniziano* (Milan, 1944), pl. 20). Another design for the Campanile was made by Giorgio Spavento in 1489 with a stone pyramidal apex (G. Gattinoni, *Il campanile di San Marco. Monografia storica* (Venice, 1910), pp. 49–55), but building was delayed until 1511–14. The Torre dell' Orologio was constructed in two stages. The main tower was built between 1496 and 1469, and the two lateral towers between 1500 and 1506 (G. Lorenzetti, *Venezia e il suo estuario*, 2nd revised edn. (Rome, 1956), pp. 139–40). Although the fact is often questioned, the present writer is inclined to believe that these side towers are shown on No. A777, as indeed they are on Sebastiano del Piombo's *Death of Adonis*. The two columns on the Molo with the Lion of S. Mark and S. Teodoro, and the façade of the basilica of S. Marco, are peculiarly observed on No. A777. On the question of topographical accuracy as a whole with

reference to this particular view of Venice, see W. Ivins, *Prints and Visual Communication* (London, 1953), pp. 36–8. 9. G. Gronau, *Giovanni Bellini. Klassiker der Kunst* (Stuttgart, 1930), pp. 56 and 111. 10. For Carpaccio, see J. Lauts, *Carpaccio* (London, 1962), pls. 48, 143, 47, and 89. For Palma Vecchio, see G. Gombosi, *Klassiker der Kunst* (Stuttgart, 1937), p. 1, with bibliography in G. Mariacher, *Palma il Vecchio* (Milan, 1968), p. 94, to which should be added S. J. Freedberg, *Painting in Italy 1500 to 1600* (Harmondsworth, 1971), p. 480 n. 78. For Cima, see L. Coletti, *Cima da Conegliano* (Venice, 1959), p. 70, pl. 1.

## GIOTTO 1276–1337

Florentine school. His full name was Giotto di Bondone. He was also active in Padua, Assisi, Rimini, and, at a later date, Naples. From 1311 he ran a large and active workshop in Florence. Traditionally he has been regarded as the pupil of Cimabue, but, in fact, his style is more closely dependent upon that of Cavallini, which suggests a Roman training. The date of birth is either 1267 or 1276: most scholars favour the former, but the latter is more likely. The key work is the series of frescoes in the Scrovegni Chapel in Padua. The Ognissanti Madonna in the Uffizi is the touchstone for Giotto's style o painting on panel, but the attribution of many of the other panels assigned to him remains unsettled. Bernardo Daddi, Maso di Banco, and Taddeo Gaddi were his most distinguished Florentine pupils. Giotto is usually considered to be the founder of the modern school of painting.

## STUDIO OF GIOTTO 1310–1315

### A332 VIRGIN AND CHILD **Pls. 60–1**

Wood. Painted surface 28·5 × 19·7. 32·9 × 24·3 (including frame).

Condition: fair. Cleaned and restored in 1946.[1] Many small repairs have been made throughout; for example, at the top of the Virgin's veil, on the left side of the face, in the neck, and on the back of Her right hand. The top half of the Child's head (above the hairline) is repainted and a number of small damages to His drapery, particularly in the lower parts, have been made good. The bottom half of the Virgin's drapery has been badly damaged and a passage in the centre, which includes the Child's right foot, has been repainted. The bottom edge of the panel has sustained some damage. The gold background is comparatively well preserved. A hole has been pierced through the panel, top centre.

Anderson Gift, 1913.[2]

Literature: T. Borenius, 'The Anderson Gift to the Ashmolean Museum, Oxford', *Burlington Magazine*, 25 (1914), 325 repr.; O. Sirén, *Giotto and Some of His Followers*, i (Oxford, 1917), 100–1 repr.; O. Sirén, 'Some Paintings by a Follower of Giotto', *Burlington Magazine*, 43 (1923), 259 repr.; Van Marle, *Development*, iii (1924), 249; H. Beenken, 'A Polyptych Ascribed to Giotto', *Burlington Magazine*, 65 (1934), 109 repr.; R. Oertel,

'Giotto-Ausstellung in Firenz', *Zeitschrift für Kunstgeschichte*, 6 (1937), 237; G. Sinibaldi and G. Brunetti, *Pittura italiana dei Duecento e del Trecento. Catalogo della Mostra Giottesca di Firenze del 1937* (Florence, 1943), p. 423 No. 134; L. Coletti, *Gli affreschi della Basilica di Assisi* (Bergamo, 1949), p. 99; D. Schorr, *The Christ Child in Devotional Images in Italy during the XIV Century* (New York, 1954), p. 118 repr.; E. Sandberg-Vavalà, *Studies in the Florentine Churches*, Pt. 1: *Pre-Renaissance Period* (Florence, 1959), p. 63; Berenson, 1963, 84; C. Volpe, 'Un momento di Giotto e "Il Maestro di Vicchio a Rimaggio"', *Paragone*, 157 (1963), 3–14 repr.; G. Previtali, *Giotto e la sua bottega* (Milan, 1967), pp. 64 and 346 repr.; C. Ragghianti, 'Percorso di Giotto', *Critica d'arte*, 16 (1969), 50; F. Bologna, *Novità su Giotto* (Turin, 1969), pp. 34–7, n. 2 repr.; P. Venturoli, 'Giotto', *Storia dell'arte*, 1/2 (1969), 151–2.

No. A332 is a panel of high quality, in the attribution of which earlier writers showed a wide degree of variance. Borenius suggested an anonymous painter of the Umbro-Tuscan school. Sirén favoured the Master of the S. Nicholas Chapel, whom he later (1923) tentatively identified with Stefano Fiorentino. Coletti proposed the Master of Santa Cecilia and Van Marle indicated a possible connection with Pacino di Bonaguida. Beenken cautiously advanced the name of Taddeo Gaddi.

The tenor of more recent discussion was set by Professor Robert Oertel in his discursive review of the Giotto exhibition of 1937, when he pointed out that the composition of No. A332 was in all probability derived from a Giottesque prototype. Berenson listed No. A332 under the category of close follower of Giotto. Recently, there has been a tendency to attribute the panel to Giotto's own hand. This was first proposed by Professor Carlo Volpe and his attribution has been tentatively supported by Professor Giovanni Previtali and also, by implication, by Professor Carlo Ragghianti. Such an attribution, however, has by no means been unanimously accepted, and was in fact rejected by Professor Ferdinando Bologna, who preferred that first made by Sirén to the Master of the S. Nicholas Chapel, and also by Dr. Paolo Venturoli, who favours an anonymous follower of Giotto.

Two of these recent opinions should be discussed in greater detail. Volpe grouped No. A332 with the Badia polyptych (on loan to the Uffizi), the altar-piece in the church of S. Giorgio alla Costa, Florence, and the signed panel of *S. Francis Receiving the Stigmata* in the Louvre, all of which he dates *c.* 1300 after the frescoes at Assisi and before the cycle in the Scrovegni Chapel, Padua. Bologna, on the other hand, paid close

attention to the apparent similarities between the style of No. A332 and that of the frescoes in the S. Nicholas Chapel in the Lower Church at Assisi, painted by an assistant of Giotto before 1307/8. Previtali has shown more recently that these frescoes, together with the frescoed triptych on the altar wall of the same chapel, are in a Paduan style and were most probably painted by a member of Giotto's workshop, who, as it now appears, not only assisted him in the Arena chapel, but also in the Magdalen chapel in the Lower Church at Assisi.[3] The compiler agrees in essence with Bologna. The painter of No. A332 clearly shares the newly established principles of painting in common with those followers of Giotto who were working in the two chapels in the Lower Church at Assisi, one of whom may possibly have executed the panel now in Oxford.

Oertel first drew attention to the fact that the pose of the Virgin and Child on No. A332 is identical with that on an altar-piece of *The Virgin and Child Enthroned* in the church of S. Lorenzo, Vicchio di Rimaggio, painted by a retardataire Florentine painter, sometime during the first two decades of the fourteenth century.[4] The striding figure of the Child, with His right hand extended towards the Virgin's left cheek and the short kerchief placed over the Virgin's head, are the salient features common to both works. Oertel argued that the painter of the altar-piece at Vicchio di Rimaggio derived his grouping of the Virgin and Child from an example such as No. A332, which, in his opinion, formed part of a coherent development within Giotto's workshop. In fact, the altar-piece at Vicchio di Rimaggio can now be shown to be related to three other altar-pieces, each earlier in date than No. A332, thereby implying that this particular rendering of the Virgin and Child was based upon an established tradition.[5] Significantly, the painter of No. A332 appears to have broken with that tradition, by reducing the figures to half-lengths.

A number of panels dating from the first half of the fifteenth century reproduce the composition of No. A332.[6] In view of the close proximity in which the painter of No. A332 stood in relation to Giotto, it is conceivable that the panel in Oxford, and not an autograph work by the master himself, served as a prototype for these later derivations.

REFERENCES: 1. For a reproduction before cleaning, see O. Sirén, 'Some Paintings by a Follower of Giotto', *Burlington Magazine*, 43 (1923), pl. Ia, opp. 260. 2. Bt. in Perugia in 1887 (see letter of 12 Feb. 1913 from Mrs. Reddie Anderson). 3. For reproductions of the frescoes in the S. Nicholas Chapel and also for the newly cleaned frescoes in the Magdalen Chapel, see the illustrations accompanying G. Previtali, 'Le cappelle di S. Nicola e di S. Maria Maddalena nella Chiesa Inferiore di San Francesco', in *Giotto e i*

*giotteschi in Assisi*, ed. G. Palumbo, 2nd edn. (Rome, 1970), between pp. 93 and 127. The dating of the frescoes in these two chapels is still disputed. See, for example, the comments on Previtali's dating made by M. Boskovits, 'Nuovi studi su Giotto e Assisi', *Paragone*, 261 (1971), 43–7. 4. Offner, *Corpus*, sec. III, vol. vi (1956), 118–19, pl. 39. 5. D. Schorr, *The Christ Child in Devotional Images in Italy during the XIV Century* (New York, 1954), type 18, Variation 2 Scrambling Child, nos. 3 and 4. Also compare the *Virgin and Child Enthroned* in the church of S. Remigio, Florence, repr. G. Sinibaldi and G. Brunetti, *Pittura italiana del Duecento e Trecento. Catalogo della Mostra Giottesca di Firenze del 1937* (Florence, 1943), p. 297, No. 94. 6. Dr. Zeri (letter of 14 May 1969) has kindly pointed out that a replica of No. 178, ascribed to a follower of Giotto, was sold at Christie's 28 Mar. 1969, lot 15 (28×20). Zeri attributes this panel to the Master of the Griggs Crucifixion and has stated (letter of 29 Oct. 1973) that the same painter also used the composition for a small altar-piece in the collection of the Ospedale di Santo Spirito in Sassia, Rome, which was first published by him in 'La Mostra "Arte in Valdelsa" a Certaldo', *Bollettino d'arte*, 48 (1963), 257, n. 9. L. Bellosi, 'Il Maestro della Crocifissione Griggs: Giovanni Toscani', *Paragone*, 193 (1966), 47, drew attention to the similarities in the pose of the Virigin and Child on a panel in the Corsi collection, Florence, repr. Schorr, op. cit., type 18, Florence No. 26. The same writer (op. cit., p. 57, n. 11), also noticed that another variant was published by R. Longhi, 'Un'aggiunta al "Maestro del Bambino Vispo" (Miguel Alcañiz?)', *Paragone*, 185 (1965), 38–40, pl. 45, colour pl. II.

# GIOVANNI ANTONIO DA PESARO          active 1462/3

Marchigian school. A provincial painter whose style was ultimately derived from that of Gentile da Fabriano, but whose work also reveals the influence of the Emilian school.

### A882   S. MARK (CENTRE PANEL OF A TRIPTYCH)          Pl. 62

Wood (cradled). 170 × 55 (arched). The paint does not continue to the edges and there is a border of 3·4 cm. around the whole panel, possibly once covered by part of the original frame.

Signed and dated in Gothic script along the bottom, 1463 IANNUARII IOHAÑES ANTONIUS PISAURENSIS PIX̂.

The book held by S. Mark is inscribed [left page] *Pax. tibi. m/arce. evange / lista meus.*[1] *Sequentia. siti / evangelii.s̄c̄s̄ / marcus. glz̄i. / tibi. dñe. / Inillo tp̄re. /* [right page] *recunbentibus / undecis disciplis. / apparint illis / ih̄s. et expbra / vit incredulita / tis illos et diri / tiam . . . / quia hiis . . . . . / viderant . . .*[2] The book held by the lion at the bottom left of the panel is inscribed, *Pax / tibi m / arce evang / elista m / eus. Sc̄q / tia Arti / evangeli / sta marc̄e.*

Condition: fair. Cleaned in 1955. Blisters have been laid above the right eye and in the neck. Vertical splits in the panel are visible at top right and bottom left. There are some blemishes in the drapery and on the right-hand page of the book. The gold background is virtually intact, although

the gold highlighting on the drapery is worn. Disfigurement has been caused by worm holes, which are in the main limited to the figure. Collections: Nicolò Paglini, Pesaro:[3] Monte di Pietà, Rome (sold 3 Mar. 1875, lot 938).[4] Not recorded again until in the collection of K. J. Hewett, Ashford, Kent, from whom bought by H. Bier.[5]

Purchased 1955.

Literature: Van Marle, *Development*, viii (1927), 292 repr.; L. Serra, *L'arte nelle Marche. Il periodo del Rinascimento* (Rome, 1934), pp. 230–2; F. Zeri, 'Me Pinxit 3. Giovanni Antonio da Pesaro', *Proporzioni*, 2 (1948), 165; *Annual Report*, 1955, 60–1; P. Zampetti, *Paintings from the Marches. Gentile to Raphael*, Eng. edn. (London, 1971), p. 236.

No. A882 once formed the centre of a triptych. The two lateral panels with four saints grouped in pairs, one above the other, have recently come to light in Rome in the collection of Prince Antonio Ruffo della Scaletta.[6]

A *Madonna della Misericordia* in the church of S. Maria del Arzilla, Candelara, the only other extant work signed and dated by Giovanni Antonio da Pesaro, was painted one year before No. A882.[7]

REFERENCES: 1. *Acta Sanctorum*, Aprilis iii (Antwerp, 1675), 348, 8. 2. From Mark 16: 14. The Latin should read: 'Novissime recumbentibus illis undecim apparuit; et exprobravit incredulitatem eorum et duritiam cordis; quia iis, qui viderant eum resurrexisse, non crediderunt.' 3. L. Serra, *L'arte nelle Marche. Il periodo del Rinascimento* (Rome, 1934), pp. 232–3, refers to Antaldo Antaldi, *Notizie di architetti, pittori, scultori di Urbino, Pesaro e dei luoghi circonvicini* (the manuscript of which in the Biblioteca Oliveriana, Pesaro (inv. 936), is dated 1805), who mentions a triptych in the house of a certain Nicolò Paglini in Pesaro. Antaldi records that the signature on a central panel accords with that found on No. A882, but the saint is identified as S. Jerome. In the *Annual Report* of 1955 Sir Karl Parker pointed out that it is most unlikely that two panels from one complex would have been identically or so elaborately inscribed and, alternatively, it is equally unlikely for two altar-pieces of this size to have been completed and signed in the same month. It is therefore likely that Antaldi confused the identity of the saint. 4. *Catalogo per la vendita dei quadri, sculturi in marmo, musaici, pietre colorate, bronzi ed altri oggetti di belle arti esistenti nella Galleria già del Monte di Pietà di Roma ora della cassa dei depositi e prestiti*, Rome 1875, lot 938 (1129), 'Giovanni Antonio Pisani: S. Marco Evangelista: a piedi del dipinto a tempera leggesi Johannes Antonius Pisaurensis pinxit 1463. Tavola con sesto che con le altre due seguenti formavo un trittico alta met 1·69 larga cent. 55. 1000 lire. Lot 939 (1130), 'Altra tavola rappresentante quattro santi alta metri 1·64 larga cent. 51. 750 lire.' Lot 940 (1131), 'Altra tavola rappresentante quattro santi alta metri 1·64 cent. 51. 750 lire'. Prince Ruffo della Scaletta kindly drew the compiler's attention to this sale (letter of 3 Nov. 1969). Lots 939 and 940 were evidently bought in, as they were resold at another sale at the Monte di Pietà in 1884 (31 Mar.–28 Apr.) where they were bought by the great-grandfather of Prince Ruffo. The compiler has been unable to trace the catalogue of the

sale held in 1884. 5. Letter from H. Bier of 4 Aug. 1970. 6. In the left wing the artist has painted SS. Blaise and John the Baptist above with SS. Sebastian and Jerome below. In the right wing are SS. James Major and Anthony Abbot above with SS. Peter and Paul below. The compiler is indebted to Principe Ruffo della Scaletta for photographs of the panels in his possession. As stated in a letter of 15 May 1970, Dr. Federico Zeri was already aware of the connection between No. A882 and these two panels, which came to his attention after the publication of his article in *Proporzioni* in 1948. 7. Repr. Serra, op. cit., fig. 291.

## GIOVANNI DI PAOLO

active 1420,
last mentioned 1482

Sienese school. He was the son of Paolo di Grazia. The number of dismembered altarpieces from the early and middle phases of his life and the reliance on workshop assistance during the last phase has made the chronological arrangement of Giovanni di Paolo's *œuvre* difficult. He was also a miniature painter. His style, with its tortuous outlines and expressive drawing, is at its most idiosyncratic in his predella panels. There are stylistic affinities with Sassetta, Gentile da Fabriano, and Fra Angelico, but some of the earlier works are dependent upon Taddeo di Bartolo and Paolo di Giovanni Fei. Towards the end of his life his style moves closer towards that of Sano di Pietro and Matteo di Giovanni.

A333　THE BAPTISM OF CHRIST (PREDELLA PANEL FROM
AN ALTAR-PIECE)　　　　　　　　　　　　　**Pl. 63**

Wood. 25·7 × 35·7 (slightly bowed).

Condition: fairly good. There is a considerable amount of surface dirt.

Anderson Gift, 1913.[1]

Literature: *Annual Report*, 1913, 13; Crowe and Cavalcaselle, *History*, 2nd edn., v (1914), 177–8 n.; T. Borenius, 'The Anderson Gift to the Ashmolean Museum, Oxford', *Burlington Magazine*, 25 (1914), 326 repr.; Van Marle, *Development*, ix (1927), 446; Berenson, 1932, 247: 1936, 212: 1968, 179; J. Pope-Hennessy, *Giovanni di Paolo* (London, 1937), pp. 90–1 and 173; C. Brandi, 'Giovanni di Paolo', *Le arti*, 3 (1941), 321; C. Brandi, *Giovanni di Paolo* (Florence, 1947), 40–1, 78–9, and 121 repr.; M. Meiss, 'A New Panel by Giovanni di Paolo from his Altar-piece of the Baptist', *Bnrlington Magazine*, 116 (1974), 77.

The attribution of No. A333 to Giovanni di Paolo has been accepted by all writers, but the panel is generally not considered to be of such high quality as the other two known examples of this subject painted by the master. These are the panels now in London (National Gallery)[2] and in Princeton (The Art Museum, Princeton University, on loan from the

Norton Simon Foundation),[3] both belonging to separate series of panels illustrating scenes from the life of S. John the Baptist. The panel in London, like No. A333, comes from the predella of an altar-piece, while, according to the late Professor Millard Meiss, the panel in America was originally placed in the right shutter of a folding altar-piece. Meiss considered the panel belonging to the Norton Simon Foundation to have been painted at the beginning of the sixth decade and that the panels in London and Oxford were later revivals of the composition.

The composition of No. A333 differs from that on the panel in London in the exclusion of the Angels attendant upon God the Father and in the inclusion of an orange tree in the landscape on the right. Both panels have a similar format, differing in this respect from the vertical axis of the composition in Princeton, which is arched with God the Father placed well above the scene of the Baptism. None the less, the constituent elements of the design and the poses of the figures are repeated on all three panels. Sir John Pope-Hennessy first observed that Lorenzo Ghiberti's design for the bronze panel of the *Baptism of Christ* on the font in the Baptistery of Siena Cathedral served as the prototype for Giovanni di Paolo's depictions.[4]

A number of panels are believed to have belonged to the same predella as No. A333. Pope-Hennessy, on the basis of the fact that the subject is equally well suited to a predella with scenes from the life of Christ as to one showing scenes from the life of S. John the Baptist, associated No. A333 with a *Nativity* (Cambridge, Mass., Fogg Art Museum),[5] an *Adoration of Kings* (New York, J. Linksy collection),[6] and a *Christ Disputing with the Doctors* (Boston, Isabella Stewart Gardner Museum).[7] Pope-Hennessy further suggested that, owing to its shape and subject matter, the panel in Oxford would have been placed in the middle of the predella with scenes from the early life of Christ on the left and scenes from Christ's mission on the right. On internal evidence alone, Pope-Hennessy dates No. A333 *c.* 1460, at about the same time as the series in London and later than the series to which the *Baptism of Christ* in Princeton belongs, which he places *c.* 1455–60.

Professor Cesare Brandi does not accept Pope-Hennessy's reconstruction and dates No. A333 separately from the related panels sometime between 1449 and 1453. The same writer wrongly identifies No. A333 with a panel mentioned in Brogi's *Inventory of Works of Art in the Province of Siena*.[8]

REFERENCES: 1. Bt. by J. R. Anderson in Siena in 1875 (letter of 12 Feb. 1913). 2. Inv. 5451. M. Davies, *National Gallery Catalogues. The Earlier Italian Schools*, 2nd edn. (London, 1961), pp. 243–5. 3. Repr. M. Meiss, 'A New Panel by Giovanni di Paolo from his

Altar-piece of the Baptist', *Burlington Magazine*, 116 (1974), fig. 1.  4. J. von Schlosser, *Leben und Meinungen des florentinischen Bildners Lorenzo Ghiberti* (Basle, 1941), pl. 49.  5. Inv. 1943. 112, 27·9×23·5. Repr. J. Breck, 'Some Paintings by Giovanni di Paolo—I', *Art in America*, 2 (1914), fig. 3 on 186, when in the Greville L. Winthrop collection. 6. Repr. *Pantheon*, 25 (1967), 465.  7. Measuring 27·5×23·9. P. Hendy, *European and American Paintings in the Isabella Stewart Gardner Museum, Boston* (1974), p. 107 repr. 8. For the refutation see J. Byam Shaw, *Paintings by Old Masters at Christ Church Oxford* (London, 1967), p. 46, No. 30.

A972   VIRGIN AND CHILD                                      **Pl. 64**

Wood. 35 × 25·5 (upper corners sloped).

Condition: fair. A heavy craquelure covers the whole surface. The background is restored on the right and there is some damage along the lower edge of the panel. The modelling of the flesh parts is slightly worn, but the facial features are quite well preserved. The Virgin's drapery has been fairly extensively repainted.

Collections: Ferretti, Perugia; Dan Fellows Platt; E. A. Silberman Gallery, New York. Next recorded at auction London, Christie's, 9 Apr. 1954, lot 58, Property of a Gentleman; P. & D. Colnaghi & Co. Ltd., London, 1955; F. F. Madan.

Madan Bequest, 1962.

Exhibited: London, P. & D. Colnaghi & Co. Ltd., *Old Master Paintings*, 1956 (18); London, P. & D. Colnaghi & Co. Ltd., *Memorial Exhibition of Paintings and Drawings from the Collection of Francis Falconer Madan*, 1962 (58).

Literature: J. Breck, 'Some Paintings by Giovanni di Paolo—II', *Art in America*, 2 (1914), 283; F. M. Perkins, 'Dipinti senesi sconosciuti o inediti', *Rassagna d'arte antica e moderna*, i (1914), 165, n. 1; Berenson, 1932, 245: 1936, 211: 1968, 166; J. Pope-Hennessy, *Giovanni di Paolo* (London, 1937), pp. 133, 145, and 172; C. Brandi, 'Giovanni di Paolo', *Le arti*, 3 (1941), 337–8, n. 82; C. Brandi, *Giovanni di Paolo* (Florence, 1947), pp. 92 and 124 repr.; 'Notable Works of Art now on the Market', *Burlington Magazine*, 97 (1955), July Supplement, pl. 1 repr.; *Annual Report*, 1962, 35 repr.

No. A972 was first attributed to Giovanni di Paolo by Breck and this was accepted at first by Berenson (1932 and 1936) and by Sir John Pope-Hennessy. Professor Cesare Brandi (1941 and 1947) assigned No. A972 to a later follower of Giovanni di Paolo and in the 1968 edition of Berenson's Lists an attribution to Giacomo del Pisano was preferred. No. A972,

however, bears the hallmarks of Giovanni di Paolo's late style and is in fact a panel of some quality. The attribution to Giacomo del Pisano is unjustified.

On the basis of the stylistic affinity with the predella panels showing scenes from the life of S. Catherine, Pope-Hennessy suggests a date *c.* 1463, that is at the beginning of the last phase of the master's life.[1]

REFERENCES: 1. It should be observed that the date of the predella panels with scenes from the life of S. Catherine is disputed. For a summary see H. W. van Os, 'Giovanni di Paolo's Pizzicaiuolo Altar-piece', *Art Bulletin*, 53 (1971), 289-302.

## FRANCESCO GRANACCI                       1469/70–1543

Florentine school. His full name was Francesco di Andrea di Marco. The family name was Granacci. He was a follower of Domenico Ghirlandaio and strongly influenced by his fellow pupil Fra Bartolommeo and by the works of Raphael's Florentine period. Vasari writes of his friendship with Michelangelo with whom he visited Rome on one occasion. Granacci's work is fresh in colour, almost suave in technique, becoming increasingly mannered in drawing, while the compositions remain firmly rooted in the tradition of the quattrocento.

AIOO  S. ANTHONY OF PADUA (FRAGMENT FROM AN
       ALTAR-PIECE)                                    **Pl. 65**

Wood transferred to canvas. 32·7 × 14 (arched at both ends). On the stretcher the remnants, no part of which is decipherable, of a wax impression of a seal presumably removed from the back of the panel when it was planed down.

Condition: poor. There are numerous paint losses and small retouches, but the original quality is by no means totally lost.[1] The features are quite well preserved.

Fox-Strangways Gift, 1850.

Literature: see No. AI01 below.

AI01  AN ANGEL (FRAGMENT FROM AN ALTAR-PIECE)        **Pl. 66**

Wood transferred to canvas. 32·7 × 14 (arched at both ends). On the stretcher the remnants, no part of which is decipherable, of a wax impression of a seal, presumably removed from the back of the panel when it was planed down.

Condition: poor. There are several paint losses and small retouches.[2]

Fox-Strangways Gift, 1850.

Literature: Crowe and Cavalcaselle, *History*, iii (1866), 540; 2nd edn., vi (1914), 159; Berenson, 1912, 145: 1932, 267: 1936, 229: 1963, 99; Venturi, *Storia*, ix, pt. 1 (1925), 489 n.; C. von Holst, *Francesco Granacci* (Munich, 1974), pp. 30 and 153, Cat. nos. 38 and 40 repr.; A. D. Fraser Jenkins, 'A Florentine marble tabernacle with a door by Francesco Granacci', *Burlington Magazine*, 117 (1975), 44.

There is a pentimento along the right forearm of the Angel depicted on No. A101.

Borenius first observed that a panel of *S. Francis* in the Gallery at Christ Church, Oxford, also came from the same collection as Nos. A100 and A101 and must originally have formed part of the same altar-piece.[3] A fourth panel of the *Risen Christ*, which is now attached to a marble tabernacle, is in the National Gallery of Wales, Cardiff.[4] Dr. Christian von Holst has suggested a date *c.* 1520–2 close to the predella panels in the Stibbert Museum, Florence.[5]

Panels of this shape and size were usually placed in the pilasters of large altar-pieces. The placing of the figures in niches surmounted by a scalloped semi-domes was a convention often employed by Domenico Ghirlandaio in whose workshop Granacci worked.[6]

REFERENCES: 1. Crowe and Cavalcaselle, *History*, iii (1866), 540, record that 'The colour in part fallen out, and more dropping'. 2. See note 1 above. 3. T. Borenius, *Pictures by the Old Masters in the Library of Christ Church, Oxford* (Oxford, 1916), p. 35, No. 55. Also J. Byam Shaw, *Paintings by Old Masters at Christ Church Oxford* (London, 1967), pp. 59–60, No. 60 repr. A label inscribed by a nineteenth-century hand on the back of the *S. Francis* at Christ Church reads *S. Francesco di Francesco Granacci della Galleria dei Conti Guidi di Firenze*. C. von Holst, *Francesco Granacci* (Munich, 1974), pp. 152–3, Cat. no. 37 repr. 4. Inv. 149a, 27·9 × 12·7. Repr. von Holst, op. cit., p. 153 fig. 65. Attention was first drawn to this related panel by Mr. David Carritt in a letter dated 3 June 1970. The *Risen Christ* was cleaned in 1971 when it was discovered that the panel had been slightly cut at the bottom and trimmed on both sides. It was adapted to serve as the door of a marble tabernacle once attributed to Mino da Fiesole and formerly in the church of S. Maria alle Campora, to the south of Florence, which in 1833 was placed by the Revd. John Sanford in Nynehead parish church near Taunton, Somerset, where he was rector from 1811 to 1818. For the church of S. Maria alle Campora see G. Carocci, *I dintorni di Firenze*, ii (Florence, 1907), 340–1. A seal, deciphered by Mr. David Fraser Jenkins of the National Gallery of Wales as *DC* on a palette, occurs on the back of the panel. The same seal occurs on the back of the *S. Francis* at Christ Church. Sanford bought a number of pictures from the Guidi collection for which see B. Nicolson, 'The Sanford Collection', *Burlington Magazine*, 97 (1955), 207–14. The compiler is grateful to Mr. Fraser Jenkins for the provision of photographs and information regarding the tabernacle in Cardiff. 5. Repr. C. von Holst, op. cit., p. 152, Cat. nos. 34–6, figs. 58–63, from an

altar-piece the preparatory drawing for which is in the British Museum (inv. 1895-9-15-468, discussed by von Holst, op. cit., pp. 151-2, Cat. no. 33 repr. fig. 57). 6. Compare the saints flanking the centre panel of the high altar-piece begun by Ghirlandaio for S. Maria Novella, Florence, but completed after his death by his studio. For a reconstruction see C. von Holst, 'Domenico Ghirlandaio: l'altare maggiore di Santa Maria Novella a Firenze ricostruito', *Antichità viva*, 8 (1969), 36-41. The treatment of the saints in the apse window designed by Ghirlandaio for the same church is also comparable. For reproductions see G. Marchini, *Italian Stained Glass Windows*, Eng. edn. (London, 1957), pp. 54 and 250, No. 65 repr. figs. 66 and 67.

## ANONYMOUS ITALIAN 1550–1570

### A20 PORTRAIT OF AN ARTIST **Pl. 67**

Canvas (relined). 100·5 × 78·8.

Condition: fair. There seems to be a certain amount of repaint, particularly about the features. The surface is obscured by a layer of old varnish.

Collections: Thomas Gibson (1714);[1] Dr. Richard Rawlinson (1747).[2]

Presented to the Bodleian Library by Dr. Richard Rawlinson (1689/90–1755) at an uncertain date.[3] Transferred to the Ashmolean at an uncertain date.[4]

Exhibited: Oxford, *Oxford Historical Portraits. A Loan Collection of Portraits of English Historical Personages who died prior to the year 1625*, 1904 (97) repr.

Literature: *The Walpole Society*, 26 (1937–8), Vertue Note Books, v. 61; Mrs. R. L. Poole, *Catalogue of Portraits in the Possession of the University, Colleges, City, and County of Oxford*, i (Oxford, 1912), 170, No. 409.

The sitter on No. A20 is shown with the traditional attributes of drawing—a set square and a pair of compasses.[5] The direct gaze with which the sitter fixes the spectator suggests that No. A20 is a self-portrait. George Vertue is the first to record that No. A20 was traditionally regarded as a self-portrait by Federico Zuccaro and this opinion was upheld in the earlier editions of the catalogues of the pictures in the Bodleian Library.[6] The portrait was engraved by Alexander Bannerman (1730–70) to illustrate the first and second editions of Horace Walpole's *Anecdotes of Painting in England*.[7]

The identification with Federico Zuccaro cannot be so confidently upheld today. The iconography of Federico Zuccaro is fairly extensive, but none of the distinguishing features evident in the authentic likenesses—the bulbous nose, the wide-set eyes, the high forehead—characterizes the subject of No. A20.[8] Cleaning may help to establish both the subject and the style of the portrait.

REFERENCES: 1. *The Walpole Society*, 18 (1929–30), Vertue Note Books, i. 31. This reference was noted by my colleague, Mr. Hugh Macandrew. 2. *The Walpole Society*, 26 (1937–8), Vertue Note Books, v. 61. 3. No. A20 is listed with other portraits in a notebook kept by Rawlinson of his loans and gifts to the Bodleian Library (Rawl. MS. C 8 11, f. 66). Unfortunately, the notebook is undated. The compiler is most grateful to Dr. R. W. Hunt for tracing this reference on his behalf. 4. The portrait is first recorded in the Bodleian Catalogue of 1759 compiled by N. Bull, *A Catalogue of the Several Pictures, Statues, and Busts in the Picture Gallery, Bodleian Library and Ashmolean Museum at Oxford* (Oxford, 1759), p. 8. It is last recorded in the Bodleian in 1840 (J. Norris, *A Catalogue of the Pictures, Models, Busts etc. in the Bodleian Gallery, Oxford* (Oxford, 1840), p. 54. The portrait is not listed in F. Madan, *List of Books, Manuscripts, Portraits etc. Exhibited in the Bodleian Library, Oxford* (Oxford, 1881), although in an annotated copy which once belonged to T. W. Jackson and is now in the library of the Department of Western Art in the Ashmolean Museum, it is added and so may still have been in the Bodleian at this late date. No. A20 is first mentioned in the Ashmolean in *A Provisional Catalogue of the Paintings Exhibited in the University Galleries Oxford* (Oxford, 1891), p. 26, No. 36. 5. C. Ripa, *Iconologia* (Padua, 1611), pp. 96–7, relates the attributes of a pair of compasses and a set square when shown together, as on No. A20, with *Considerazione* meaning high regard, or esteem, for proficiency. See further, C. Gilbert, The Literature of Art, 'The Renaissance Portrait'. Review of *The Portrait in the Renaissance* by J. Pope-Hennessy, *Burlington Magazine*, 110 (1968), 281, n. 3. Also C. Gould, 'An Identification for the Sitter of a Bellinesque Portrait', *Burlington Magazine*, 110 (1968), 626. 6. A convenient list of the catalogues of the Bodleian Library is given by W. D. MacRae, *Annals of the Bodleian Library*, 2nd edn. (Oxford, 1890), pp. 257–8. 7. H. Walpole, *Anecdotes of Painting in England*, i (London, 1762), opp. p. 140; 2nd end. (London, 1765), opp. p. 150. Walpole (1762 edn., i. 142) mentions that Zuccaro painted a self-portrait while in England, but neither he nor later editors specifically identified the portrait with that exhibited in the Bodleian Library. 8. The authentic likenesses may be listed as follows: Uffizi, Florence (inv. 7457), repr. Venturi, *Storia*, ix, pt. 5 (1932), fig. 532, for which R. Strong, *The English Icon: Elizabethan and Jacobean Portraiture* (London, and New York, 1969), p. 163, suggests an attribution to Francesco Pourbus; Accademia di S. Lucca, Rome (inv. 275), repr. W. Körte, *Der Palazzo Zuccari in Rom* (Leipzig, 1935), pl. 1, as a self-portrait, on which a further portrait by P. L. Ghezzi also in the Accademia di S. Lucca (inv. 193) is based (V. Golzio, *La galleria e le collezione della R. Accademia di San Luca in Roma* (Roma, 1939), p. 7 repr.; Capitoline Museum, Rome (S. Bocconi, *Collezioni Capitoline* (Rome, 1950), p. 337). The personal iconography of Federico Zuccaro may be extended to the frescoes in the Palazzo Zuccaro in Rome, especially the lunettes in the Sala Terrena for which see Körte, op. cit., pls. 21a and 23a.

## LEONARDO DA VINCI                                      1452–1519

Florentine school. Painter, sculptor, architect, engineer, and scientist. He was the son of Ser di Piero. He also worked in Milan, Rome, and Amboise, where he died, and he is known to have visited Mantua and Venice. Leonardo was the pupil of Andrea Verrocchio. While the number of autograph paintings is comparatively small, there is a large corpus of drawings, many of which provide evidence for the compositions of lost works. He had several important pupils who frequently used compositions designed by the master.

For most, the fertility of his mind and the universality of his genius epitomize the Renaissance in Italy.

## STUDIO OF LEONARDO DA VINCI

A503   S. JOHN THE BAPTIST                                    **Pl. 68**

Wood.[1] 75 × 53·4.

On the back the number *13* occurs, together with two crosses which have been branded on to the panel. Several other enumerations have been crossed through. Three wax impressions of seals, one in black wax, the others in red, each now indecipherable, also occur.

Condition: good. The right eye is slightly rubbed. The paint surface is discoloured by varnish.

Collections: F. R. Leyland (Christie's, 28 May 1892, lot 102, bt. Waters for 36 gns.); W. G. Waters and thence by direct inheritance to Dr. Arthur Waters.

Presented by Dr. Arthur Waters, 1937.

Exhibited: London, New Gallery, *Exhibition of Early Italian Art from 1300–1550*, 1893–4 (193 misprinted 198); London, *Royal Academy, Exhibition of Works by the Old Masters*, Winter Exhibition, 1908 (35); London, Royal Academy, *Leonardo da Vinci. Quincentenary Exhibition*, 1952 (250).

Literature: P. Müller-Walde, 'Beiträge zur Kenntnis des Leonardo da Vinci III: Vorbereitungen zum hl. Johannes des Louvre unter Plänen zum Trivulzio–Grabmal und geometrischen Berechnungen', *Jahrbuch der Königlich Preussischen Kunstsammlungen*, 19 (1898), 229, 232, and 246–7 repr.; E. Muntz, *Léonard de Vinci* (Paris, 1899), p. 509; E. Jacobsen, 'Italienische Gemälde im Louvre', *Reportorium für Kunstwissenschaft*, 25 (1902), 285; E. Möller, 'Leonardo da Vincis Brustbild eines Engels und seine Kompositionen des S. Johannes-Baptista', *Monatshefte für Kunstwissenschaft*, 4 (1911), 530–45 repr.; O. Sirén, *Leonardo da Vinci*, Eng. edn. (Yale, 1916), p. 197 repr.; E. Hildenbrandt, *Leonardo da Vinci* (Berlin, 1927), pp. 193–4 repr.; E. Möller, 'Salai und Leonardo da Vinci', *Jahrbuch der Kunsthistorischen Sammlungen in Wien*, N.F. 2 (1928), 156 repr. (detail); W. Suida, *Leonardo und sein Kreis* (Munich, 1929), pp. 229, 273, and 306; H. Bodmer, *Leonardo. Klassiker der Kunst* (Stuttgart, 1931), pp. 60 and 371 repr.; C. Pedretti, *Leonardo. A Study in Chronology and Style* (London, 1973), p. 167 repr.

The drawing of the figure, particularly the foreshortening of the left arm, is of high quality.

Müller-Walde attempted to show in great detail that No. A503 is either a copy or a variant of a lost composition of S. John the Baptist, which Leonardo worked on prior to, and independently of, the famous composition of the *Baptist* dating from 1508–9 now in the Louvre.[2] There is, however, little positive evidence that Leonardo himself ever completed a painting or cartoon of S. John the Baptist according to the design of No. A503. An alternative hypothesis, which has won the support of most modern authorities, is that the composition is a variant of one described by Vasari as follows: 'Questa [a head of Medusa] è fra le cose eccellenti nel palazzo del duca Cosimo, insieme con una testa d'uno angelo, che alza un braccio in aria, che scorta dalla spalla al gomito venendo innanzi, e l'altro ne va al petto con una mano' (iv. 26). It will be noted that the figure described in this passage is of an Angel and not of S. John the Baptist.[3]

Jacobsen, and at a later date Möller, both pointed out that this composition is recorded in two other studio works besides No. A503. These are the panels in the Kunstsammlungen, Basle,[4] and in the Hermitage Museum, Leningrad.[5] It is now clear, particularly since the cleaning of the painting in Basle, that the figures on these panels represent the *Angel of the Annunciation*, but it is equally clear that the figure on No. A503 is dressed in hair-cord and can therefore only be intended for a S. John the Baptist, although the traditional attributes of a staff and scroll are lacking.[6] It therefore seems likely, following the hypothesis first proposed by Jacobsen and reiterated by Möller, that the panels in Basle and Leningrad are copies after Leonardo's own composition of the *Angel of the Annunciation*, which is preserved in a drawing by a pupil at Windsor dating from c. 1505,[7] whereas No. A503 is an adaptation probably evolved in the studio by one of his assistants.

Möller (1911) tentatively suggested that the *Baptist*, formerly in the Bendelack Hewetson collection and now in the Walters Art Gallery, Baltimore,[8] should also be attributed to the painter of No. A503. An attribution to Andrea Salai was posited by Suida, who also asserted that the painting of the *Baptist* in the Ambrosiana, Milan, is by the same hand.[9] The panel in Oxford is certainly in the style adopted by Leonardo during his second stay in Milan between 1506 and 1513 and there are indeed definite stylistic affinities with the panel in Milan.

REFERENCES: 1. H. Bodmer, *Leonardo. Klassiker der Kunst* (Stuttgart, 1931), p. 371, states incorrectly that No. A503 is on canvas. 2. Inv. 1597. Repr. H. Bodmer, op. cit., p. 38. 3. E. Möller, 'Zu Leonardo da Vincis Brustbild eines Engels', *Monatshefte*

*für Kunstwissenschaft*, 5 (1912), 97–8 records that Georg Gronau discovered a reference in one of the Medici inventories to a head of S. John the Baptist attributed to Leonardo, but this does not appear to have been discussed elsewhere. 4. Inv. 1879, formerly in the possession of Dr. Fritz Sarasin. See *Öffentliche Kunstsammlung Basle. Katalog* (Basle, 1946), p. 35. For repr. before cleaning see E. Möller, 'Leonardo da Vincis Brustbild eines Engels und seine Kompositionen des S. Johannes-Baptista', *Monatshefte für Kunstwissenschaft*, 4 (1911), pl. 118, fig. 5. For repr. after cleaning see Bodmer, op. cit., p. 59. 5. Inv. 1637. Repr. Möller, loc. cit. (1911), 533–4, pl. 116, fig. 2, who suggested that the picture is indentifiable with that mentioned by Milanesi in his commentary to Vasari's text (iv. 26, n. 2) as once in Florence. O. Sirén, *Leonardo da Vinci*, Eng edn. (Yale, 1916), p. 198, n., regarded this picture as a nineteenth-century imitation. 6 Bodmer, op. cit., p. 371, presumably judging from a reproduction, stated that the outline of a wing is visible on No. A503. This is not so. 7. K. Clark and C. Pedretti, *The Drawings of Leonardo da Vinci in the Collection of Her Majesty the Queen at Windsor Castle*, 2nd edn., i (London, 1968), 27–8, No. 12328 recto. 8. Inv. 37. 1090. Repr. Bodmer, op. cit., p. 57. 9. Repr. Bodmer, op. cit., p. 58. For a full bibliography see A. Falchetti, *La Pinacoteca Ambrosiana* (Vicenza, 1969), p. 168.

## STUDIO OF LEONARDO DA VINCI

A790 VIRGIN AND CHILD WITH THE YOUNG S. JOHN
(MADONNA WITH THE CHILDREN AT PLAY)  **Pl. 69**

Wood. 72·2 × 50·5.

On the back a wax impression of a seal (see Collections below).

Condition: very poor. The present appearance of the panel is almost certainly due to overcleaning. There is no reason to believe that the panel was left unfinished. The residue of paint left on the figures and in the landscape is original, apart from some retouching on the face of the Christ Child. There are two thin vertical cracks in the paint surface, one to the right of the Virgin's head, the other extending through the neck.

Collections: Walter Landor (born 1733), Ipsley Court, Warwickshire;[1] thence by direct inheritance to Walter Savage Landor (1775–1859), Walter Landor's eldest son by his second wife, Elizabeth Savage.

Bequeathed by Henry Harris, 1950.[2]

Exhibited: Milan, *Mostra di Leonardo da Vinci*, 1939 (42); London, Royal Academy, *Leonardo da Vinci. Quincentenary Exhibition*, 1952 (245).

Literature: E. Möller, 'Die Madonna mit den spielenden Kindern aus der Werkstatt Leonardos', *Zeitschrift für bildende Kunst*, 62 (1929), 219; E. Möller, 'Studi vinciani V', *Raccolta vinciana*, 13 (1926–9), 63–6 repr.; T. Borenius, 'Leonardo's Madonna with the Children at Play', *Burlington Magazine*, 56 (1930), 142–3 repr.; H. Bodmer, *Leonardo. Klassiker der Kunst*

(Stuttgart, 1931), pp. 373–4; A. E. Popham, *The Drawings of Leonardo da Vinci* (London, 1946), pp. 117–18; *Annual Report*, 1950, 41–2; L. H. Heydenreich, *Leonardo da Vinci*, Eng. edn. (Basle, 1954), p. 181, No. 26; B. Berenson, *I disegni dei pittori fiorentini*, ii (Milan, 1961), 205, No. 1049 C; L. Goldscheider, *Leonardo da Vinci*, 8th edn. (London, 1967), p. 168, No. 70; K. Clark and C. Pedretti, *The Drawings of Leonardo da Vinci in the Collection of Her Majesty the Queen at Windsor Castle*, 2nd edn., i (London, 1968), 105–6, No. 12560; J. Wasserman, 'A Rediscovered Cartoon by Leonardo da Vinci', *Burlington Magazine*, 112 (1970), 201, n. 26; C. Pedretti, *Leonardo. A Study in Chronology and Style* (London, 1973), pp. 59–60 repr.

Borenius was alone in claiming No. A790 as an original work by Leonardo da Vinci. This attribution has received no support from other writers, most of whom are of the opinion that the panel is by an anonymous follower. Professor Jack Wasserman contends that the composition is a pastiche, but other scholars regard the design as either a copy, or else a variant, of a lost composition by Leonardo. This conclusion is based upon the fact that three other Leonardesque paintings have certain compositional motifs in common with No. A790, most notably the Virgin's pose in relation to the two children, which is clearly derived from ideas worked out by Leonardo in various drawings. Of the three paintings, that in the Uffizi[3] is most closely related to No. A790, while slight variations in design and format occur in the other two, the first of which is in Milan (formerly Melzi d'Eril collection, now in the possession of Conte Giuseppe Gallarati-Scotti)[4] and the second in Budapest.[5] The prototype, which, if fully evolved, could have taken the form of either a painting or a cartoon, has not survived and on the basis of the related drawings alone it cannot be precisely determined to what stage Leonardo himself developed the composition.

The related drawings include a small compositional study on a sheet of studies in the Royal collection at Windsor Castle[6] and four studies on a sheet in the Metropolitan Museum, New York.[7] It is now generally agreed that these studies were originally intended for a *Nativity* or an *Adoration of the Child*. The central study on the sheet in New York includes a second child, presumably the Young S. John and this led many writers in the past to associate the drawing with the genesis of the *Virgin of the Rocks*. The Virgin's pose on No. A790, however, was probably directly derived from that first explored in the studies found on these two drawings, and Professor Carlo Pedretti (1973), following Möller (1929), argues that the composition of the *Madonna with the Children at Play* was contiguous with

the design devised for the *Nativity*. Thus, Pedretti dates the *Nativity c.* 1497 and the *Madonna with the Children at Play c.* 1500. Two further drawings in the Royal collection at Windsor,[8] and another formerly in the Grand-Ducal collection at Weimar[9] with studies for a S. John the Baptist with a Lamb, are directly connected with the composition recorded on No. A790.

Möller (1929) argued that the design was a composite workshop production, perhaps devised by Cesare da Sesto from motifs discarded by the master, and drew attention to references to two lost paintings of 'nostre donne' made in the drafts of two letters written in 1508.[10] Other writers refer to still other lost works. Suida,[11] Goldscheider, and, more tentatively, Mr. Cecil Gould,[12] propose an association with a *Nativity*, which, according to the Anonimo Gaddiano and to Vasari (iv. 29), was commissioned by Lodovico Sforza from Leonardo da Vinci shortly after the painter's arrival in Milan in 1482 as a gift for the Holy Roman Emperor. Professor Ludwig Heydenreich posits an identification with a picture of 'Nostra Donna' commissioned in 1485 by Lodovico Sforza as a gift for Matthias Corvinus, King of Hungary.[13] None of the evidence for any of these suggestions is conclusive.

REFERENCES: 1. The seal on the back of the panel was identified as that of Walter Landor and dated 1760–9 by Mr. Michael Maclagan of Trinity College, Oxford, to whom the compiler is indebted (letter of 8 Oct. 1971). For the lineage of Walter Savage Landor see Sir Bernard Burke, *Genealogical and Heraldic History of the Landed Gentry*, 15th, centenary, edn. (London, 1937), pp. 1321–2. No. A790 was not sold with other parts of Walter Savage Landor's collection sent for auction at Christie's, 5 Dec. 1857 and 19 Mar. 1859. 2. Vague indications as to the panel's whereabouts immediately prior to acquisition by Henry Harris are given by E. Möller, 'Studi vinciani V', *Raccolta vinciana*, 13 (1926–9), 63–6. 3. Inv. 1335, Depositi, 75×50. Repr. H. Bodmer, *Leonardo. Klassiker der Kunst* (Stuttgart, 1931), p. 78. 4. Round, diameter 77. Repr. Bodmer, op. cit., p. 79. Both P. D'Ancona, 'Antichi pittori lombardi', *Dedalo*, 4 (1923–4), 372, and M. Salmi, 'Una mostra di antica pittura lombarda', *L'Arte* 26 (1923), 157, attributed this version to the Florentine school, specifically, in Salmi's opinion, to Franciabigio. An attribution to Cesare da Sesto is now more widely accepted. See the exhibition catalogue *Capolavori d'arte lombarda. I leonardeschi ai raggi 'X'* (Milan, 1972), pp. 98–9. 5. Inv. 4238, 113·3×76·5. Repr. E. Möller, 'Die Madonna mit den spielenden Kindern aus der Werkstatt Leonardos', *Zeitschrift für bildende Kunst*, 62 (1929), 221, as Salai. For bibliography see A. Pigler, *Katalog der Galerie Alter Meister* (Budapest, 1968), p. 612. W. Suida, 'Leonardo da Vinci und seine Schule in Mailand, IV', *Monatshefte für Kunstwissenschaft*, 13 (1920), 284, mentions another variant in the Galleria Borghese, Rome, but Möller (loc. cit., 219) was unable to trace this and Suida later omitted the reference in his book *Leonardo und sein Kreis* (Munich, 1929). Yet another variant, last recorded in the Schenfelen collection in Stuttgart in 1933, appears from the photograph in the Berenson Fototeca, Villa I Tatti, Florence, to be late sixteenth century or early seventeenth century. In

this painting the composition is given a lower viewpoint, but apart from this the only major difference is the omission of the Lamb, although the Young Baptist is given the same pose. 6. Inv. 12560. K. Clark, and C. Pedretti, *The Drawings of Leonardo da Vinci in the Collection of Her Majesty the Queen at Windsor Castle*, 2nd edn., i (London, 1968), 105–6. 7. Inv. 17.142.1 See J. Bean and F. Stampfle, *Drawings from New York collections*, i, *The Italian Renaissance*. The Metropolitan Museum of Art (1965), p. 26, No. 15, with full bibliography. For the date see C. Pedretti, *Leonardo. A Study in Chronology and Style* (London, 1973), pp. 59–60. 8. Inv. 12539 and 12540. Clark and Pedretti, op. cit., pp. 98–9. J. Wasserman, 'A Re-discovered Cartoon by Leonardo da Vinci', *Burlington Magazine* 112 (1970), 194–204, has connected these drawings, together with the drawing formerly at Weimar (see note 9 below), with a lost cartoon described by Vasari in his Life of Leonardo da Vinci (iv. 38–9), to which he also relates two further compositional drawings. The argument is not wholly convincing. 9. First published by Suida, loc. cit., (1920), 284. Recto and verso are repr. by Möller, loc. cit., 226, and discussed on 221. 10. The drafts of the letters are found in the Codex Atlanticus, f. 372$^v$a and f. 317$^r$b, for which see G. Calvi, *I manoscritti di Leonardo da Vinci dal punto di vista cronologico, storico e biografico* (Bologna, 1925), pp. 263–7. 11. Suida, loc. cit., 285. 12. In *Leonardo da Vinci. Catalogue of Quincentenary Exhibition* (London, 1952), pp. 65–6, No. 245. 13. L. H. Heydenreich, *Leonardo da Vinci*, Eng. edn. (Basle, 1954), Notes on the Plates, v Pl. 34. The text of the letter written by Lodovico Sforza to his ambassador in Hungary, Maffeo Trevigliese, can be found in A. de Rinaldis, *Storia dell' opera pittorica di Leonardo da Vinci* (Bologna, 1922), p. 120, and also in Venturi, *Storia*, ix, pt. 1 (1925), 26, n.

## COPY AFTER LEONARDO DA VINCI OR AMBROGIO DE'PREDIS

**A713  PORTRAIT OF AN UNKNOWN WOMAN**                          **Pl. 70**

Canvas (twice relined and extended on all sides by 1·5–2·0 cm.). 46 × 33·7.

On the back an inscription written in ink by a nineteenth-century hand occurs along the top of the stretcher: *Bianca Beatrice Sforza | married Emperor Maximilian 1493 | vide drawing in the Academy Venice*. A label, now somewhat mutilated, has been stuck on to the bottom of the stretcher. Only the following words written by a nineteenth-century hand can be made out . . . *moglie . . . Lodovico Sforza | morta del 1497. | Altro dipinto da Leonardo sul legno è di più finita è nella| Pinacoteca Ambrosiana a Mil?. Inquella io dico spe | cialmente ammirabile l'occhio. Le dimensioni di quello | dell' Ambrosiana sono 0·20 per 0·40. Questo ha magg°. larghetta . . . e la . . . variano poi gli | ornamenti della testa . . . bolla (le perle)*. Below this on the frame there is another label by a third nineteenth-century hand inscribed *Beatrice d'Este | formerly supposed to be by Leonardo | da Vinci, now by Ambrogio (vide Morelli) original in Milan*.

Condition: fair. The drapery is rather badly worn and the surface is somewhat darkened by dirt. The hand with the attributes of S. Catherine

is most probably not a later addition, as might appear to be the case from the reproduction, but seems to have suffered more than the rest of the painting during the process of relining.

Collections: George Salting.[1]

Bequeathed by Miss E. G. Kemp, 1940, but not deposited until 1945.

Literature: W. Bode, 'Ein Bildnis der zweiten Gemahlin Kaiser Maximilians, Bianca Maria Sforza, von Ambrogio de' Predis', *Jahrbuch der Königlich Preuszischen Kunstsammlungen*, 10 (1889), 79; I. Lermolieff (G. Morelli), *Italian Painters. Critical Studies of Their Works. The Borghese and Doria–Pamfili Galleries in Rome*, Eng. edn. (London, 1900), pp. 189–90, n. 7; *Burlington Magazine*, 16 (1909–10), 116 repr.; F. Malaguzzi Valeri, *La corte di Lodovico il Moro*. iii *Gli artisti lombardi*, (Milan, 1917), 26–8 n. 1, and 31 repr.

No. A713 is an interesting and able copy, dating from either the seventeenth century or the beginning of the eighteenth century, after the *Portrait of an Unknown Lady* in the Pinacoteca Ambrosiana, Milan.[2] On No. A713 the sitter has been given the attributes of S. Catherine and various modifications have been made to the dress and to the jewellery worn at the top of the sleeve.

The portrait in Milan has been attributed by some scholars to Leonardo da Vinci and was formerly believed to represent Beatrice d'Este, the wife of Lodovico Sforza, called Il Moro. Malaguzzi Valeri demonstrated convincingly that the sitter is not Beatrice d'Este.[3] Neither is the identification, referred to in one of the inscriptions on the back of No. A713 (see above), with Bianca Maria Sforza, the second wife of the Holy Roman Emperor, Maximilian I, correct.[4]

Morelli was the first to ascribe the portrait in Milan to Ambrogio de' Predis and his attribution has been accepted by a number of scholars in preference to the traditional one to Leonardo da Vinci. Bode ascribed No. A713 to Ambrogio de' Predis, but both Morelli and Malaguzzi Valeri strongly refuted this, regarding the portrait, then in the Salting collection, as a poor copy of the painting in Milan.

REFERENCES: 1. Seen in the Salting Collection by Morelli and others (I. Lermolieff (G. Morelli) *Italian Painters. Critical Studies of Their Works. The Borghese and Doria–Pamfili Galleries in Rome*, Eng. edn. (London, 1900), pp. 189–90, n. 7). 2. Inv. 100. A. Falchetti, *La Pinacoteca Ambrosiana* (Vicenza, 1969), pp. 170–1 repr. For a brief summary of opinion about this portrait see L. Goldscheider, *Leonardo da Vinci*, 8th edn. (London, 1967), pp. 156–7, No. 27. 3. F. Malaguzzi Valeri, *La corte di Lodovico il Moro*. iii *Gli artisti lombardi*, (Milan, 1917), 25–31. 4. See further the catalogue of the exhibition *Capolavori d'arte*

*lombarda. I leonardeschi ai raggi 'X'* (Milan, 1972), pp. 8–9, where an identification of the sitter with Bianca Giovanna Sforza (*c.* 1482–96), the daughter of Lodovico il Moro, who married Galeazzo di Sanseverino in 1490, is reported. This identification is apparently based on the insignia worn on the ribbon attached to the sitter's hair. It should be noted that F. Malaguzzi Valeri, *La corte di Lodovico il Moro. i La vita privata e l'arte a Milano nella seconda metà del Quattrocento* (Milan, 1913), pp. 464–7, had already considered this identification and rejected it, although without observing the insignia.

## BERNARDINO LICINIO                         born 1491,
                                     last documented 1549

Venetian school. He was from a family of painters of Bergamask origin. The main sources of his style were Giorgione, Titian, Pordenone, and Palma Vecchio, from all of whom he derived many of his religious compositions. There are a large number of portraits in Licinio's *œuvre*.

A721   PORTRAIT OF A YOUNG MAN WITH A SKULL           **Pl. 71**

Canvas (relined and extended by 5 cm. on both sides). 75·7 × 63·3.

Condition: poor. A tear in the right sleeve has been repaired. Cleaned in 1956 when thick repaint in the face, drapery, and background was removed, together with a layer of yellow varnish. As a result, the appearance of the portrait was radically altered.[1] The background is completely repainted and there are further retouches in the drapery, the face and in the neck. The hands are badly rubbed and partly repainted. Original paint on the parapet and on the skull, apart from the top of the cranium, is still intact.

Collections: Cardinal Ludovico Ludovisi (1595–1632) (?); Thomas Howard, 2nd Earl of Arundel (1585–1646) (?).[2] Next certainly recorded in the collection of Louisa, Lady Ashburton (1827–1903), the second wife of William Baring, 2nd Baron Ashburton (1799–1864),[3] and thence by direct inheritance to William Compton, 5th Marquess of Northampton (1851–1913), who sold part of the Ashburton collection (Christie's, 8 July 1905, lot 15, bt. Farrer); Sir William Farrer.

Bequeathed by G. O. Farrer through the National Art-Collections Fund, 1946.

Exhibited: London, Burlington House, *Exhibition of the Works of the Old Masters*, 1871 (94); London, New Gallery, *Exhibition of Venetian Art*, 1894–5 (91); London, Burlington House, *Exhibition of Works by the Old Masters*, 1904 (32); London, Burlington Fine Arts Club, *Venetian Pictures. Titian and his Contemporaries*, 1915 (17); London, Burlington

House, *Exhibition of Italian Art*, 1930 (379), Commemorative Catalogue (412).

Literature: C. J. Ffoulkes, 'L'esposizione dell' arte veneta a Londra', *Archivio storico dell'arte*, Ser. 2, 1 (1895), 80 repr.; W. von Seidlitz, 'Die Ausstellung venezianischer Kunst in der New Gallery zu London im Winter 1894–5', *Reportorium für Kunstwissenschaft*, 18 (1895), 214; B. Berenson, *The Study and Criticism of Italian Art* (London, 1901), pp. 137–9 repr.; H. Cook, 'Venetian Portraits and Some Problems', *Burlington Magazine*, 16 (1909–10), 333 repr.; Berenson, 1911 Venetian, 111 : 1932, 283 : 1936, 243 : 1957, 97 repr.; Crowe and Cavalcaselle, *History North Italy*, iii, 2nd edn. (London, 1912), 189–90, n. 2; G. Fiocco, 'L'esposizione d'arte veneziana al Burlington Fine Arts Club di Londra', *L'Arte*, xvii (1914), 383; W. Arslan, in Thieme–Becker, *Lexikon*, xxiii (1929), 193; W. Suida, 'Zur Kenntnis der Bernardino Licinio', *Belvedere*, 12 (1934–7), 126; R. Pallucchini, *La Pittura veneziana del cinquecento*, i (Novara, 1944), p. xxxix repr. *Annual Report*, 1946 25; K. Garas, 'Giorgione et giorgionisme au xviie siècle', *Bulletin du Musée Hongrois des Beaux-Arts*, 27 (1965), 56 n. 43 repr.; R. Pallucchini, 'Due concerti bergamaschi del cinquecento', *Arte veneta*, 20 (1966), 92; K. Garas, 'The Ludovisi Collection of Pictures in 1633—II', *Burlington Magazine*, 109 (1967), 347 repr.; I. Smirnova, 'Un nuovo Bernardino Licinio a Mosca', *Arte veneta*, 21 (1967), 214; S. J. Freedberg, *Painting in Italy 1500 to 1600* (Harmondsworth, 1971), p. 228; *I pittori bergamaschi dal XIII al XIX secolo. Il cinquecento*, i (Bergamo, 1975), pp. 373, 375, and 428, No. 87 repr.

Probably owing to its over-painted state, No. A721 was once entitled *Portrait of a Lady Professor at Bologna*, which provoked the following riposte from Berenson (1901): 'This portrait is neither of a lady, nor of a professor, nor of Bologna.'

The present attribution, in place of the traditional one to Giorgione, was first suggested by Berenson and is undisputed. Professor Rodolfo Pallucchini (1966) posited an early date for No. A721, that is during the decade 1510–20, not long after Licinio's arrival in Venice. The same writer has listed a number of other works, which, in his opinion, were painted during the same decade. Other writers have preferred a later date, Suida *c*. 1520, Dr. Irina Smirnova implying 1528, and Professor Sydney Freedberg *c*. 1525. Pallucchini's early dating, however, seems to be correct. No. A721 is almost certainly earlier than the *Portrait of a Woman* in Budapest, which is dated 1522 and is the first of Licinio's dated works.[4] Furthermore, the Palmesque mood of No. A721, which was first noted by Sir Karl Parker in

the *Annual Report* of 1946, gives added support to Pallucchini's early dating, since the portrait in Oxford compares favourably with those painted by Palma between 1510–20.[5]

REFERENCES: 1. Compare the old photograph repr. in B. Berenson, *The Study and Criticism of Italian Art* (London, 1901), opp. p. 138, where the colour tone of the portrait is described as 'between ivory and amber'. 2. The identification of No A721 with a picture listed in a posthumous inventory of the Ludovisi collection drawn up in 1633 was proposed by K. Garas, 'The Ludovisi Collection of Pictures in 1633—II', *Burlington Magazine*, 109 (1967), 347. If this identification is correct, then the tenuous connection suggested by M. F. S. Hervey, *The Life, Correspondence and Collection of Thomas Howard Earl of Arundel* (Cambridge, 1921), p. 479, between No. A721 and an entry in the Arundel inventory of 1655 (No. 145) becomes a distinct possibility, since Arundel's agents were in contact with Ludovico Ludovisi's heir, Niccolò Ludovisi, Principe di Piombino. Admittedly, contact with the Ludovisi family was established on behalf of Charles I, but it is also likely that Arundel hoped to add to his own collection (F. C. Springell, *Connoisseur and Diplomat* (London, 1963), pp. 247, 251, 253, and 255). The inventory in Italian of the Arundel collection was published by L. Cust, 'Notes on the Collections formed by Thomas Howard', *Burlington Magazine*, 19 (1911), 284, *Una dama tenendo una testa de morte piccola*. It will be observed from the Commentary below that the sitter on No. A721 was considered to be a female even as late as 1894/5, the time of the Venetian Exhibition at the New Gallery in London. 3. Perhaps identifiable with a portrait attributed to Giorgione seen by Waagen, *Treasures*, ii 100, 'An admirable portrait of a man has at least very much of the feeling of Giorgione'. 4. Inv. 51. 802. See A. Pigler, *Katalog der Galerie Alter Meister* (Budapest, 1968), pp. 382–3 repr. 5. Compare G. Gombosi, *Palma Vecchio. Klassiker der Kunst* (Stuttgart–Berlin, 1937), pp. 29, 44, 47, and 48.

## FRA FILIPPO LIPPI                                               *c.* 1406–1469

Florentine school. He was the son of a butcher, Tomaso di Lippi, but is first recorded as a monk at the Carmine in Florence. He also worked in Padua, Prato, and Spoleto, where he died. Lippi's style was closely modelled upon that of Masaccio, but he was later influenced by Donatello and Fra Angelico. The chronology of his *œuvre* has been much discussed. He was patronized by the Medici family and had a number of talented pupils and assistants, among them Pesellino and Botticelli.

A81   THE MEETING OF JOACHIM AND ANNA AT THE
      GOLDEN GATE (PREDELLA PANEL FROM AN ALTAR-
      PIECE)                                                        **Pl. 72**

Wood. Painted surface 18·5 × 47·9 (originally rounded at both ends, see Commentary below). Size of panel 20·5 × 47·9 (slightly bowed). The paint surface does not extend to the upper or lower edges of the panel.

On the back a label inscribed by an eighteenth-century hand: *Cassone Pesello Peselli / No.*

Condition: poor. Cleaned in 1955. The surface is badly worn throughout with a number of local repairs on the draperies and in the landscape. Yet the figures of Joachim and Anna have retained much of their original quality, although the servant has fared less well. The passage in the landscape top right appears to have been somewhat repainted, possibly at the time when the composition was extended to the corners.

Fox-Strangways Gift, 1850.

Exhibited: London, Royal Academy, *Italian Art and Britain*, 1960 (282).

Literature: I. Lermolieff (G. Morelli), *Italian Painters. Critical Studies of their Works. The Galleries of Munich and Dresden* Eng. edn. (London, 1907), p. 95; F. Schottmüller, 'Ein Predellenbild des Fra Filippo Lippi im Kaiser Friedrich-Museum', *Jahrbuch der Königlich Preuszischen Kunstsammlungen*, 28 (1907), 37–8; H. Mendelsohn, *Fra Filippo Lippi* (Berlin, 1909), pp. 197–8; Venturi, *Storia*, vii, pt. 1 (1911), 382, n. 1; Berenson, 1912, 151: 1932, 288: 1936, 248: 1963, 113; Van Marle, *Development*, x (1928), 459, n. 1.; G. Gronau, in Thieme–Becker, *Lexikon*, xiii (1929), 273; G. Pudelko, 'Per la datazione delle opere di Fra Filippo Lippi', *Rivista d'arte*, 18 (1936), 56 n.; R. Oertel, *Fra Filippo Lippi* (Vienna, 1942), p. 65, No. 50 repr.; M. Pittaluga, *Filippo Lippi* (Florence, 1949), p. 205 repr.

The composition has been extended by a later hand for about 6 cm. into each corner of the panel so that it is now rectangular. It was originally rounded at both ends where the old frame-marks are still visible. There are *pentimenti* along the right edge of Anna's drapery and at her left shoulder.

Morelli, Schottmüller, Venturi, Professor Robert Oertel, and Dottoressa Mary Pittaluga all accepted No. A81 as an autograph work by Filippo Lippi. Mendelsohn and Van Marle favoured an attribution to Pesellino, whereas Crowe and Cavalcaselle and Pudelko assigned the panel to Lippi's workshop, more specifically in Pudelko's opinion, to the 'scolaro di Prato'. Although in comparatively poor condition, the sense of form, the treatment of light, and the delicate colours (rose, violet, yellow, and green) show that No. A81 was once a panel of considerable quality and an attribution to Lippi's own hand need not be doubted. Vasari (ii. 626) emphasized the beauty of Lippi's predella panels in general, and No. A81 in particular won high praise from Morelli.

The panel in Oxford originally formed part of a predella tentatively associated by Oertel with the *Annunciation* in Munich (Alte Pinakothek),

the main panel of an altar-piece commissioned from Lippi in 1443 by Giovanni dei Benci for the Convento delle Murate but probably painted towards the end of the decade.[1] Another predella panel showing the scene of the *Nativity* in the Kress collection (National Gallery, Washington)[2] was said by Pittaluga to come from the same altar-piece. Basic differences, however, in the physical format of these two panels preclude this association.[3] Furthermore, although on iconographical grounds there can be no objection to No. A81 being placed in the predella of an altar-piece of which the main subject is an *Annunciation*,[4] the present writer, judging from the best preserved parts of the panel, doubts whether No. A81 is stylistically compatible with the central panel of the Murate altar-piece now in Munich, for which Oertel suggests a date *c.* 1450, at the beginning of what he terms Lippi's 'romantic period'. It is probably slightly later in date, perhaps closer in mood to the *Adoration of the Child* painted *c.* 1455 for the Convent of Annalena, Florence, and now in the Uffizi,[5] or that of the *Adoration of the Child* in Berlin–Dahlem (Staatliche Museen),[6] formerly in the chapel of the Palazzo Medici, Florence, which dates from the second half of the same decade.

REFERENCES: 1. Inv. 1072. *Alte Pinakothek München* (Munich, 1957), p. 55. Also see M. Pittaluga, *Filippo Lippi* (Florence, 1949), pp. 200–1, repr. figs. 49–52. 2. K 497, 23·4×58. F. R. Shapley, *Paintings from the Samuel H. Kress Collection. Italian Schools XIII–XV Century* (London, 1966), p. 108, fig. 291. 3. F. R. Shapley, *Paintings from the Samuel H. Kress Collection. Italian Schools XVI–XVIII Century*. Addenda to Vol. I (London, 1973), p. 385. 4. See M. Levi d'Ancona, *The Iconography of the Immaculate Conception in the Middle Ages and Early Renaissance*, Monographs on Archaeology and Fine Arts VII (College Art Association of America, 1957), pp. 36–8 and 43–6. The supposition that No. A81 was designed by an advocate of the immaculist doctrine is proved by the fact that both Joachim and Anna have been given haloes, signifying the fact that the miracle of the Immaculate Conception of the Virgin Mary had already taken place, while the figure of the Angel joining their heads symbolizes the act of divine intervention. Also see A. M. Lépicier, *L'Immaculée Conception dans l'art et l'iconographie* (Spa, 1956), p. 316. 5. Inv. 8350. Pittaluga op. cit., p. 174, figs. 84–5. 6. Inv. 69. Pittaluga, op. cit., pp. 196–7, fig. 152.

## ANONYMOUS LOMBARD SCHOOL       1520–1530

A141    THREE *PUTTI* WITH MUSICAL INSTRUMENTS       Pl. 73

Canvas laid on wood. 14·5 × 44.

Condition: fair. There is considerable surface dirt throughout with small retouches on the flesh parts.

Chambers Hall Gift, 1855.

The donor's attribution to Bernardino Luini is recorded on the stretcher. The style of No. A141, however, is perhaps closer to that of Gaudenzio Ferrari. Similarly, the characterization of the *putti* is not absolutely typical of Luini.[1]

REFERENCES: 1. Compare the partly repainted *putti* by Gaudenzio Ferrari in the Accademia Carrara, Bergamo (inv. 293–6) for which see F. Russoli, *Accademia Carrara. Galleria di Belle Arti in Bergamo* (Bergamo, 1967), p. 90, with reproductions in L. Mallée, *Incontri con Gaudenzio* (Turin, 1969), p. 249, pls. 223a and b.

## LORENZO DI CREDI 1456–1536

Florentine school. The full name was Lorenzo d'Andrea d'Oderigho. He apparently received some training in the art of goldsmith's work, but he is recorded at an early date in Verrocchio's workshop. He was influenced primarily by Leonardo da Vinci, Botticelli, and Fra Bartolommeo. There is a paucity of dated or documented works and his style appears to have developed little. The identification of early work is particularly problematic and involves discussion of the Pistoia altar-piece (Pistoia, Duomo, Capella del Sacramento), the contract for which was given to Verrocchio. He had a number of pupils, who repeatedly used his compositions and imitated his manner, thereby making their individual styles difficult to separate.

A103 VIRGIN AND CHILD Pl. 74

Wood. 56·9 × 39·2.

On the back a label inscribed by an eighteenth-century hand, *Madonna con Putto di / Lorenzo di Credi / No.* The number *.1.* occurs together with *641* which has been crossed through (repr. fig. 1).

Condition: good.

Fox-Strangways Gift, 1850.

Literature: Waagen, *Treasures*, iii. 53; Crowe and Cavalcaselle, *History*, iii (1866), 414: 2nd edn., vi (1914), 42; Berenson, 1912, 132: 1932, 297: 1936, 255: 1963, 116; Van Marle, *Development*, xiii (1931), 314, n. 3; G. Dalli Regoli, *Lorenzo di Credi* (Cremona, 1966), pp. 27–8 and 118, Cat. no. 35 repr.

No. A103 is unfinished. The most finished parts are the landscape, the Virgin's face, and the interior. The underdrawing for both the figures is clearly visible. Waagen's description of No. A103 as having 'delicate feeling, but unusually pale in the colours' is accurate.

No. A103 was ascribed by Crowe and Cavalcaselle to the workshop of Lorenzo di Credi and the panel was not accepted as autograph in the earlier

editions of Berenson's Lists (1912, 1932, and 1936). Van Marle was, in fact, the first writer to acknowledge No. A103 as an original work by Credi. Of this there can be little doubt, although Dottoressa Dalli Regoli has recently asserted with little real justification that the unfinished parts of the panel were intended to be filled in by studio assistants.

The composition of No. A103 is particularly close to that found on two other panels of the *Virgin and Child*, both of which can be attributed either to Credi or to his school. These are at Ajaccio (Musée Fesch)[1] and at Strasbourg (Musée des Beaux-Arts).[2] In the opinion of Dalli Regoli, the size and shape of these panels, together with the similarity of the poses, suggests that the same cartoon was used for the figures on all three paintings. There are also several studio variants of this composition.[3]

Dalli Regoli dates No. A103 at about the time of the completion of the Pistoia altar-piece (*c.* 1485), but an earlier date is not impossible.[4]

It is often stated that Credi's earlier compositions were based on designs made by Leonardo da Vinci, who was in Verrocchio's studio until *c.* 1482, but in the case of No. A103 there are closer affinities with the marble reliefs of Mino da Fiesole, Benedetto da Maiano, and Verrocchio, while the character and handling of the landscape reflect the influence of Flemish artists, particularly of Hans Memlinc and, more distantly, of Dieric Bouts. The high finish, so evident in the finished parts of No. A103, was, according to Vasari, characteristic of Credi (iv. 569).

REFERENCES: 1. Inv. 852. 1. 703. See G. Dalli Regoli, *Lorenzo di Credi* (Cremona, 1966), p. 105, Cat. no. 10, figs. 15–17. 2. Inv. 218. Dalli Regoli, op. cit., pp. 117–18, Cat. no. 34, figs. 12 and 22. 3. Listed and repr. by Dalli Regoli, op. cit., p. 105, Cat. no. 10. The same writer (p. 192, Cat. no. 245, fig. 276) also publishes another variant (Museo Civico, San Remo), where the interior appears to have been copied from No. A103. 4. D. Covi, 'Four New Documents Concerning Andrea del Verrocchio', *Art Bulletin*, 48 (1966), 103, Document IV, provides evidence, admittedly still in need of further clarification, which implies that Credi was in Verrocchio's workshop at an earlier date (1473–4) than previously thought. If this is acceptable, together with the early birth date (1456), then it is necessary to alter the chronology of Credi's early works. In this context it is pertinent to note that B. Degenhart, 'Di alcuni problemi di sviluppo della pittura nella bottega del Verrocchio, di Leonardo e di Lorenzo di Credi', *Rivista d'arte*, 14 (1932), 298 and 443, dates the panel at Strasbourg *c.* 1477–8. Dalli Regoli (op. cit., p. 117, Cat. no. 34) quotes Dr. Bernhard Degenhart incorrectly with regard to this date.

## GIOVANNI MANSUETI
first documented 1485,
died 1526/7

Venetian school. On one of his signed works Mansueti stipulated that he was the pupil of Giovanni Bellini, but there is, in fact, a closer stylistic relationship at the outset of his

career with Gentile Bellini. At a later date he was influenced by Cima da Conegliano and Carpaccio.

## ATTRIBUTED TO GIOVANNI MANSUETI

A736b   VIRGIN AND CHILD                                                    **Pl. 75**

Wood. 53 × 42.

On the back two numerations, *J 69* and *No. 311*, both drawn with the brush in brown stain.

Condition: fair. Cleaned and restored in 1971. The background was originally all gold, but was apparently over-painted at an early date with the dark-greeny-blue ground visible today, which has been repaired on the right. The contours of the figures are lost, particularly around the Child's hand raised in the act of blessing. The figures are fairly well preserved, although the facial features are slightly rubbed. There is re-touching along a vertical crack in the paint surface extending down the left side of the Virgin's face, as well as on both the haloes. On the whole much of the original quality has been preserved.

Presented by the daughters of J. R. Anderson, 1947.

There is a *pentimento* at the fingertips of the Virgin's left hand.

The panel was transformed by cleaning in 1971, when the deep, warm-toned colours of the Virgin's draperies (red and blue) offset by the resplendent gold of the haloes, were fully revealed. The traditional attribution to Mansueti, which appears to the compiler to be perfectly acceptable, dates from the time of acquisition. The firm drawing of the features and the precise modelling of the draperies, which invest the group with a certain hierarchical stiffness, are highly characteristic of Mansueti's style, exemplified in such works as the *Coronation of the Virgin*, formerly in the Crespi collection, Milan.[1]

REFERENCE: 1. Repr. Berenson, 1957, pl. 367.

## MASO DA SAN FRIANO                                        1531-1571.

Florentine school. His full name was Tomaso d'Antonio Manzuoli, called Maso da San Friano (or Fedriano). He was the pupil of Pierfrancesco di Jacopo Toschi and also of Carlo Portelli da Loro, but his style is more firmly based upon the examples of Andrea del Sarto, Fra Bartolommeo, and Pontormo. Later, he seems to have been influenced by Northern mannerism. A number of portraits by Maso are known besides several altar-pieces and the mythological works painted for the Studiolo of Francesco I. He was a founder member of the Accademia delle Arti del Disegno in 1562/3.

A793   THE HOLY FAMILY WITH THE YOUNG S. JOHN          Pl. 76.

Wood. 102·9 × 83·4.

Condition: fair. Cleaned in 1950 and again in 1962/3 when areas of old retouching were removed. The head and drapery of Joseph, the face and lower half of the figure of the Young S. John, parts of the Virgin's drapery, and the head of the Christ Child are somewhat rubbed.

Collections: John Rushout, 2nd Baron Northwick (1770–1859) (Northwick Sale, Thirlestane House, 26 July 1859, lot 1654 (?), as style of Parmigianino, no measurements given, bt. Barns for 6 gns.); Sir Thomas Phillips, passing by direct inheritance to Phillips Fenwick and then to A. G. Fenwick (Christie's, 21 July 1950, lot 119, as Andrea del Sarto, bt. P. & D. Colnaghi & Co. Ltd.).

Purchased 1950.

Literature: *Annual Report*, 1950, 50; L. Berti, 'Fortuna del Pontormo', *Quaderni pontormeschi*, ii (Empoli, 1956), 23, n. 4 repr.; U. Schlegel, 'Ein Terrakotta-Modell des Frühmanierismus', *Pantheon*, 19 (1961), 35 repr.; L. Berti, 'Nota a Maso da San Friano', *Scritti di storia dell' arte in onore di Mario Salmi*, 3 (Rome, 1963), 88, n. 20, repr.; S. J. Freedberg, *Andrea del Sarto* (Cambridge, Mass., 1963), *Catalogue raisonné*, p. 230; K. W. Forster, *Pontormo* (Munich, 1966), p. 111 repr.; P. Cannon-Brookes, 'A Madonna and Child by Maso da San Friano'. *Apollo*, 92 (1970), 349 repr. (before cleaning of 1962/3); S. J. Freedberg, *Painting in Italy 1500 to 1600* (Harmondsworth, 1971), p. 321 repr.; K. W. Forster, 'A Madonna by Maso da San Friano', *Museum Studies. The Art Institute of Chicago*, 7 (1972), 48–9 repr. (before cleaning of 1962/3).

No. A793 is unfinished, particularly the Virgin's drapery and the head of Joseph, even allowing for rubbing.

   At the time of acquisition No. A793 was attributed to Francesco Salviati. The present attribution was first suggested by Mr. P. M. R. Pouncey (verbal communication). Dr. Peter Cannon-Brookes considers No. A793 to be 'an autograph replica of a lost painting by Maso', dating from *c.* 1560–5,[1] in close proximity to the *Virgin and Child with the Young S. John* in Leningrad.[2] Professor Sydney Freedberg (1971) suggests a date *c.*1570, while Professor Kurt Forster (1972) regards some time during the course of the seventh decade as the most likely moment in Maso's development. Both the technique and the composition of the panel in Oxford are undeniably Sartesque and comparison may be made with the *Virgin and Child* by Andrea del Sarto in the Borghese Gallery, Rome.[3] Forster (1966) states that

there are also compositional affinities with a lost painting of the *Virgin and Child* by Pontormo, which is known through numerous copies,[4] but a terracotta *modello* of the *Holy Family with the Young S. John* in Berlin–Dahlem (Staatliche Museen), first attributed to Pontormo by Dr. Ursula Schlegel, is much closer.[5]

Cannon-Brookes discovered a drawing in the Uffizi, which he tentatively suggested might be a preliminary study for the figure of the Young S. John.[6]

Numerous copies and variants of the composition of No. A793 are extant.[7]

REFERENCES: 1. P. Cannon-Brookes, 'Maso da San Friano' (Ph.D. thesis, University of London, 1968), pp. 114–15, Cat. no. 28. The compiler is grateful to Dr. Peter Cannon-Brookes for permission to consult and to quote from his thesis. 2. Inv. 9868. Repr. Cannon-Brookes, loc. cit., pp. 112–13, Cat. no. 27. 3. Inv. 334. J. Shearman, *Andrea del Sarto*, i (Oxford, 1965), pl. 51a, and ii, 235–6, No. 45. 4. K. W. Forster, *Pontormo* (Munich, 1966), pp. 111 and 153, Cat. no. 34, pl. 76. Others are repr. in *Mostra del Pontormo e del primo manierismo fiorentino* (Florence, 1956), pp. 41–3, Nos. 67 and 68, pls. LX and LXI. 5. Inv. 2382. U. Schlegel, 'Ein Terrakotta-Modell des Frühmanierismus', *Pantheon*, 19 (1961), 28–38 repr. The connection is upheld by C. von Holst, 'Ein Marmorrelief von Pontormo', *Jahrbuch der Berliner Museen*, 8 (1966), 225, and by K. Forster, 'A Madonna by Maso da San Friano', *Museum Studies. The Art Institute of Chicago*, 7 (1972), 48–9, who, however, views the attribution of the terracotta *modello* to Pontormo with some scepticism. 6. Gabinetto Disegni e Stampe, Inv. 1602 orn. Cannon-Brookes, loc. cit., pp. 114–15, Cat. no. 28. The drawing was exhibited in the *Mostra di disegni dei fondatori dell' Accademia delle Arti del Disegno* (Florence, 1963), p. 43, No. 45 repr. pl. 34. 7. These are listed and briefly discussed by Cannon-Brookes (loc. cit., pp. 114–15, Cat. no. 28) as follows: Vienna, Dr. Adalbert Nemers collection, panel, 107×80; Arezzo, Pinacoteca, panel, 97×71, probably seventeenth century; Florence, private collection, panel, 100×75, contemporary but not autograph; formerly Stockholm, Sterbhus sale (Bukowski's, 26 Sept. 1924, lot 36, as Passarotti); Florence, Albright collection, panel (?), no measurements known, the composition reversed and with some changes. To these should be added a panel exhibited in Milan, at Galleria Finarte, 6–23 Dec. 1969, No. 7, panel, 108×86·5, described as a replica.

## MASTER OF THE DOMINICAN EFFIGIES active 1336–1345

Florentine school. The name is derived from a panel in the sacristy of S. Maria Novella, Florence (*Christ and the Virgin Enthroned Attended by Seventeen Dominicans*). Panels now ascribed to this hand were previously ascribed to the Master of the Lord Lee Polyptych and to the Master of Terenzano. The Lee Polyptych, now in the Courtauld Institute Galleries, London, is known to have once been dated 1345. His style is derived from Pacino di Bonaguida and Jacopo del Casentino. He was predominantly a miniaturist.

A676 THE CRUCIFIXION Pl. 77

Wood. 29·5×12·1.

On the back a mutilated wax impression of a seal.

Condition: good. Cleaned in 1958. The sides of the panel are slightly damaged in places. The gold background is intact, apart from one scratch, and the figures are well preserved. The draperies are rather rubbed.

Presented by Harold Bompas, 1941.

Literature: see No. A677 below.

### A677   THE LAMENTATION                                  Pl. 77

Panel. 29·8 × 12·1.

On the back the traces of a saleroom cypher.[1]

Condition: fairly good. Cleaned in 1958. Similar to that of No. A676 above, except for the gold background, which is slightly more worn on either side of the cross. There are faint scratches in the paint surface visible just to the right of the lower part of the Cross and extending vertically down the panel.

Presented by Harold Bompas, 1941.

Literature: *Annual Report*, 1941, 17; Offner, *Corpus*, sec. III. vii (1957), 36 repr. (before cleaning).

On both panels incised lines have been used to mark the horizontal beams of the cross.

The present attribution is due to Offner.

Originally, Nos. A676 and A677 may have served as the shutters of a portable tabernacle used for private worship.[2] A *Virgin and Child Enthroned Attended by Saints* probably formed the centre panel, as in the tabernacle belonging to M. Pierre Gustave Coulette (Paris), which Offner also attributed to the Master of the Dominican Effigies.[3] Two panels of the *Annunciation*, usually attached to the shutters as terminals, have probably been cut away.

There is some difficulty in identifying all the figures on No. A677. Those standing immediately beneath the Cross are most probably Nicodemus on the left holding the Crown of Thorns, and Joseph of Arimathea on the right with the hammer and nails.[4] Alternatively, the figure kneeling in the foreground might be meant for Joseph of Arimathea. The pose of this figure is reminiscent of the gesture of the King who kisses Christ's foot in contemporary depictions of the *Adoration of Kings*.[5] The two figures without haloes at the outer edges of the composition are perhaps only onlookers, but the well-dressed figure at the right may be a patron.

REFERENCES: 1. Letter from Mr. William Mostyn Owen, dated 20 Dec. 1971. states that Nos. A676 and A677 were delivered to Christie's in October 1902, but were passed

to Foster's unoffered. 2. Both panels are made up at the back and have been covered with a paint simulating porphyry. A design resembling the Greek letter φ (the vertical stroke is not continued through the circle) in *gesso* is also on the back of the panel. It is possible that the missing central panel may have similar markings. There are no signs of any hinge marks on Nos. A676 and A677, probably as a result of trimming. 3. Offner, *Corpus*, sec. III. vii (1957), pl. X. 4. See W. Stechow, 'Joseph of Arimathea or Nicodemus', in *Studien zur toskanischen Kunst. Festschrift für Ludwig Heinrich Heydenreich zum 23. März 1963* (Munich, 1964), pp. 290–7. 5. Similarly, M. Meiss, *Painting in Florence and Siena after the Black Death* (Princeton, 1951), p. 145, regards the 'Vesperbild' as the counterpart of the *Madonna dell' Umiltà*.

## MASTER OF MARRADI active *c.* 1500

Florentine school. So named after the altar-piece and other paintings in the church of Badia del Borgo, near Marradi, between Florence and Faenza. He was a minor follower of Domenico Ghirlandaio and Botticelli, who, towards the end of his life, was also influenced by Perugino.

### ATTRIBUTED TO THE MARRADI MASTER

A520d VIRGIN AND CHILD WITH THE YOUNG S. JOHN
AND AN ANGEL **Pl. 78**

Wood. 88 (round).

The scroll held by S. John the Baptist is inscribed ECCE AGNUS DEI. The text on the book held by the Virgin is Luke 1: 28.

Condition: fairly good. There is slight damage at the edges and some stippling on the flesh parts, but no extensive repainting.

Collections: C. J. Longman.

Bequeathed by Mrs. H. A. Longman, 1938.

No. A520d was attributed to Gerino da Pistoia at the time of acquisition.

Dr. Christian von Holst has suggested that the painter of No. A520d is in fact closely related to the Master of Marradi, whose *œuvre* was first reconstructed by Dr. Federico Zeri.[1] Another panel attributed to this painter, with several compositional features in common with No. A520d, was recently exhibited in Milan.[2]

REFERENCES: 1. F. Zeri, 'La mostra "Arte in Valdelsa", a Certaldo', *Bollettino d'arte*, 48 (1963), 249–50. 2. G. Algranti, *Selezione 1973* (Milan), no pagination.

## MASTER OF THE S. LOUIS ALTAR-PIECE active 1486

Florentine school. The name is derived from the altar-piece of the *Virgin and Child Enthroned between SS. Louis and John the Evangelist with Two Donors* in the City Art Museum, St. Louis, Missouri. He was a close follower of Domenico Ghirlandaio.

A84   SS. NICHOLAS OF BARI AND DOMINIC          **Pl. 79**

Wood. 69·6×30·8 (including the gold border around all the edges which measures approximately 2 cm.).

On the back a label inscribed by an eighteenth-century hand, *Due Santi di Domenico | Gillandajo . . . | No. 28.* This has been stuck over the number .(*2*)*8.* .

Condition: fair. The right side of S. Dominic, including the back of his head, has been heavily retouched. There are a number of small retouches in the drapery of S. Nicholas. The panel is damaged at the right edge on a level with S. Dominic's head and the bottom left corner has been renewed (8·5×5). The figure of S. Nicholas and the landscape are comparatively well-preserved.

Fox-Strangways Gift, 1850.

Literature: F. Knapp, *Piero di Cosimo* (Halle, 1899), p. 113; Crowe and Cavalcaselle, *History*, 2nd edn., iv (1911), 338; Berenson, 1932, 492: 1936, 423: 1963, 191; E. Fahy, 'Some Early Italian Pictures in the Gambier-Parry Collection', *Burlington Magazine*, 109 (1967), 137, n. 34.

An attribution to Cosimo Rosselli was first proposed by Knapp and won the support of Berenson. In the second edition of Crowe and Cavalcaselle, Langton Douglas recorded that at one time the name of Domenico Ghirlandaio had also been suggested, although he himself was of the opinion that the panel was by a weak follower of that painter. Recently, Mr. Everett Fahy has been able to isolate a number of panels by a follower of Ghirlandaio, whose personality is quite distinct within the Ghirlandaio–Mainardi orbit, and it is to this follower, now known as the Master of S. Louis, that No. A84 has been convincingly ascribed.[1] A date of 1480–90 is likely.

The original location of No. A84 is not easy to establish. The pose of the figures and the direction of their gazes suggests that this is a fragment from a small altar-piece, but the gold border along the edges appears to be original and the panel might have been used as a free-standing tabernacle.[2]

The crowns above the head of S. Dominic are an iconographical oddity: they are usually borne aloft by angels.[3]

REFERENCES: 1. The altar-piece after which the painter is named is repr. in Van Marle, *Development*, xiii (1931), fig. 159, as by Bartolommeo di Giovanni. 2. There are some markings on the back of the panel: a semicircular strip of *gesso* in the top left corner and a similar strip in the shape of a lop-sided L runs diagonally across the back. The other parts are painted to simulate porphyry as on the back of the panel attributed to Barna da Siena (pp. 15–18, above) and the triptych attributed to a follower of Fra

Angelico (pp. 5–6, above). 3. A crown also occurs on a panel of *S. Sebastian* at York Art Gallery (inv. 819a) attributed to 'Utili' (Biagio di Antonio da Firenze). The catalogue describes this crown as a later addition (*City of York Art Gallery. Catalogue of Paintings 1. Foreign Schools 1350–1800* (York, 1961), p. 9 repr.). The two crowns on No. A374 appear, however, to be original. Gold highlighting has not been used on the lower one.

# MASTER OF SAN MARTINO ALLA PALMA    active 1325–1350

Florentine school. The name is derived from an altar-piece of the *Virgin and Child with Angels and Donors* in the local church of S. Martino alla Palma, near Florence. The painter worked within the ambience of Bernardo Daddi and at times his style resembles that of Jacopo del Casentino. His paintings combine the main characteristics of both the Florentine and the Sienese schools.

A300    THE ENTOMBMENT                                    **Pl. 80**

Wood. 31·5 × 23·7.

On the back, fragments of several wax impressions of seals.

Condition: fairly good. Cleaned in 1957. On this occasion the gold background and the top of the mountain were reconstructed after earlier attempts at reconstruction, for example, the tooled border now half hidden by the modern gold ground, were thought to have been inaccurate.[1] The figures are extremely well preserved and the colours in the draperies have lost none of their lustre. There are horizontal cracks in the paint surface above the Virgin's head.

Fortnum Bequest, 1899.[2]

Literature: *Annual Report*, 1899, 21; R. Offner, 'The Mostra del Tesoro di Firenze Sacra . . . I', *Burlington Magazine*, 63 (1933), 83, n. 53; Berenson, 1936, 144: 1963, 56; Offner, *Corpus*, sec. III. v (1947), 46 repr.; R. Fremantle, *Florentine Gothic Painters* (London, 1975), p. 70 repr. (before cleaning and restoration).

In two editions of the Lists (1936 and 1963) Berenson retained an attribution to Bernardo Daddi, although Offner had already assigned No. A300, together with several other panels formerly attributed to Daddi, to a painter whom he designated as the 'Amico di Daddi'. This painter was later given the appellation Master of San Martino alla Palma.

A series of panels with scenes from the Passion, apparently originally placed together in one complex, is at Göttingen (Kunstsammlung Universität). Offner assigned these panels to the painter's workshop. The series includes an *Entombment*, which has some features in common with the design of No. A300.[3]

The panel in Oxford, owing to its subject, size, and format, may have been placed in one of the shutters of an elaborate tabernacle.[4]

In Offner's opinion, No. A300, which is of high quality, particularly in the use of colour and the characterization of the figures, marks 'the change from the middle to the final phase of our painter's development' that occurred c. 1345, shortly before the *Crucifixion* in Berlin–Dahlem (Staatliche Museen), which is a late work.[5]

There is no scriptural foundation for all the figures shown on No. A300, and the treatment of the subject reveals the influence of such items of contemporary literature as the *Meditationes Vitae Christi*.

REFERENCES: 1. Compare the repr. in Offner, *Corpus*, sec. III. v (1947), pl. IX. Also see the letter in the departmental files from the restorer, J. C. Deliss, dated 6 Apr. 1957. 2. Bought in Florence in 1864, as recorded in Fortnum's manuscript catalogue, vol. IV, f. 83, No. 3, ascribed to Giottino. 3. Inv. 60. Repr. Offner, op. cit., 47–9, pl. X and X[1]. The direction and the shape of the hill in the background is reversed on the panel at Göttingen and the female mourner kneeling in front of the tomb does not occur on No. A300. 4. Compare the panels divided between the collections of the New York Historical Society and the Kress Foundation (K 197), and the panel formerly in the collection of Sir Thomas Barlow, all of which are discussed by Offner, op. cit., 17–19 and 21–4, pls. III[1–2] and IV[a–b]. 5. Inv. 1428. Repr. Offner, op. cit., 52–3, pls. XI–XI[1–3].

## MASTER OF SANTO SPIRITO      active c. 1480–1520

Florentine school. The painter is named after three altar-pieces in the church of Santo Spirito, Florence. He appears to have been a pupil, or an assistant, of Domenico Ghirlandaio, and was also influenced by Cosimo Rosselli, and at a later stage by Filippino Lippi and Raffaellino del Garbo.

### A99   SS. BARTHOLOMEW AND JULIAN THE HOSPITALER (FRAGMENT FROM AN ALTAR-PIECE)     **Pl. 81**

Wood (cradled). 77·9×64.

On the back the remains of a wax impression of a seal.

Inscribed along the top of the wall behind the figures, BARTOLOMUS. APLŪS. SCS. JULIANUS.

Condition: poor. S. Bartholomew on the left is extensively damaged. The back of the head and the right side of the figure, particularly, the hand holding the book, have been heavily repainted. S. Julian is quite well preserved, except for his right forearm and hand, which have also been heavily repainted. The first four letters of BARTOLOMUS have been renewed.

Fox-Strangways Gift, 1850.

Literature: Crowe and Cavalcaselle, *History*, 2nd edn., iv (1912), 340; Berenson, 1912, 156: 1932, 223: 1936, 192: 1963, 73; F. Zeri, 'Eccentrici fiorentini', *Bollettino d'arte*, 47 (1962), 236, n. 2.

Dr. Federico Zeri was the first to attribute No. A99 to the Master of Santo Spirito. Crowe and Cavalcaselle had described the style of the panel as 'in the manner of Mainardi'. Berenson's earlier attributions to Mainardi (1912) and to Davide Ghirlandaio (1932 and 1936), the second of which was retained in the 1963 edition of the Lists, are now unacceptable although they were stylistically apt.

Professor Sir Ellis Waterhouse (verbal communication) appears to have been the first to point out that another fragment from the same altarpiece as No. A99 is in the Campana collection now being reconstituted in Aix-en-Provence. This represents half-lengths of *SS. Leonard and James the Greater.*[1]

S. Julian the Hospitaler was the patron saint of Castiglione Fiorentino.

REFERENCE: 1. Inv. 413. Berenson, 1963, 198, as Sellaio.

# ALTOBELLO MELONE                documented 1516–1518

Cremonese school. The only documented work is a series of seven frescoes in the Duomo at Cremona painted between 1516 and 1518. His work is occasionally mistaken for that of Gerolamo Romanino with whom he often worked in close proximity. Melone's style shows an admixture of Venetian, Emilian, Lombard, and Northern elements.

## A290   TOBIAS AND THE ANGEL                **Pl. 82**

Wood (fastened at the back with two horizontal battens inserted into the panel). Painted surface 112 × 47·9 (arched).

The bottom of the panel, at the back, has been planed down by 3·5.

On the back inscribed on the panel in pencil *Cassa N. 14.*

Condition: fair. Cleaned in 1952. There is an area of damage on the left side of the face of Tobias and also on the left side of the Angel's drapery. The panel has been damaged at the edges along which there are small retouches. The upper half of the figure of the Angel is comparatively well preserved, likewise the lower part of the figure of Tobias and the foreground.

Collections: See No. A29 below.

Literature: See No. A291 below.

A291   S. HELENA                                             Pl. 83

Wood (fastened at the back with two horizontal battens inserted into the panel). Painted surface 112×46·9 (arched).

The bottom of the panel, at the back, has been planed down by 3·5.

Condition: good. Cleaned in 1952. A small area of damage in the sky on the left below the beam of the Cross has been made good.

Collections: Sommi-Picenardi, Cremona (sale held in Milan in 1869, by the heirs Araldi-Erizzo, bt. by an English dealer);[1] J. D. Chambers. Chambers Bequest, 1897.

Literature: L. Grassi, 'Ingegno di Altobello Meloni', *Proporzioni*, 3 (1950), 153–5 repr.; F. Zeri, 'Altobello Melone: Quattro tavole', *Paragone*, 39 (1953), 43; F. Bologna, 'Altobello Melone', *Burlington Magazine*, 97 (1955), 249; M. Gregori, 'Altobello e Giovanni Francesco Bembo', *Paragone*, 93 (1957), 32–3; M. Panazza, *Mostra di Girolamo Romanino* (Brescia, 1965), p. 148; Berenson, 1968, 3; S. J. Freedberg, *Painting in Italy 1500 to 1600* (Harmondsworth, 1971), p. 253.

Dr. Luigi Grassi, with acknowledgement to Longhi and to Professor Luigi Salerno, first observed in print that Nos. A290 and A291 were the lateral panels of a triptych (known as the Picenardi triptych), the central panel of which is a *Virgin and Child* in the Kress collection now exhibited in the University of Missouri Art Gallery, Columbia.[2] Dr. Federico Zeri and Dottoressa Mina Gregori have identified two of the predella panels: the *Finding of the True Cross* (Algiers, Musée des Beaux-Arts)[3] and the *Journey of S. Helena to Jerusalem* (present whereabouts unknown).[4] The second of these two predella panels appears from the photographs to be rather badly worn. A third has still to be traced. The missing panel may have represented the scene of the testing of the True Cross, or one of the earlier episodes involving Judas.[5]

The composition of the Picenardi triptych is rather perplexing, for the eye is led first into the recesses of the niche of the central panel in which the Virgin and Child are seated, and then outwards across the landscape of the lateral panels.[6] Yet the connection between these three panels is confirmed by the detailed description of the triptych published by Sacchi in 1872,[7] to which attention was first drawn by Grassi. It would appear from the dimensions given by Sacchi that the main panels were probably set fairly close together, in which case the compositional discrepancies referred to above could only have been slightly mitigated by the framework.

The obvious affinities with Romanino in the central panel of the *Virgin*

*and Child*—particularly the oval face of the Virgin, the silky texture of the draperies, the rich colouring—have caused most writers to date the Picenardi triptych shortly after the completion of Melone's frescoes in the Duomo at Cremona (usually 1520–5), when Romanino's influence on the artist is generally considered to have been most strongly felt. Dr. Ferdinando Bologna, however, prefers a date immediately before the first fresco in the Duomo, which was the *Flight into Egypt*, dated 1517,[8] at the same time as a *Virgin and Child* in the Accademia Carrara, Bergamo.[9] Comparison of the Angel on No. A290 with the Angel on the fresco of the *Flight into Egypt* indicates how close these works are in date.

The composition of No. A290 is similar to that of the fresco, now fragmentary and transferred to canvas, of the same subject by Antonio della Corna in the Pinacoteca, Cremona.[10]

REFERENCES: 1. As recorded by F. Sacchi, *Notizie pittoriche cremonesi* (Cremona, 1872), p. 134. The relevant passage is quoted by L. Grassi, 'Ingegno di Altobello Meloni', *Proporzioni*, 3 (1950), 159, n. 25. The Sommi-Picenardi collection, formed by Conte Giovanni Battista Biffi (d. 1807), a cousin of the Picenardi family, was inherited by Serafini Sommi (d. 1857) who, by 1838, had made over his possessions to his sons, Gerolamo and Antonio Sommi-Picenardi. These facts are tabulated by G. Sommi-Picenardi, *La famiglia Sommi-Picenardi* (privately printed, Cremona, 1893), pl. XV. See further M. Gregori, 'Altobello, il Romanino e il '500 Cremonese', *Paragone*, 69 (1955), 4. 2. K 1097, 111·8×47·6. F. R. Shapley, *Paintings from the Samuel H. Kress Collection. Italian Schools XV–XVI Century* (London, 1968), p. 86 repr. 3. Measuring 28×50. F. Zeri, 'Altobello Melone: Quattro tavole', *Paragone*, 39 (1953), 43, fig. 22. Also repr. Berenson, 1968, pl. 1669. 4. Measuring 25·5×46·5. M. Gregori, 'Altobello e Giovanni Francesco Bembo', *Paragone*, 93 (1957), 32–3, fig. 22. 5. As recounted in *The Golden Legend of Jacobus de Voragine*, ed. G. Ryan and H. Ripperger (New York, 1948), pp. 269–76. 6. The three panels are repr. together by Berenson, 1968, pls. 1666–8. 7. Sacchi, loc. cit., who is the first writer to attribute the triptych to Melone. According to Gregori, op. cit. (1955), 4, the panels were attributed to Giovanni Francesco Bembo when in the Picenardi collection. 8. Repr. Grassi, op. cit., pls. CLIX and CLXI, figs. 5 and 7. 9. Inv. 344. Repr. F. Bologna, 'Altobello Melone', *Burlington Magazine*, 97 (1955), 241–2, fig. 3. 10. A. Puerari, *La pinacoteca di Cremona* (Cremona, 1951), pp. 55–6, Cat. no. 77, fig. 66. Also see G. dell'Acqua and F. Mazzini, *Affreschi lombardi del Quattrocento* (Milan, 1965), pp. 631–2 repr.

# MICHELANGELO BUONARROTI    1475–1564

Florentine school. Sculptor, painter, architect, and poet. For a short time he was the pupil of Domenico and Davide Ghirlandaio, but was then transferred to the school run by the sculptor Bertoldo di Giovanni in the Giardino dei Medici, opposite S. Marco. He was active mainly in Florence and Rome, where he was employed by the Papacy, and also in Bologna and in Siena. While most parts of his extensive *œuvre* are fairly well defined,

the authorship of some of the panels attributed to him is still disputed. Vasari regarded Michelangelo's achievement as the summation of all art. The Ashmolean Museum possesses one of the most extensive collections of original drawings by Michelangelo.

## ATTRIBUTED TO MICHELANGELO BUONARROTI

### A66c  THE HOLY FAMILY WITH THE YOUNG S. JOHN
### (THE RETURN OF THE HOLY FAMILY FROM EGYPT?)        Pl. 84

Wood (cradled). 65 × 53·5. The medium is a brown monochrome wash (*bistre*) on a green prepared *gesso* ground.

Condition: fair. Cleaned in 1934. The surface is scoured, particularly in the lower half, and pitted. The faded appearance of the figures is most probably due to the fact that the *bistre* has not bound properly into the prepared ground. There has also been some rubbing, and there is a certain amount of ingrained surface dirt. Two vertical splits in the panel, one to the right of the central figure and the other, slightly finer, to the left of her head have been retouched.

Collections: Royal Collection, Naples;[1] W. Y. Ottley (1770/1–1836); Sir Thomas Lawrence (1769–1830);[2] Samuel Woodburn & Bros.

Presented by a Body of Subscribers, 1846.

Exhibited: London, S. Woodburn & Bros., 112, St. Martin's Lane, *The Lawrence Gallery. Tenth Exhibition. A Catalogue of One Hundred Drawings by Michel Angelo*, 1836 (48).

Literature: W. Y. Ottley, *The Italian School of Design* (London, 1823), p. 31 n.; J. C. Robinson, *A Critical Account of the Drawings by Michel Angelo and Raffaello in the University Galleries, Oxford* (Oxford, 1870), pp. 89–90, No. 76; B. Berenson, *The Drawings of the Florentine Painters*, ii (edn. Chicago, 1938), p. 239, No. 1725a repr.; B. Berenson, *I disegni dei pittori fiorentini*, ii (edn. Milan, 1961), pp. 399–400, No. 1725a; F. Hartt, *Michelangelo* (New York, 1964), p. 55 repr.

There are several minor *pentimenti*, specifically in the legs of the main male and female figures.

No. A66c is unfinished. The physical appearance of the panel has been adequately described by Robinson and again, more recently, by Berenson. A unique copy of Robinson's *Critical Account*, illustrated with water-colour copies of each drawing made by Joseph Fisher, shows the head of an ass in the upper right-hand corner.[3] This is a misreading, with which Robinson appears to have concurred, probably resulting from the interpretation of the subject-matter as the Return of the Holy Family from Egypt. It

seems more reasonable to interpret this passage as the left shoulder and extended arm of an unfinished figure.

No. A66c received close critical attention from both Robinson and Berenson, but has been disregarded by all recent authorities with the exception of Professor Frederick Hartt.

As regards the attribution of No. A66c, a number of possibilities present themselves and these may be tabulated as follows:

1. An unfinished autograph work by Michelangelo, as suggested by Robinson with a date during 'the later period of Michel Angelo's career'.

2. An unfinished copy after a lost drawing by Michelangelo attributable to a close follower, as posited by Berenson.

3. The underdrawing of a painting laid in by Michelangelo, but left for completion by a painter such as Marcello Venusti, or another purveyor of the master's designs.

4. The underdrawing of a painting laid in by an assistant of Michelangelo, but touched up, or corrected, by the master in the area of the drapery over the central figure.

5. A variant, designed by a follower, of a specific composition by Michelangelo, for instance the cartoon entitled *Epifania* in the British Museum, London,[4] as Berenson also proposed, although he was inclined to think that the style of No. A66c lay between that of the drawings executed for Tommaso Cavalieri and the *Last Judgement* (that is between *c.* 1532 and 1541), several years before the *Epifania*. Professor Charles de Tolnay (written communication) also regards No. A66c as a variant designed by a follower of Michelangelo, suggesting a date between 1545 and 1555.[5]

Berenson was puzzled by the fact that No. A66c is not obviously in the style of any of the recognized followers of Michelangelo. There can be little doubt that the panel reflects an original design by the master, as opposed to a pastiche of Michelangelesque motifs. The drawing of the central figure and of the stooping figure on the left is certainly convincing and of some quality. The technique is singular, possibly unique, as far as Michelangelo is concerned, and there is nothing in his *œuvre*, or even in that of his immediate followers, comparable with No. A66c.[6]

Dr. Paul Joannides (written communication)[7] has argued tentatively in favour of the first of the alternatives tabulated above, but, like Berenson, he is not convinced by the late dating. Joannides suggests that both the types

and the style are much more closely related to works of the third decade. Comparison may be made, for instance, with the *Study of a Nude Woman* in the Uffizi,[8] which could have been drawn in connection with one of the allegorical figures originally designed to flank the statue of Giuliano de' Medici in the Medici Chapel in S. Lorenzo, Florence; or with the figure of Christ in the drawing of the *Flagellation* in the British Museum, which is an early idea for Sebastiano del Piombo's altar-piece in S. Pietro in Montorio, Rome.[9] A number of other analogies with works dating from the period 1516–30 have been cited by Joannides in support of his suggestion, which is sufficiently compelling to warrant further examination.

Further difficulties arise over the interpretation of the subject-matter. Ottley was the first to suggest the *Return of the Holy Family from Egypt*, which has received some measure of support.[10] Berenson, in order to show his uncertainty, hinted at the possibilities of a pagan subject. De Tolnay[11] and Hartt entitle the composition *Holy Family with the Young S. John* and de Tolnay presses the comparison with the *Epifania* in the British Museum, identifying the central figure on No. A66c as the Virgin, with the Christ Child in front of Her and the young S. John on Her left. Joseph must therefore be identified as the shadowy figure top right, since, following Thode's suggestion for the comparable figure on the cartoon in London, de Tolnay tentatively identifies the nude figure on the left as the prophet Isaiah.

A related drawing by a weak hand is in the collection at Rugby school, Warwickshire.[12]

REFERENCES: 1. As stated by W. Ottley, *The Italian School of Design* (London, 1823), p. 31 n. 2. Possibly identifiable with No. 12 of the *Inventory of the Collection of Drawings by Old Masters formed by Sir Thomas Lawrence. P.R.A.*, *drawn up while the collection was still in his house*, described as *A Griselle in black and white in oil, female and two children, etc.* 3. The copy is preserved in the Print Room of the Department of Western Art, Ashmolean Museum. 4. J. Wilde, *Italian Drawings in the Department of Prints and Drawings in the British Museum. Michelangelo and His Studio* (London, 1953), pp. 114–16, No. 75 repr. Also see Charles de Tolnay, *Michelangelo*, V, *The Final Period* (Princeton, 1960), 66–7 and 213–15, No. 236, with full bibliography. 5. Letter of 2 Sept. 1970. 6. But in the 1801 sale of Ottley's drawings (Christie's, 16 May 1801) lot 7, ascribed to Michelangelo, is described as follows: '"The Samaritan Woman at the Well". The preparation for a picture, perhaps intended to have been finished by himself. M. Angelo is generally believed to have painted only two or three pictures in oil: those small ones we so frequently see ascribed to him, are all painted by his scholars, from his designs; many have been painted from his drawings, which formerly had a place in the collection of the King of Naples, at Capi di Monte. 1 ft. 11½ × 2 ft. 7 on pannel.' Resold Christie's, 25 May 1811, lot 34. This picture, once owned by William Roscoe and now sadly darkened, is in the Walker Art Gallery, Liverpool (inv. 2789), for which see M. Compton, *Walker Art*

*Gallery. Foreign Schools Catalogue* (Liverpool, 1963), pp. 117–18. 7. Letter of 12 Mar. 1974.
8. Inv. 251Fr. P. Barrochi, *Michelangelo e la sua scuola. I disegni di Casa Buonarroti e degli Uffizi*, i (Florence, 1962), 292–3, repr. ii, pl. CCCXLI, who attributes the drawing to the school of Michelangelo. 9. Inv. 1895–9–15–500. Wilde, op. cit., pp. 27–8, No. 15. 10. The association of the young S. John with the *Return of the Holy Family from Egypt* is well founded and based on the influential *Vita di San Giovambatista*, compiled by an anonymous early fourteenth-century Italian writer, who, in the main, appears to have based his account of the meeting of the young christ with the Baptist in the wilderness on the *Meditationes Vitae Christi* (see M. Lavin, 'Giovannino Battista: A Study in Renaissance Religious Symbolism', *Art Bulletin*, 37 (1955), 89–91, with corrections 'Giovannino Battista: A Supplement', *Art Bulletin*, 43 (1961), 320–1 and 323). While the author of the *Meditationes Vitae Christi* (ed. I. Ragusa and R. Green (Princeton, 1961), pp. 80–4) allows the Holy Family to travel on without the Baptist, the writer of the *Vita di San Giovambatista* (ed. D. M. Manni, *Delle vite dei SS. Padri*, iii (Florence, 1734), pp. 209–16) narrates that they travelled out of the desert together and visited the Baptist's parents. See further, P. A. Dunford, 'The Iconography of the Frescoes in the Oratorio di S. Giovanni at Urbino', *Journal of the Warburg and Courtauld Institutes*, 36 (1973), particularly 370–1, and by the same author 'A Suggestion for the Dating of the Baptistery Mosaics at Florence', *Burlington Magazine*, 116 (1974), 96–8. 11. Letter referred to in note 5 above. 12. *Study of a Woman Leading Two Children with one held by the Hand*, black chalk, 199 × 270 mm. Colls. Woodburn; Bloxam. Watermark (anchor in circle). A number of drawings from this collection were published by A. Schmarsow, 'Aus dem Kunstmuseum der Schule zu Rugby', *Jahrbuch der Königlich Preussischen Kunstsammlungen*, 9 (1888), 132–6. The drawing under discussion is not mentioned. A provisional catalogue, from which the details given here were kindly extracted by Mr. Philip Snow, was compiled by Miss Anne Popham.

## MICHELE DI RIDOLFO                          1503–1577

Florentine school. His real name was Michele di Jacopo Tosini. He was a pupil of Lorenzo di Credi, but served as an assistant to Ridolfo del Ghirlandaio for a far longer period. Later the influences of Raphael and Fra Bartolommeo were dominant and towards the end of his life he worked with Vasari in the Palazzo Vecchio, Florence. This represents a wide and rapid development. His portraits are painted in the manner of Francesco Salviati. Francesco Brina was a close follower of Michele di Radolfo and many of his works are remarkably similar in style.

## STUDIO OF MICHELE DI RIDOLFO

A504a   VIRGIN AND CHILD WITH THE YOUNG S. JOHN        **Pl. 85**

Wood (cradled). 87 × 69·5. The panel has been extended on all sides by 3 cm. at the top, 6·5 cm. at the bottom, 6 cm. on the left, and 7 cm. on the right.

Condition: fair. The features of the Virgin and Child have been touched up. The figure of S. John the Baptist, may be a later addition. The surface is covered by a thick layer of varnish and there are several vertical

splits in the panel to the right of centre, with two others clearly visible on the left, one extending through the landscape and the other through the Child's face.

Collections: first recorded at Christie's, 23 Nov. 1901, lot 39 (as Ponni). Different Properties, bt. Waters; W. G. Waters and thence by direct inheritance to Dr. Arthur Waters.

Presented by Dr. Arthur Waters, 1937.

Exhibited: London, Burlington Fine Arts Club, *Exhibition of Works by the Old Masters*, 1907 (33).

There is a *pentimento* at the tip of the fingers of the Christ Child's left hand.

The pose of the Virgin and Child is taken from Raphael's *Bridgewater Madonna*, now on loan to the National Gallery of Scotland. A variant of the composition of No. A504a, with only slight differences in the background, was sold at auction in Aachen in 1933.[1]

At the time of the exhibition held at the Burlington Fine Arts Club in 1907, No. A504a was attributed to Perino del Vaga. Dr. Valentino Pace (written communication)[2] has suggested that No. A504a was painted by an artist working close to Michele di Ridolfo, which seems convincing and has received some measure of support from Mr. Everett Fahy.[3] Comparison should be made with the *Virgin and Child with the Young S. John* by Michele di Ridolfo in the Art Gallery and Museum, Glasgow.[4]

REFERENCES: 1. Sold by Kreutzer, Kaulhausen sale, 23–4 May 1933, No. 133, repr. pl. 3 as Francesco Francia, 58×42 cm. Repr. in the Witt Library, London. 2. Letter of 27 Dec. 1973. 3. Letters of 17 Jan. 1974 and 28 Feb. 1974. 4. Inv. 165 repr. *Catalogue of Italian Paintings. Illustrations* (Glasgow, 1970), p. 97.

## BARTOLOMEO MONTAGNA                   living 1459, died 1523

Vicentine school. His real name was Bartolomeo Cincani, called Montagna. He was active mainly in the Veneto. Montagna was apparently influenced at first by painters of the Veronese and Paduan schools, but he may have received some training in the workshop of Giovanni Bellini in Venice. There are also stylistic affinities with the work of Antonello da Messina, Alvise Vivarini, Cima da Conegliano, and later with Giorgione. His son, Benedetto, was a painter, but achieved greater fame as an engraver.

A724   VIRGIN AND CHILD                               **Pl. 86**

Wood. 34×28.

Condition: poor. Repairs have been made to the right side of the Virgin's veil. An area of repaint on the Child's chest, which has blistered, has been

laid and the top of the Virgin's thumb has also been repainted. There are large areas of retouching on the right side of the Virgin's face, in the neck, and on the back of Her left hand. The landscape and the Child's head are intact.

Collections: Bonomi-Cereda, Milan;[1] Sir William Farrer.

Bequeathed by G. O. Farrer, through the National Art-Collections Fund, 1946.

Exhibited: London, New Gallery, *Exhibition of Venetian Art*, 1894-5 (72); London, Grafton Gallery, *Exhibition of Old Masters*, 1911 (14); London, Royal Academy, *Italian Art and Britain*, 1960, (346).

Literature: C. J. Ffoulkes, 'L'esposizione dell'arte veneta a Londra', *Archivio storico dell'arte*, ser. 2. i (1895), 248 repr.; B. Berenson, *The Study and Criticism of Italian Art* (London, 1901), p. 114 repr.; A. Foratti, *Bartolomeo Montagna* (Padua, 1908), pp. 14-15; T. Borenius, *The Painters of Vicenza* (London, 1909), pp. 21-2; Berenson, 1911 Venetian, 117: 1932, 367: 1936, 315: 1957, 116; Crowe and Cavalcaselle, *History North Italy*, 2nd edn., ii (1912), 126, n. 1; Venturi, *Storia*, vii, pt. 4 (1915), 445-7; A. Foratti, in Thieme–Becker, *Lexikon*, xxv (1931), 75; *Annual Report*, 1946, 25 repr.; R. Pallucchini, 'La pittura veneta alla Mostra "Italian Art and Britain": appunti e proposte' in *Eberhard Haufstaengel zum 75 Geburtstag* (Munich, 1961), p. 74; L. Puppi, *Bartolomeo Montagna* (Venice, 1962), pp. 43 and 116 (Cat.) repr.

The attribution of No. A724 to Montagna, which appears to be of some age, has been unanimously accepted and there is also general agreement about the early dating. In Dr. Lionello Puppi's opinion, No. A724 is stylistically compatible with the altar-piece of the *Virgin and Child with SS. Monica and Mary Magdalen* in the Museo Civico, Vicenza, for which he suggests a date c. 1482-3.[2] Other writers have only proposed slight variations on this date.[3]

The tender relationship between the Virgin and Child and the moulding of the figures into the contours of the clear Vicentine landscape show how much Montagna had absorbed of the examples of Giovanni Bellini and Antonello da Messina.

A comparable work of approximately the same date is the *Virgin and Child with a Donor, Francesco Gonzaga*, formerly in the collection of Sir Thomas Merton and now on loan to the National Gallery, London.[4]

REFERENCES: 1. As stated in all the Exhibition catalogues. The only recorded Bonomi-Cereda sale was held in Milan in 1896 (14-16 Dec. 1896, by A. Genolini, Via Giulini,

Milan), by which time No. A724 was already in the Farrer collection. 2. Inv. A3. L. Puppi, *Bartolomeo Montagna* (Venice, 1962), pp. 137–8, figs. 22–3. Also see F. Barbieri, *Museo Civico di Vicenza. Dipinti e Sculture dal XIV al XV Secolo* (Venice, 1962), pp. 164–7. 3. B. Berenson, *The Study and Criticism of Italian Art* (London, 1901), p. 114, described No. A724 as 'the earliest of all Montagna's existing works'. T. Borenius, *The Painters of Vicenza* (London, 1909), pp. 21–2, groups No. A724 together with the *Virgin and Child with a Donor, Francesco Gonzaga* (formerly in the collection of Sir Thomas Merton and now on loan to the National Gallery, London), and the altar-piece of the *Virgin and Child with SS. Monica and Mary Magdalen*, implying a date of 1488–90. Venturi, *Storia*, vii, pt. 4 (1915), 445–7, places No. A724 before the *Virgin and Child Enthroned between SS. John the Baptist, Bartholomew, Augustine and Sebastian* in the Museo Civico, Vicenza (inv. A1), which he dates shortly after 1487. A. Scharf, *A Catalogue of Pictures and Drawings from the collection of Sir Thomas Merton F.R.S.* (London, 1950), p. 30, No. XI, dates both No. A724 and the Hertz Madonna *c.* 1499. 4. Puppi, op. cit., p. 107, fig. 29.

A722    THE MARRIAGE OF ANTIOCHUS AND STRATONICE          Pl. 87

Wood. 29 (round).

Condition: poor. The surface is badly rubbed throughout, more so than on No. A723. There are several horizontal splits in the panel, some minor repairs, and a number of small retouches on the figures.

Collections: see No. A723 below.

Exhibited: London, New Gallery, *Exhibition of Venetian Art*, 1894–5 (134). Literature: see No. A723 below.

A723    AN INCIDENT IN THE STORY OF THE VESTAL
        CLAUDIA                                            Pl. 88

Wood. 29 (round).

Condition: fair. The surface is rather worn in places with several minor repairs, particularly in the centre of the panel. A vertical split in the middle, extending the height of the panel, opens out at top and bottom. The quality of No. A723, however, is by no means totally lost.

Collections: H. Merritt, from whom bt. by Sir William Farrer in 1874.[1] Bequeathed by G. O. Farrer through the National Art-Collections Fund, 1946.

Exhibited: London, New Gallery, *Exhibition of Venetian Art*, 1894–5 (132). Literature: C. J. Ffoulkes, 'L'esposizione dell'arte veneta a Londra', *Archivio storico dell'arte*, ser. 2. i (1895), 248; B. Berenson, *The Study and Criticism of Italian Art* (London, 1901), pp. 115–16; T. Borenius, *The Painters of Vicenza* (London, 1909), p. 67, n. 2; Berenson, 1911 Venetian, 117: 1932, 367: 1936, 315: 1957, 116; Crowe and Cavalcaselle, *History North Italy*, 2nd edn., ii (1912), 136, n. 2; *Annual Report*, 1946, 25; Schubring,

*Cassoni* (1915), 365, Nos. 634–5; E. K. Waterhouse, 'Two Panels from a Cassone by Montagna in the Ashmolean Museum', *Burlington Magazine*, 89 (1947), 46–9; L. Puppi, *Bartolomeo Montagna* (Venice, 1962), pp. 51 and 116–17 (Cat.) repr.; L. Vertova, 'La Visita del Medico. Osservazioni su alcuni dipinti di Bonifazio de' Pitati', *Mitteilungen des Kunsthistorischen Institutes in Florenz*, 16 (1972), 179.

Nos. A722 and A723 were originally inserted into the front of a *cassone*. Traditionally held to be by Carpaccio, both panels were first attributed to Montagna by Berenson after the exhibition of Venetian Art held at the New Gallery in London in 1894–5. This attribution is now widely accepted. Professor Sir Ellis Waterhouse, following Berenson and Ffoulkes, pointed out that a complete *cassone* in the Museo Poldi Pezzoli, Milan, has similar roundels inserted into the front,[2] and could well be the companion to the one from which Nos. A722 and A723 were removed. The scenes depicted in the roundels in Milan (*Duilius and Bilia* and *An Incident in the Life of the Vestal Tuccia*) are certainly compatible with those on Nos. A722 and A723. Since all the incidents portrayed illustrate the theme of chastity, it seems highly likely, as Waterhouse concluded, that these two *cassoni* were commissioned as a pair to celebrate a marriage.

Dr. Lionello Puppi dates these four roundels c. 1492.[3] The deep resonant tone of the colours, particularly the brick reds, and the greater concern for the correct use of perspective in the architecture are common to many Montagna's works dating from the beginning of the last decade of the fifteenth century.

Although Schubring attributed a number of *cassoni* panels to Montagna,[4] Puppi only attributes the four mentioned here.

The literary source for No. A723 is most probably Ovid, *Fasti*, IV. 305–28 (ed. Sir J. G. Frazer, i (London, 1929), 198–200).[5] Waterhouse identified the subject of No. A722 as the *Marriage of Antiochus and Stratonice*, the story of which is first recounted by Valerius Maximus, *Factorum et Dictorum Memorabilium*, V. 7.[6]

REFERENCES: 1. As stated by E. K. Waterhouse, 'Two Panels from a Cassone by Montagna in the Ashmolean Museum', *Burlington Magazine*, 89 (1947), 49, n. 1. 2. Inv. 676 L. Puppi, *Bartolomeo Montagna* (Venice 1962), pp. 110–11, repr. figs. 69–70. The whole *cassone* is repr. by F. Russoli, *La Pinacoteca Poldi Pezzoli* (Milan, 1955), pp. 190–1, fig. 95. The *cassone* bears the arms of the Buri family from Verona. 3. T. Borenius, *The Painters of Vicenza* (London, 1909), p. 67, n. 2 dated the *tondi* at Milan c. 1507, but thought that Nos. A722 and A723 were even later in date. B. Berenson, *The Study and Criticism of Italian Art* (London, 1901), pp. 115–16, also placed the *tondi* in Oxford in Montagna's late period. Russoli, op. cit., assigns the *cassone* in Milan to the central period with no firm dating,

but makes no mention of Nos. A722 and A723. C. J. Ffoulkes, 'L'esposizione dell' arte veneta a Londra', *Archivo storico dell' arte*, ser. 2. 1 (1895), 248, regarded all four roundels as contemporaneous, but did not attempt a specific dating. 4. Schubring, *Cassoni*, i (1915), 364–7, Nos. 630–8 and 640–1. See further observations by Puppi, op. cit., p. 51, n. 15. 5. Alternatively, Livy, *Ab Urbe Condita*, XXIX. 14. 12; Suetonius, *Lives of the Caesars, Tiberius*, II. 3, or Propertius, *Elegiae*, IV. 11. 52. For another rendering of the subject see the painting by Garofalo in the Galleria Nazionale, Rome (inv. 1443), repr. by N. di Carpegna, *Catalogue of the National Gallery. Barberini Palace, Rome* (Rome, 1964), p. 27, fig. 90. 6. A discussion of the iconography of Antiochus and Stratonice may be found in L. Vertova, 'La Visita del Medico. Osservazioni su alcuni dipinti di Bonifazio de' Pitati', *Mitteilungen des Kunsthistorischen Institutes in Florenz*, 16 (1972), 175–84 and 336, with further literary sources and full bibliography.

## A874    CHRIST CARRYING THE CROSS                              Pl. 89

Wood (cradled). 28·4 × 21·6.

Condition: fair. The right side of the face and the right shoulder are slightly rubbed. There are several fine horizontal cracks in the paint surface. Three extend across the face and another across the neck. The left side of the face has some minor blemishes.

Collections: first recorded at Christie's, 3 Mar. 1933, lot 76 (as Cima), Various Properties; Sotheby's, 30 July 1947, lot 69 (as Cima), Various Properties; Christie's, 23 Nov. 1951, lot 44 (as Cima), Various Properties, bt. P. & D. Colnaghi & Co. Ltd.; Sir Thomas Barlow; P. & D. Colnaghi & Co. Ltd.

Presented through the National Art-Collections Fund, 1955.

Exhibited: P. & D. Colnaghi & Co. Ltd., *Paintings by Old Masters*, 1952 (8) repr.; Paris, Musée des Arts Décoratifs, *Chefs-d'oeuvre de la curiosité du monde*, 1954, (30).

Literature: 'Notable Works of Art on the Market', *Burlington Magazine*, 96 (1954), July Supplement, pl. IV repr.; *Annual Report*, 1955, 52–3 repr.; Berenson, 1957, 116; L. Puppi, *Bartolomeo Montagna* (Venice, 1962), pp. 60–1 and 117 (Cat.) repr.

There is a *pentimento* at the top of the head.

No. A874 is a characteristic example of Montagna's style at the beginning of the cinquecento. The old attribution to Cima da Conegliano, which was at one time widely accepted, is not at all unreasonable in the light of comparison with such works as Cima's *Christ Crowned with Thorns* in the National Gallery, London.[1] The attribution of No. A874 to Montagna was first suggested by Longhi, Professor Antonio Morassi, and by Berenson.[2] This is accepted by Dr. Lionello Puppi, who posits a date

c. 1503, just before the frescoes in SS. Nazzaro e Celso, Verona (1504–6). Panels of similar format and of approximately the same date as No. A874 are the *Christ Blessing* in the Sabauda Gallery, Turin, dated 1502,[3] and the *Young Christ* in the Borghese Gallery, Rome,[4] although with regard to the subject matter, the painting of *Christ Carrying the Cross* in the Museo Civico, Vicenza, is more strictly comparable.[5]

As Sir Karl Parker pointed out in the *Annual Report* of 1955, the subject of *Christ Carrying the Cross* is often found in northern Italy at this time, particularly among the Lombard followers of Leonardo da Vinci.[6] Closely related to these renderings is the small pen-and-ink drawing by Leonardo da Vinci of the *Head of Christ under the Cross*, dating from c. 1495–7.[7] That Leonardo himself introduced the design into Venice during his visit there in 1500 is uncertain, but Giovanni Bellini's treatment of the subject in the Museum of Fine Arts, Toledo,[8] could well have been derived from Leonardo's drawing and thereby led to its further diffusion among the Venetian painter's many followers.[9]

REFERENCES: 1. Inv. 1310. Repr. *National Gallery Catalogues. Earlier Italian Schools Plates*, i. 99. 2. As stated in 'Notable Works of Art on the Market', *Burlington Magazine*, 96 (1954), July Supplement, pl. IV. 3. Inv. 667. Repr. L. Puppi, *Bartolomeo Montagna* (Venice, 1962), fig. 110. Also see N. Gabrielli, *Galleria Sabauda maestri italiani* (Turin, 1971), p. 177, pl. 36, fig. 64. 4. Inv. 43A. Repr. Puppi, op. cit., fig. 111. 5. Inv. A335. See Puppi, op. cit., p. 140, fig. 148. Also see F. Barbieri, *Il Museo Civico di Vicenza. Dipinti e sculture dal XIV al XV secolo* (Venice, 1962), pp. 179–80. 6. W. Suida, *Leonardo und sein Kreis* (Munich, 1929), pp. 88–9, pls. 97–100. 7. A. E. Popham, *The Drawings of Leonardo da Vinci* (London, 1946), p. 120, pl. 171B repr., and L. H. Heydenreich, *I disegni di Leonardo da Vinci e della sua scuola conservati nella Galleria dell' Accademia di Venezia* (Florence, 1949), pp. 10–11, pl. vii. 8. G. Robertson, *Giovanni Bellini* (Oxford, 1968), p. 124, pl. CXIIa. 9. F. Heinemann, *Giovanni bellini e i belliniani*, i (Venice, n.d.), 45–7, lists fifty-seven panels derived from Bellini's composition, some of which are repr. ii, figs. 258–61. To these may be added a picture recently at auction in London (Sotheby's, 26 Mar. 1969, lot 71). In the context of Montagna, it is noteworthy that the famous version, often attributed to Giorgione, now in the Isabella Stewart Gardner Museum, Boston, was once in the Palazzo Loschi, Vicenza.

# MORETTO DA BRESCIA                                    c. 1498–1554

Brescian school. His real name was Alessandro Bonvicino, called Moretto. He was most probably a pupil of Titian and his work retained a pronounced influence of Venetian painting, although his early style is also dependent upon the Lombard school and the heritage of Vincenzo Foppa. The influence of Lotto and Savoldo is also evident and several compositions reveal a knowledge of developments in Central Italian painting. Only a few of his portraits have survived, but he was highly regarded as a portrait painter during his lifetime.

A980   VIRGIN AND CHILD WITH S. JEROME                        Pl. 90

Wood (cradled). 50·4 × 58·7.

On the back a wax impression of a seal with a coat of arms showing a pile *bendoise* on a bend between an eagle displayed sinister chief and a scallop(?) dexter base. Crest, a wyvern's or eagle's head erased.[1]

Condition: fairly good. Cradling appears to have caused the corrugated effect visible across the upper half of the panel. There are small areas of damage beneath the Virgin's chin, at the top of the Child's head, on the Virgin's left hand, and on S. Jerome's right forearm. The blue of the part of the Virgin's drapery in shadow has darkened. The head, shoulder, and left arm of S. Jerome and the landscape are well preserved.

Collections: Henry Manfield (Sotheby's, 21 Feb. 1945, lot 118, bt. P. & D. Colnaghi & Co. Ltd.); F. F. Madan.

Madan Bequest, 1962.

Exhibited: London, P. & D. Colnaghi & Co. Ltd., *Old Master Paintings*, 1945 (for which no catalogue was issued); Birmingham, *Italian Art*, 1955 (75); London, P. & D. Colnaghi & Co. Ltd., *Memorial Exhibition of Paintings and Drawings from the Collection of F. F. Madan*, 1962 (1) repr.

Literature: *Annual Report*, 1962, 35 repr.; Berenson, 1968, 278.

Apparently unrecorded in the literature until the 1968 edition of Berenson's Central Italian and North Italian Lists, No. A980 was correctly recognized as a work by Moretto when sent to auction in London in 1945.

The feathery brushwork and silver-grey tone, most evident on the figure of S. Jerome, suggest that No. A980 is a mature work, perhaps dating from between 1530 and 1535.[2] An early copy of No. A980 with only minor differences is in the reserve collection of the Accademia Carrara, Bergamo,[3] and a later copy was last recorded in Milan in 1926.[4] Both of these show a slight extension of the composition on the left, which suggests that No. A980 has been cut on that side.

REFERENCES: 1. Compare the arms of the Rushworth family described by Sir B. Burke, *The General Armory of England, Scotland, Ireland and Wales* (London, 1884), p. 879, right-hand column. 2. That is, close in date to two important altar-pieces, *S. Margherita of Cortona with SS. Jerome and Francis*, dated 1530, in the church of S. Francesco, Brescia, and the *Coronation of the Virgin with SS. Michael, Joseph, Nicholas and Francis* in the church of SS. Nazzaro e Celso, Brescia, both reproduced G. Gombosi, *Moretto da Brescia* (Basle, 1943), pls. 44 and 34–6 respectively. Gombosi (op. cit., p. 98) dates the altar-piece in SS. Nazzaro e Celso between 1526 and 1530, but it is listed in Berenson, 1968, 276, as a work

of 1534. 3. Inv. 597, panel 50×53. Listed by F. Russoli, *Accademia Carrara* (Bergamo, 1967), p. 105. This panel was once in the collection of Giovanni Morelli (see *Elenco dei quadri dell' Accademia Carrara in Bergamo* (Bergamo, 1912), p. 112). The fruit is omitted in the foreground and the panel appears to have been trimmed at the top. The haloes are also missing, but they may have been rubbed. 4. Photograph in the Berenson Fototeca, Villa I Tatti, Florence. The copy is on canvas and measures 40×55. It was last recorded in the possession of Carlo Foresti, a dealer in Milan in 1926. The fruit in the foreground is again omitted.

## GIOVANNI BATTISTA MORONI active 1547, died 1577

Brescian school. He was also active in Trento and Bergamo. He was the pupil of Moretto and through that painter he was influenced by the work of Titian, Lotto, and Savoldo. There are a number of portraits in his extensive *œuvre* and these reveal the influence of the same painters. His style developed little and the portraits are generally thought to be of greater import than the religious paintings.

### A446  THE MYSTIC MARRIAGE OF S. CATHERINE Pl. 91

Canvas (relined). 82·6 × 67·5.

On the back two wax impressions of a seal (three heads of a greyhound in a coat of arms surrounded by an indecipherable motto and the Order of the Golden Fleece), which almost exactly answers the description of the Sampieri arms.[1] The enumeration *N 11* is drawn with the brush on the back of the canvas where there also occurs an inscription *Alessandro Bonvicino detto il Moretto da Bresia Na: 1514 Mo: 1566* written by an eighteenth-century hand.

Condition: good. There is a little damage along the edges.

Collections: Sampieri,[2] Bologna; Sir Robert Gordon (Christie's, 6 May 1848, lot 36, bt. Seguier); Samuel Rogers;[3] M. A. Whyte;[4] thence by descent (?)[5] to Capt. A. F. Dawson (1835–1928), Barrow Hill, Rocester, Staffordshire (Sotheby's, 14 Dec. 1921, lot 115 repr. bt. in).[6]

Purchased 1935.

Exhibited: London, British Institution, 1837 (163): 1848 (107); Derby, Drill Hall, *The Midland Counties Exhibition of Works of Art and Industrial Products*, 1870 (174); London, Burlington House, *Exhibition of Works by the Old Masters*, 1910 (37); London, P. & D Colnaghi & Co. Ltd., *Old Master Paintings*, 1934 (6).

Literature: Venturi, *Storia*, ix pt. 4 (1929), 201 n.; *Annual Report*, 1935, 25.

Approximately 1·6 cm. of the original composition has been folded over the top of the stretcher, which explains the rather cramped appearance of the background on the left.

No. A446 was attributed to Moroni at the time of acquisition. On all previous occasions the painting had been ascribed to Moroni's master, Alessandro Moretto. The even modelling of the flesh tones, the care lavished on such details as dress and hair, and the short richly loaded brush strokes used for the decorative pattern on the Virgin's drapery, are characteristic of Moroni's style and technique, so well summed up in Boschini's phrase 'impastà de late e fiori'.[7] The influence of Moretto is still evident on No. A446 and the painting may therefore be fairly early in date, perhaps from the sixth decade. The figure of S. Catherine is reminiscent of the types painted by Lorenzo Lotto.

The tower in the background on the left is the Torre del Commune, Bergamo.[8]

REFERENCES: 1. G.B. di Crollalanza, *Dizionario storico-blasonico delle famiglie nobili e notabili italiane estinte e fiorenti*, ii (Pisa, 1888), 476, right-hand column. 2. Possibly identifiable with the painting described in the Sampieri inventory of 1743, which was drawn up on the death of Francesco Giovanni Sampieri and was published by G. Campori, *Raccolta di cataloghi ed inventarii inediti di quadri, statue . . . dal secolo XV al secolo XIX* (Modena, 1870), pp. 598–602, No. LVI, 'Un detto, lo sposalizio di S. Caterina, della scuola del Parmigiani, mezze figure'. The Sampieri collection was acquired by Prince Eugène de Beauharnais in 1811. Since No. A446 is not recorded in the official catalogues of Prince Eugène's collection (J. N. Muxel, *Verzeichniss der Bildergallerie seiner königlichen Hoheit des Prinzen Eugen, Herzogs von Leuchtenberg in München* (Munich, 1835 and 1843), it is possible that the picture was sold when the Sampieri collection was dispersed in 1811. No. A446 is first stated to be from the Sampieri collection in the sale catalogue of Sir Robert Gordon's collection (Christie's, 6 May 1848, lot 36). It is interesting to note that at least nine of the pictures lent by Sir Robert Gordon to the exhibition held at the British Institution in 1837 came from important Bolognese collections. 3. As stated in the *Annual Report*, 1935, 25, on the basis of notes in the files of P. & D. Colnaghi & Co. Ltd., No. A446 was not sent for auction at the Samuel Rogers's sale held at Christie's, 2 and 3 May 1856, and there is no external evidence to prove that the picture was in Rogers's collection at any time. 4. When exhibited at the British Institution for the second time in 1848 No. A446 was lent by a Mrs. Whyte. Waagen visited the collection of a certain M. A. Whyte of Barron Hill, Staffordshire, describing Mrs. Whyte as 'a lady well acquainted with the arts', (*Treasures*, iii. 390). It is possible that Barron Hill is a misprint for Barrow Hill (see above). 5. On analogy with the provenance of the predella panel of the *Pietà* by Raphael now in the Isabella Stewart Gardner Museum, Boston, for which see P. Hendy, *European and American Paintings in the Isabella Stewart Gardner Museum* (Boston, 1974), pp. 193–4. 6. Incorrectly stated by Venturi, *Storia* ix, pt. 4 (1929), 203 n., as once belonging to Lord Amherst of Hackney, whose collection was dispersed in the same sale at Sotheby's as Capt. Dawson's. 7. M. Boschini, *La carta del Navegar Pitoresco* (Venice, 1660), ed. A. Pallucchini (Venice,

1966), p. 354. 8. The Torre del Commune also occurs on the *Portrait of Count Pietro Secco-Suardo* in the Uffizi, signed and dated 1563, repr. D. Cugini, *Moroni pittore* (Bergamo, 1939), pl. 21. It occurs again on the *Portrait of Bartolomeo Bongo* in the Metropolitan Museum, New York, of which there is a variant at Prague (National Gallery inv. O.8328) ascribed to an anonymous Italian painter of the second half of the sixteenth century.

# GIOVANNI BATTISTA NALDINI                         1537–1591

Florentine school. He was also active in Rome. He began as the pupil of Pontormo, but a more forceful directive came from Vasari with whom he often collaborated. There are a number of altar-pieces by Naldini in the main Florentine churches. He was a prolific draughtsman and a number of his drawings are in the collection at Christ Church, Oxford. He became a member of the Accademia del Disegno in 1564.

## A1014    CHRIST IN GLORY WITH SS. AGNES AND HELENA
         (*MODELLO* FOR AN ALTAR-PIECE)                          **Pl. 92**

Wood. 49 × 32 (arched).

On the back an old inscription in brown stain: *Già Esistente | nella Galleria | Riccardi in | via Larga* and the number *20* in the top right corner.

Condition: good.

Collections: Palazzo Riccardi, Florence.[1]

Purchased 1964.

Exhibited: London, P. & D. Colnaghi & Co. Ltd., *Paintings by Old Masters*, 1964 (5) repr.

Literature: *Annual Report*, 1964, 37–9 repr.; P. Barocchi, 'Itinerario di Giovambattista Naldini', *Arte antica e moderna*, 31–2 (1965), 254; P. Cannon-Brookes, 'Three Notes on Maso da San Friano', *Burlington Magazine*, 107 (1965), 195–6 repr.

The present attribution of No. A1014 to Naldini is due to Mr. P. M. R. Pouncey, who also identified the panel as the *modello* for the altar-piece once in the chapel of the Compagnia di S. Agnese in the church of S. Maria del Carmine, Florence. There can be little doubt that this altar-piece was destroyed in the fire of 1771.[2] It was much admired in its time and was fully described by Baldinucci,[3] Borghini,[4] and Bocchi-Cinelli,[5] who all clearly recognized it as a work by Naldini.[6] No. A1014 is therefore of considerable historical importance as a record of the design of the lost altar-piece. Vasari (iii. 197–9) describes an Ascension play that was performed in the Carmine on the eve of the festival and, since the performance was staged by the Compagnia di S. Agnese, it is highly likely that this event may have influenced the choice of a subject for their altar-piece.

Dr. Peter Cannon-Brookes has drawn attention to a number of drawings in the Gabinetto Disegni e Stampe of the Uffizi (see Drawings below), which appear to relate to the altar-piece, but are attributable to Maso da San Friano. With the aid of documents Cannon-Brookes has made the following convincing reconstruction of the events surrounding the painting of the altarpiece. In 1564 the old altar appears to have been removed from the chapel of the Compagnia di S. Agnese. An architect, Baccino di Filippo d'Agnolo, was appointed in 1566 to reorganize the church and by 1568 the structural changes were under way. Cannon-Brookes did not find a document to connect Maso da San Friano directly with any of these events, but on the evidence of a compositional drawing in the Uffizi (inv. 602S) and the date (*2ᵈ agosto 1565*) which occurs on the verso of another related drawing (Uffizi, 14426F), he surmises that the altar-piece was originally commissioned from Maso da San Friano *c.* 1564–5. It appears that at first its execution was held up, owing to the structural changes being made to the chapel at this time, and that, finally, it was not completed, owing to the artist's death in 1571. Cannon-Brookes, therefore, reasonably concludes that the commission for the altar-piece was transferred to Naldini some time during the first half of the eighth decade.[6]

Naldini seems to have made several compositional changes when granted the commission. Comparison of No. A1014 with the important preparatory drawing by Maso da San Friano (Uffizi 602S) shows that on the *modello* the Virgin has now become the pivot of the whole composition linking the figure of the Risen Christ with the saints on the ground below. Cannon-Brookes observed that these compositional changes reflect one of Maso da San Friano's own rejected designs (see the *pentimenti* on the drawing, Uffizi, 602S), but, equally, many of the figures are also derived from Vasari.[7]

Dr. Marcia Hall (verbal communication) proposes that the Carmine altar-piece should be dated between the *Nativity* in the Mazzinghi chapel in S. Maria Novella, Florence, documented in 1573, and the *Deposition* in the Verrazani chapel in S. Croce, Florence, which is signed and dated 1583. More specifically, Hall regards the Carmine altar-piece as a work painted contemporaneously with the *Purification of the Virgin* in the Sommaia chapel in S. Maria Novella, Florence, which is documented in 1577.

REFERENCES: 1. As stated in the inscription on the back of the panel, but No. A1014 is not recorded in the Riccardi inventory of 1612 published in full by H. Keutner, 'Zu einigen Bildnissen des frühen Florentiner Manierismus', *Mitteilungen des Kunsthistorischen Institutes in*

*Florenz*, 8 (1959), 151–5. 2. U. Procacci, 'L'incendio della Chiesa del Carmine del 1771', *Rivista d'arte*, 14 (1932), 167. Also see W. and E. Paatz, *Die Kirchen von Florenz*, iii (Frankfurt am Main, 1952), 234. 3. F. Baldinucci, *Notizie de' professori del disegno da Cimabue in qua*, v (Florence, 1702), 178. 4. R. Borghini, *Il Riposo* (edn. Florence, 1730), pp. 163 and 503–4. Borghini levels criticism at the altar-piece on grounds of iconography (op. cit., pp. 88–9), pointing out that the Virgin was made to look too young and that neither SS. Agnes nor Helena were alive at the time of the Ascension. Dr. Peter Cannon-Brookes ('Three Notes on Maso da San Friano', *Burlington Magazine*, 107 (1965), 195) has suggested that the inclusion of S. Helena may be explained by the fact that Elena Ottonelli (d. 1576) bequeathed funds for the altar-piece and had shown an interest in its development some years before her death. Professor Luke Herrmann has pointed out (notes in the departmental files) that the chapel adjacent to that of the Compagnia di S. Agnese in the Carmine was dedicated to S. Helena. 5. F. Bocchi, *Le bellezze della città di Firenze* (ed. G. Cinelli, Florence, 1677), pp. 158–9. 6. L. Berti, 'Nota a Maso da San Friano', in *Scritti di storia dell' arte in onore di Mario Salmi*, iii (Rome, 1963), 86, refers to a *modello* in a private collection in Genoa of an *Ascension*, which he attributes to Maso da San Friano. A letter from Dr. Luciano Berti dated 17 Dec. 1964 confirms that No. A1014 is not the *modello* to which he referred, and Dr. Valentino Pace (verbal communication) has kindly informed the compiler that a photograph of the *modello* seen by Berti is now in the possession of Professor Giuliano Briganti. Pace confirms the attribution of the *modello* to Maso da San Friano, but the photograph remains unpublished. 7. As pointed out by the compiler of the exhibition entitled *The Age of Vasari*, Notre Dame, Indiana, and Binghamton, 1970, pp. 75–6 D 11.

## DRAWINGS

Attributed to Maso da San Friano:

1. Florence, Uffizi, Gabinetto Disegni e Stampe, *Study for the Ascension of Christ with SS. Agnese and Helena*, inv. 602S. 410 × 270 mm., pen and brown ink and brown wash over black chalk on greenish-tinted paper.

2. Florence, Uffizi, Gabinetto Disegni e Stampe, *Study for S. Agnese*, inv. 14419F, cut down, circular 86 mm., black chalk.

3. Florence, Uffizi, Gabinetto Disegni e Stampe, *Study for S. Agnese*, inv. 14426F, 124 × 102 mm., black chalk. Inscribed on verso, '. . . 2ᵈ *agosto 1565/fa la famosa signora posa*(?) . .'.

4. Florence, Uffizi, Gabinetto Disegni e Stampe, *Study for S. Helena*, inv. 14423F, 144 × 83 mm., black chalk.

5. Florence, Uffizi, Gabinetto Disegni e Stampe, *Study for S. Helena*, inv. 14424F, 124 × 99 mm., black chalk.

6. Florence, Uffizi, Gabinetto Disegni e Stampe, *Study for the figure of Christ*, inv. 7283F, 435 × 262 mm., black chalk.

7. Florence, Uffizi, Gabinetto Disegni e Stampe, *Study for S. Agnese*(?), inv. 14428F, 228 × 115 mm., black chalk.

Nos. 1–5 published and repr. by P. Cannon-Brookes, 'Three Notes on Maso da San Friano', *Burlington Magazine*, 107 (1965), 195–6, figs. 32–6. No. 7 is repr. in *Mostra di*

*disegni dei fondatori dell' Accademia delle Arti del Disegno* (Florence, 1963), pp. 42–3, No 44, fig. 35.

Attributed to Naldini:

1. Paris, Louvre, Cabinet des Dessins, *Study for the Ascension of Christ with SS. Agnese an Helena*, inv. 10 306, 272×261, red chalk heightened with white. Repr. C. Monbei Goguel, 'Giorgio Vasari et son temps', *Revue de l'art*, 14 (1971), 107, fig. 3.

2. Present whereabouts unknown, *Study for the Head of S. Helena*, 335×260 mm., e collection of C. R. Rudolf. Photograph in the departmental files.

3. Washington D.C., Edmund Pillsbury collection, *Study for the Ascension of Christ wit SS. Agnes and Helena*, 191×181 mm., pen and brown ink and brown wash on pape prepared with a red wash. Collections: Padre Sebastiano Resta (inscribed *m 157*), a Cesare Nebbia; H. S. Olivier (Christie's, 27 June 1967, lot 175, as Cesare Nebbia). Repr *The Age of Vasari*, an exhibition held at Notre Dame, Indiana, and Binghamton, 1970 Catalogue, pp. 75–6 D 11.

## ANONYMOUS NEAPOLITAN SCHOOL (?)          1400–142C

### A231   TARQUIN AND LUCRETIA (*CASSONE* PANEL)          Pl. 9.

Wood. Painted surface, 29 × 115·5. Size of panel, including frame, 51·7× 136·6. The frame is, for the most part, original, but it has been gessoec and regilt along the upper and lower edges, and at both ends. It shoulc be emphasized that these repairs do not include the emblems decoratin; the panel immediately above and below the painted surface, although th two coats of arms placed at both ends of the *cassone* do appear to have bee mutilated.

Condition: poor. The surface is scoured and abraded throughout and th figures are badly rubbed. Several of the faces are disfigured by ol retouching and there is some flaking on the left.

Presented by the Revd. Greville John Chester, 1864.

Literature: Schubring, *Cassoni*, i (1915), 368, No. 645 (with inaccurat measurements).

There are incised lines in the architecture.

The painter has followed the story of Tarquin and Lucretia as recounte by Livy, *Ab Urbe Condita*, I. 58–60. On the left, Sextus Tarquin, son o Superbus Tarquin, enters Lucretia's chamber. The second scene show Lucretia dictating a letter to her husband, L. Tarquinius Collatinus, ask ing him to return to Collatia. Collatinus is depicted arriving on the righ and in the next scene, Lucretia stabs herself in front of him. The final scen represents the expulsion of the Tarquins from Rome.

The composition of No. A231 is repeated almost exactly on a much damaged *cassone* in the Landesmuseum, Zurich, which is, in all probability, a product of the same workshop.[1] The same composition occurs again, with some minor variations, on another *cassone* panel in the Musée Jacquemart-André, Paris.[2]

Schubring ascribed the panel to the school of Verona. The compiler believes that No. A231 is by the same hand as two *cassone* panels recently published by Professor Ferdinando Bologna, with an attribution to an anonymous painter active in Naples at the beginning of the fifteenth century, whom he designates as the Master of the Siege of Taranto.[3] The name-piece is now in the Metropolitan Museum, New York (*Scenes from the Siege of Taranto*),[4] and to this panel Bologna has added one in the Bargello Museum, Florence (*A Scene from Giovanni Bocaccio's Decamerone, Giornata X, Novella 9*).[5] The spirited treatment of the figures, characterized by their large noses and by a curious stooping movement caused by the bending of the body from the waist, the handling of the architecture, and the drawing of the horses are all features found on No. A231, as well as on the two panels cited by Bologna. The same writer justly claims that the style of this anonymous painter is closely related to that of one of the artists responsible for the Marian cycle in the church of S. Caterina, Galatina.[6]

The insignia decorating the inner part of the framework of No. A231 (fleurs-de-lys and lion/leopard passant) are an undeniable Angevin reference.

It does not necessarily follow from the extant evidence that the painter of this group of works was Neapolitan. His style does have affinities with that of the Florentine painter Giovanni Toscani (the Master of the Griggs Crucifixion)[7] and with the closely related and very prolific painter of *cassoni* and *deschi*, who may be designated as the Master of Cracow.[8]

REFERENCES: 1. Inv. 7254, 29·5 × 120. Negative numbers 11283–7. This information was kindly sent by Dr. W. Trechsler. 2. Inv. 1046, 32 × 105. See Schubring, *Cassoni*, i. 368, No. 644, repr. ii, pl. CXXXVIII. 3. F. Bologna, *I pittori alla corte angioina di Napoli 1266–1414* (Rome, 1969), pp. 343–6. 4. Inv. 07. 120. 1. H. B. Wehle, *A Catalogue of Italian, Spanish and Byzantine Paintings* (New York, 1940), p. 19, with repr. of details by Bologna, op. cit. viii. 2–3. 5. Inv. (Mobili Antichi) 160, 69 × 145. Details repr. by Bologna, op. cit., viii. 4–5. 6. See A. Putignani, *Il Tempio di S. Caterina in Galatina*, 2nd edn. (Galatina, 1968), pp. 65–73, repr. on pp. 69, 74, and 79. 7. For whom see L. Bellosi, 'Il Maestro della Crocifissione Griggs: Giovanni Toscani', *Paragone* 193 (1966), 44–58. 8. The name-piece, *Scenes from the 'Gesta Romanorum'* (?), is in the National Museum, Cracow (inv. XII–198), for which see the exhibition catalogue *La Peinture italienne des XIVᵉ et XVᵉ siècles* (Cracow, 1961), p. 53, No. 33 repr. A number of panels can be ascribed to this hand. The appellation was first suggested by Dr. Miklòs Boskovits.

# NICOLA DI MAESTRO ANTONIO D'ANCONA

active 1472

Marchigian school. The name is known from an altar-piece signed and dated 1472, which is now in the Pittsburgh Museum of Art. The style of Nicola di Maestro Antonio appears to have been chiefly derived from Paduan, in particular Giorgio Schiavone, and Central Italian sources. At certain stages he also appears to have been influenced by Carlo Crivelli and at others he displays knowledge of the work of Piero della Francesca. His present known *œuvre* is small.

A96   S. MARY MAGDALEN                                       Pl. 94

Wood. 60×34·5 (quatrefoil).

Condition: good.[1] There are a few local damages in the drapery and on the ear, but the other flesh parts are particularly well preserved.

Fox-Strangways Gift, 1850.

Exhibited: Venice, Palazzo Ducale, *Carlo Crivelli e I Crivelleschi*, 1961 (54).

Literature: see No. A97 below.

A97   S. JAMES OF THE MARCHES (?)                           Pl. 95

Wood. 60·5×33·8 (quatrefoil).

Condition: fair.[2] The head is badly damaged. There are several blemishes in the face, particularly above the right eye, but the mouth and chin are reasonably well intact. The hands and the left sleeve are better preserved. There is some damage around the edges of the panel. The condition of No. A97 is generally not as good as that of No. A96.

Fox-Strangways Gift, 1850.

Exhibited: Venice, Palazzo Ducale, *Carlo Crivelli e I Crivelleschi*, 1961 (55).

Literature: Crowe and Cavalcaselle, *History*, iii (1866), 134: 2nd edn., v (1914), 242; B. Berenson, 'Nicola di Maestro Antonio di Ancona', *Rassegna d'arte*, 2 (1915), 168–70 repr.; Thieme–Becker, *Lexikon*, xxv (1931), 431; L. Serra, *L'arte nelle Marche. Il periodo del Rinascimento* (Rome, 1934), p. 372, n. 32; Van Marle, *Development*, xv (1934), 97 repr.; Berenson, 1936, 342: 1957, 121; R. Pallucchini, 'Commento alla mostra di Ancona', *Arte veneta*, 4 (1950), 18; F. Zeri, 'Qualcosa su Nicola di Maestro Antonio', *Paragone*, 107 (1958), 40; G. Briganti, 'Un inedito di Nicola di Maestro Antonio', *Arte antica e moderna*, 13–16 (1961), 177–8; P. Zampetti, *Catalogo della mostra Carlo Crivelli e i Crivelleschi* (Venice, 1961), p. 172, Nos. 54–5 repr.; R. Pallucchini, 'Carlo Crivelli in Palazzo Ducale',

*Pantheon*, 19 (1961), 282; P. Zampetti, *Paintings from the Marches. Gentile to Raphael*, Eng. edn. (London, 1971), pp. 196–7 repr.

Nos. A96 and A97 were first attributed to Nicola di Maestro Antonio d'Ancona by Berenson. His attribution superseded those made in the first and second editions, respectively, of Crowe and Cavalcaselle to the ambience of Niccolò Alunno da Foligno and to Vittorio Crivelli.

Two other panels of similar dimensions and with similarly shaped frames are known: *S. Peter* (formerly Gambier Parry collection, now London, Courtauld Institute Galleries)[3] and *S. Bartholomew* (La Spezia, Amadeo Lia collection).[4] Low relief has been used to heighten the key and the collar of S. Peter.

Berenson stated that the panels in Oxford and London came from a dismembered polyptych. This presupposes a number of other quatrefoil panels in the original structure to balance the three male saints facing to the left and the S. Mary Magdalen, who also faces to the left, although her body is directed to the right. Berenson did not stipulate to which part of the altar-piece these panels once belonged and their location has prompted some discussion. The frames of Nos. A96 and A97 and that of *S. Peter* in London are undoubtedly nineteenth century, but the original shape of the panels seems to have been preserved. Professor Rodolfo Pallucchini (1950) has argued unreasonably that the unusual shape is the result of a latter-day extravaganza, whereas, in fact, examination of the punching shows that the panels may have been trimmed, as opposed to extensively cut down. Dr. Federico Zeri (written communication) has pointed out that it was not uncommon in the Marches at this date for quatrefoil panels to be used in the shutters of altar-pieces.[5] Professor Giuliano Briganti indicated that they are often placed in the terminals of polyptyches and they are also sometimes found in predellas.[6]

Pallucchini (1950 and 1961) claimed that two other panels, *Christ in the Tomb* (Jesi, Pinacoteca) and *S. John the Baptist* (Baltimore, Walters Art Gallery)[7] came from the same complex as Nos. A96 and A97. Briganti rightly rejected this suggestion on grounds of stylistic incompatibility and the different treatment of the gold ground.

Nos. A96 and A97 have been variously dated, although all writers place them after the altar-piece of 1472. Zeri suggests that they must belong to a Crivellesque moment at the opening of the painter's last phase towards the end of the eighth decade, perhaps close to the Stonyhurst Madonna.[8]

The usual identification of the saint on No. A97 with S. Francis is not convincing. Briganti tentatively suggests a local saint, S. James of the

Marches (born 1391 at Monte Brandone, near Ascoli Piceno, died 1476 at Naples). This identification is a distinct possibility, although the saint is not depicted elsewhere with a crucifix in his hand.[9]

REFERENCES: 1. Crowe and Cavalcaselle, *History*, iii (1866), 134, stated that the 'character of these two foliated panels is uncertain on account of repainting' and No. A96 is described in their text as 'S. Catherine(?)'. 2. See note 1. The old attribution for both panels, as noted by Crowe and Cavalcaselle, was to Giotto. 3. Inv. 35, 59·3 × 33, facing left. First published with Nos. A96 and A97 by B. Berenson, 'Nicola di Maestro Antonio di Ancona', *Rassegna d'arte*, 2 (1915), 168–70 repr. The following information is on the back of the panel: *Massacio : 17 : Alex. Murray Esq. | No. 8; TMW 1855 and St. Peter | early Florentine | end of 14th Century | TMW Augst. 1855 | (?)£ a DF | from Lord Kilmoreys Collectn.* The compiler would like to thank Dr. Philip Troutman for his help while examining this panel. 4. Measuring 67 × 40, facing left, Published by G. Briganti, 'Un inedito di Nicola di Maestro Antonio', *Arte antica e moderna*, 13–16 (1961), 177–8. The panel was exhibited in Venice, Palazzo Ducale, *Mostra Carlo Crivelli e i Crivelleschi*, 1961 (56). 5. Letter of 3 Feb. 1969 referring to a triptych in the Walters Art Gallery, Baltimore (inv. 37. 699 A, B, C) attributed to Carlo da Camerino by Zeri and reproduced by G. Vitalini Sacconi, *Pittura marchigiana. La scuola camerinese* (Trieste, 1968), p. 64, pl. XVI. 6. See F. Santi, *Galleria Nazionale dell'Umbria. Dipinti, sculture e oggetti d'arte di età romanica e gotica* (Rome, 1969), p. 122, Cat. no. 101 repr., for a polyptych by a follower of Antonio da Fabriano with panels of quatrefoil shape in the predella. Also see the altar-piece signed and dated 1422 by Pietro di Domenico da Montepulciano, now in the Pinacoteca at Recanati, which was exhibited in the exhibition *Pittura nel maceratese dal duecento al tardo gotico*, Macerata, Chiesa di S. Paolo, 1971, pp. 153–4, Cat. no. 38 repr. 7. The panel at Jesi was exhibited at the *Mostra Carlo Crivelli e i Crivelleschi*, Venice, Palazzo Ducale, 1961 (53). The *S. John the Baptist* at Baltimore (inv. 37. 687) is reproduced by Berenson, op. cit., on p. 171. 8. The Stonyhurst Madonna was sold at Sotheby's, 6 Dec. 1967, lot 24 repr. 9. G. Kaftal, *Iconography of the Saints in Central and South Italian Schools of Painting* (Florence, 1965), cols. 586–8, No. 193. But see L. Réau, *Iconographie de l'art chrétien*, iii, pt. 2 (Paris, 1958), 705–6, where he says that one of the saint's attributes is a gangrenous wound and this is possibly what is depicted on No. A97. For a biography of this saint see G. Fiori, *San Giacomo della Marca* (Rome, 1964), and his sermons have been examined by C. Delcorno, 'Due prediche volgari di Jacopo della Marca recitate a Padova nel 1460', *Atti dell' Istituto Veneto di Scienza, Lettere ed Arti*, 128 (1969–70), 135–205.

## ORCAGNA                                        active 1343, died 1368

Florentine school. His real name was Andrea di Cione, called Orcagna. Painter, architect and sculptor. The Strozzi altar-piece in S. Maria Novella, Florence, is his most important work on panel. There are only fragmentary remains of the extensive fresco cycles painted for S. Croce and S. Maria Novella. He may have been the pupil of Maso di Banco. His brothers Nardo and Jacopo were also painters and another brother, Matteo, was certainly active in his workshop. While the style of Nardo is distinctive that of Jacopo is still much disputed.

## STUDIO OF ORCAGNA

A74 THE BIRTH OF THE VIRGIN (PREDELLA PANEL FROM
AN ALTAR-PIECE) **Pl. 96**

Wood. 37·4×65·2 (sloped at the corners).

On the back a label inscribed by an eighteenth-century hand, *Cassone che rappresen | ta Nativita della Mad | onna di Taddeo Gaddi | No.* The number .*2(o)*. occurs. Another number *63* has been crossed through. Both these numbers are partly covered by a Fox-Strangways label (*No. 9*).

Condition: good. Repairs have been made to the drapery of the figure holding the Child in the right foreground and the Child's left foot has been repainted. The drapery of the woman at the extreme left of the composition is rather worn and the lower half is retouched. The left shoulder of the woman receiving the two visitors is repainted, the left side of her face damaged, and the highlights on her drapery strengthened. The faces of all the other figures are extremely well preserved, also the details of the interior. There is some damage to the red blanket on the bed.

Exhibited: London, Royal Academy, *Italian Art and Britain*, 1960 (277).

Fox-Strangways Gift, 1850.

Literature: Crowe and Cavalcaselle, *History*, 2nd edn., ii (1903), 136, n. 5; W. Suida, 'Studien zur Trecentomalerei', *Reportium für Kunstwissenschaft*, 31 (1908), 209; W. Suida, 'Zur florentiner Trecentomalerei', *Monatshefte für Kunstwissenschaft*, 1 (1908), 1011–12 repr.; O. Sirén, 'Addenda und Errata zu meinen Giottino-Buch', *Monatshefte für Kunstwissenschaft*, 1 (1908), 1122; B. Khvoshinsky and M. Salmi, *Pittori toscani del trecento*, ii (Rome, 1914), 32; O. Sirén, 'Pictures in America by Bernardo Daddi, Taddeo Gaddi, Andrea Orcagna and his Brothers—I', *Art in America*, 2 (1914), 270 and 273; O. Sirén, *Giotto and Some of His Followers* (Oxford, 1917), pp. 228 and 275; Van Marle, *Development*, iii (1924), 469, n. 2, and 508 n.; Berenson, 1932, 403: 1936, 346: 1963, 163: K. Steinweg, in Thieme–Becker, *Lexikon*, xxvi (1932), 38; H. D. Gronau, *Andrea Orcagna und Nardo di Cione* (Berlin, 1937), pp. 55 and 86, n. 150 repr.; G. Marchini, 'Gli affreschi perduti di Giotto in una cappella di S. Croce', *Rivista d'arte*, 20 (1938), 220 and 223 repr.; M. Meiss, *Painting in Florence and Siena after the Black Death* (Princeton, 1951), p. 21, n. 27; Offner, *Corpus*, sec. IV. ii (1960), 91, n. 12; 96, n. 11, iii (1965), 77, n. 11; M. Boskovits, 'Orcagna in 1357—and in Other Times', *Burlington Magazine*, 113 (1971), 239, n. 7, and *Pittura fiorentina alla vigilia del Rinascimanto* (Florence, 1975), pp. 51, 202 n. 104, 210 n. 38, and 374 repr. (detail only, fig. 90), R. Fremantle, *Florentine Gothic Painters* (London, 1975), pp. 143 and 583 repr.

The architecture on No. A74 has been rather clumsily drawn and the parapet coarsely painted.

Sirén (1917) was the first writer to observe that No. A74 came from the same predella as a panel of the *Presentation of Christ in the Temple*, now in a private collection in Florence.[1] Steinweg suggested that two panels in the Pinacoteca Vaticana (*Annunciation of Joachim* and the *Flight into Egypt*) also belonged.[2] Steinweg reasonably supposed that a panel of the *Marriage of the Virgin* might have been the subject of one of the missing predella panels. Owing to their shape, the two panels in the Pinacoteca Vaticana were almost certainly placed beneath the pilasters of the altar-piece at either end of the predella.

Only Berenson and Sirén (1914 and 1917) regarded the panel as of sufficient quality to merit an attribution to Orcagna himself.[3] Offner nominated No. A74 as the head of a small group of panels ascribed to an anonymous painter whom he designated as the Master of the Ashmolean Predella.[4] In terms of style, the Master of the Ashmolean Predella stands midway between Orcagna and Jacopo di Cione for both of whom, according to Dr. Miklòs Boskovits (1975), the painter appears to have worked as an assistant at different times. His abilities are probably best represented on No. A74, which, in Boskovits's opinion, was painted between 1365 and 1370. As Offner first observed, the Master of the Ashmolean Predella appears to have assisted the painter responsible for the altar-piece of the *Crucifixion* in the National Gallery, London, which is usually ascribed to Jacopo di Cione.[5]

Gronau compared the composition of No. A74 with Orcagna's representation of the same scene on the marble Tabernacle in Orsanmichele, Florence, and also with the fresco in the chapel of S. Anne in the cloisters of S. Maria Novella, painted by a follower of Nardo di Cione.[6] Professor Giuseppe Marchini suggested that another prototype for the panel in Oxford might have been the lost fresco in the Tosinghi chapel, in S. Croce, Florence, ascribed by Vasari (i. 374) to Giotto.

REFERENCES: 1. Measuring 38 × 68·5. The panel was formerly in the collection of C. Moll, Vienna (sold by P. Cassirer, Berlin, 15 Mar. 1917, No. 3) and Dr. F. Haniel, Munich. The panel was offered for sale at Christie's, 1 July 1966, lot 52, Various Properties, and bt. in. It was offered for sale again at Christie's, 24 Nov. 1967, lot 74 repr., Various Properties. The panel was exhibited at Galleria Finarte, Milan, *Mostra di dipinti del XIV e XV secolo*, pp. 20–1, No. 6 repr.; another repr. in M. Meiss, *Painting in Florence and Siena after the Black Death* (Princeton, 1951), pl. 18. 2. Inv. 103 and 96, each 38 × 35. For repr. see Mons. E. Francia, *Pinacoteca Vaticana* (Milan, 1960), pls. 20 and 26 respectively. Both panels were first published by O. Sirén, 'Alcune note aggiuntive a quadri primitivi nella Galleria Vaticana', *L'arte*, 24 (1921), 100. 3. With reference to the Literature

above specific attributions for No. A74 have been suggested as follows: by Langton Douglas, in the second edition of Crowe and Cavalcaselle, to Niccolò di Pietro Gerini; by Suida (1908)[1] to Nardo di Cione (?), but later (1908)[2] to the workshop of Orcagna; by Sirén (1908) to Jacopo di Cione influenced by Niccolò di Pietro Gerini; by Khvoshinksy and Salmi to Jacopo di Cione; by Steinweg to an anonymous painter influenced by both Andrea and Nardo di Cione; by Gronau (1937) to the workshop of Nardo di Cione. Meiss describes the panel simply as 'Cionesque'. 4. The Master of the Ashmolean Predella has recently been discussed by M. Boskovits, *Pittura fiorentina alla vigilia del Rinascimento* (Florence, 1975), pp. 51, 98, 202, n. 104, 210, n. 38, 217, n. 90, 233, n. 132. A list of works attributed to this master by Dr. Boskovits will be found on pp. 372–6 of the publication cited here. The appellation was originally due to Offner (*Corpus*, sec. IV. iii (1965), 77, n. 11), and first occurs in his discussion (op. cit., 75–81) of the Orcagnesque altarpiece of the *Crucifixion* in the National Gallery, London (inv. 1468), for which see note 5 below, and not in Offner's article 'The Straus Collection goes to Texas', *Art News*, xliv (1945), 19, as Boskovits asserted on a previous occasion ('Orcagna in 1357—and in Other Times', *Burlington Magazine*, cliii (1971), 239 n. 7). The late Klara Steinweg kindly supplied the compiler with a list of the works attributed by Offner to the Master of the Ashmolean Predella while this catalogue was in preparation and in his latest publication Boskovits (op. cit., 372–6) has added considerably to this list. In the process he re-attributes two of the works originally regarded by Offner as being by the Master of the Ashmolean Predella: Pisa, Museo di S. Martino, formerly Calci, Certosa, *Virgin and Child with SS. Peter, Catherine, Anthony and an unidentified female Saint*, to the Maestro del altare di S. Niccolò (op. cit., p. 211, n. 55) and Le Mans, Musée, *SS. James and Bartholomew*, to the Master della Cappella Rinuccini (op. cit., p. 359 repr. fig. 59). Boskovits argues that the Master of the Ashmolean Predella worked not only on the altar-piece of the *Crucifixion* in the National Gallery, but also on the altar-piece of *S. Matthew* in the Uffizi (inv. 3163). 5. Inv. 1468. M. Davies, *National Gallery Catalogues. The Earlier Italian Schools*, 2nd edn. (London, 1962), pp. 396–7, as style of Orcagna. There is a detailed stylistic analysis of the altar-piece by Offner, *Corpus*, sec. IV. iii (1965), 75–81, pls. IV–IV[1–6]. The compiler believes that the Master of the Ashmolean Predella played a more important part in the painting of this altar-piece than Offner concluded. 6. Repr. H. D. Gronau, *Andrea Orcagna und Nardo di Cione* (Berlin, 1937), figs. 11 and 42 respectively. Also compare the composition of the scene as depicted by Niccolò di Pietro Gerini, or his workshop, in the choir of the Oratorio di S. Maria Primerana, Fiesole.

A300a THE ANGEL ANNUNCIANT (FRAGMENT FROM A
  SMALL PORTABLE ALTAR-PIECE)                    Pl. 97

Wood. 6·5 (round).

Condition: good.

Fortnum Bequest, 1899.

Literature: see No. A300b below.

A300b THE VIRGIN ANNUNCIATE (FRAGMENT FROM A
  SMALL PORTABLE ALTAR-PIECE)                    Pl. 97

Wood. 6·5 (round).

Condition: good.

Fortnum Bequest, 1899.

Literature: R. Offner, 'The Straus Collection goes to Texas. Comments on its more Important Aspects', *Art News*, 44 (1945), 21; M. Boskovits, *Pittura fiorentina alla vigilia del Rinascimento* (Florence, 1975), p. 374.

At the time of acquisition both roundels were framed together with No. A300. They are clearly not related to that panel, which is now attributed to the Master of San Martino alla Palma (see pp. 111–12 above). The roundels have obviously been cut from a larger complex and were perhaps originally found in the gables of a small portable altar-piece.

In earlier catalogues of the Ashmolean Museum Nos. A300a and b were described as 'style of Orcagna' and related to the altar-piece of the *Crucifixion* in the National Gallery, London (inv. 1468). Offner ascribed these fragments to an anonymous follower of Orcagna, whom he designated the Master of the Golden Gate.[1] This painter is named after a predella panel of the *Meeting at the Golden Gate*, formerly in the Straus collection and now in the Museum of Fine Arts, Houston.[2] Dr. Miklòs Boskovits with some justification, regards the Master of the Golden Gate as the same personality as the Master of the Ashmolean Predella, and suggests a date of 1370–5 for these two roundels.[3]

REFERENCES: 1. A list of Offner's attributions to the Master of the Golden Gate was kindly supplied by the late Dr. Klara Steinweg. 2. Inv. 44. 561. 3. M. Boskovits, *Pittura fiorentina alla vigilia del Rinascimento* (Florence, 1975), p. 210 n. 38.

A366   THE CRUCIFIXION WITH THE VIRGIN MARY AND
          S. JOHN (PANEL FROM A DIPTYCH)                    Pl. 98

Wood (cradled). 24×18.

Condition: poor. Cleaned in 1958. The gold background is intact, apart from some damage on the right and a heavy craquelure. The figure of Christ is badly abraded and the draperies of the Virgin and S. John are rubbed. There are a number of small repairs, but generally much of the original quality has survived.[1]

Presented by G. Gidley Robinson, 1921.

Literature: *Annual Report*, 1921, 23; T. Borenius, 'Notes on Various Works of Art', *Burlington Magazine*, 40 (1922), 139 repr.; Van Marle, *Development*, ix (1927), 177, n.; M. Boskovits, *Pittura fiorentina alla vigilia del Rinascimento* (Florence, 1975), p. 328.

The panel has been trimmed along the edges, but, although there are no signs of hinge marks, it is most probable that No. A366 was orginally the wing of a small diptych.

No. A366 was published by Borenius as a work by a follower of Lorenzo Monaco, an opinion shared by C. F. Bell in the *Annual Report* of 1921 and also by Van Marle. This attribution cannot be substantiated and, in fact, the panel appears to be slightly earlier in date.

Offner ascribed No. A366 to the Master of the Academy Crucifixion, an anonymous Orcagnesque painter, whose name is derived from a *Crucifixion with the Virgin and S. John* in the Accademia, Florence,[2] and to whom Offner assigned a number of other panels, all of which, in his opinion, showed some influence of Jacopo di Cione. Dr. Miklòs Boskovits attributes No. A366 to Jacopo di Cione and suggests a date of 1380–5.

A panel of the *Crucifixion with the Virgin Mary and S. John* in the Capodimonte Gallery, Naples,[3] is not by the same hand as No. A366, as suggested in the 1961 edition of the Ashmolean catalogue.

With regard to the iconography, both the seated figures on No. A366, the Virgin with Her hands crossed at the wrists and S. John with his right hand supporting his head, are depicted with the traditional gestures of grief.[4]

REFERENCES: 1. For the state of the panel before cleaning see the reproduction in T. Borenius, 'Notes on Various Works of Art,' *Burlington Magazine*, 40 (1922), pl. IID, opp. 139. 2. Inv. 4670. L. Marcucci, *Gallerie Nazionali di Firenze. I dipinti toscani del secolo XIV* (Rome, 1965), pp. 106–7, No. 65 repr. as by Niccolò di Pietro Gerini. A list of Offner's attributions to the Master of the Academy Crucifixion was kindly supplied by the late Dr. Klara Steinweg. M. Boskovits, *Pittura fiorentina alla vigilia del Rinascimento* (Florence, 1975), p. 323, attributes the *Crucifixion* to Jacopo di Cione. 3. Inv. 84266. Published by A. O. Quintavalle, 'Tavolette del tardo Trecento e del Quattrocento nella Pinacoteca del Museo Nazionale di Napoli', *Bollettino d'arte*, 25 (1932), 400–1 repr., with an attribution to a follower of Giovanni di Paolo. 4. D. Schorr, 'The Mourning Virgin and S. John', *Art Bulletin*, 22 (1940), 61–9. For a discussion of the seated Virgin and S. John see M. Meiss, 'Highlands in the Lowlands. Jan van Eyck, the Master of Flémalle and the Franco-Italian Tradition', *Gazette des beaux-arts*, 57 (1961), 284–8.

# LELIO ORSI 1511–1589

Modenese school. Painter and architect. He was active in Novellara, Reggio Emilia, and Parma. He is known to have visited Venice and Rome. Orsi specialized in painting small easel pictures, some of which treat traditional subjects with great imaginative force. His style combined the colour of Correggio with the drawing of Michelangelo, but some influence of Giulio Romano and Parmigianino is also evident.

A938   S. MICHAEL SUBDUING SATAN AND WEIGHING
       THE SOULS OF THE DEAD                                    **Pl. 99**

Wood (fastened at the back with two horizontal battens). 52·3 × 39·5.

On the back several wax impressions of seals, four of these with the letters *IB* (?) in scrolled italics. There are also six very faint impressions of a larger oval seal in brown wax, now hardly decipherable, but possibly showing the letters *A* and *C* in a circle joined horizontally by a straight line and surmounted by a cross.

Condition: fair. There are several vertical splits in the panel and a number of small retouches on the figures.

Collections: Cowper, Panshanger (Christie's, 16 Oct. 1953, lot 108, bt. Arthur Kauffmann); John Harinden, Lechlade, Gloucestershire.

Purchased 1960.

Exhibited: Bordeaux, *Bosch, Goya et la fantastique*, 1957 (130) repr.

Literature: *Annual Report*, 1960, 55.

The text is Revelation 12: 7–9.

The attribution of No. A938 to Lelio Orsi first appears in print in the catalogue of the Cowper sale.

No strict chronology has yet been established for Orsi's varied *œuvre* and No. A938 cannot be dated with any certainty. Sir Karl Parker writing in the *Annual Report* of 1960 suggested a date close to the panel of *S. George and the Dragon* in the Capodimonte Gallery, Naples, which has similar rhythms created by the flying draperies and the same phosphorescent effect in the colour.[1] These characteristics are also found on the *Martyrdom of S. Catherine* in the Estense Gallery, Modena,[2] and in each of these three works Correggiesque elements may be said to dominate. The *S. George and the Dragon* at Naples has been dated by Professor Roberto Salvini before Orsi's visit to Rome in 1554–5, while the *Martyrdom of S. Catherine* at Modena has been dated by the same writer in the period immediately after the painter's return to Emilia.

The subject of No. A938 is *S. Michael Subduing Satan* and not the *Last Judgement*, as was once thought. S. Michael is shown in the dual role of conqueror of Satan and weigher of souls. The depiction of Hell recalls the imaginative renderings of Hieronymous Bosch and of Pieter Brueghel the Elder.

REFERENCES: 1. Inv. 83. See R. Salvini and A. M. Chiodi, *Mostra di Lelio Orsi* (Reggio Emilia, 1950), p. 20, Cat. no. 15 repr., and B. Molajoli, *Notizie su Capodimonte* (Naples, 1960), p. 39 repr. 2. Inv. 231. Salvini and Chiodi, op. cit., p. 24, Cat. no. 17 repr.

# GEROLAMO DEL PACCHIA 1477, still active 1533

Sienese school. He was the son of Giovanni di Giovanni da Zagreb. He is also recorded in Rome and Florence and may subsequently have gone to work in France, where he probably died. Gerolamo was apparently a pupil of Pacchiarotto, but he was mainly influenced by Beccafumi, Sodoma, Fra Bartolommeo, and Perugino, amongst others. He painted a number of altar-pieces for Sienese churches and some of the frescoes in the Oratorio di San Bernardino, Siena.

## A88 THE HOLY FAMILY WITH THE YOUNG S. JOHN Pl. 100

Wood (fastened at the back with two horizontal battens). 102·5 (round). Condition: fair. There are two vertical splits in the panel at the top and a horizontal crack in the paint surface between the Virgin's feet. The figures are well preserved, but the surface is rather dirty.

Fox-Strangways Gift, 1950.

Literature: Crowe and Cavalcaselle, *History*, 2nd edn., iv (1911), 248.

The signature *Brogi*, visible to the right of the Virgin's stone seat, is a later and unexplained addition.

No. A88 was described by Langton Douglas in the second edition of Crowe and Cavalcaselle as a 'defective production of the time of Girolamo del Pacchia'. Dottoressa Luisa Vertova Nicolson (verbal communication) regards the panel as an autograph work by Gerolamo.

# GIACOMO PACCHIAROTTO 1474–1540 or later

Sienese school. There are no signed or dated works and most of the documents refer to his soldiering activities. Those works now ascribed to this name show at an early stage the influence of Guidoccio Cozzarelli and Matteo di Giovanni, while later works reveal the influence of Signorelli, Perugino, Domenico Ghirlandaio, and Sodoma. His style appears to have developed little.

## A930 VIRGIN AND CHILD WITH SS. JEROME, BERNARDINO OF SIENA, CATHERINE OF ALEXANDRIA, AND FRANCIS Pl. 101

Wood. 74·6 × 52·7 (arched).

On the back an old attribution to *Franciabigio* and the remnants of a wax impression of a seal no part of which is decipherable.

Condition: very good. Cleaned in 1959. The surface is unrestored and free of varnish. The Virgin's drapery, which appears to be damaged in reproduction, is, in fact, coarsely painted.

Provenance: S. Matteo, Ortignano di Raggiolo.[1] Next recorded in the collection of Richard Fisher, then by direct inheritance to Gunhilda Fisher (Sotheby's, 2 July 1958, lot 28, as Bartolomeo Vivarini, bt. P. & D. Colnaghi & Co. Ltd.).

Purchased 1959.

Literature: *Annual Report*, 1959, 52–3 repr.; Berenson, 1968, 309; F. Russell, 'The Evolution of a Sienese Painter: Some early Madonnas of Pacchiarotto', *Burlington Magazine*, 115 (1973), 802.

The decorative motifs on the Virgin's drapery have been incised and heightened with gold applied with a fine brush.

There can be little doubt that No. A930 belongs to the group of works at present associated with the name of Giacomo Pacchiarotto. The attribution is due to Mr. James Byam Shaw and first occurs in print in the *Annual Report* of 1959.

This composition was often used by Matteo di Giovanni and his followers with only minor variations in the number or character of the saints. Mr. Francis Russell has argued that No. A930 belongs to a group of works painted towards the middle of the last decade of the fifteenth century, that is during the period of Pacchiarotto's early maturity. He places No. A930 between the *Nativity with SS. Bernardino and Anthony of Padua*, formerly in the church of S. Agostino at Massa Maritima,[2] and the altar-piece of the *Coronation of the Virgin with S. John the Baptist, Leonard, Bartholomew and Cassianus* in the church of S. Leonardo at S. Casciano dei Bagni.[3] The chronology of the works attributed to Pacchiarotto is by no means certain, but Russell's argument seems convincing. The same writer also pointed out that the characterization of S. Jerome on No. A930 is similar to that of the same saint on a panel of the *Virgin and Child with SS. Jerome and Nicholas of Bari* in a private collection.[4]

The pale colours of No. A930 (grey, mushroom-pink, blue, and faded orange) and the delicate hatching are highly characteristic of Pacchiarotto's technique.

REFERENCES: 1. A modern replica of No. A930 is now in the church of S. Matteo at Ortignano di Raggiolo (*The Times Literary Supplement*, 2 Jan. 1969, p. 9). The latest edition of the Berenson Lists (1968) tentatively suggests that No. A930 is a replica of the picture now at Ortignano. This is most definitely not the case, as confirmed by Mr. Everett Fahy in a letter of 15 Oct. 1967. 2. Repr. Berenson, 1968, ii, pl. 918. 3. Repr. Berenson, op. cit., pl. 917. 4. Published by F. Russell, 'The Evolution of a Sienese Painter: Some early Madonnas of Pacchiarotto', *Burlington Magazine*, 115 (1973), fig. 51.

JACOPO PALMA $c.$ 1480–1528

Venetian school. The real name was Jacopo Nigreti or Negreti, known as Palma il Vecchio. He was born near Bergamo and often painted in that region, although he belongs to the Venetian school. The late works of Giovanni Bellini, together with the influence of Titian and Giorgione, were the main sources of his style. He painted numerous *Sacre Conversazioni*, a theme which he developed as a suitable vehicle for the warm colours, melting contours, and poetic landscapes of his mature style.

A504 SACRA CONVERSAZIONE (VIRGIN AND CHILD WITH
SS. JOSEPH AND MARY MAGDALEN) **Pls. 102–3**

Wood (cradled). 64·8 × 100·5.

Condition: very poor. Extensively damaged and subsequently ruined by repainting during the course of restoration in 1942–3. Original paint has been preserved on the drapery around Joseph's right arm, on small areas of the Virgin's drapery, and at points where the bodice of the Magdalen shows through. The tree on the extreme right is almost intact, but the whole of the rest of the landscape and the faces of the figures are entirely repainted.

Presented by Dr. Arthur Waters, 1937.

Literature: *Annual Report*, 1937, 34; Berenson, 1957, 125; G. Mariacher, *Palma Vecchio* (Milan, 1968), p. 104; *I pittori bergamaschi dal XIII al XIX secolo. Il Cinquecento*, i (Bergamo, 1975), 221 No. 102 repr.

No. A504 can only be described as a ruin. The attribution to Palma Vecchio, accepted at the time of acquisition and subsequently by Berenson, has recently been rejected by Professor Giovanni Mariacher. The original quality of the panel, however, can to some extent be detected in a photograph taken before restoration (pl. 102). Judging from this visual record and from the composition, No. A504 might have been painted by Palma between 1500 and 1510.[1]

REFERENCES: 1. For the composition compare the *Sacra Conversazione* in the Pinacoteca dei Concordi, Rovigo (inv. 95), for which see G. Mariacher, *Palma Vecchio* (Milan, 1968), pp. 53–4, Cat. no. 19, pl. 19, where a date of 1510–15 is suggested. For a more recent discussion of this picture see U. Ruggeri, 'Le collezioni pittoriche rodigine' in *L'Accademia dei Concordi di Rovigo* (Vicenza, 1972), p. 47 repr. Also compare the *Virgin and Child between John the Baptist and Mary Magdalen* in the Accademia Carrara, Bergamo (inv. 63), repr. Mariacher, op. cit., p. 53, Cat. no. 18, pl. 18.

PIETRO PERUGINO first documented 1469,
died 1523

Umbrian school. His real name was Pietro Vanucci, called Perugino. He was mainly active in Perugia, Florence, and Rome. Traditionally, Perugino is regarded as the pupil of

Verrocchio, but some early contact with Piero della Francesca is possible. He ran an active studio in which Raphael received some training. There is a large *œuvre*.

## COPY AFTER PIETRO PERUGINO

A108  HEAD OF THE VIRGIN                                   Pl. 104

Canvas. 31·7 × 24·1.

Condition: poor. The surface is almost totally obscured by dirt.

Fox-Strangways Gift, 1850.

No. A108 would appear to be a free copy, perhaps dating from the eighteenth century, of the head of the Virgin on the altar-piece of the *Madonna della Consolazione* painted by Perugino in 1498 for the confraternity of S. Maria Novella, Perugia.[1] At the beginning of the nineteenth century the confraternity was amalgamated with that of S. Peter Martyr and the altar-piece was transferred accordingly, before passing to the National Gallery, Perugia. It is by no means absolutely certain that this altar-piece served as the specific prototype for the copyist responsible for No. A108 and it may just be pastiche.

REFERENCE: 1. F. Canuti, *Il Perugino* i (Siena, 1931), 122–4, repr. pl. LXXXVI and ii. 342, No. 94.

## PIER FRANCESCO FIORENTINO                        1444/5,
                                                  still active 1497

Florentine school. He was the son of Bartolommeo di Donato, a painter, and worked mainly in San Gimignano and the environs. At the outset he was a follower of Benozzo Gozzoli, but his work also shows the influence of Andrea del Castagno, Filippo Lippi, and Baldovinetti. By 1469/70 Pier Francesco had been ordained priest. His style of painting is wholly provincial and many of his compositions are derivative.

## FORMERLY ASCRIBED TO PIER FRANCESCO
## FIORENTINO

A348  VIRGIN AND CHILD WITH TWO ANGELS              Pl. 105

Wood (fastened at the back with two horizontal battens). 45 (round).

On the back a label inscribed by Charlotte Bywater, wife of Ingram Bywater, *Pier Francesco Fiorentino | who signed— | Petrus Franciscus presbyter | Fiorentino—at S. Agostino | in S. Gimignano | Bt. at Oxford 1897. B. Berenson.*

Condition: ruined and almost totally obscured by a heavy craquelure.

Bequeathed by Ingram Bywater, 1915.

Literature: *Annual Report*, 1915, 14.

As far as the terrible state of the panel allows one to judge today, the attribution inscribed on the back seems to be correct.

## PIERO DI COSIMO 1461/2–1521

Florentine school. He was the son of Lorenzo di Piero d'Antonio, a metalworker. The attribution of much of his *œuvre* and its chronology is based upon Vasari. As his name suggests, Piero was the pupil of Cosimo Rosselli with whom he worked in Rome (1481–2). His style appears to have been developed in the main through the influence of Domenico Ghirlandaio, Leonardo da Vinci, Hugo van der Goes, Filippino Lippi, and Signorelli.

A420 THE FOREST FIRE **Pl. 106**

Wood (fastened at the back with four vertical battens). 71·2 × 202.

No. A420 is made up of four panels of varying sizes. The horizontal joins are 17·5 cm., 43 cm., and 65·9 cm. respectively from the top. Only the fourth join is visible all the way along. At the back, each end of the panel has been planed down by 9 cm., presumably so that it could be let into some part of a room, or into a piece of furniture.

Condition: fairly good. The paint surface is comparatively free from retouching and minor repairs have been made only in places that have been affected by movement along the joins (for example, a blister laid at the edge of the forest on the left approximately 30 cm. from the top).

Provenance: Francesco del Pugliese, Florence (see Commentary below). Next recorded in the collection of Conte Giulio Rucellai, Florence; Prince Paul of Yugoslavia.[1]

Presented by the National Art-Collections Fund, 1933.[2]

Exhibited: London, Burlington Fine Arts Club, 1921;[3] London, Royal Academy, *Italian Art*, 1930 (225), *A Commemorative Catalogue of the Exhibition of Italian Art*, i (Oxford, 1931), 103, No. 299; London, National Gallery, *National Art-Collections Fund Exhibition*, 1945/6 (33).

Literature: R. Fry, 'Pictures at the Burlington Fine Arts Club,' *Burlington Magazine*, 38 (1921), 131–7 repr.; P. Schubring, *Cassoni. Supplement* (1923), 5, No. 932 repr.; P. Schubring, 'Neue Cassoni', *Belvedere*, 9 (1930), 3 repr.; Van Marle, *Development*, xiii (1931), 346 repr.; *Annual*

*Report*, 1933, 22–3 repr.; B. Degenhart, in Thieme–Becker, *Lexikon*, xxvii (1933), 16; T. Borenius, 'Rundschau', *Pantheon*, 13 (1934), 158 repr.; Berenson, 1936, 390: 1963, 176 repr. (detail); C. Gamba, 'Poesia di Piero di Cosimo e suoi quadri mitologici', *Bollettino d'arte*, 30 (1936–7), 53; E. Panofsky, 'The Early History of Man in a Series of Paintings by Piero di Cosimo', *Journal of the Warburg Institute*, 1 (1937–8), 24 and 26–7, reprinted with the title 'The Early History of Man in Two Series of Paintings by Piero di Cosimo', in *Studies in Iconology* (Oxford and New York, 1939 and 1962), pp. 51 and 54–5 repr.; G. Pudelko, 'Piero di Cosimo, Peintre Bizarre', *Minotaure* (1938), 24 repr.; T. Bodkin, *Dismembered Masterpieces* (London, 1945), 19 repr.; R. Langton Douglas, *Piero di Cosimo* (Chicago, 1946), pp. 16–17, 31, 33, 64, and 115 repr.; K. Clark, *Landscape into Art* (London, 1949), pp. 39–40; P. Morselli, 'Ragioni di un pittore fiorentino: Piero di Cosimo', *L'arte*, 56 (1957), 134–5 repr.; F. Zeri, 'Rivedendo Piero di Cosimo', *Paragone*, 115 (1959), 44; A. Chastel, *Art et humanisme à Florence au temps de Laurent le Magnifique* (Paris, 1959), pp. 176–7; L. Grassi, *Piero di Cosimo e il problema della conversione al cinquecento nella pittura fiorentina ed emiliana* (Rome, 1963), p. 42; P. Bonicatti, *Aspetti dell'umanesimo nella pittura veneta dal 1455 al 1515* (Rome, 1964), p. 71, n.; E. Fahy, 'Some Later Works of Piero di Cosimo', *Gazette des beaux-arts*, 65 (1965), 206; A. R. Turner, *The Vision of Landscape in Renaissance Italy* (Princeton, 1966), p. 43 repr.; M. Bacci, *Piero di Cosimo* (Milan, 1966), pp. 29 and 74, Cat. no. 12 repr.; F. Abbate, 'Scelta di Libri', '*Piero di Cosimo di Mina Bacci*', *Paragone*, 215 (1968), 76–7; J. Barclay Lloyd, *African Animals in Renaissance Literature and Art* (Oxford, 1971), p. 50.

The present attribution of No. A420 to Piero di Cosimo, which is evidently of some age, although only first mentioned in print by Fry in 1921, has been widely accepted. Schubring alone ventured to propose an alternative, suggesting Bartolomeo di Giovanni.

Fry recognized that No. A420 is stylistically compatible with two panels now in the Metropolitan Museum, New York, the *Hunt* and the *Return from the Hunt*,[4] but thought it unlikely that all three formed part of the same decorative scheme. Schubring (1923) was the first writer to suggest that No. A420 formed a series with the two panels now in the Metropolitan Museum, which had been separately grouped together by him in 1915 as illustrations of Ovid, *Metamorphoses*, XII.[5] Gamba followed Schubring, but mistakenly regarded the panels as part of a decorative scheme painted by Piero di Cosimo for the Vespucci family described by Vasari in his Life of Piero di Cosimo (iv. 141–2).

Panofsky made a more convincing connection with another passage in Vasari's Life (iv. 139).

Fece parimente in casa di Francesco del Pugliese intorno a una camera diverse storie di figure piccole; nè si può esprimere la diversità delle cose fantastiche che egli in tutte quelle si dilettò dipingere, e di casamenti a d'animali a di abiti e strumenti diversi, ed altre fantasie, che gli sovvennono per essere storie di favole. Queste istorie, doppo la morte di Francesco del Pugliese e de'figliuoli, sono state levate, nè so ove sieno capitate. E così un quadro di Marte e Venere con i suoi amori e Vulcano, fatto con una grande arte e con una pazienza incredibile.

In addition to No. A420 and the two panels in the Metropolitan Museum, New York, Panofsky associated two other pictures, which in his opinion answered to Vasari's brief description. These are *The Fall of Vulcan* in the Wadsworth Athenaeum, Hartford,[6] and *Vulcan and Aeolus* in the National Gallery, Ottawa.[7] Panofsky argued that these five pictures illustrated a unified iconographical programme of the history of primordial man, which formed a decorative scheme, possibly identifiable with that described by Vasari. Panofsky's contention rests upon the widest possible interpretation of Vasari's text (particularly on the meaning of the words 'E così') and certain practical difficulties are not satisfactorily accounted for in his argument. Thus, No. A420 and the two panels in New York are of the same height, but of different lengths, whereas the pictures at Hartford and Ottawa are on canvas, somewhat larger in size and of different format. According to Panofsky, such variations were dictated by the proportions of the room (or rooms) or by the nature of the iconographical programme. Thus, he allocates No. A420 and the two panels in New York to an ante-room and the pictures at Hartford and Ottawa to an adjacent room of larger proportions. No. A420, depicting 'a transition from the unmitigated bestiality to a comparatively human life', was placed above the doorway. Panofsky's reconstruction has been challenged by Langton Douglas,[8] Dr. Federico Zeri,[9] and Dr. Francesco Abbate.[10]

Panofsky traced the literary sources for the episodes depicted on these panels and his interpretation of the subject-matter of No. A420 and the two panels in New York remains unchallenged.[11] He suggested that No. A420 may illustrate a passage in Giovanni Boccaccio's *Della Genealogia Deorum*, XII. lxx (ed. V. Romano, ii (Bari, 1951), 624), where the writer quotes at some length from Vitruvius (*De Architectura*, II. i.):[12]

The men of old were born like the wild beasts, in woods, caves, and groves, and lived on savage fare. As time went on, the thickly crowded trees in a certain place, tossed by storms and winds, and rubbing their branches against one another, caught fire, and so the inhabitants of the place were put to flight,

being terrified by the furious flame. (Vitruvius, *The Ten Books on Architecture* trans. M. H. Morgan (Harvard University Press, 1914), p. 38.)

Chronologically, therefore, the two panels of the *Hunt* and the *Return from the Hunt*, together with No. A420, depict scenes from man's life *ante-Vulcanum*. These are followed by the paintings at Hartford and Ottawa representing scenes from man's life *sub Vulcano*. This scheme of man's development would have been completed, according to Panofsky, by the *Discovery of Honey* (Worcester Art Museum, Massachusetts),[13] the *Misfortune of Silenus* (Cambridge, Mass., Fogg Art Museum),[14] and the two panels of the *Myth of Prometheus* in Strasbourg (Musée des Beaux-Arts)[15] and Munich (Alte Pinakothek).[16]

With regard to dating, the completion of the building of the Casa Pugliese in 1488 may be accepted as the *terminus post quem* and the expulsion of Francesco del Pugliese from Florence in 1513 as the *terminus ante quem*.[17] Specific dates have been suggested for No. A420: 1487–8 by Langton Douglas, 1505–7 by Zeri, *c.* 1507 by Mr. Everett Fahy, *c.* 1490 by Dottoressa Mina Bacci, while Abbate implies a date of 1500–3.

REFERENCES: 1. An entry in a Rucellai inventory of 1894, which reads 'Quadro rettangolare rapp. l'Isola di Circe di Pier di Cosimo', is most probably intended for No. A420. Conte Bernardo Rucellai has kindly informed the compiler (letter of 17 Mar. 1972) that his uncle Conte Giulio Rucellai sold the painting to Mr. Arthur Acton, who subsequently sold it to Prince Paul of Yugoslavia, possibly in 1917/18. Prince Paul of Yugoslavia (letter of 21 June 1970) states, however, that he bought No. A420 directly from the Rucellai family. 2. *National Art-Collections Fund* (1933), pp. 23–4, No. 853. 3. The catalogue of this exhibition appears to have been issued in typescript only. 4. Inv. 75. 7. 2 and 75. 7. 1, measuring 70·5 × 169·5 and 70·5 × 168·9 respectively. F. Zeri and E. Gardner, *Italian Paintings. A Catalogue of The Collection of The Metropolitan Museum of Art. Florentine School* (The Metropolitan Museum of Art, 1971), pp. 176–80. 5. Schubring, *Cassoni* (1915), pp. 310–11, Nos. 383–4. 6. Measuring 155 × 175. See M. Bacci, *Piero di Cosimo* (Milan, 1966), pp. 76–7, pl. 15 7. Inv. 4287, 155 × 165. See Bacci, op. cit., pp. 77–8, pl. 16. 8. R. Langton Douglas, *Piero di Cosimo* (Chicago, 1946), p. 31, who argued in favour of including the *Fight between the Lapiths and Centaurs* in the National Gallery, London (inv. 4890). 9. F. Zeri, 'Rivedendo Piero di Cosimo', *Paragone*, 115 (1959), 44, who contends that the *Building of a House* in the Ringling Museum, Sarasota, marks the close of the series published by Panofsky. 10. F. Abbate, '*Piero di Cosimo* di Mina Bacci', *Paragone*, 215 (1968), 76–7. 11. However, Langton Douglas, op. cit., pp. 34–9, did contest Panofsky's interpretation of the picture at Hartford. See the subsequent correspondence in the *Art Bulletin*, 28 (1946), 286–9, and 29 (1947), 143–7. 12. The subject of the origins of fire interested a number of ancient authors, among them Pliny the Elder, Lucretius, and Diodorus Siculus (references in E. Panofsky, 'The Early History of Man in a Series of Paintings by Piero di Cosimo', *Journal of the Warburg Institute*, 1 (1937/8), 17, n. 3, and 18, nn. 1–2). Also see on this subject Sir. J. G. Frazer, *Myths of the Origin of Fire* (London, 1930), pp. 195 and 205–6.

The animals with human faces have prompted several other suggestions for the literary source of No. A420, for example, the passage on the evolution of man in Lucretius, *De Rerum Natura*, V. 821–924, ed. C. Bailey, i (Oxford, 1947), 474–81. The compilers of the *Commemorative Catalogue of the Exhibition of Italian Art* (1930) referred to the Circe legend and an anonymous contributor to the *Burlington Magazine*, 38 (1921), 257, presumably without knowledge of the comparatively recent label on the back of the panel making the same suggestion, points to a possible connection with the *Verae Historia* of Lucian (Loeb. edn., A. M. Harmon, i (London, 1913), 249–357). Panofsky's discussion of the sources should be supplemented by A. R. Turner, *The Vision of Landscape in Renaissance Italy* (Princeton, 1966), pp. 47–9, where it is suggested that Piero's imagination could just as easily have been inspired by many of the images found in Lorenzo de' Medici's poetry, for example, *Selve d'amore*, i. 5–8 (*Opere di Lorenzo de' Medici*, ii (edn. Florence, 1825), 8–9, quoted in translation by Turner). 13. Inv. 1937. 76, 79·5 × 128. See Bacci, op. cit., pp. 92–3, pl. 35. 14. Inv. 1940. 85, 79·5 × 128. See Bacci, ibid., pl. 36. 15. Inv. 223, 68 × 120. See Bacci, op. cit., p. 100, pl. 47. 16. Inv. 8973, 66 × 118·7. See Bacci, ibid., pl. 48. 17. The references are given by Bacci, op. cit., pp. 75–6.

# PIETRO DEGLI INGANNATI

active, 1529,
last mentioned 1547

Venetian school. He was a follower of Giovanni Bellini and was later influenced by Palma Vecchio and by Giorgione. At times his style approaches that of Francesco Bissolo.

## ATTRIBUTED TO PIETRO DEGLI INGANNATI

A400Z   VIRGIN AND CHILD WITH S. PETER AND THREE
       UNIDENTIFIED SAINTS                    **Pl. 107**

Canvas (relined). 70·7 × 109·5.

Condition: fair. The surface is obscured by dirt and old varnish beneath which the figures appear to be well preserved. The area bottom right is not abraded, but affected by damp.

Unknown provenance.

The attribution to Pietro degli Ingannati is based upon comparison with the signed *Virgin and Child with SS. John the Baptist, Dorothy, Nicholas of Tolentino and Mary Magdalen*, formerly in Berlin.[1] The style of No. A400Z also accords well with the *Virgin and Child with S. John the Baptist and a Female Saint*, which is another signed work dating from Ingannati's early period when his style was still dependent upon that of Giovanni Bellini.[2]

The composition of No. A400Z may, in fact, have been derived from one devised by Giovanni Bellini. A panel of *Christ Blessing with Four Saints* in a private collection in Milan, recently published as a late work by Giovanni

Bellini *c.* 1505, is similarly composed, although on No. A400z the Virgin and Child have been substituted for the figure of Christ.[3]

REFERENCES: I. Inv. 41, destroyed 1939–45 war. *Beschreibendes Verzeichnis der Gemälde im Kaiser-Friedrich Museum* (Berlin, 1931), p. 229. Repr. Berenson, 1957, pl. 617. 2. Vercelli, Museo Borgogna. Repr. R. Heinemann, *Giovanni Bellini e i belliniani* (Venice, n.d.), ii, pl. 370 on p. 335. 3. See *Acropoli*, 3 (1963), 76–8 repr.

# BERNARDINO PINTORICCHIO          *c.* 1454–1513

Umbrian school. His real name was Bernardino di Betto, called Pintoricchio. Painter and miniaturist. He worked extensively in Rome, but also in Siena, Spello, Spoleto, and Orvieto. Pintoricchio was initially a follower, and possibly even a pupil, of either Fiorenzo di Lorenzo or Bartolomeo Caporali, but he was more profoundly influenced by Perugino and slightly less so by Florentine painters such as Benozzo Gozzoli. He may have collaborated with Perugino on occasions, for example, on the series of panels illustrating the Miracles of S. Bernardino in the National Gallery, Perugia, but this is disputed.

## A303   VIRGIN AND CHILD                          Pl. 108

Wood (extended on both sides by 2 cm.). 41·3 × 30·2 (slightly bowed).

Condition: fair. Cleaned in 1951. The Virgin's drapery is repainted and the contour of the right side of Her raised hand is lost. The Child's dress is rubbed and the distant landscape is somewhat worn. The faces are the best preserved parts. At the sides, where the composition has been extended, there is considerable retouching and several small areas of local damage along the joins.

Fortnum Bequest, 1899.[1]

Exhibited: London, Royal Academy, *Exhibition of Works by the Old Masters*, 1883 (179). London, Burlington Fine Arts Club, *Pictures of the Umbrian School*, 1909–10 (17).

Literature: *Annual Report*, 1899, 7 and 21; C. Ricci, *Pintoricchio* (London, 1902), pp. 15 and 237 repr.; R. Fry, 'The Umbrian Exhibition at the Burlington Fine Arts Club', *Burlington Magazine*, 16 (1910), 268; Crowe and Cavalcaselle, *History*, 2nd edn., v (1914), 416, n. 4; Venturi, *Storia*, vii, pt. 2 (1913), 661, n. 1; C. Ricci, *Pintoricchio* (Perugia, 1915), pp. 29–30 and 333; U. Gnoli, *Pittori e miniatori nell'Umbria* (Spoleto, 1923), p. 296; Berenson, 1932, 460: 1936, 395: 1968, 345; Van Marle, *Development*, xiv (1933), 255.

No. A303 was acquired by Fortnum as a work by Pintoricchio and the attribution has not been challenged by later authorities, although no reference is made to it in Professor Enzo Carli's recent monograph on the

painter. There is, however, little reason to doubt that the panel in Oxford is by Pintoricchio's own hand.

Of the various panels of the *Virgin and Child* attributed to Pintoricchio, the representations in the Kress collection (Raleigh, Museum of Art),[2] Boston (Isabella Stewart Gardner Museum),[3] and Cambridge (Fitzwilliam Museum),[4] match the style of No. A303. These are all compatible with the altar-piece commissioned in 1495 from Pintoricchio for the church of S. Maria dei Fossi, now in the National Gallery, Perugia.[5] Opinions differ as to which of these panels should be placed either before or after this altar-piece. For No. A303 Ricci at first (1902) suggested a date of 1474–c. 1480, but later (1915) narrowed this to 1473–8 (?). Van Marle proposed a date of 1494–1501.

REFERENCES: 1. Bought in Florence in 1864, as stated in Fortnum's manuscript catalogue in the Ashmolean Museum, Vol. IV, f. 86, No. 10. 2. K 47. F. R. Shapley, *Paintings from the Samuel H. Kress Collection. Italian Schools XV–XVI Century* (London, 1968), pp. 101–2 repr. 3. P. Hendy, *European and American Paintings in the Isabella Stewart Gardner Museum* (Boston, 1974), pp. 184–6 repr. 4. Inv. 119. J. Goodison and G. Robertson, *Fitzwilliam Museum Cambridge. Catalogue of Paintings*, ii. *Italian Schools* (Cambridge, 1967), pp. 133–4 repr. 5. Inv. 275. Repr. E. Carli, *Il Pintoricchio* (Milan, 1960), pls. 88–95.

## ANONYMOUS PISAN SCHOOL (?) 1310–1325

A365 A TRIPTYCH: VIRGIN AND CHILD (centre panel),
     S. JOHN THE EVANGELIST (left panel),
     S. CATHERINE OF ALEXANDRIA (right panel) **Pl. 109**

Wood. Painted surface: centre 75 × 54 (gabled); left 57 × 37·5 (gabled); right 57·5 × 37 (gabled). Size of frame over-all: 90·5 × 151. Height of gables: centre 85·5; left 72·0; right 72·0. Both ends of the frame and the strip along the bottom are modern additions. The supporting columns at each end have also been renewed, but those on either side of the centre panel appear to be original. Inscribed on the scroll held by S. John the Evangelist: I / N / PRINCI / PIO.ER / AT. ÙBÙ / ZŪBŪ.ER / AT.APD / DEU (?) ... (presumably intended for John 1 : 1).

Condition: poor. Cleaning tests were carried out in 1971. The figures have been heavily repainted. The gold striations on the Virgin's drapery and much of the decoration on the drapery of S. Catherine of Alexandria are later additions. The gold background on all three panels is worn and also heavily retouched. The panel is intact, apart from a vertical split to the

left of S. Catherine of Alexandria, which extends through her right elbow and a small vertical split above the Virgin's left shoulder. It has been cut at both ends and trimmed along the bottom.

Presented by G. Gidley Robinson, 1921.

Literature: *Annual Report*, 1921, 22–3; T. Borenius, 'Notes on Various Works of Art', *Burlington Magazine*, 40 (1922), 134–5 repr.; C. L. Ragghianti, 'Notizie e lettura', *Critica d'arte*, 3 (1938), xxxvii repr.; E. Garrison, *Italian Romanesque Panel Painting. An Illustrated Index* (Florence, 1949), p. 169, No. 439 repr. (the article by Borenius listed above is incorrectly cited by Garrison as the work of R. R. Tatlock); E. Carli, *Pittura pisana del trecento. Dal 'Maestro di S. Torpé' al 'Trionfo della Morte'* (Milan, 1958), p. 15; M. Bucci, 'Contributi al "Maestro di San Torpé"', *Paragone*, 153 (1962), 6.

In its present form No. A365 is shaped as a triptych, but Mr. Edward Garrison has suggested that the panels are probably the remnants of a pentaptych.

Borenius argued that No. A365 was by an Umbro-Tuscan painter and referred to the influence of Segna di Bonaventura. Garrison tentatively ascribed the panel to the Pisan school, suggesting a date of 1315–25.

Professor Carlo Ragghianti first proposed the name of the Master of S. Torpé, thereby establishing No. A365 as part of a small number of works initially grouped together by Evelyn Sandberg-Vavalà.[1] Dr. Mario Bucci and Professor Enzo Carli have dissented from this view, the last writer even doubting whether No. A365 is Pisan. In view of the extensive over-painting on No. A365, further statements on the quality of the panel and attempts at specific attribution should be deferred until after cleaning.

REFERENCE: 1. E. Sandberg-Vavalà, 'Some Partial Reconstructions', *Burlington Magazine*, 71 (1937), 234, where the painter is defined as a Ducciesque with dugento characteristics, active outside of Siena and possibly Pisan. In addition to the studies cited in the Literature above, see R. Longhi, 'Qualità del "Maestro di S. Torpé"', *Paragone*, 153 (1962), 10–15, and P. P. Donati, 'Aggiunte al Maestro di San Torpé', *Commentari*, 19 (1968), 245–52, with further bibliography.

## PORDENONE                                    1483–1539

Friulian school. His real name was Giovanni Antonio de Sacchis, called Pordenone. He was mainly active in the Veneto, but a visit to Rome is likely. He appears to have been a

pupil of Giovanfrancesco da Tolmezzo, but he was more profoundly influenced by Titian, Giorgione, and Palma Vecchio. Much of his surviving work is in fresco.

## COPY AFTER PORDENONE

A144   HEAD OF DON FRANCESCO TETIO                    **Pl. 110**

Wood. 17·3 × 12·4.

Inscribed on the back by Chambers Hall: *Study painted by Pordenone | of the Head of Don Francesco | Tetio for his portrait which oc | curs (as well as that of his wife) | in a picture by this master | representing 'the Virgin, S. Joseph | & S. Christopher', still existing | in the Duomo of Pordenone. | Bought Decemb^r 1837 | in that Town of Count Monte | Reale-Mantica, a collateral | Descendant of the above Family. | C.H.*

Condition: poor. The paint surface is pitted and dirty.

Collection: Montereale-Mantica, Pordenone.

Chambers Hall Gift, 1855.

No. A144 almost certainly dates from the eighteenth century.[1]

REFERENCE: 1. The altar-piece from which No. A144 must have been copied is repr. by G. Fiocco, *Giovanni Antonio Pordenone* (Udine, 1939), pl. 47.

## SCIPIONE PULZONE                    active 1569, died 1598

Roman school. He was also active in Naples and Florence, achieving considerable fame as a portrait painter. He was the pupil of Jacopino del Conte, but also made a profound study of Titian, Raphael, and Sebastiano del Piombo, as well as being subject to the influence of various contemporaries, such as Siciolante da Sermoneta and Gerolamo Muziano.

## COPY AFTER SCIPIONE PULZONE (?)

A256   PORTRAIT OF A YOUNG MAN WEARING A PENDANT
**Pl. 111**

Canvas (relined). 64·7 × 52·8.

Inscribed below on the stretcher *G. J. Chester | Firenze Nov. 24 1875* (?).
Condition: poor. There is a considerable amount of surface dirt throughout and a thick layer of old varnish. The paint is flaking top right and in other places is rather worn.

Presented by the Revd. Greville Chester, 1892.

No. A256 appears to have been painted sometime towards the end of the seventeenth century in a manner reminiscent of portraits by Scipione Pulzone, after whom this bust-length figure may have been copied. The sitter is depicted wearing a Medici collar and a pendant, but the compiler has failed to discover the whereabouts of the original portrait.

## RAPHAEL                                              1483–1520

Florentine and Roman schools. Painter, architect, and poet. Raffaello Sanzio was born in Urbino, the son of Giovanni Santi, a painter. His early style was based mainly upon that of Perugino, but, after 1504 when he was active in Florence, the work of Leonardo, Michelangelo, Fra Bartolommeo, and Signorelli impressed itself upon him. In 1508 he left Florence for Rome where he was employed by the Papacy. It was in Rome that he established a large studio, which included Giulio Romano, Giovanni Francesco Penni, Perino del Vaga, and Baldassare Peruzzi, amongst others. Beyond his personal influence, the compositions of his finished works were of the utmost importance for the development of European painting. The Ashmolean Museum possesses a large and distinguished collection of his original drawings.

### COPIES AFTER RAPHAEL

A45  THE SCHOOL OF ATHENS                              Pl. 112

Canvas (relined). 170·4 × 234.

Condition: fair. Apart from surface dirt the painting is well preserved.

Presented to the Bodleian Library by Sir Francis Page in 1804[1] and transferred to the Ashmolean probably before 1847.[2]

No. A45 is a fine seventeenth-century copy after the famous fresco in the Stanza della Segnatura in the Vatican, Rome, painted by Raphael some time between 1509 and 1511. The allegorical figures in the spandrels of No. A45 are additions by the copyist inspired by the Sybils painted by Michelangelo on the Sistine ceiling.

   A traditional attribution to Giulio Romano is recorded for No. A45 in nearly all the manuscript and printed catalogues of the pictures in the Bodleian Library.[3] An anonymous pamphlet entitled *The History of the Celebrated Painting in the Picture Gallery at Oxford called 'The School of Athens' supposed to be painted by Julio Romano*, issued at the beginning of the nineteenth century, concerns itself primarily with the iconography, referring to the fresco as 'The Temple of the Grecian Philosophy'.[4] The copy

was exhibited in the University galleries during the course of the nineteenth century, accompanied by a key to the identification of the figures engraved by 'Matthews, of this City'.

REFERENCES: 1. *Bodleian Register of Benefactions*, D, p. 117. 2. No. A45 was last recorded in the Bodleian Library by J. Norris, *A Catalogue of the Pictures, Models, Busts etc. in the Bodleian Library, Oxford* (Oxford, 1840), p. 59, but was omitted from the 1847 edition. The painting is first recorded in the Ashmolean in the *Handbook Guide for the University Galleries, Oxford* (Oxford, 1859), p. 55. 3. For a convenient list of the innumerable catalogues and handlists issued by the Bodleian Library see W. D. Macray, *Annals of the Bodleian Library*, 2nd edn. (Oxford, 1890), pp. 257–8. 4. Professor Bernard Smith of the Power Institute of Fine Arts, University of Sydney, has kindly drawn attention to a lecture delivered by Benjamin Duterran in Australia in 1849 entitled 'The School of Athens, as it assimilates with the Mechanics Institution'. Duterran appears to have known of the composition only through No. A45, and his lecture, which is devoted to the iconography, is clearly based upon the anonymous pamphlet referred to above.

## A59 PORTRAIT OF BINDO ALTOVITI Pl. 113

Canvas (relined). 65·6 × 56.

Condition: fair. The surface is obscured by dirt and old varnish.

Transferred from the Bodleian Library, probably before 1847.[1]

No. A59 is a copy of indifferent quality, probably dating from the late seventeenth or early eighteenth century, after the Portrait now in the Kress collection.[2]

REFERENCES: 1. The portrait may possibly be the one described as a *Self-Portrait* by Raphael which is listed by J. Norris, *A Catalogue of the Pictures, Models, Busts etc. in the Bodleian Library, Oxford* (Oxford, 1840), p. 45. There is no mention of the picture in the 1847 edition of this catalogue. It is first recorded in the Ashmolean in 1859 (*Handbook Guide for the University Galleries, Oxford* (Oxford, 1859), p. 53, No. 16. 2. K 1239. F. R. Shapley, *Paintings from the Samuel H. Kress Collection. Italian Schools XV–XVI Century* (London, 1968), pp. 105–6.

## A228 JUPITER FONDLING CUPID Pl. 114

Canvas (relined). 195·7 × 152·3.

Condition: fair. The canvas has been punctured on the right. The surface is covered by a layer of dirt and old varnish, but the figures appear to be well preserved.

Presented by John Bayley, 1859.

No. A228 is a free copy, dating from the late seventeenth or early eighteenth century, after the fresco in one of the spandrels of the *Sala di Psiche*

in the Villa Farnesina, Rome, which was decorated for Agostini Chigi by Raphael and his studio in 1518–19.[1] The over-all scheme, illustrating the story of Cupid and Psyche, was almost certainly designed by Raphael, but the frescoes themselves, including *Jupiter Fondling Cupid*, were painted by members of the studio (Giulio Romano, Penni, Giovanni da Udine). In Dussler's opinion *Jupiter Fondling Cupid* was executed by Giulio Romano.[2]

The copyist has faithfully rendered the two figures and the eagle, in the right background, but has altered the format so that the composition is square rather than spandrel-shaped.

REFERENCES: 1. Repr. G. Gronau, *Raphael. Des Meisters Gemälde. Klassiker der Kunst* (Stuttgart and Leipzig, 1909), p. 154. 2. L. Dussler, *Raphael. A Critical Catalogue of his Pictures, Wall-Paintings and Tapestries* (London, 1971), p. 99.

## SANO DI PIETRO                                    1406–1481

Sienese school. His real name was Ansano di Pietro di Mencio, called Sano di Pietro. Painter and miniaturist. There are no signed or dated works before 1444, which has led some authorities to identify him with the painter of certain panels ascribed by others to the Maestro dell' Osservanza, a fellow pupil of Sassetta. His style appears to have developed little and his compositions became increasingly formularized. He was, in essence, a popular religious painter described by contemporaries as 'homo totus deditus Deo'.

A76   VIRGIN AND CHILD WITH SS. JEROME AND CATHERINE
      OF ALEXANDRIA WITH TWO ANGELS                **Pl. 115**

Wood. 49·7 × 35·4 (slightly bowed).

Condition: good. There are some blemishes in the draperies of both the Virgin and the Child. Otherwise, with the exception of the neck of the Child, the flesh parts are well preserved. There are two vertical cracks in the paint surface extending through the Virgin's face and a scratch running diagonally across Her forehead on to the Child's forehead. The frame is original.

Fox-Strangways Gift, 1850.

Literature: Waagen, *Treasures*, iii. 53; Berenson, 1911, 239; 1932, 500: 1936, 430: 1968, 377; Crowe and Cavalcaselle, *History*, 2nd edn., v (1914), 174; E. Gaillard, *Sano di Pietro* (Chambéry, 1923), p. 202; Van Marle, *Development*, ix (1927), 527, n. 2.

There is a minor *pentimento* along the forefinger of the Virgin's right hand.

Waagen aptly described No. A76 as 'an indubitable picture to all

acquainted with the master'. Many similar panels of approximately the same dimensions and with only minor changes in the composition, usually in the number and character of the saints, were painted in Sano di Pietro's studio. An acceptable date for No. A76 would appear to be 1470–80.

# ANDREA DEL SARTO                                            1486–1530

Florentine school. He was the son of Agnolo di Francesco, a tailor, from whose profession Andrea derives the patronymic by which he is generally known. He was the pupil of Raffaellino del Garbo, but Leonardo da Vinci, Fra Bartolommeo, Michelangelo, Raphael, and Northern engravings, as well as the sculpture of Jacopo Sansovino, all influenced Sarto in varying degrees. He was mainly active in Florence and the environs, but he also worked at Fontainebleau. There are a number of important altar-pieces and two famous fresco cycles (Santissima Annunziata, Florence, and the Chiostro dello Scalzo, Florence). His mature style was immensely influential for the later development of Italian painting. Pontormo and Rosso were his main pupils.

## COPY AFTER ANDREA DEL SARTO

A102   THE LAST SUPPER                                            **Pl. 116**

Wood (fastened at the back with two vertical battens possibly contemporary with the panel). 74 × 179. No. A102 is made up of three panels joined horizontally 26·7 and 49·2, respectively from the top.

On the back a label inscribed by Fox-Strangways: *Sketch for the Cenacolo | San Salvi, near Florence | Andrea del Sarto.* There are several mutilated wax impressions of seals, but none is now decipherable.

Condition: poor. There are some minor paint losses in the lower half and at top right, where the panel has split in the corner. The paint surface is dirty, rather scratched, and somewhat rubbed. Several fairly large areas of damage have been made good in the left half of the composition.

Fox-Strangways Gift, 1850.[1]

Literature: A. Reumont, *Andrea del Sarto* (Leipzig, 1835), p. 164, n. 1; Crowe and Cavalcaselle, *History*, iii (1866), 574–5; 2nd edn., vi (1914), 190; H. Janitschek, *The Early Teutonic, Italian and French Masters*, ed. R. Dohme, Eng. edn. (London, 1879), p. 443; W. Lübke, *Geschichte der italienischen Malerei*, ii (Stuttgart, 1879), 200–1; A. Woltmann and K. Woermann, *History of Painting*, Eng. edn., ii (London, 1887), 519; H. Guinness, *Andrea del Sarto* (London, 1899), p. 89 (erroneously described as 'in the library at Christ Church'); S. J. Freedberg, *Andrea del Sarto*,

*Catalogue Raisonné* (Cambridge, Mass , 1963), p 144; J. Shearman, *Andrea del Sarto*, ii (Oxford, 1965), 256.

No. A102 was accepted by all the earlier authorities as an autograph preparatory 'sketch' for the fresco of the *Last Supper* in the refectory of the Vallombrosan monastery of San Salvi, Florence, commissioned in 1511, but probably executed later, perhaps in 1526–7.[2] Crowe and Cavalcaselle, for example, wrote that 'The panel is a counterpart of the fresco without the people at the window, painted in oil with the utmost ease, extraordinarily full of life, but particularly charming for the transparence and harmony of its colour'. Neither the high quality of the panel, as implied by this description, nor its designated purpose as a preparatory study for the fresco can be substantiated today.

Both Professor Sydney Freedberg and Dr. John Shearman list No. A102 as a copy after the fresco, the last writer describing it as 'a poor replica'. In fact, No. A102 is a free and rather inexpertly painted copy of the fresco possibly, but not certainly, dating from the close of the sixteenth century.

There are several fundamental differences between the panel and the fresco. The disposition of the figures is unchanged, but the background is totally altered with the upper part of the room above the inner panelling being omitted and replaced by a large expanse of open sky, which creates more of the atmosphere of a loggia. Several details in the foreground, for example, the vase on the left and the patterning on the floor, are also omitted.

REFERENCES: 1. J. Shearman, *Andrea del Sarto*, ii (Oxford, 1965), 256, stated on the authority of A. Reumont (*Andrea del Sarto* (Leipzig, 1835), p. 164, n. 1) that No. A102 was acquired in Vienna. This is not actually what Reumont says ('Eine sehr interessante Farbenskizze dieses Bildes (in Oel) kam vor wenigen Jahren in den Besitz des englischen Botschaftsecretaire in Wien, herrn. Fox Strangways') and most of the evidence adduced in the Introduction to this catalogue shows that the Fox-Strangways collection was in all probability formed in Italy. 2. See Shearman, op. cit. i. 93–7, repr. pl. 110, and ii. 254–8, Cat. no. 65.

## SEBASTIANO SECANTE                    active 1518–1576

Friulian school. His real name was Sebastiano Segatto di Porcia di Pordenone, known as Sebastiano Secante il Vecchio. He was active mostly in Udine, but he also worked in Rome. He came from a family of painters, who all painted in the manner of Pomponio Amalteo. Sebastiano, being the eldest, was subject to the direct influence of Pordenone.

## ATTRIBUTED TO SEBASTIANO SECANTE

A939   VIRGIN AND CHILD WITH SS. STEPHEN, AUGUSTINE,
    JUDE, AND JEROME                                    **Pl. 117**

Wood. 24·5 × 33.

On the back a label inscribed *Giorgione P. | from the Palazzo Porto, Vicenza | 1855*. There are two wax impressions of a seal both now indecipherable.

Condition: fair. There are several horizontal cracks in the paint surface, as distinct from the heavy craquelure and a number of small retouches. The Virgin's drapery is rather badly worn. S. Jerome, the vegetation in the foreground, and parts of the landscape are comparatively well preserved. The panel is also damaged at the edges.

Collections: Palazzo Porto, Vicenza.[1] Next recorded in the collection of Major-General F. E. Sotheby, Acton Hall, Northampton (Sotheby's, 12 Oct. 1955, lot 65, bt. P. & D. Colnaghi & Co. Ltd.).

Purchased 1960.

Exhibited: P. & D. Colnaghi & Co. Ltd., *Old Master Paintings*, 1957 (2).

Literature: *Annual Report*, 1960, 54–5.

An attribution to Morto da Feltre was first proposed by Mr. James Byam Shaw in place of the traditional ascription to Bonafazio de' Pitati. While in the *Annual Report* of 1960 Sir Karl Parker tentatively regarded this attribution as plausible, he went on to point out that there are affinities with the earlier works of Francesco Vecellio. Professor Roger Rearick (verbal communication) intimated that No. A939 might be Friulian, possibly by a follower of Pomponio Amalteo. Of the followers of Amalteo the panel comes closest to the style of Sebastiano Secante il Vecchio. Comparison may be made with the altar-piece of the *Virgin and Child with SS. Ermacora and Fortunato*, signed and dated 1558, in the church of S. Giovanni, Gemona.[2] It is not always easy to isolate the style of each member of the Secante family and it should be stated that No. A939 does have certain affinities with the work of Giacomo Secante, the brother of Sebastiano.[3]

As regards the dating of No. A939, Parker observed that a *terminus post quem* might be established by the Child's pose across the Virgin's lap, which is strikingly close, although reversed, to that employed by Raphael for the Bridgewater Madonna, painted *c.* 1507/8.[4]

REFERENCES: 1. As stated on the label at the back (see above). 2. See Carlo Someda de Marco, *Cinque secoli di pittura friuliana dal secolo XV alla metà del secolo XIX* (Udine,

1948), p. 80, No. 26 repr. The most extensive discussion on the Secante family may be found in R. Zotti, *Pomponio Amalteo. Pittore del sec. XVI. Sua vita, sue opere e suoi tempi* (Udine, 1905), pp. 162–4, 175–9. 3. Someda de Marco, op. cit., pp. 62–4, Nos. 20–1. 4. Raphael's own sources for the pose of the Christ Child on the Bridgewater Madonna are discussed in general terms by J. Pope-Hennessy, *Raphael* (London, 1970), p. 187–90. See further C. de Tolnay, *Michelangelo*. i. *Youth* (Princeton, 1943), 104 and 162–3, and J. Wasserman, 'The Dating and Patronage of Leonardo's Burlington House cartoon', *Art Bulletin*, 53 (1971), 312–25.

SIMONE DEI CROCIFISSI                    documented 1355,
                                       last mentioned 1399

Bolognese school. He was the son of Filippo di Benvenuto and known as Simone dei Crocifissi. He was a follower of Vitale da Bologna, whom he helped, together with other followers, to paint the fresco cycle in the church of S. Apollonia, Mezzaratta. Simone's later style is remarkable for its vigorous drawing and coarse technique.

A255   A TRIPTYCH: THE CRUCIFIXION WITH THE
       VIRGIN MARY, S. JOHN, AND S. MARY MAGDALEN
       (CENTRE); THE ANGEL GABRIEL AND AN UNIDENTI-
       FIED SAINT (LEFT WING); THE VIRGIN AND S. JAMES
       THE GREATER (RIGHT WING), AND A DONOR
       (RIGHT WING, BELOW)                         **Pl. 118**

Wood. Painted surface, 39·5 × 20·5 (centre); 45·5 × 9·5 (left wing); 45·4 × 9·3 (right wing).

Condition: poor. Cleaned and restored in 1959. There is extensive retouching on the centre panel, particularly on the figures, which are all virtually repainted, apart from that of Christ and the drapery of S. John. The gold background is badly worn and retouched. The lateral panels, although dull in tone, are intact, apart from the gold ground, which has been regilt. There are no signs of a figure in the lower half of the left wing to balance the donor just visible on the right wing. The frame is late nineteenth century and heavily gilded.

Bequeathed by the Revd. Greville Chester, 1892.

Literature: *Annual Report*, 1959, 34.

The attribution to Simone dei Crocifissi was first proposed in print by Sir Karl Parker after the triptych was cleaned in 1959.

Judging from the composition and the style of the figures on the lateral panels, which have not been restored, the date would appear to be fairly

late, perhaps *c.* 1380. A similar date has been suggested for the highly characteristic rendering of the *Nativity* in the Uffizi, Florence.[1]

REFERENCES: 1. L. Marcucci, *Gallerie Nazionali di Firenze. I dipinti toscani del secoli XIV* (Rome, 1965), p. 181, No. 123 repr.

## ANDREA SOLARIO                            *c.* 1473/4, died 1524

Milanese school. He was also active in Venice, Pavia, Rome, and in France (Gaillon, Blois, Amboise). Solario was apparently influenced at first by his brother Cristoforo and by Pietro Lombardo, both sculptors, but there are echoes of the style of Vincenzo Foppa and Antonello da Messina in his early works, while during the middle and later phases of his life the paramount influence was that of Leonardo da Vinci.

### A817   ECCE HOMO                                      **Pl. 119**

Wood. 58 × 43·4 (bowed).

Condition: good. Cleaned in 1951. The paint has a hard, enamel-like texture and there is a slight bloom over the whole surface. The faces are particularly well preserved, although there is a little rubbing in the neck of Christ, where there are also some small retouches. The flesh parts of the other figures are also slightly rubbed.

Collections: Lord Conway of Allington (1856–1937);[1] the Hon. Mrs. A. E. Horsfield (Sotheby's, 31 Jan. 1951, lot 38, bt. P. & D. Colnaghi & Co. Ltd.).

Purchased 1951.

Literature: K. Badt, *Andrea Solario* (Leipzig, 1914), p. 196; Berenson, 1936, 466: 1968, 411; L. Cogliati Arano, *Andrea Solario* (Milan, 1965), p. 94 repr.; C. Gould, 'On Dürer's Graphic and Italian Painting', *Gazette des beaux-arts*, 75 (1970), 109 repr.

Several representations of this subject and of closely related themes from the Passion are attributable to Andrea Solario or his studio.[2] A similar composition of half-length figures, but with Pilate on the right, is in the Wallraf–Richartz–Museum, Cologne.[3]

Badt attributed No. A817 to the young Bernardino Luini and, more recently, the attribution to Solario has again been unjustly rejected by Dottoressa Cogliati Arano in favour of one to his studio. Only Berenson maintained that the panel in Oxford was by Solario's own hand and comparison of No. A817 with the *Christ Carrying the Cross* in the Galleria Borghese, Rome, which is signed and dated 1511 on the back,[4] warrants the retention of this attribution.

The subject of No. A817 is *Ecce Homo*, on the basis of the inclusion of

Pliate. Sometimes the theme of *Ecce Homo* is fused with that of *Christ as the Man of Sorrows*.[5] Dr. S. Ringbom cites the painting by Mantegna, or his studio, in the Musée Jacquemart-André, Paris, as a possible prototype for the three-figure grouping of *Ecce Homo*, but concludes that Solario may well have devised the composition himself.[6] Mr. Cecil Gould has shown that in Italian art the depiction of Pilate in paintings of *Ecce Homo* is comparatively rare before the popularity of Dürer's two woodcut series of the Large and Small Passions, both published in 1511.

REFERENCES: 1. Sir Martin Conway, *The Sport of Collecting* (London, 1914), p. 57 repr., where it is stated that the picture was bought in Brescia as a work by Solario. 2. See L. Cogliati Arano, *Andrea Solario* (Milan, 1965), figs. 64–5, 67, 69, and 72–5. 3. Inv. 528, 71·5×56·7 B. Klesse, *Katalog der italienischen, französischen und spanischen Gemälde bis 1800 im Wallraf–Richartz-Museum* (Cologne, 1973), pp. 71–3. 4. P. della Pergola, *Galleria Borghese. I dipinti*, i (Rome, 1955), 84, No. 150 repr., who, however, doubts the authenticity of the signature and the date, although it seems to be accepted by Cogliati Arano, op. cit., p. 83, No. 39 and by the compilers of the exhibition catalogue *Capolavori d'arte lombarda. I leonardeschi ai raggi 'X'* (Milan, 1972), pp. 122–3. 5. See E. Panofsky, 'Jean Hey's Ecce Homo', *Bulletin Musées Royaux des Beaux-Arts*, 5 (1956), 95. 6. S. Ringbom, *Icon to Narrative. The Rise of the Dramatic Close-Up in Fifteenth Century Devotional Painting* (Äbo, 1965), pp. 142–7.

## LAMBERT SUSTRIS                    active 1548, still working 1591

Venetian school. Of Netherlandish origin, but most of his work was done in the Veneto, chiefly in Padua. He also visited Rome and had two separate periods of activity in Augsburg, the first in the company of Titian. He was most probably a pupil of Jan van Scorel, but on reaching Venice worked in the manner of Titian and Tintoretto. There is also an Emilian flavour in many of his works.

## ATTRIBUTED TO LAMBERT SUSTRIS

A717   S. JEROME IN THE WILDERNESS                    **Pl. 120**

Canvas (relined). 94·   ×7·1132.

Condition: fair. The sky has been retouched, but both the figure and the landscape are quite well preserved. Much of the *impasto* has been lost as a result of relining.

Collections: William Angerstein (Christie's, 24 Feb. 1883, lot 223, as Titian, bt. Freshfield for 10 gns.); D. W. Freshfield, Wych Cross Place, Forest Row, Sussex (Christie's, 27 May 1921, lot 115, bt. Fenwick Owen for £120. 15s.); G. Fenwick Owen.[1]

Purchased 1945.

Exhibited: London, Burlington Fine Arts Club, 1921.[2]

Literature: R. Fry, 'Pictures at the Burlington Fine Arts Club', *Burlington Magazine*, 38 (1921), 138 repr.; L. Fröhlich-Bum, 'Studien zu Handzeichnungen der italienischen Renaissance', *Jahrbuch der Kunsthistorischen Sammlungen in Wien*, N.F. 2 (1928), 193–4; *Annual Report*, 1945, 21 repr.; Berenson, 1957; 168; A. Ballarin, 'Profilo di Lamberto di Amsterdam. (Lambert Sustris)', *Arte veneta*, 16 (1962), 74 repr.; A. Ballarin, 'Lamberto d'Amsterdam (Lamberto Sustris): Le fonti e la critica', *Atti dell' Istituto Veneto di Scienze, Lettere ed Arti* 121 (1962–3), 361; A. Boschetto, *Giovan Gerolamo Savoldo* (Milan, 1963), p. 226.

No. A717 was formerly ascribed to Savoldo by Fry, Fröhlich-Bum, and also, but with more caution, by Sir Karl Parker in the *Annual Report* of 1945. Professor Creighton Gilbert (written communication)[3] proposed an attribution to Farinati and, according to the 1961 edition of the Ashmolean catalogue which is followed by Boschetto, Fiocco suggested Muziano. The present attribution to Lambert Sustris is first found in Berenson's Lists of 1957 and is accepted and fully discussed by Dr. Alessandro Ballarin (1962). It is also accepted by Dr. Antonio Boschetto. Ballarin dates No. A717 between 1565 and 1570. According to his chronology, the painting in Oxford forms part of a group of works painted during the seventh decade, in which he includes the *Rape of Proserpine* (Cambridge, Fitzwilliam Museum),[4] the *Rape of Europa* (Milan, Prince Castelbarco Albani),[5] *Diana and Actaeon* (Oxford, Christ Church),[6] and an *Allegory* (Chicago, The Art Institute).[7] The homogeneity of this group of pictures is highly questionable. In addition, the strong affinities with Tintoretto, most evident in the contraposto of the figure of S. Jerome,[8] indicate that a date later than the seventh decade might be preferable.[9]

The landscape on No. A717 is divided into two zones—the foreground rhythmically and rather dryly painted, in contrast with the shimmering blue tone of the background so reminiscent of the finest achievements of Venetian painting.

REFERENCES: 1. An early reference to a painting of S. Jerome attributed to Sustris occurs in a list of paintings located as 'In casa del Gobbo' found among the manuscripts belonging to the Duke of Hamilton and Brandon at Lennoxlove and published by E. K. Waterhouse, 'Paintings from Venice for Seventeenth-Century England: Some Records of a Forgotten Transaction', *Italian Studies*, 7 (1952), 1–23, particularly 22–3, No. 3. The list was inscribed 'Note of pictures for my Lord Marquis from my Lord Fieldings' and was sent by Viscount Feilding, English Ambassador in Venice from 1634 to 1639 and later 2nd Earl of Denbigh, to his brother-in-law, the 3rd Marquess (later 1st Duke) of Hamilton. The identification of No. A717 with this reference cannot be advanced with

any certainty. 2. The catalogue of this exhibition appears to have been issued in typescript only. 3. Letter of 13 Feb. 1952. 4. Inv. 1778. J. Goodison and G. Robertson, *Fitwilliam Museum, Cambridge. Catalogue of Paintings ii. Italian Schools* (Cambridge, 1967), pp. 187–90, attributed to Christoph Schwarz. 5. Repr. A. Ballarin, 'Profilo di Lamberto di Amsterdam. (Lambert Sustris)', *Arte veneta*, 16 (1962), fig. 91. 6. J. Byam Shaw, *Paintings by Old Masters at Christ Church Oxford* (London, 1967), pp. 73–4, No. 91. 7. Repr. Ballarin, loc. cit., fig. 90. 8. Compare the figure of *S. Jerome in the Wilderness* by Tintoretto in the Kunsthistorisches Museum, Vienna (inv. 46), repr. E. von der Bercken, *Die Gemälde des Jacopo Tintoretto* (Munich, 1942), p. 134, pl. 130. 9. As R. A. Peltzer, 'Chi è il pittore "Alberto de Ollanda?"', *Arte veneta*, 4 (1950), 118–22, showed Sustris's adherence to the style of Tintoretto itensified towards the end of his life, a point which Ballarin does not take properly into account.

## DOMENICO TINTORETTO                              1560–1635

Venetian school. His real name was Domenico Robusti, baptized Giovanni Battista, the son of Jacopo Tintoretto. He was also active in Ferrara and Mantua. In his early years he acted as an assistant to his father, but there are signed and dated works from the ninth decade of the sixteenth century, which provide a firm starting-point for the development of his personal style. He achieved considerable fame as a portrait painter and after his father's death he continued to serve the Republic in an official capacity.

### A731   PORTRAIT OF A MAN                              **Pl. 121**

Canvas. 64 × 48·5.

On the back the indecipherable remains of a wax impression of a seal.

Condition: good. Cleaned in 1961.

Purchased 1946.

Literature: *Annual Report*, 1946, 28 repr.; Berenson, 1957, 19; E. Arslan, *I Bassano*, i (Milan, 1960), 359; P. Rossi, 'Alcuni ritratti di Domenico Tintoretto', *Arte veneta*, 22 (1968), 64 repr.

At the time of acquisition No. A731 was tentatively attributed to Jacopo Bassano, an attribution which Berenson supported with some reserve in the Venetian Lists of 1957. Arslan rejected the proposed attribution to Jacopo Bassano, assigning this fine portrait to an anonymous Venetian painter *c.* 1570–80. The attribution to Domenico Tintoretto, which is accepted by Dottoressa Paola Rossi, is first found in print in the 1961 edition of the Ashmolean catalogue.

Rossi argues convincingly that No. A731 belongs to the earliest phase of Domenico Tintoretto's working life, close in date to the *Portrait of a Sculptor* in the Alte Pinakothek, Munich,[1] and to the *Portrait of a Man*

*Wearing a Toga* in the Prado, Madrid,[2] both painted a little after the *Portrait of a Man with a Crucifix* in the collection of the Duke of Sutherland, which is dated 1589.[3]

REFERENCES: 1. Inv. 965. Repr. P. Rossi, 'Alcuni ritratti di Domenico Tintoretto', *Arte veneta*, 22 (1968), pl. 87. 2. Inv. 374. Repr. Rossi, op. cit., pl. 86. 3. Reproduced Rossi, op. cit., pl. 77.

## JACOPO TINTORETTO                                                   1518–1594

Venetian school. His real name was Jacopo Robusti, called Tintoretto. Apart from a short visit to Mantua and possibly an early journey to Rome, he worked almost wholly in Venice, where much of his work, particularly in the Scuola di San Rocco, is still preserved. His artistic training is uncertain. Tintoretto apparently spent only ten days in Titian's workshop, after which, it seems, he joined the workshop of one of the other leading Venetian artists of the day—Bonifazio de' Pitati or Bordone. His mature style is often described as combining the drawing of Michelangelo with the colour of Titian. Two sons, Domenico and Marco, and a daughter, Marietta, were also painters.

A678a   HEAD OF A BEARDED MAN                                         **Pl. 122**

Canvas (relined). 42 × 34·3.

The canvas has been extended at the top by 0·5 and at the bottom by 2·5.

Condition: poor. Cleaned in 1943 and relined in 1961. No. A678a would appear to have suffered considerable damage in the past. The features are rubbed and damages have been made good in the corner of the left eye and on the left side of the nose. The background has been strengthened and the contour of the right side of the face thereby weakened.

Collections: Lord Leighton, P. R. A. (Christie's, 11–13 July 1896, lot 364, bt. Sichel). Recorded again at Christie's, 19 Apr. 1902, lot 147, Various Properties, bt. Shepherd.

Presented by H. Bompas, 1941.

Exhibited: Birmingham, *Italian Art from the 13th Century to the 17th Century*, 1955 (104).

Literature: Berenson, 1957, p. 176; P. Rossi, *Jacopo Tintoretto i. I ritratti* (Venice, 1974), p. 148 repr.

No. A678a could possibly be a fragment cut from a larger painting, but the forward tilt of the head and the fact that other portraits in this format are known, suggest that the present portrait was originally confined to the head and shoulders.

Berenson listed No. A678a as an early work by Jacopo Tintoretto and there can be little doubt that the portrait was once of fine quality possibly

painted as early as the fifth decade.[1] Dottoressa Paola Rossi, however, assigns the portrait to the school of Jacopo Tintoretto.

REFERENCES: 1. Related material is discussed and reproduced by R. Pallucchini, *La giovinezza del Tintoretto* (Milan, 1950), pp. 115–19 and by P. Rossi, *Jacopo Tintoretto* i. *I ritratti* (Venice, 1974), p. 148 repr.

## JACOPO TINTORETTO WITH STUDIO ASSISTANCE

### A720   THE RESURRECTION OF CHRIST                    Pl. 123

Canvas (relined). Painted surface 161·8 × 153·6.

The original format of the canvas was octagonal, measuring 132·5 × 102·5 (sloping edge at top left 36·8, top edge 66·7, sloping edge at top right 39·4, edge at right 78·7, sloping edge at bottom right 35·6, bottom edge 56·5, sloping edge at bottom left 36·8, edge at left 74·9). The extensions were most probably made in the seventeenth century.

Condition: fairly good.

Collections: William Douglas-Hamilton, 12th Duke of Hamilton (1845–95), (Hamilton Palace sale, 24 June 1882, lot 371, bt. William Dyer for £157 10s.);[1] Sir William Farrer.

Bequeathed by G. O. Farrer through the National Art-Collections Fund, 1946.

Exhibited: London, Burlington House, *Exhibition of Works by the Old Masters*, 1884 (161); Manchester, *Between Renaissance and Baroque*, 1965 (227).

Literature: Waagen, *Treasures*, iii. 303; H. Thode, *Tintoretto* (1901), pp. 116 and 139; J. B. S. Holborn, *Jacopo Robusti called Tintoretto* (London, 1903), p. 102; Berenson, 1911, 136: 1932, 560: 1936, 482: 1957, 176; E. M. Phillipps, *Tintoretto* (London, 1911), p. 159; F. R. B. Osmaston, *The Art and Genius of Tintoret*, ii (London, 1915), 187; E. von der Bercken and A. L. Mayer, *Jacopo Tintoretto*, i (Munich, 1923), 218; M. Pittaluga, *Il Tintoretto* (Bologna, 1924), p. 272; E. von der Bercken, *Die Gemälde des Jacopo Tintoretto* (Munich, 1942), pp. 83 and 113 repr.; *Annual Report*, 1946, 24–5.

There are a number of *pentimenti* in the figure of the guard leaning on his elbow in the middle ground on the right.

As stated above, No. A720 has been extended on all sides, thus transforming the original octagonal format of the canvas into a square format. The seventeenth-century additions include the foliage above the figure

of Christ from the top of the flag, the landscape to the left of the wrist of the left hand of the fleeing soldier, the foreground from the boss of the shield below the sleeping soldier, and the angel on the right just above the empty tomb.

The octagonal format of the original canvas prompts comparison with the similarly shaped *Deposition from the Cross* in the Musée des Beaux-Arts, Caen.[2] The dimensions and the use of two viewpoints are comparable in both paintings. Stylistically they are also related, both having been painted *c.* 1570–5 with a considerable amount of studio intervention. Although No. A720 is of better quality than the *Deposition*, these similarities suggest that the two paintings might have formed part of the same decorative scheme, most probably a series of the *Passion*.

Waagen, who saw No. A720 when it was still in the Hamilton collection attributed to Giorgione,[3] first proposed an attribution to Jacopo Tintoretto, describing the effect as 'very dramatic, and very animated in the figures'. Stoughton Holborn, Thode, and von der Bercken (1923 and 1942), regarded No. A720 as a preparatory study for the *Resurrection* in the Upper Hall of the Scuola di San Rocco, Venice, datable some time between 1578 and 1581.[4] Although this was firmly refuted by Osmaston as early as 1915, the statement is still often reiterated. There are, indeed, compositional similarities with the *Resurrection* in the Scuola di San Rocco, but to regard No. A720 as a preparatory sketch is to misunderstand Tintoretto's working methods.[5] Some of the compositional motifs of No. A720 recur on the *Resurrection of Christ* in the Staatsgalerie, Stuttgart.[6]

Professor Juergen Schulz (written communication)[7] has emphasized the role of the studio in the painting of No. A720, but the present writer is convinced that Jacopo himself was responsible for the sleeping guard in the foreground and for the other guard on the right leaning on his left elbow. The fact that there is a preparatory drawing for this last-mentioned figure (see below) attributable to Jacopo certainly suggests at the very least that he designed the composition.

REFERENCES: 1. *The Hamilton Palace Collection. Illustrated Priced Catalogue* (London, 1882), p. 53. 2. Inv. 49, 134×101. Exhibited and repr. *Le Seizième Siècle européen. peintures et dessins dans les collections publiques françaises* (Paris, Petit-Palais, 1965), p. 229, No. 277, with full bibliography, to which should be added R. Pallucchini, 'Inediti di Jacopo Tintoretto', *Arte veneta*, 23 (1969), 40–1. There is a replica in the Musée des Beaux-Arts, Strasbourg (inv. 280), repr. E. von der Bercken, *Die Gemälde des Jacopo Tintoretto* (Munich, 1942), pl. 206. 3. The attribution to Giorgione may have been based on the engraving of a painting of the same subject in Leopold's collection in Vienna made by Theodor van Kessel for D. Teniers, *Schilder-Thooneel van David Teniers, gheboortigh*

*van Antwerpen Schilder Ende Camer-Diender des Doorl*ste. *Princen Leopol. Guil. Arts-Hertogh en Don Jan van Oostenr.* (Brussels, 1660). Reference was made to this engraving by F. Haskell, 'Some Collectors of Venetian Art at the End of the Eighteenth Century', in *Studies in Renaissance and Baroque Art presented to Anthony Blunt on his Sixtieth Birthday* (London, 1967), p. 175, n. 17. 4. Repr. von der Bercken, op. cit., fig. 270. 5. See H. Tietze, 'Bozzetti di Jacopo Tintoretto', *Arte veneta*, 5 (1951), 55–64, and 'Il bozzetto della Probatica Piscina del Tintoretto', *Arte veneta*, 6 (1952), 189–90. 6. Inv. 2471, for which see *Katalog der Staatsgalerie Stuttgart i. Alte Meister* (Stuttgart, 1962), p. 220 repr. 7. Letter of 12 June 1969. Professor Schulz independently referred to the *Deposition* at Caen as a painting with features in common with No. A720.

## DRAWINGS

Attributable to Jacopo Tintoretto.

1. London, British Museum, inv. 1913-3-31-179, *Study of a Man Leaning on his Left Arm*, black chalk on blue paper, 236 × 316. First published with the attribution to Jacopo Tintoretto and connected with the guard on the right of No. 433 by D. F. von Hadeln, 'Some Drawings by Tintoretto', *Burlington Magazine*, 44 (1924), 283, repr. on 281, pl. II E. Listed by H. Tietze and E. Tietze-Conrat, *The Drawings of the Venetian Painters in the 15th and 16th Centuries* (New York, 1944), p. 301, No. 1834, as workshop of Tintoretto.

2. London, Courtauld Institute Galleries, inv. 674 (formerly, Sir Robert Witt collection), *Study of a Nude Man Lying on his Back* (recto and verso), black chalk on faded blue paper, 202 × 300 (squared). Tietze and Tietze-Conrat, op. cit., p. 289, No. 1714, as Jacopo Tintoretto, late period, but not connected with any specific composition. Perhaps a study for the sleeping guard in the right foreground of No. A720, but the connection is only very tentative. There are, for instance, similarities with the sleeping apostle in the right foreground of the *Agony in the Garden* in the Upper Hall of the Scuola di San Rocco.

## COPY AFTER JACOPO TINTORETTO

A397　THE ANNUNCIATION　　　　　　　　　　　　　　　**Pl. 124**

Canvas (relined). 88·8 × 56·8.

Condition: good.

Presented by Sir Arthur Evans, 1929.

No. A397 is a vividly painted copy, dating in all probability from either the late seventeenth or the early eighteenth century, of the *Annunciation* painted on the right-hand organ shutter of the church of S. Rocco, Venice.[1] On reducing the scale the copyist has omitted the dove descending from the clouds, together with the ray of light projecting from the Heavens.

The left-hand shutter showed *S. Roch Presented to the Pope*. Both shutters, now much restored, were probably painted sometime between 1574 and 1584, but by the end of the eighteenth century they had been detached from the organ and hung on the walls of the church.[2]

An attribution to Domenico Tintoretto has been suggested, but is incorrect.[3]

REFERENCES: 1. See E. von der Bercken, *Die Gemälde des Jacopo Tintoretto* (Munich, 1942), p. 124, pl. 140. 2. M. Boschini, *Descrizione di tutte le pubbliche pitture della città di Venezia* (ed., Venice, 1733), p. 302, and A. M. Zanetti, *Della pittura veneziana* (Venice, 1771), p. 139. 3. The attribution occurs in the *Summary Guide. Ashmolean Museum, Department of Fine Art* (Oxford, 1931), p. 21.

# TITIAN                                              *c.* 1477–1576

Venetian school. His real name was Tiziano Vecelli. He was a pupil of Giovanni Bellini, but was also profoundly influenced at the outset by his fellow pupil Giorgione. Titian worked in Venice, Mantua, Ferrara, Augsburg, and Rome, enjoying the patronage of such families as the Este, the Gonzaga, the della Rovere, and the Farnese, as well as of Francis I of France, Charles V and Philip II of Spain, His influence on the course of Venetian painting was paramount. He was able to paint religious and mythological themes with equal success and the dexterity of his technique perfectly matched the fertility of his mind.

## COPY AFTER TITIAN

### A226   VENUS BLINDFOLDING CUPID                     **Pl. 125**

Canvas. 45·1 × 72.

Condition: fair. The surface is almost totally obscured by dirt, but the figures appear to be well preserved. The canvas is rather loose and there are now some creases along the bottom edge.

Unknown provenance.[1]

No. A226 is a reduced, but exact copy after the painting by Titian in the Borghese Gallery, Rome.[2] The subject is sometimes called the *Education of Cupid*.[3] The quality and date of No. A226 cannot be properly judged until after cleaning, but the copyist appears to have been skilled.

REFERENCES: 1. No. A226 is first recorded in the Ashmolean Museum in 1859 (*Handbook Guide for the University Galleries, Oxford* (Oxford, 1859), p. 56). 2. Inv. 170. P. della Pergola, *Galleria Borghese. I dipinti*, i (Rome, 1955), 131–2, Cat. no. 235. 3. See E. Panofsky, *Problems in Titian Mostly Iconographic* (London, 1969), pp. 129–37.

## ANONYMOUS TUSCAN SCHOOL   fourteenth century

A451C   HEAD OF AN ANGEL (FRAGMENT FROM A FRESCO)   **Pl. 126**

23 (round).

Condition: fair. There is a vertical fissure in the centre, in addition to the more prominent diagonal crack. The paint surface is intact, but there is an area of retouching beneath the left eye.

Presented by Mrs. L. Milne, 1936.

Literature: *Annual Report*, 1936, 27.

In the *Annual Report* of 1936 No. A451C was described as being of the fifteenth century. The fragment would appear to be slightly earlier, perhaps from the last quarter of the fourteenth century.

## PAOLO UCCELLO   1396/7–1475

Florentine school. His real name was Paolo di Dono, called Uccello. He also worked in Venice, Padua, and Urbino. The major fresco cycles in Florence (S. Maria Novella, S. Miniato al Monte, and S. Martino alla Scala) are either in a ruinous condition or else fragmentary. The equestrian portrait of *Sir John Hawkwood* and the decoration of the clock-face (Duomo, Florence) are well preserved. Few panel paintings of undisputed attribution have survived. He was a pupil of Lorenzo Ghiberti. There is a striking visual conflict in his mature work between the decorative effects of the International Gothic style and the scientific analysis of composition based upon his mastery of perspective.

A79   THE HUNT IN THE FOREST   **Pl. 127**

Panel. 73·5 × 177.

No. A79 is made up of two horizontal panels, each approximately half the height of the painted surface.

On the back a label inscribed by an old hand, *Una Caccia nelli Boschi di Pisa di Benozzo | Gozzoli*. A Fox-Strangways label (No. 2) also occurs.

Condition: good. There are cracks in the paint surface at the right edge, on either side of the join in the centre of the panel. All the figures and the animals are well preserved, although the faces are slightly rubbed. No major restoration has been undertaken, but some of the pigments—reds, blues, and greens—have darkened. There are some paint losses in the foliage of the trees.

Fox-Strangways Gift, 1850.

Exhibited: London, Burlington Fine Arts Club, *Exhibition of Florentine Painting before 1500*, 1920 (22).

Literature: C. Loeser, 'Paolo Uccello', *Reportorium für Kunstwissenschaft,* 21 (1898), 87–8; C. Gamba, 'Di alcuni quadri di Paolo Uccello o della sua Scuola', *Rivista d'arte,* 6 (1909), 27–8 repr.; A. Venturi, *Storia,* vii, pt. 1 (1911), 340 repr. (detail only); Crowe and Cavalcaselle, *History,* 2nd edn., iv (1911), 122 n.; Berenson, 1912, 186: 1932, 582: 1936, 500: 1963, 209; Schubring, *Cassoni* (1915), 242, No. 101 repr.; C. Phillips, 'Florentine Painting before 1500', *Burlington Magazine,* 34 (1919), 215 repr.; F. Antal, 'Studien zur Gotik im Quattrocento', *Jahrbuch der Preuszischen Kunstsammlungen,* 46 (1925), 9 repr.; Van Marle, *Development,* x (1928), 208–10 repr.; P. Soupault, *Paolo Uccello* (Paris, 1929), pp. 39–40 repr.; R. Van Marle, *Iconographie de l'art profane au Moyen-Âge et à la Renaissance,* i (La Haye, 1931), p. 244 repr.; M. Marangoni, 'Una predella di Paolo Uccello', *Dedalo,* 12 (1932), 346; W. Boeck, 'Uccello-Studien', *Zeitschrift für Kunstgeschichte,* 2 (1933), 267–9 and 274 repr.; J. von Schlosser, 'Künstlerprobleme der Frührenaissance. III. Paolo Uccello', *Akademie der Wissenschaften in Wien. Sitzungsberichte,* 214 (1933), 37–8; W. Paatz, 'Una Natività di Paolo Uccello e alcune considerazioni sull'arte del Maestro', *Rivista d'arte,* 16 (1934), 148; G. Pudelko, 'The Early Works of Paolo Uccello', *Art Bulletin,* 16 (1934), 254; M. Salmi, *Paolo Uccello, Andrea del Castagno, Domenico Veneziano* (Milan, 1938), pp. 40–1, 109, and 151–2 repr.; G. Pudelko, in Thieme–Becker, *Lexikon,* xxxiii (1939), 525; W. Boeck, *Paolo Uccello* (Berlin, 1939), pp. 70–4, and 116 repr.; M. Wackernagel, 'Paolo Uccello', *Pantheon,* 27 (1941), 110 repr.; K. Clark, *Landscape into Art* (London, 1949), p. 13; M. Pittaluga, *Paolo Uccello* (Rome, 1946), pp. 16–18 repr.; J. Pope-Hennessy, *Paolo Uccello* (London, 1950), pp. 26 and 154 repr.: 2nd edn. 1969, pp. 23–4 and 157; M. Salmi, 'Riflessioni su Paolo Uccello', *Commentari,* 1 (1950), 29–30; E. Sindona, *Paolo Uccello* (Milan, 1957), pp. 41–2 and 61 repr.; D. Gioseffi 'Complementi di prospettiva, 2', *Critica d'arte,* 5 (1958), 133 and 136–7; P. D'Ancona, *Paolo Uccello,* Eng. edn. (London, 1960), p. 18; L. Berti, 'Una nuova Madonnae degli appunti su un grande Maestro', *Pantheon,* 19 (1961), 300 and 304; A. Parronchi, 'Le fonti di Paolo Uccello', in *Studi su la dolce prospettiva* (Milan, 1964), p. 478; E. Flaiano and L. Tongiorgi Tomasi, *L'opera completa di Paolo Uccello* (Milan, 1971), p. 99, No. 57 repr.; E. Sindona, 'Introduzione alla poetica di Paolo Uccello. Relazioni tra prospettiva e pensiero teoretico', *L'arte,* 17 (1972), 31–2, 43–4, and 96–100 repr.

The attribution of No. A79 to Uccello was first suggested by Loeser in 1898. Venturi and Schlosser both rejected this attribution, advocating a comparison with the tondo of the *Adoration of the Magi* in Berlin–Dahlem

(Staatliche Museen), now attributed to Domenico Veneziano. All other writers follow Loeser.

There is widespread agreement about the date of No. A79,[1] as the panel is undoubtedly in Uccello's late style and was in all probability painted during the seventh decade either shortly before or shortly after the predella panels of the *Profanation of the Host* (Urbino, Galleria Nazionale) dating from *c*. 1466–7.[2] It cannot be totally excluded that No. A79 was painted for Federico da Montefeltro while Uccello was in Urbino.[3]

It has been generally assumed that No. A79 was set into the front of a *cassone*. The dimensions and comparatively good condition of the panel suggest a different location. The system of perspective, so cleverly concealed from the eye by such features as colour and internal rhythm, has given rise to much discussion, but never with regard to establishing the specific placing of the panel within the confines of a room. The most detailed study with numerous diagrams of the system of perspective devised by Uccello for No. A79 is that of Dr. Enio Sindona (1972).

Regarding the subject-matter of No. A79, Professor Mario Salmi's proposal (1938) that Lorenzo de' Medici is shown hunting in the pine forest outside Pisa is hardly demonstrable, although he attempted to support the suggestion by oblique references to contemporary poetry, including those poems written by Lorenzo de' Medici himself. Sir John Pope-Hennessy's contention that the painter has illustrated a scene from a contemporary novella is still in need of confirmation. Usually, scenes of hunting were treated in the medieval tradition to illustrate the occupations of the months of the year. It is far harder to find examples of such scenes depicted independently, either on panel or in fresco.[4]

It may be observed that on No. A79 the moon, which is the astral sign of Diana, the goddess of hunting, is placed top centre. If some symbolic significance can be admitted, then the problem which Schubring posed of whether the scene takes place at night, or in the early hours of the morning, becomes irrelevant. The late Professor Wind (written communication)[5] tentatively proposed a connection with the astronomical system devised by Manilius (*Astronomicum*, ii. 439–47, ed. A. E. Housman (London, 1912), pp. 45–6), an Augustan poet rediscovered at the time of the early Renaissance.[6] Warburg noticed that the deviser of the scheme adopted by the painters of the Schifanoia frescoes in Ferrara (1470)[7] had used Manilius as a source for the distribution of the gods in their roles as tutelary deities over the zodiacal signs. Thus, in Manilius' text the goddess Diana is correlated with Sagittarius, the zodiacal sign of hunting ('venantem Diana virum, sed partis equinae'). A possible explanation therefore, as

proposed by Wind, is that No. A79 may originally have formed part of a series of paintings depicting the various occupations of the months of the year based on the *Astronomicum*, where hunting occupies the ninth month—November.[8] This hypothesis, however, assumes the execution of a number of other panels to complete the cycle of months, unless for some reason the series was abandoned at an early stage.

REFERENCES: 1. Only two writers regard No. A79 as an early work; Van Marle, *Development*, x (1928), 208–10 and M. Marangoni, 'Una predella di Paolo Uccello', *Dedalo*, 12 (1932), 346, who date the panel before 1436. W. Paatz, 'Una Natività di Paolo Uccello e alcune considerazioni sull' arte del Maestro', *Rivista d'arte*, 16 (1934), 148, and M. Pittaluga, *Paolo Uccello* (Rome, 1946), p. 18, both suggest a later date, but one before 1459. 2. J. Pope-Hennessy, *Paolo Uccello* (London, 1950), pp. 153–4, pls. 81–6. 3. Professor Mario Salmi rejects a suggestion made by Georg Gronau that No. A79 might be identifiable with a painting mentioned in an inventory (apparently undated) of the court of Urbino, transcribed by Salmi, *Paolo Uccello, Andrea del Castagno, Domenico Veneziano* (Milan, 1938), p. 152, as the sizes do not correspond. 4. See Vasari, *Life of Dello Delli*, ii. 148. Also R. van Marle, *Iconographie de l'art profane au Moyen-Âge et à la Renaissance*, i (La Haye, 1931), Ch. v. pp. 197–278. Salmi, op. cit., pp. 111–12, discusses the painting of a *Hunt* by Pesellino mentioned in the Medici inventory of 1492. 5. Letter of 1 June 1969. 6. For a translation of, and commentary on, Book II of the *Astronomicum* see particularly the edition by H. W. Garrod (Oxford, 1911). 7. A. Warburg, 'Italienische Kunst und internationale Astrologie im Palazzo Schifanoja zu Ferrara', in *Die Erneuerung der heidnischen Antike. Kulturwissenschaftliche Beiträge zur Geschichte der europäischen Renaissance. Gesammelte Schriften*, ii (Berlin, 1932), 459–81, particularly 469–72. 8. November is also correlated with Sagittarius in a series of frescoes painted by Veronese artists c. 1450 in the Torre dell' Aquila at Trento, for which see *Scritti d'arte di Gino Fogolari* (Milan, 1946), 'Il ciclo dei mesi nella Torre dell' Aquila a Trento e la pittura di costume veronese del principio dell'quattrocento', pp. 29–38 repr. A. Morassi, *Storia della pittura nella Venezia tridentia* (Rome, 1934), p. 289, fig. 176.

## 'UTILI' (BIAGIO DI ANTONIO DA FIRENZE)
documented between 1476 and 1504

Florentine school. Biagio di Antonio da Firenze has been plausibly identified as the painter of a group of pictures which was until recently ascribed to a painter designated as 'Utili'. He painted in the Sistine Chapel in Rome, although extant documents only refer to his activity in the Marches. The origins of his style, however, are decidedly Florentine with echoes of Filippo Lippi, Pesellino, Cosimo Rosselli, Verrocchio, and Domenico Ghirlandaio. In his later works there is a Filippinesque vein.

### A82   THE FLIGHT OF THE VESTAL VIRGINS          Pl. 128

Wood. 67·3 × 173 (bowed). No. A82 is made up of three horizontal panels, the joins clearly visible in the paint surface approximately 25 cm. and 43·5 cm. respectively from the top.

On the back a Fox-Strangways label half hidden by a modern batten and a second label inscribed by Fox-Strangways with the title *Procession of Roman Virgins*.

Condition: fair. Many of the figures are well preserved, but some of those in the foreground, particularly at the extreme left of the composition, are damaged (for example, the mother and child on horseback crossing the bridge). The face of the small boy on the right being handed down from the front of the carriage in the centre is repainted. There are cracks in the paint surface extending across the drapery of the leading Vestal Virgin in the centre about to take her place in the carriage. The architecture and landscape are intact, although the panel is damaged along each edge.

Fox-Strangways Gift, 1850.

Literature: Waagen, *Treasures*, iii. 53; Crowe and Cavalcaselle, *History*, ii (1864), 350: 2nd edn., iv (1912), 176; W. Weisbach, *Francesco Pesellino und die Romantik der Renaissance* (Berlin, 1901), p. 125; A. Schiaparelli, *La casa fiorentina e i suoi arredi nei secoli XIV e XV* (Florence, 1908), p. 285; C. Hülsen, 'Di alcune nuove vedute prospettiche di Roma', *Bullettino della Commissione Archaeologica Comunale di Roma*, 39 (1911), 13; C. Hülsen, 'On Some Florentine "Cassoni" Illustrating Ancient Roman Legends', *Journal of the British and American Archaeological Society of Rome*, 4 (1911), 474–6 repr.; Schubring, *Cassoni* (1915), 86, 116, and 244, No. 108 repr.; O. Sirén, 'Early Italian Pictures at Cambridge', *Burlington Magazine*, 37 (1920), 300; Van Marle, *Development*, x (1928), 556–7 and 568–9; Berenson, 1932, 585: 1936, 504: 1963, 211; H. W. Grohn, 'Zwei Cassoni mit Darstellungen aus der Erzählung von Amor und Psyche, Frühwerke des "Meisters der Argonauten-Tafeln"', *Staatliche Museen zu Berlin. Forschungen und Berichte*, 1 (1957), 97–8.

The attribution to 'Utili' was first proposed by Berenson (1932). The diversity of the attributions made by other scholars reflects the numerous stylistic influences at play within this painter's work. Waagen suggested Filippo Lippi and Langton Douglas, in the second edition of Crowe and Cavalcaselle, the school of Filippo Lippi. Weisbach favoured an attribution to an anonymous follower of Pesellino and Van Marle one to the school of Pesellino. Schubring listed No. A82 as a work by the Anghiari Master and Dr. Hans Werner Grohn, following Weisbach and Sirén in grouping the panel with two others in the Metropolitan Museum, New York, representing *Scenes from the Story of the Argonauts*, rejected Berenson's attribution to 'Utili', suggesting incorrectly that the painter was inde-

pendent and should be called the Argonaut Master. The figures emerging from the city in the left background of No. A82 are almost certainly by an assistant.[1]

The large number of panels of similar format illustrating scenes from Roman history, suggests that Biagio di Antonio ran a busy and prosperous workshop, analogous to that run by Apollonio di Giovanni, specializing in this type of panel painting.

Hülsen was the first to point out that a panel entitled the *Battle of Allia* in the Sabauda Gallery, Turin,[2] formed a pair with No. A82. Another panel, *The Triumph of Camillus*, now in the Kress collection, is certainly related in subject-matter and may have formed part of a decorative scheme around the same room.[3] The literary source for these three scenes appears to have been Livy.[4] The series was probably painted sometime between 1470 and 1490 serving perhaps as *spalliere*. The panels are certainly too large to have been inserted into the front of a *cassone*.

The events on No. A82 are as follows: on the left, the Gauls attack Rome (390 B.C.) where, within the city walls, the murder of the city elder, M. Papirius, takes place; to the left of centre, the Flamen Quirinalis escapes out of the city with the Vestal Virgins; in the centre, Lucius Albinius offers his carriage to the Vestal Virgins encouraging his family to dismount; on the right, the carriage, now carrying the Vestal Virgins with Albinius and his family walking alongside, approaches the Temple of Caere where, top right, they are shown arriving.

Hülsen identified the buildings as follows (from left to right): the column of Marcus Aurelius (incorrectly decorated with reliefs of Lapiths and Centaurs),[5] the church of S. Silvestro in Capite, the Pantheon (with no inscription along the pediment, but showing the bell tower added in 1470 at the top of the pediment),[6] Hadrian's Mausoleum (Castel S. Angelo),[7] and the pyramid of Caius Cestius (the presumed burial place of Remus). Some buildings are unidentifiable. The parts of the city depicted on the left of No. A82 and on the right of the composition of the panel in Turin form a panoramic view of Rome.

REFERENCES: 1. The same assistant might have been employed on a comparable task on two *cassone* panels in the Fitzwilliam Museum, Cambridge (inv. M 44 and M 45), *The Death of Hector* and *The Wooden Horse*, for which see J. Goodison and G. Robertson, *Fitzwilliam Museum, Cambridge. Catalogue of Paintings*, ii. *Italian Schools* (Cambridge, 1967), pp. 17–18 repr. 2. Inv. 111, 60×154. Repr. Schubring, *Cassoni* (1915), 244, No. 107, repr. ii, pl. XIX. The panel is cradled and is now on loan to the Italian Embassy, London, where the present writer was kindly allowed to view it. There is no mention of this panel in N. Gabrielli, *Galleria Sabauda. Maestri Italiani* (Turin, 1971). 3. K 299, 60×154. F. R. Shapley, *Paintings from the Samuel H. Kress Collection. Italian Schools XIII–*

*XV Century* (London, 1966), p. 132 repr., and, by the same author, *Paintings from the Samuel H. Kress Collection. Italian Schools XVI–XVIII Century*, Addenda to Volume I (London, 1973), 386. 4. For the *Battle of Allia, Ab Urbe Condita*, V. 36–8, for No. A82 *Ab Urbe Condita*, V. 40–2, and for the *Triumph of Camillus, Ab Urbe Condita*, V. 49. C. Hülsen ('On Some Florentine Cassoni Illustrating Ancient Roman Legends', *Journal of the British and American Archaeological Society of Rome*, 4 (1912), 474) suggests that the painter may have known Livy's text through the abridged compilation of the history of Rome written by Lucius Annaeus Florus, who records that the Vestal Virgins fled from the city barefoot (*Epitomae de Tito Livio Bellorum Omnium Annorum DCC*, i. 7, ed. P. Jal, *Florus Oeuvres*, i (Paris, 1967), 25), as shown on No. 444 ('Virgines simul ex sacerdotio Vestae nudo pede fugientia sacra comitantur'). An alternative source may have been Plutarch's *Life of Camillus* (Loeb edn. B. Perrin, ii (London, 1959), xviii–xxiv, 133–55) where all the events depicted on these three related panels are also given in some detail. 5. Hülsen, loc. cit., 475, n. 2, observed that similar figures occur on the column in the miniature of the *Death of Panthus* (Biblioteca Riccardiana, Cod. Ricc. 492) now attributed to Apollonio di Giovanni, repr. Schubring, *Cassoni* (1915), ii, pl. LI, No. 232. 6. As shown in Marten van Heemskerk's drawing of 1534, repr. E. Nash, *Pictorial Dictionary of Ancient Rome*, ii (London, 1962), fig. 900. 7. According to Hülsen (op. cit., 475–6) the Moles Hadriani is also depicted with a square base in a drawing of the city made by Alessandro Strozzi in Venice in 1474 (Biblioteca Mediceo-Laurenziana, Florence, Cod. Redi. 77, ff. VII^v–VIII^r for which see A. P. Frutaz, *Le piante di Roma*, i (Rome, 1962), 140–2, LXXXIX, and ii, pl. 159), which may have been derived from the same prototype as miniatures executed by Pietro del Massaio in two manuscripts of Ptolemy's *Cosmography* (two of which are dated 1469 and 1471), dicussed and repr. by Frutaz, op. cit., pp. 137–40, LXXXVII and LXXXVIII, and ii, pls. 157–8.

## ANDREA VANNI      documented between 1353 and 1413

Sienese school. He was a late follower of Simone Martini and probably a pupil of one of Simone's more immediate followers, such as Lippo Memmi or the Master of the Palazzo Venezia Madonna. Vanni divided his life between politics and painting. Most of the documents and extant letters refer to his political activities in Rome, Pisa, Naples, and Avignon, but he continued to paint in these places and also in Sicily. He was in partnership with Bartolo di Fredi in 1353. In his later works the outlines are harder and the figures more rigid.

A696    VIRGIN AND CHILD (MADONNA DEL LATTE) WITH
       THE ANGEL OF THE ANNUNCIATION IN THE GABLE
       (LEFT WING OF A DIPTYCH)       **Pl. 129**

Wood. 58·3 × 25·8 (gabled panel with three crockets). Size of painted surface below the gable 36·0×22·5. The diameter of the roundel in the gable is 8 cm.

On the back a label inscribed by a nineteenth-century hand: *Cimabue (Jean) / 1283*. There is also a wax impression of a seal showing a mitred bishop with a crook in his hand blessing a kneeling suppliant, the whole encircled by an inscription (DIO . . . CL(E)R(I)C(U)S NICO(L)AS. . .).

Condition: fair. The gold background is worn, particularly in the upper parts, and the Virgin's drapery, including the gold border, has been heavily repainted. The flesh parts are slightly worn and small damages to the right side of the Virgin's face have been made good. There are also small damages on the Virgin's forehead and on the backs of both Her hands. The drops of milk painted on the breast are original, although they may appear in reproduction to be later additions. There are small retouches on the Child's hand and forearm and His hair has been repainted. The angel in the gable is well preserved, although the flesh parts are slightly worn.

Presented by the National Art-Collections Fund, 1942.[1]

Literature: *Annual Report*, 1942, 16–17; J. Pope-Hennessy, 'A Madonna by Andrea Vanni', *Burlington Magazine*, 83 (1943), 174–7 repr.; Berenson, 1968, 441; M. Mallory, 'A Lost Madonna del Latte by Ambrogio Lorenzetti', *Art Bulletin*, 51 (1969), 44, n. 21 repr.; A. Sherwood Fehm, 'Notes on the Exhibition of Sienese Paintings from Dutch Collections', *Burlington Magazine*, 111 (1969), 577 repr.

The outline of the figure of the Virgin has been incised.

Hinge marks on the right side of the frame indicate that No. A696 was the left wing of a diptych. The right wing has been identified by Professor Sherwood Fehm as a panel of the *Crucifixion* in the Fogg Art Museum, Cambridge, Massachusetts.[2]

The attribution to Andrea Vanni was first proposed by Sir John Pope-Hennessy, who considered No. A696 to be an early work painted not later than 1365. Other panels generally regarded as early works by Vanni with which No. A696 may be compared, are the *Virgin and Child* in Berlin-Dahlem (Staatliche Museen),[3] the pinnacle panels of the *Annunciation* in the Fogg Art Museum,[4] and the *Virgin and Child* in the Fitzwilliam Museum, Cambridge.[5] Recently, doubts have been cast on the validity of the attribution of No. A696 to Vanni; firstly by Sherwood Fehm, who assigns the panel to Vanni's workshop, and secondly by Dr. Michael Mallory who, for no very sound reason, doubts whether the panel is Sienese.

Mallory has also attempted to show that the pose of the Virgin and Child on No. A696 reflects a lost composition of the *Madonna del Latte* painted by Ambrogio Lorenzetti *c.* 1320 between the *Virgin and Child*, once in S. Angelo, Vico l'Abate (1319) and the *Virgin and Child* formerly in S. Francesco, Siena (*c.* 1340).[6]

REFERENCES: 1. *National Art-Collections Fund Report*, 1942, p. 16, No. 1282. 2. Inv. 1965. 563, 58·7 × 25·7, repr. A. Sherwood Fehm, 'Notes on the Exhibition of Sienese

Paintings from Dutch Collections , *Burlington Magazine*, III (1969), fig. 58. The panel is much damaged, but the decorative elements, such as the frame and the punching, are identical. 3. Inv. 1054A. *Beschreibendes Verzeichnis der Gemälde im Kaiser-Friedrich-Museum* (Berlin, 1931), p. 496. 4. Inv. 1914. 9. *Fogg Art Museum. Harvard University Collection of Mediaeval and Renaissance Paintings* (Cambridge, Mass., 1919), pp. III–113 5. Inv. 560. J. Goodison and G. Robertson, *Fitzwilliam Museum, Cambridge. Catalogue of Paintings*, ii. *Italian Schools* (Cambridge, 1967), pp. 180–1 repr. 6. It should be stressed that Dr. Michael Mallory ('A Lost Madonna del Latte by Ambrogio Lorenzetti', *Art Bulletin*, 51 (1969), 44, n. 21) was wrongly informed when he wrote on the Museum's authority that the drops of milk on the Virgin's breast were damages. The fact that the paint is original in this area, as stated under Condition above, in no way alters the purport of his argument.

## GIORGIO VASARI                                         1511–1574

Florentine school. Painter, architect, and historian. He was born in Arezzo, but led a peripatetic life carrying out commissions in Rome, Bologna, Naples, and Rimini, among many other places. Florence was the scene of his major projects—the redecoration of the Palazzo Vecchio and the redesigning of S. Maria Novella and Santa Croce. He employed a large number of assistants and had an immense influence on the course of Florentine painting. He was the founder of the Accademia del Disegno in 1562/3. The first edition of his *Lives of the Painters* was published in 1550 with a second edition in 1568.

A991   AN ALLEGORY OF THE IMMACULATE CONCEPTION   **Pl. 130**

Wood (cradled). 57·5 × 41·2.

On the back the traces of a saleroom cipher can be made out, but they are not clearly distinguishable.

Inscribed in the scroll carried by the Angels attending the Virgin: QUOS EVE CULPA DA̅AVIT / MARIE GRATIA SOLVIT. Inscribed in the scroll carried by S. John the Baptist: ECCE AGNIU[S]. Inscribed on Abraham's shoulder-strap: UNIUS ONNOSTAAT.

Condition: fair. There is retouching along a vertical split in the centre extending the height of the panel. There is further retouching along other splits to the left of centre. Apart from any disfigurement in these areas, the figures are well preserved, particularly the flesh tones. There is, however, damage along all the edges.

Collections: Sir Philip Miles, Bt., Leigh Court, Bristol (Christie's, 28 June 1884, lot 147, bt. Davis for £46).[1] Next recorded at P. & D. Colnaghi & Co. Ltd.

Purchased 1962.

Exhibited: London, P. & D. Colnaghi & Co. Ltd., *Old Master Paintings* 1962 (6), repr.

Literature: *Annual Report*, 1962, 57–9 repr.; P. Barocchi, *Vasari pittore* (Milan, 1964), pp. 116–17.

No. A991 is a reduced version, in all probability by Vasari himself, of the famous altar-piece commissioned by his patron Bindo Altoviti in 1540 for the Altoviti chapel in SS. Apostoli, Florence.[2] The success of this altar-piece, famed no less for the skill of the painter than for the complexities of the iconography, is evident from the fact that Vasari used the same composition for an altar-piece in the church of S. Francesco, Arezzo,[3] and again at a later date (1541–3), in a more developed style and with some minor variations, on another altar-piece painted for the Cappella Mei in S. Piero Cigoli, Lucca.[4] At about the same date Vasari also made a small replica of approximately the same dimensions as No. A991 for Bindo Altoviti, which is now in the Uffizi.[5] The repetition of the main features of the composition in drawings and paintings made by Vasari's followers and contemporaries attests the interest taken in the altar-piece.

No. A991, like the altar-piece in Lucca and the replica in the Uffizi, is not rounded at the top, but both the composition and the style suggest that the panel in Oxford is a *ricordo* of the altar-piece in SS. Apostoli, Florence.

Vasari's sources for the SS. Apostoli altar-piece were widespread. He drew upon the work of Raphael, Michelangelo, Andrea del Sarto, Rosso, and Bronzino. Specific quotations from Andrea del Sarto should be noted, namely the use of figures occurring on *The Sacrifice of Isaac* in the Cleveland Museum of Art and on the *Virgin and Child in Glory with Saints* in the Pitti Palace, Florence. The diversity of these visual sources and the compilation of a learned iconographic scheme exemplify Vasari's exegetical approach to painting. He himself records in his Autobiography (vii. 668–9) the significance of the success of the altar-piece for the progress of his career and explains the iconography in some detail.

D'ottobre adunque, l'anno 1540, cominciai la tavola di messer Bindo per farvi una storia che dimostrasse la Concezione di Nostra Donna, secondo che era il titolo della cappella: la qual cosa, perchè a me era assai malagevole, avutone messer Bindo ed io il parere di molti comuni amici, uomini letterati, la feci finalmente in questa maniera. Figurato l'albero del peccato originale nel mezzo della tavola, alle radici di esso, come primi trasgressori del comandamento di Dio, feci ignudi e legati Adamo ed Eva; e dopo agli altri rami legati di mano in mano Abram, Isac, Jacob, Moisè, Aron, Iosuè, David, e gli altri re successivamente, secondo i tempi; tutti, dico, legati per ambedue le braccia, eccetto

Samuel e San Giovan Batista, i quali sono legati per un solo braccio, per essere stati santificati nel ventre. Al tronco dell'albero, feci avvolto con la coda, l'antico serpente; il quale, avendo dal mezzo in su forma umana, ha le mani legate di dietro; sopra il capo gli ha un piede, calcandogli le corna, la gloriosa Vergine, che l'altro tiene sopra una luna, essendo vestita di sole e coronata di dodici stelle; la qual Vergine, dico, è sostenuta in aria dentro a uno splendore da molti Angeletti nudi, illuminati dai raggi che vengono da lei; i quali raggi parimente, passando fra le foglie dell'albero, rendono lume ai legati, e pare che vadono loro sciogliendo i legami con la virtù e grazia che hanno do colei, donde procedono. In cielo poi, cioè nel più alto della tavola, sono due putti che tengono in mano alcune carte, nella quali sono scritte queste parole: *Quos Evae culpa damnavit, Mariae gratia solvit*. Insomma, io non aveva fino allora fatto opera (per quello che mi ricorda) nè con più studio, nè con più amore e fatica di questa: ma tuttavia, sebbene satisfeci ad altri, per aventura non satisfeci già a me stesso; come io sappia il tempo, lo studio e l'opera ch'io misi particolarmente negl'ignudi, nelle teste, e finalmente in ogni cosa.

The *Allegory of the Immaculate Conception* was already frequently represented in Italian art by the beginning of the sixteenth century, although the doctrine itself was not officially recognized by the Church until the nineteenth century. The Virgin is here represented as the agent of salvation triumphing over the cause of perdition symbolized by Eve. The allegory is inspired by Genesis 3: 15 and Revelation 12: 1, but there is no scriptural basis for the main inscription found on No. A991. Rather, it is an explanatory label attached to an elaborate and inconclusive doctrinal argument.[6]

A number of preparatory drawings by Vasari are known and these in their turn gave rise to a large number of copies.[7]

REFERENCES: 1. Etched by J. Young, *A Catalogue of the Pictures at Leigh Court, near Bristol; the seat of Philip John Miles, Esq., M P.* (London, 1822), p. 10, No. 14, 'Grace Triumphing over Sin' as by 'Parmigiano' measuring '1 ft. 10 ins. × 1 ft. 4 ins.' The panel was seen in the Leigh Court collection by G. F. Waagen, *Works of Art and Artists in England*, iii (London, 1838), 144, and described as 'A small picture, of very noble design, warm colouring, and careful execution'. 2. Repr. P. Barocchi, *Vasari pittore* (Milan, 1964), pp. 116–17, pl. XI. 3. Repr. Venturi, *Storia*, ix, pt. 6 (1933), fig. 170, together with the altar-piece in SS. Apostoli (fig. 169). 4. Repr. Venturi, ibid., fig. 171. 5. Inv. 1890. 1524. 6. For a detailed discussion of the origins and development of the iconography of the Immaculate Conception see M. Levi d'Ancona, *The Iconography of the Immaculate Conception in the Middle Ages and Early Renaissance*, Monographs on Archaeology and Fine Arts Sponsored by the Archaeological Institute of America and the College of Art Association of America, vii (1957), particularly 35–6 with further bibliography, although A. M. Lépicier, *L'Immaculée Conception dans l'art et l'iconographie* (Spa, 1956), pp. 1–5 and 37–51, is omitted. 7. See C. Monbeig-Goguel, *Musée du Louvre. Cabinet des Dessins. Inventaire général des dessins italiens i. Maîtres toscans nés après 1500, morts avant 1600. Vasari et son temps* (Paris, 1972), pp. 147–50, Cat. Nos. 191–3.

# ANONYMOUS VENETIAN SCHOOL (?)  1500–1520

A293  DOUBLE PORTRAIT OF PETRARCH (1304–1374) AND
      LAURA DE NOVES (1307/8–1348)  **Pl. 131**

Canvas (relined). 56·2 × 70·5.

On the back inscribed on the stretcher *Petrarca & Laura | early Venetian bought by Pinti for me | at Florence 1859 NB the portrait of | Laura agrees with the earliest engravings & paintings.*

Condition: poor. Areas of retouching are evident on the figure of Laura. The facial features of Petrarch and much of his drapery have been strengthened. There are various abrasions at the edges of the canvas and the figures are somewhat obscured by varnish.

Bequeathed by J. D. Chambers, 1897.[1]

Literature: *Annual Report*, 1897, 13.

The portraits are based upon those found in a fifteenth-century manuscript of *Canzoniere e Trionfi* now in the Biblioteca Laurenziana.[2] In this manuscript the subjects are depicted separately, but the painter of No. A293, although he has used the same poses and almost identical costume, has chosen to place the two figures together in a double portrait. The compiler has only been able to trace one other painted double portrait of Petrarch and Laura.[3] The manuscript in the Biblioteca Laurenziana is of Tuscan facture, and if, as seems likely, No. A293 is correctly ascribed to the Venetian school, it must be assumed that these two portraits were used in other manuscripts circulated in northern Italy.

The iconography of Petrarch is based upon the portraits found in contemporary, or nearly contemporary, manuscripts of his works. No authentic likeness of Laura is known.[4] The laurel branch, carried by Laura on No. A293, does not occur in the prototype, but on the reverse of a medal struck in Florence (the obverse of which has a portrait of Petrarch) a female figure, who represents either Poetry, or alternatively Roma, is depicted walking in a wood, plucking laurels with which to crown the poet.[5]

The treatment of the figures on No. A293 is distinctly reminiscent of the style of Bartolomeo Veneto.

REFERENCES: 1. See inscription recorded above for indications of earlier provenance. 2. Inv. MS. Plut. 41.1. See *Mostra storica nazionale della miniatura*, Palazzo di Venezia. Rome, 2nd edn. (Florence, 1954), p. 330, No. 521. 3. Musée Calvet, Avignon (inv. 712) attributed to an anonymous painter of the seventeenth century. In this, the two figures have been given the same pose and attributes as the figures on No. A293. The format,

however, is vertical and not horizontal and there is a parapet in the foreground. 4. See for both Petrarch and Laura, Prince d'Essling and E. Muntz, *Pétrarque, ses études d'art, son influence sur les artistes, ses portraits et ceux de Laure* (Paris, 1902), pp. 61–82, Ch. 2. 5. G. F. Hill, *A Corpus of Italian Medals of the Renaissance before Cellini*, i (London, 1930), 282, pt. VI, No. 1094, repr.

## ANONYMOUS VERONESE SCHOOL 1480–1500

### A94 PORTRAIT OF A BOY IN PROFILE TO RIGHT Pl. 132

Wood (cradled). 36·5 × 25·3.

Condition: fair. There is a vertical split in the panel left of centre, along which there is heavy retouching. There are a few slight cracks in the paint surface at the front of the cap and in the drapery, together with a number of other small blemishes.

Fox-Strangways Gift, 1850.

Exhibited: London, New Gallery, *Exhibition of Venetian Art*, 1894–5 (39).

Literature: see No A95 below.

### A95 PORTRAIT OF A BOY IN PROFILE TO LEFT Pl. 133

Wood (cradled). 36·0 × 25·8.

Condition: fair, but better than No. A94. There is retouching in the drapery just to the left of centre, along a vertical split in the panel, which extends from the lower edge only as far as the neck. There are also a few small blemishes in the drapery and in the hair. The background is rubbed.

Fox-Strangways Gift, 1850.

Exhibited: London, New Gallery, *Exhibition of Venetian Art*, 1894–5 (43).

Literature: Crowe and Cavalcaselle, *History*, i (1864), 549: 2nd edn., iv (1911), 63; Crowe and Cavalcaselle, *History North Italy*, i (1871), 121: 2nd edn., i (1912), 122; C. J. Ffoulkes, L'esposizione dell'arte veneta a Londra', *Archivio storico dell'arte*, ser. 2, i (1895), 72; G. Gronau, 'Correspondance d'Angleterre. L'art vénitien à Londres, à propos de l'exposition de la New Gallery—II', *Gazette des beaux-arts*, 13 (1895), 251; G. Gronau, 'Litteratur-bericht. Venetian Art. Thirty-six reproductions of pictures exhibited at the New Gallery 1894–5 (London, 1895)', *Reportorium für Kunstwissenschaft*, 19 (1896), 136; B. Berenson, *The Study and Criticism of Italian Art* (London, 1901), p. 118; T. Borenius, *The Picture Gallery of Andrea Vendramin* (London, 1923), p. 41; W. Boeck, 'Zwei Bildnisse vom Meister der Berliner Verlobung', *Pantheon*, 11 (1933), 185–8 repr.; C. L. Ragghianti,

'Note ai disegni di Francesco di Giorgio', *Critica d'arte*, 14 fasc. 89 (1967), 47–9 repr. (wrongly described as 'formerly' in the Ashmolean Museum.) Both portraits have incised lines in the hair.

Crowe and Cavalcaselle first attributed Nos. A94 and A95 to the studio of Gentile Bellini, and this was accepted on the occasion of the Exhibition of Venetian Art held at the New Gallery, London, in 1894–5. Most authorities rejected this suggestion outright at the time of the exhibition. Berenson posited, as an alternative, an attribution to an anonymous painter of the school of Verona. Gronau contended that a painting entitled *The Betrothal*, at Berlin-Dahlem (Staatliche Museen),[1] also attributed to an anonymous Veronese painter, was by the same hand as Nos. A94 and A95. At a later date Boeck, apparently independently, made the same observation as Gronau, suggesting a date *c.* 1470 for the three panels. More recently, Professor Carlo Ragghianti has ascribed the portraits to Francesco di Giorgio.

The compiler agrees with the views that Nos. A94 and A95 are Veronese on the strength of the evident similarities with the style of Francesco Bonsignori. The lighting of the faces, for instance, particularly in the case of No. A95 is rendered in the manner of Bonsignori.[2]

REFERENCES: 1. Inv. 1175. *Beschreibendes Verzeichnis der Gemälde im Kaiser-Friedrich-Museum* (Berlin, 1931), p. 509; a good repr. in Schubring, *Cassoni* (1915), ii, pl. CXLVIII, No. 676. 2. An abundance of comparative material may be found in U. Schmitt, 'Francesco Bonsignori', *Münchner Jahrbuch der bildenden Kunst*, 12 (1961), 73–152.

## ANONYMOUS VERONESE SCHOOL 1550–1560

A512   THE ADORATION OF THE SHEPHERDS                    Pl. 134

Wood (fastened at the back with two horizontal battens and several stops placed along the joins).[1] 119 × 111·3.

No. A512 comprises eight vertical panels of varying widths, measuring from left to right 3·5, 17, 14·2, 14, 19·5, 16·5, 16·5, and 11 cm. respectively.

Condition: good. Movement along the joins of the panels has unsettled the paint surface, but on the whole No. A512 is well preserved.

Collections: William Young Ottley (1770/1–1836) (Christie's, 25 May 1811, lot 80 (?), 'The Shepherd's Offering. There is a prodigious mastery in the drawing and execution of this picture, which is coloured in some parts with all the delicacy of Baroccio', bt. in by Newton for 80 gns. and resold Christie's, 4 Mar. 1837, lot 83, bt. in by Morgan for 83 gns.); Warner Ottley (1775–1846), brother of William Young Ottley (Foster's,

24 June 1850, lot 71, as Perino del Vaga, bt. in by Edward for £13. 2s. 6d.);
thence by direct inheritance to William Young Ottley's nephew,
Lieutenant-Colonel Warner Ottley (born 1805);[2] R. Langton Douglas.

Presented by the National Art-Collections Fund, 1937.

Literature: *Annual Report*, 1937, 35, repr.; H. Bodmer, 'Nuove attribu-
zioni a Pellegrino Tibaldi', *Rivista d'arte*, 19 (1937), 18–20 repr.; W.
Arslan, 'Nuovi dipinti dei Bassano', *Bollettino d'arte*, 31 (1937–8), 464 repr.;
H. Bodmer, in Thieme-Becker, *Lexikon*, xxxiii (1939), 130; G. Briganti, *Il
manierismo e Pellegrino Tibaldi* (Rome, 1945), pp. 121–2 (incorrectly
designated as in the Fitzwilliam Museum, Cambridge); A. E. Popham,
'Disegni veneziani acquistati recentemente dal British Museum', *Arte
veneta*, 1 (1947), 229; G. Guglielmi, 'Profilo di Giovanni Demio', *Arte
veneta*, 20 (1966), 110.

No. A512 was acquired as a work by Girolamo da Carpi. Bodmer first
suggested (1937), and later upheld (1939), an attribution to Pellegrino
Tibaldi, regarding the period of the frescoes in the Palazzo Poggi, Bologna,
begun, in his opinion, *c.* 1552, as the most likely date for No. A512.
Both Professor Giuliano Briganti and Popham rejected this, independently
proposing the name of Giovanni Demio.[3] In his recent study on Demio,
however, Dr. Giuseppe Guglielmi firmly denies any connection with this
painter. Mr. John Gere (verbal communication), in accordance with a
suggestion first made by Arslan, has intimated that No. A512 might have
been painted in Verona between 1550 and 1560, on the basis of affinities
with the work of Battista del Moro.

In the *Annual Report* of 1937, Sir Karl Parker drew attention to an
*Adoration of the Shepherds* (National Gallery of Ireland), at present attribu-
ted to Girolamo da Carpi, which has some compositional features in
common with No. A512.[4]

The offering of a basin or bowl made by the shepherd on the right of
No. A512 is almost certainly a reference to the washing of the new born
Child, which foreshadows His Baptism.[5]

The present frame around No. A512, which bears the date 1578 with
a dedicatory inscription in an oval cartouche, was adapted to the picture in
1955.[6]

REFERENCES: 1. A photograph of No. A512 before the addition of the slip along the
bottom (see Commentary and note 6 below), is published in *The National Art-Collections
Fund*, 1937, opposite p. 31. 2. See E. K. Waterhouse, 'Some Notes on William Young
Ottley's Collection of Italian Primitives', *Italian Studies presented to E. R. Vincent* (1962),
272–80, who refers to a list in the National Gallery archives of pictures still in the possession

of Lieutenant-Colonel Warner Ottley in 1899. Only one picture on this list, entitled *The Holy Family with the Shepherds Offering*, attributed to Titian, might possibly be identified as No. A512. 3. There is no reference to No. A512 in W. Arslan, 'An Unknown Painting by Jacopo Bassano', *Art in America*, 22 (1934), 123–4, as stated by G. Briganti, *Il manierismo e Pellegrino Tibaldi* (Rome, 1945), pp. 121–2, probably as a result of a misprint in W. Arslan, 'Nuovi dipinti dei Bassano', *Bollettino d'arte*, 31 (1937–8), 464 and 472. 4. Inv. 367. *National Gallery of Ireland. Catalogue of the Paintings* (Dublin, 1971), p. 18. Comparison should also be made with a panel of the same subject in the Palazzo Pitti, Florence (inv. 114), exhibited *Mostra di Lelio Orsi* (Reggio Emilia, 1950), p. 68, No. 52 repr. 5. See L. Réau, *Iconographie de l'art chrétien*, ii, pt. 2 (Paris, 1957), 223–4, and E. and D. Panofsky, 'The Iconography of the Galerie François I<sup>er</sup> at Fontaine-bleau', *Gazette des beaux-arts*, 52 (1958), 167–8, n. 28. 6. *Annual Report*, 1955, 46–7. The slip of 4 cm., mentioned above in note 1, was added on this occasion.

# PAOLO VERONESE                                            1528–1588

Venetian school. His real name was Paolo Caliari, called Veronese. He was born in Verona, where he became the pupil of Antonio Badile and of Giovanni Francesco Caroto. Veronese's mature style was influenced by Titian, Tintoretto, Giulio Romano, and Parmigianino. Together with Titian and Tintoretto, Veronese stands in the forefront of Venetian cinquecento painting. His large output included altar-pieces and decorative schemes for churches, as well as official commissions for the Republic and works for the adornment of private villas. A number of later works are signed by the 'heirs of Paolo Veronese', which means Paolo's brother, Benedetto, and his two sons, Gabriele and Carletto.

## A863   THE HOLY FAMILY WITH S. GEORGE                     **Pl. 135**

Canvas (relined). 41 × 50.

Condition: fair. There is an area of damage bottom centre extending as far as the left edge. The head and the body of S. John the Baptist, the hands of the Christ Child, and the lower part of the Virgin's drapery have been repainted. The faces of S. George, the Virgin, Joseph, and the Christ Child are well preserved.

Collections: Sir Richard Green Price, 2nd Bt. (1839–1909), Norton Manor, Radnorshire (Christie's, 23 Apr. 1892, lot 151, no dimensions given, bt. Marcus). Next recorded again at Christie's, 29 June 1945, lot 113, Various Properties, bt. Lessore.

Purchased 1952.

Literature: *Annual Report*, 1952, 134 repr.; Berenson, 1957, 50 repr.; G. Piovene and R. Marini, *L'opera completa del Veronese* (Milan, 1968), p. 87, No. 9.

Although recorded as a work by Paolo Veronese in a sale catalogue dating from the end of the nineteenth century (see Collections above), No. A863 has only been briefly mentioned in the recent literature on the painter. The attribution to Veronese was accepted at the time of acquisition in 1952 and was confirmed by Berenson (1957).

No. A863 may be placed among the earliest works of the master. When due allowance is made for the difference in scale and the areas of damage on both works, points of comparison can be found with the Bevilaqua-Lazise altar-piece, formerly in S. Fermo Maggiore, Verona, and now in the Museo Castelvecchio.[1] The facial type of the Virgin on No. A863 closely resembles that of the allegorical figures of *Temperance* and *Justice* painted in fresco in 1551 with the help of Battista Zelotti at the Villa Soranza at Treville, near Castelfranco.[2] This same date is usually accepted for the altar-piece in the church of S. Francesco della Vigna, Venice, a work with which No. A863 is also compatible, particularly with regard to the handling of the Christ Child and the Young S. John the Baptist.[3] Professor Rodolfo Pallucchini is quoted in *L'opera completa* as suggesting a date of 1555–60 for No. A863, but one *c.* 1550 is preferable.

The composition of the panel in Oxford seems to have been the first essay on a theme to which Veronese often returned at later stages in his life, always varying the balance of the figures, or adjusting the internal rhythm, thereby creating a degree of intimacy that is sometimes lost in the larger set pieces.

REFERENCES: 1. Inv. 243. Repr. R. Pallucchini, *Veronese*, 2nd edn. (Bergamo, 1943), pl. 1. Compare particularly the face of S. George on No. A863 with that of S. John the Baptist on the altar-piece. The date of the Bevilacqua-Lazise altar-piece is based on the presumed date of the consecration of the chapel on the assumption that it was commissioned by Giovanni Bevilacqua and his second wife Lucrezia Malaspina. This has recently been challenged by R. Cocke, 'An Early Drawing by P. Veronese', *Burlington Magazine*, 113 (1971), 730–1, who, on the basis of alternative documentary evidence discussed by A. Bevilacqua-Lazise, 'Un quadro di autore controverso al Museo Civico di Verona', *Madonna Verona*, 5 (1911), 106–11, attributes the altar-piece to Carletto Caliari and proposes a date *c.* 1571–80. 2. Repr. Pallucchini, op. cit., pl. 3, and G. Fiocco, *Paolo Veronese* (Bologna, 1928), pl. 1. The fresco of *Glory* reproduced by M. Levey, 'An Early Dated Veronese and Veronese's Early Work', *Burlington Magazine*, 102 (1960), fig. 11, facing p. 107, which is certainly weaker than the other fragments, is dated 1551. For the history of these fragments see G. Schweikhart, 'Paolo Veronese in der Villa Soranza'. *Mitteilungen des Kunsthistorischen Instituts in Florenz*, 15 (1971), 187–206. Those fragments remaining in Italy are now divided between the Duomo in Castelfranco (*Time and Fame*, *Temperance, Justice*) and the Pinacoteca del Seminario Patriarcale, Venice (*Glory*). 3. Repr. Pallucchini, op. cit., pl. 4. The date of the altar-piece is based on the date of the consecration of the chapel.

A377–82 SIX SCENES FROM THE STORY OF JUDITH **Pls. 136–41**

A377 THE FLIGHT OF ACHIOR FROM THE CAMP OF HOLOFERNES (Judith 6: 2) **Pl. 136**

A378 JUDITH RECEIVING THE ANCIENTS OF BETHULIA (Judith 8: 10) **Pl. 137**

A379 JUDITH LEAVING BETHULIA (Judith 10: 10) **Pl. 138**

A380 JUDITH RECEIVED BY HOLOFERNES (Judith 10: 20–3) **Pl. 139**

A381 JUDITH FEASTED BY HOLOFERNES (Judith 12: 1–4) **Pl. 140**

A382 JUDITH ABOUT TO KILL HOLOFERNES (Judith 13: 6–10) **Pl. 141**

Canvas (each relined). Each 27 × 57.

Condition: fairly good. Each is slightly rubbed and there are a number of small retouches, mainly in the foregrounds, but no extensive areas of restoration. The flatness of several of the passages in the series is most probably due to the process of relining.

Collections: Sir Paul Methuen (1672–1757) and thence by descent to the third Baron Methuen (1845–1932), Corsham Court, Chippenham, Wiltshire.[1]

Presented by Mrs. W. F. R. Weldon, 1926.

Exhibited: London, Burlington House, *Exhibition of Works by the Old Masters*, 1904 (29–31 and 36–8); Birmingham, *Italian Art from the 13th Century to the 17th Century*, 1955 (110–11); Manchester, *Between Renaissance and Baroque. European Art 1520–1600*, 1960 (236–7).

Literature: *Annual Report*, 1926, 20–1; Berenson, 1932, 424; 1936, 364; 1957, 134; W. Suida, 'Notes sur Paul Véronèse', *Gazette des beaux-arts*, 19 (1938), 176 (erroneously described as scenes from the history of Esther); G. Piovene and R. Marini, *L'opera completa del Veronese* (Milan, 1968), p. 134, No. 372.

The attribution to Veronese is traditional, dating from the time when the series was in the collection of Sir Paul Methuen. Modern writers have tended to retain this attribution, but have too easily categorized them as juvenilia. Berenson (1957) stated that Nos. A377–82 are either partly autograph or restored. An alternative, but unsatisfactory, attribution to Schiavone, apparently suggested by Arslan, is quoted in *L'opera*

*completa.* The compiler believes that the series was painted by Paolo Veronese himself. The compositions, especially those of Nos. A377 and A379, are of high quality. The relationship of the figures to the space is particularly eloquent. The execution is admittedly clumsy in certain passages, but on Nos. A380 and A381 it reaches a high level of competence. The handling of the light throughout the series is of the utmost subtlety. Comparison with four 'spalliere' depicting various mythological subjects in the Museum of Fine Arts, Boston,[2] enhances the validity of such an attribution, although there must be a slight difference in date between the two series.

REFERENCES: 1. First recorded in the Methuen collection in *London and its Environs Described*, iii (London, 1761), 92 and 96, mentioned in 'A List of Pictures that are at present hung up in the two first floors of the house of Paul Methuen Esq. in Grosvenor Street'. They are next recorded by J. Britton, *An Historical Account of Corsham House in Wiltshire* (London, 1806), p. 35, Nos. 34, 40, 61, 63, 72, and 74. G. F. Waagen, *Works of Art and Artists in England*, iii (London, 1838), 102, records that he saw 'Four pretty little pictures of an oblong shape, with the history of Judith' when he visited Corsham Court. The panels were still in the Methuen collection in 1903, *Catalogue* (privately printed, London, 1903), p. 15, Nos. 161–3 and 166–8. A photograph in the departmental files, kindly sent by Lord Methuen and taken in 1890, shows one of the panels hanging in the Cabinet room at Corsham Court. 2. Inv. 64. 2078, 64. 2079, 59. 260, 60. 125, each 25 × 108. See R. Pallucchini, *Mostra di Paolo Veronese* (Venice, 1939), pp. 84–7, Nos. 31–4 repr. Repr. (in colour) G. Piovene and R. Marini, *L'opera completa del Veronese* (Milan, 1968), pl. XVI, and exhibited, *Veronese and his Studio in North American Collections*, Birmingham Museum of Arts and Montgomery Museum of Fine Arts (1972), p. 18, where they are dated *c.* 1560.

## COPIES AFTER PAOLO VERONESE

A142   THE FEAST IN THE HOUSE OF LEVI                                **Pl. 142**

Canvas. 106·5 × 228.

Condition: good. Cleaned in 1973.

Chambers Hall Gift, 1855.

Exhibited: Leeds, *National Exhibition of Works of Art*, 1868 (176).

No. A142 is a reduced copy after the painting originally placed in the refectory of the convent of SS. Giovanni e Paolo, Venice, and now in the Accademia, Venice.[1] The original work is dated 1573 and was designed as a *Last Supper*, but after his examination before the Inquisition Veronese changed the title to the *Feast in the House of Levi*, which he then inscribed across the bottom of the two pillars.[2]

No. A142 appears to have been accepted as an original work by Veronese at the time of the exhibition held in Leeds in 1868. Later in the nineteenth

century the picture was described as a finished sketch for the painting in Venice.[3] Recent cleaning has shown that No. A142 is an accurate and finely executed copy, in all probability painted in Venice during the eighteenth century.

REFERENCES: 1. Inv. 374. S. Moschini Marconi, *Gallerie dell' Accademia di Venezia. Opere d'arte del secolo XVI* (Rome, 1962), pp. 83–5 repr. 2. For the cross-examination involving many aspects of the composition see P. Fehl, 'Veronese and the Inquisition', *Gazette des beaux-arts*, 58 (1961), 325–54. 3. *Provisional Catalogue of the Paintings Exhibited in the University Galleries Oxford* (Oxford, 1891), pp. 24–5.

A143   MOSES BROUGHT BEFORE PHAROAH'S DAUGHTER   **Pl. 143**

Canvas laid on panel. 54·5 × 41·3.

Condition: poor. The surface is worn throughout and obscured by dirt.

Chambers Hall Gift, 1855.

No. A143 is a nearly life-size, but undistinguished, copy probably made during the eighteenth century after Veronese's painting of this subject in the Prado, Madrid.[1] The picture in Madrid is usually dated in the eighth decade of the sixteenth century. There is a replica in the National Gallery, Washington.[2]

No. A143 appears to have been trimmed by 2 to 3 cm. on the left where the composition is incomplete.

REFERENCES: 1. Inv. 502. *Museo del Prado. Catalogo de las Pinturas* (Madrid, 1972), p. 761. Repr. G. Fiocco, *Paolo Veronese* (Bologna, 1928), p. 210, pl. LXXI. 2. Inv. 38. *National Gallery of Art. Summary Catalogue of European Paintings and Sculpture* (Washington D.C., 1965), p. 135, repr. *Illustrations*, p. 123.

# MARCO ZOPPO                                   *c.* 1433–1478

Bolognese school. His real name was Marco di Antonio di Ruggero, called Zoppo. He was born in Cento and painted in Ferrara and Venice. Zoppo was apprenticed to Squarcione in Padua, but Mantegna, Giovanni Bellini, and Tuscan artists active in the Veneto, particularly Donatello and Andrea del Castagno, were more decisive influences for the development of his style.

A98   S. PAUL                                   **Pl. 144**

Wood. 49·5 × 31 (arched).

Condition: fair. Cleaned and restored in 1946. The arched top is a reconstruction and the gold background has been completely repainted. The reconstruction is based on traces of original paint found at the time of restoration in 1946. None of the original paint in the background is now

detectable. There are retouches in the lower half of the draperies and at the right shoulder. The facial features, the beard, the flesh tones, and most of the draperies are well preserved.

Provenance: S. Giustina, Venice (?) (see Commentary below).

Fox-Strangways Gift, 1850.

Exhibited: London, Burlington Fine Arts Club, *Exhibition of Pictures Drawings and Photographs of Works of the School of Ferrara–Bologna 1440–1540*, 1894 (3).

Literature: Crowe and Cavalcaselle, *History North Italy*, i (1871), 349 n. 5: 2nd edn., ii (1912), 52, n. 5; Berenson, 1910, 304: 1932, 608: 1936, 523: 1968, 457; T. Borenius, 'On a Dismembered Altar-piece by Marco Zoppo', *Burlington Magazine*, 38 (1921), 9–10 repr.; A Moschetti, in Thieme–Becker, *Lexikon*, xxxvi (1947), 555; R. Longhi, *Ampliamente nell' officina ferrarese* (edn. *Opere Complete*, v (Florence, 1956), 139 repr.; E. Ruhmer, *Marco Zoppo* (Vicenza, 1966), pp. 51–2 and 82–4, Cat. nos. 144–7 repr.

The attribution to Zoppo occurs for the first time in Crowe and Cavalcaselle, where No. A98 is referred to as a 'rude tempera by Zoppo'.

Borenius observed that No. A98, together with three other panels of approximately the same dimensions, came from the upper tier of a polyptych. The related panels are: *S. Augustine* (London, National Gallery),[1] *S. Peter* (Kress collection),[2] and *S. Jerome* (Baltimore, Walters Art Gallery).[3] Borenius identified the polyptych with one formerly in S. Giustina, Venice, mentioned by Francesco Sansovino (1581): *Dipinse la palla grande assai gentilmente Marco Zoppo da Bologna l'anno 1468*.[4] There is no external evidence with which to confirm this hypothesis, but it is plausible on stylistic grounds, since these four panels can be placed with some certainty between the altar-piece in S. Clemente, Collegio di Spagna, Bologna (usually dated *c*. 1465) and the Pesaro altar-piece, signed and dated 1471 and now in the Staatliche Museen, Berlin-Dahlem. Mrs. Fern Rusk Shapley has suggested that a *Christ in the Tomb* (present whereabouts unknown) may have been the central panel of the upper tier of the altar-piece, flanked by the panels under discussion.[5]

The original format of the altar-piece is uncertain and the arrangement of individual panels within the complex as a whole can only be attempted when panels from the main section have been identified.[6]

REFERENCES: 1. Inv. 3541, 49·4×28·5, facing right. M. Davies, *National Gallery Catalogues. The Earlier Italian Schools*, 2nd edn. (London, 1961), pp. 562–3. 2. K 489, 48·9× 30·5, facing right. F. R. Shapley, *Paintings from the Samuel H. Kress Collection. Italian Schools*

*XIII–XV Century* (London, 1966), pp. 87–8 repr. The reproduction is misleading as the panel is square at the top. Compare the reproduction in E. Ruhmer, *Marco Zoppo* (Vicenza, 1966), pl. 146. 3. Inv. 37. 542, 54·6×32·4, facing left. Ruhmer, op. cit., pl. 147. 4. F. Sansovino, *Venetia, città nobilissima et singolare*, ed. G. Martinioni, i (Venice, 1663), 42. In the 1968 edition of the Berenson Lists the church is misprinted as S. Cristina. According to G. Lorenzetti, *Venezia e il suo estuario*, 2nd edn. (Venice, 1956), p. 374, the church was demolished in 1810. 5. The panel measures 77·5×58 and was formerly in the Vieweg collection, Brunswick. See Shapley, loc. cit., and for a repr. Ruhmer, op. cit., p. 86, Cat. no. 159, pl. 159, who doubts the attribution to Zoppo. The halo pattern is of similar design, but not identical. 6. Discussion has been hampered by the use of misleading reproductions. The panels in the Kress collection and at Oxford are square at the top, those at Baltimore and London are round. The late Sir Martin Davies (loc. cit.) argued that the present difference in shape is due to cutting and he pointed out that certain marks on the panels in Baltimore and London indicate that the original frames were in the shape of cusped arches. Similar marks are also visible on the panel in the Kress collection. Ruhmer (op. cit., pp. 82–4, Cat. nos. 144–7) argues that all the panels were once square, but he contends that the panel of *S. Peter* in the Kress collection has been cut at the bottom and was originally a whole-length figure placed in the main section of the polyptych. He surmises that the format of the altar-piece originally resembled that of *S. Luke* painted by Mantegna for the church of S. Giustina, Padua, in 1453–4 (repr. *Mostra Andrea Mantegna*, Palazzo Ducale, Venice, 1961, pl. 7).

# PART 2. ICONS

The entries are arranged according to the order of the inventory numbers

A71  THE ANNUNCIATION (recto)                                        **Pl. 145**
      THE FOUR EVANGELISTS (verso)                                    **Pl. 146**

Wood. 22·8 × 18, made up of two separate panels divided vertically in the centre, each measuring 22·8 × 9.

Condition: both recto and verso are badly damaged and begrimed with dirt. There has been considerable paint loss.

Fox-Strangways Gift, 1850.

Talbot Rice (verbal communication) dated No. A71 in the eighteenth century and regarded the painter as of Greek origin. These two panels, now framed together, may originally have formed the wings of a portable triptych, with the scene of the Annunciation exposed to view when the shutters were closed.[1] Although badly damaged, No. A71 was once of good quality.

REFERENCES: 1. Compare a triptych in Athens, Benaki Museum, repr. A. Xyngopoulos, *Catalogue of Icons. Benaki Museum, Athens* (Athens, 1936), No. 53, pl. 39a, b.

A253  THE ANNUNCIATION                                               **Pl. 147**

Canvas laid on panel. 30·7 × 23·7.

Signed bottom centre, *JOHANUS* [ἰωάνυς] beneath an inscription recording that a monk called Metrophanes consecrated the icon.

Condition: fair. The lower half of the surface is rather worn.

Bequeathed by the Revd. Greville Chester, 1892.

Talbot Rice (verbal communication) suggested that No. A253 was painted in Athens, almost certainly during the nineteenth century. The icon is crudely drawn and clumsily executed, and altogether of poor quality.

A317  ANASTASIS (HARROWING OF HELL)                                  **Pl. 148**

Wood. 18·6 × 30·7.

Condition: fairly good. There is considerable surface dirt throughout.

Transferred from the Bodleian Library sometime before 1908.

See No. A318 below.

A318   THE VIRGIN ENTHRONED WITH TWO ANGELS,
       THREE PROPHETS, AND FORTY MARTYRS           **Pl. 149**

Wood. 18·7 × 29·6.

Condition: fairly good. There is considerable surface dirt throughout.

Transferred from the Bodleian Library sometime before 1908.

No. A318 is the companion to panel No. A317 above.

   No. A317 has a raised border along the right and lower edges and the panels are therefore most probably part of a dismembered iconostasis. Both panels are of high quality and cleaning would much improve their present appearance.

   Talbot Rice (verbal communication) regarded the panels as dating from the late sixteenth century and suggested that they were in all probability painted in Salonika.

A319   S. GEORGE                                   **Pl. 150**

Wood. 42 × 31·8.

Condition: poor. There is a vertical split in the panel in the centre with some minor damages elsewhere. The paint surface is obscured by a certain amount of ingrained dirt.

Transferred from the Bodleian Library sometime before 1908.

Exhibited: London, New Grecian Gallery, *Warrior Saints*, 1972/3 (6).

Literature: D. Talbot Rice, 'The Accompanied S. George', *Actes du VI congrès international d'études byzantines*, ii (Paris, 1951), 383–7 repr.

Talbot Rice ascribed No. A319 to the Greek school and at first (1951) proposed a date sometime in the sixteenth century, but later (verbal communication) preferred to date the panel in the eighteenth century. When exhibited recently in London at the New Grecian Gallery, No. A319 was more reasonably catalogued as Creto-Venetian school and dated in the early seventeenth century.

   The diminutive figure seated on the horse behind the saint on No. A319 is by no means uncommon in representations of S. George. Talbot Rice explained the inclusion of such a figure as illustrating the legend

according to which the saint was attending communion when he received the urgent summons to rescue princess Elisabeth, daughter of the King of Silene in the province of Libya, and was forced to take his server with him.[1] The legend, which was probably of Persian origin, was variously interpreted in different parts of the Mediterranean.[2] S. Demetrios on horseback is sometimes accompanied by a similar figure.[3]

REFERENCES: 1. See D. and T. Talbot Rice, *Icons. The Natasha Allen Collection Catalogue. National Gallery of Ireland* (Dublin, 1968), p. 24, No. 5. 2. Thus the compilers of the exhibition catalogue *Icones melkites. Exposition organisée par le Musée Nicolas Sursock* (Beirut, 1969), p. 1611, No. 19, identify the figure as the child of Adimras whom S. George rescued from slavery. The silver ewer was apparently being carried by the child at the time of his rescue. 3. For an interpretation of the iconography with reference to S. Demetrios see *Warrior Saints*, catalogue of an exhibition held at the New Grecian Gallery, London (1972/3), Nos. 16–18.

## A344  POKROV VIRGIN (THE VIRGIN OF SHELTER AND REFUGE)     Pl. 151

Wood (fastened at the back with two horizontal battens). 26·3 × 22·4.

Condition: fair. There has been some paint loss in the lower half, otherwise the panel is well preserved.

Collections: Herbert Dunlop, Southern Hill, Reading.[1]

Bequeathed by Ingram Bywater, 1915.

No. A344 was attributed by Talbot Rice (verbal communication) to the Russian school, and dated in the nineteenth century. Stylistically No. A344 seems to belong to the same tradition as those icons painted in Moscow towards the end of the sixteenth century and during the course of the seventeenth century. Kondakov classified the style of these icons as the Detailed Moscow Style.[2] In the lower half of the composition immediately below the Virgin it was customary to show an incident from the life of S. Romanos, the Melodist, but since the saint is normally shown holding a sheet of music the identification of this figure on No. A344 is not absolutely certain.[3]

REFERENCES: 1. A saleroom cipher, which occurs on the back, relates to a case of seven pictures submitted by Herbert Dunlop to Christie, Manson, & Woods on 10 Feb. 1892. The pictures were returned to the owner unsold. 2. N. P. Kondakov, *The Russian Icon* Eng. edn. (Oxford, 1927), pp. 175–6, pl. LVII. 3. Compare K. Onasch, *Icons*, Eng. edn. (London, 1963), pp. 344–5 and 392, Nos. 5 and 117. Also L. Ouspensky and V. Lossky, *The Meaning of Icons* (Olten, 1952), pp. 153–4.

A345  THE PHILOXENY (THE EUCHARIST)  Pl. 152

Wood. 17 × 15.

Condition: good. The raised border along the edge is damaged in places. The paint surface is intact.

Bequeathed by Ingram Bywater, 1915.

Talbot Rice (verbal communication) considered No. A345 to be Russian in origin, more specifically in the style of the Strogonov school, possibly dating from the early part of the seventeenth century.[1] The icon is of fine quality and may be most usefully compared with those painted by the Savin family workshop.[2]

REFERENCES: 1. G. H. Hamilton, *The Art and Architecture of Russia* (Harmondsworth, 1954), pp. 153–4. 2. Compare V. I. Antonova and N. D. Mueva, *Catalogue of the Tretjakov Gallery, Moscow*, ii (Moscow, 1963, in Russian), 313–14, 315–16, 319–20, Nos. 787, 789, and 793 respectively, repr. pls. 108, 110, and 113. Also K. Kreidl-Papadopoulos, 'Die Ikonen im Kunsthistorischen Museum in Wien', *Jahrbuch der Kunsthistorischen Sammlungen in Wien*, 66 (1970), 84–6 and 119–20, Cat. no. 15.

A346  THE RAISING OF LAZARUS  Pl. 153

Wood (fastened vertically at the back with seven stops). 45 × 31·6 (severely bowed).

On the back a label inscribed by a nineteenth-century hand, *Quadro posseduto della estinta famiglia dei conti / Brasaleoni del Castello Pioppin vicino Urbino / (Castell Durante) e passato in Metterazzi (nob.)*. Inscribed below this by Charlotte Bywater, wife of Ingram Bywater, *Bought in Venice April 1891 of Bwdowski*.

Condition: fairly good. The paint surface is scratched in places. There is some retouching along a vertical split in the centre of the panel. The face of the figure handling the shrouds at the extreme right of the composition is damaged and Christ's drapery has been repainted.

Bequeathed by Ingram Bywater, 1915.

Exhibited: Edinburgh, Royal Scottish Museum, and London, Victoria and Albert Museum, *Byzantine Art*, 1958 (236); Athens, *Byzantine Art*, 1964; (181).

Literature: G. Mathew, *Byzantine Painting* (The Faber Gallery of Oriental Art) (London, 1950), p. 22 repr.; W. Felicetti-Liebenfels, *Geschichte der byzantinischen Ikonenmalerei, von ihren anfängen bis zum Ausklange unter Berücksichtigung der Maniera greca und der italo-byzantinischen Schule* (Olten,

1956), p. 99 repr.; W. D. Wixom, 'The Byzantine Art Exhibition at Athens', *Art Quarterly*, 27 (1964), 464 repr.

According to the late Revd. Gervase Mathew, panels with this steep curvature are commonly found in the south-east Peloponnese and on the island of Crete. The same writer dates No. A346 between 1410 and 1470 and, on the basis of similarities in colour and technique, tentatively concludes that the panel may be by Andronikos Byzagios, who is widely held to have painted the frescoes, including one of the *Raising of Lazarus*, in the chapel of S. George in the monastery of S. Paul on Mount Athos.[1] Felicetti-Liebenfels accepted Mathew's attribution, but there is, in fact, evidence which casts doubt on the identity of Byzagios. As Mathew himself and Xyngopoulos in the catalogue of the exhibition held in Athens in 1964 have both pointed out, an inscription in the chapel of S. Paul attributing the frescoes to Andronikos Byzagios with the date 1423 was found by Sotiriou in 1920 to be false.[2] The actual date of the frescoes is apparently 1555 and the inscription, which could easily have been copied, most probably refers to a different series either now destroyed or possibly preserved below the present one. Wixom leaves aside the Byzagios problem and dates the panel during the second half of the fifteenth century. Dr. Iain Watson (verbal communication) believes that No. A346 was painted by an artist of the Cretan school.

Mathew drew attention to the fact that the iconography of No. A346 is related to that of the *Raising of Lazarus* in the church of the Pantanassa at Mistra painted *c.* 1428 and today one of the acknowledged masterpieces of Byzantine mural painting.[3] As at Mistra, the two figures carrying the lid of the sarcophagus are moving out of the composition towards the right where the figure unwinding the shroud is also placed, but the figure holding the garment to his nose is here positioned behind the sarcophagus and not in front of it as in the Pantanassa. It has been observed that the two figures carrying the sarcophagus lid are derived from figures on a Roman sarcophagus with a relief of Meleager in the villa Pamphili, Rome.[4] Apparently, this relief might have been known in the Peloponnese.

REFERENCES: 1. G. Millet, *Monuments de l'Athos*, i, *Les Peintures. Monuments de l'art byzantin*, v (Paris, 1927), pl. 187 (4). 2. The inscription with the date 1423 was first doubted by G. Millet, 'Recueil des inscriptions chrétiennes du Mont Athos', *Bibliothèque des Écoles Françaises d'Athènes et de Rome*, 91 (1904), 436–8, repr. pl. vii (3), and the same writer later reported Sotiriou's discovery of the correct date (op. cit., (1927), p. 62). 3. Repr. G. Millet, *Monuments byzantins de Mistra. Monuments de l'art byzantin*, ii (Paris, 1910), pl. 140 (3). 4. J. Polzer, 'A Note on a Motif Derived from a Roman Meleager Sarcophagus in a Fresco at Mistra', *Marsyas*, 7 (1957), 72–4.

AI045 THE PRESENTATION OF THE VIRGIN IN THE
TEMPLE WITH THE ANNUNCIATION ABOVE **Pl. 154**

Wood. 31·5 × 29·5.

Condition: good. There are some small local damages.

Bequeathed by Thomas Balston, 1968.

No. AI045 was attributed by Talbot Rice (verbal communication) to the Greco-Venetian school and most probably dates from the seventeenth century.

AI061 VIRGIN AND CHILD **Pl. 155**

Wood. 49·5 × 39·6.

Condition: good.

Presented by Professor Martin Robertson, 1971.[1]

On the basis of technique and style, No. AI061 would appear to have been painted by a Cretan artist, who was most probably active in Venice during the second half of the sixteenth century.[2] The handling of the Christ Child distantly recalls the manner of Michel Damaskinos, one of the leading Cretan painters working in Venice between 1574 and 1582 almost solely for the confraternity of S. Giorgio degli Greci.[3] Professor Giles Robertson (verbal communication) has observed that the pose of the Virgin and Child is similar to that often used by the Vicentine painter Bartolomeo Montagna, whose compositions may well have been known to the painter of No. AI061.[4]

REFERENCES: 1. The panel was bought in Vienna in 1935/6. 2. V. Lasareff, 'Saggi sulla pittura veneziana dei sec. XIII–XIV, la maniera greca e il problema della scuola cretese (ii°)', *Arte veneta*, 20 (1966), 50–7, and M. Chatzidakis, *Icones de Saint-Georges des Grecs et de la Collection de l'Institut* (Venice, 1962), Introduction B, pp. xxxvii–l. 3. See Chatzidakis, op. cit., pp. 51–73, pls. 18–36. 4. Compare L. Puppi, *Bartolomeo Montagna* (Venice, 1962), pls. 27, 87, and 149.

# PART 3. PAINTINGS OF INDETERMINATE ORIGIN

The entries are arranged according to the order of the inventory numbers

A106  PORTRAIT OF S. THOMAS AQUINAS                    Pl. 156

Panel. 27 × 20·1.

On the back a label inscribed by an eighteenth-century hand, *Testa di Maniera del Frate*, which occurs together with a number placed between two dots drawn with the brush in brown stain and partly covered by a Fox-Strangways label (*No. 8*).

Fox-Strangways Gift, 1850.

If the panel is correctly identified as 'Head in Profile', No. A106 was at one time (Ashmolean *Catalogues*, 1859, p. 59, and 1865, pp. 59–60) attributed to Fratellini (presumably intended for Giovanna Fratellini 1666–1731). The old attribution on the label, however, probably refers to Fra Bartolommeo.

A254  S. DOMINIC                                        Pl. 157

Panel. 27·8 × 21·5.

Presented by the Revd. Greville Chester, 1892.

Almost certainly painted towards the beginning of the nineteenth century. The style is perhaps unconsciously imitative of that of the Master of the Dominican Effigies.

A736  FAKE. THE ADORATION OF THE CHILD WITH
      S. FRANCIS                                        Pl. 158

Wood. 174 × 150·5.

Presented by the daughters of J. R. Anderson, 1947.

Technique alone suggests that No. A736 is not of great age, and the composite nature of the design with the types drawn from Florentine, Sienese, and Umbrian painting is tantamount to proof that the panel is a fake.

The large size and thickness of the panel suggest that No. A736 may have served as a substitute altar-piece.

A736a  S. JOHN THE BAPTIST, A BISHOP SAINT, AND
   S. ANTHONY OF PADUA (?)      **Pl. 159**

Canvas laid on panel. 31·3 × 24·5.

Presented by the daughters of J. R. Anderson, 1947.

An ineffectual imitation of uncertain date of a Squarcionesque painter.

A873 FAKE. VIRGIN AND CHILD      **Pl. 160**

Panel (fastened at the back with two horizontal battens). 99 × 49.

Bequeathed by Mrs. R. M. Muriello-Langton, 1955.

Literature: *Annual Report*, 1955, 52.

No. A873 is undoubtedly a fake simulating the style of a fifteenth-century Sienese painter. The panel was acquired as a work purporting to be of the fifteenth century, painted by Matteo di Giovanni. Indeed, No. A873 might have been made in Siena during the last half of the nineteenth century when Federico Joni was actively employed there manufacturing such fakes.[1]

REFERENCE: 1. The pigments were examined by Mr. Arthur Lucas and Miss Joyce Plesters of the National Gallery, London, who showed that the panel must have been painted after 1820 (see notes in the departmental files dated 9 Nov. 1955).

# CONCORDANCE

It should be stressed that the attributions in the Museum Guides published in 1859, 1865, 1909, 1912, and 1931 are summary. In the 1912 and 1931 Guides scholarly opinions are recorded, but the attributions are always of a general nature. In all cases the forms of attribution used in these earlier catalogues have been retained.

## *Abbreviations*

*no attr.* = no attribution made although the painting is recorded.
— = not recorded in the catalogue although the painting was already in the collection.

## *List of the Catalogues and Guides to the Ashmolean Museum used for the Concordance*

Handbook Guide for the University Galleries, Oxford; containing catalogues of the works of art in Painting and Sculpture (Oxford, printed for J. Fisher, 1859).

Handbook Guide for the University Galleries, Oxford; containing catalogues of the works of art in Painting and Sculpture (Oxford, 1865).

A provisional Catalogue of the Paintings exhibited in the University Galleries Oxford (Oxford, 1891).

Ashmolean Museum. Summary Guide (Oxford, 1909).

Ashmolean Museum. Summary Guide (Oxford, 1912).

Ashmolean Museum. Summary Guide. Department of Fine Art (Oxford, 1931).

Catalogue of Paintings in the Ashmolean Museum (Oxford, 1950).

Catalogue of Paintings in the Ashmolean Museum (Oxford, 1961).

| 1977 Catalogue | | 1859 Guide | 1865 Guide | 1891 Catalogue |
|---|---|---|---|---|
| A732 | Altichiero, follower of | | | |
| A75 | Andrea di Bartolo | *no attr.* | *no attr.* | 1 Early Tuscan, inf of Giotto |
| A370 | Andrea del Brescianino | | | |
| A77 | Angelico, studio of | Angelico | Angelico | 5 Angelico |
| A78 | Angelico, follower of | *no attr.* | — | 6 Angelico, attribut |
| A90 | Apollonio di Giovanni, studio of | Spinello Aretino | Spinello Aretino | 16 Spinello Aretino, buted to |
| A92 | Apollonio di Giovanni, studio of | *no attr.* | *no attr.* | 25 Italian XV cent. |
| A734 | Anon. Aretine school (?) 1480–1500 | | | |
| A67 | Bacchiacca, attributed to | 39 Venusti | 30 Venusti | 34 Venusti |
| A73 | Barna da Siena, attributed to | Simone Memmi | Simone Memmi | 2 Simone Memmi |
| A93 | Bartolomeo degli Erri | *no attr.* | *no attr.* | 24 Jacopo Bellini, att buted to |
| A104 | Fra Bartolommeo, copy after | Luca Signorelli | Luca Signorelli | 27 Italian, early XVI |
| A735 | Basaiti, attributed to | | | |
| A771 | Jacopo Bassano | | | |
| A905 | Jacopo Bassano, copy after | | | |
| A445 | Leandro Bassano | | | |
| A302 | Giovanni Bellini, ascribed to | | | |
| A89 | Bicci di Lorenzo | *no attr.* | *no attr.* | 15 *no attr.* |
| A451a | Bonifazio de' Pitati | | | |
| A730 | Bonifazio de' Pitati | | | |
| A914 | Bonifazio de' Pitati | | | |
| A413 | Botticelli, studio of | | | |
| A85 | Francesco Botticini | Pollaiuolo | Pollaiuolo | 20 Antonio Pollaiuolo |
| A105 | Bronzino | 58 Bronzino | Bronzino | 30 Bronzino |
| A672 | Bronzino, after | | | |
| A520c | Bronzino, copy after | | | |
| A803 | Caporali, attributed to | | | |
| A783 | Giovan Francesco Caroto | | | |
| A347 | Giovan Francesco Caroto, attributed to | | | |
| A711 | Baldassare Carrari, attributed to | | | |
| A1062 | Naddo Ceccarelli, attributed to | | | |
| A863a | Anon. Cremonese school, 1570–90 | | | |
| A314 | Carlo Crivelli | | | |
| A301 | Vittorio Crivelli | | | |

| Guide | 1912 Guide | 1931 Guide | 1950 Catalogue | 1961 Catalogue |
|---|---|---|---|---|
| | | | 435 Tomaso da Modena (?) | 435 Altichiero, follower of |
| Tuscan school, XIV cent. | Tuscan school, XIV cent. | 75 Sienese school | 41 Andrea di Bartolo | 41 Andrea di Bartolo |
| | | — | — | A370 Andrea del Sarto, formerly attributed to |
| Angelico | Angelico | 77 Angelico | 42 Angelico, school of | 42 Angelico studio of |
| Angelico, manner of | Angelico, manner of | 78 Angelico, pupil of | 43 Angelico, school of | 43 Angelico, follower of |
| Tuscan school, XV cent. | Tuscan school, XV cent. | 90 Florentine school, c. 1450 | 269 Master of the Jarves Cassoni | 269 Apollonio di Giovanni (?) |
| Italian, XV cent. | Italian, XV cent. | 92 Florentine school, c. 1450 | 270 Master of the Jarves Cassoni | 270 Apollonio di Giovanni (?) |
| | | 134 Anon. Florentine school, c. 1480 | 32 Anon. Florentine school, c. 1480 | 32 Anon. Florentine school, c. 1480 |
| Venusti | — | — | 449 Marcello Venusti | 449 Marcello Venusti |
| Sienese school | Sienese school | 73 Sienese school | 47 Barna da Siena (?) | 47 Barna da Siena (?) |
| Italian | — | 103 Lorenzo di Credi | | A104 Lorenzo di Credi, copy after |
| North Italian school | North Italian school | 93 no attr. | 289 Domenico Morone | 289 Domenico Morone |
| | | | — | A735 Basaiti (?) |
| | | | 48 Jacopo Bassano | 48 Jacopo Bassano |
| | | | | A905 Francesco Bassano (?) |
| | | | 50 Leandro Bassano | 50 Leandro Bassano |
| | Venetian school, c. 1475–1500 | 302 Venetian school | 55 Giovanni Bellini (?) | 55 Giovanni Bellini (?) |
| Italian, XV cent. | Italian, XV cent. | 89 Bicci di Lorenzo | 60 Bicci di Lorenzo | 60 Bicci di Lorenzo |
| | | | 64 Bonifazio Veronese | 64 Bonifazio Veronese |
| | | | 65 Bonifazio Veronese | 65 Bonifazio Veronese |
| | | | | A914 Bonifazio Veronese |
| | | | 71 Botticelli, school of | 71 Botticelli, school of |
| Antonio Pollaiuolo, attributed to | Antonio Pollaiuolo, attributed to | 85 Florentine school | 33 Anon. Florentine school, c. 1490 | 33 Anon. Florentine school, c. 1490 |
| Bronzino | Bronzino | 105 Bronzino | 77 Bronzino | 77 Bronzino |
| | | | — | — |
| | | | — | — |
| | | | 63 Bonfigli | 63 Bonfigli |
| | | | 90 Giovan Francesco Caroto | 90 Giovan Francesco Caroto |
| | | | 317 Bernardino Parentino | 317 Anon. North Italian school, late XV cent. |
| | | | 397 Giovanni Santi (?) | 397 Giovanni Santi (?) |
| | | | | — |
| Carlo Crivelli, attributed to | Venetian school, XV cent. | 314 Carlo, Crivelli, Venetian school of | 126 Carlo Crivelli, school of | 126 Carlo Crivelli (?) |
| Vittorio Crivelli, | Vittorio Crivelli, attributed to | 301 Vittorio Crivelli | 27 Vittorio Crivelli | 127 Vittorio Crivelli |

| 1977 Catalogue | | 1859 Guide | 1865 Guide | 1891 Catalogue |
|---|---|---|---|---|
| A886 | Dosso Dossi, attributed to | | | |
| A335 | Anon. Ferrarese school, 1510–20 | | | |
| A733 | Francesco Bianchi Ferrari | | | |
| A678 | Camillo Filippi | | | |
| A80 | Anon. Florentine school, 1420–30 | *no attr.* | *no attr.* | 18 Pesello, formerly attributed to |
| A334 | Anon. Florentine school, 1430–50 | | | |
| A91 | Anon. Florentine school, 1450–60 | | | 9 Italian, late XV ce॰ |
| A338 | Anon. Florentine school, 1490–1500 | | | |
| A70 | Anon. Florentine school, 1580–90 | 42 Tintoretto | 42 Tintoretto | 31 Alessandro Allori ▮ |
| A86 and A87 | Francesco de' Franceschi, ascribed to | Giotto [?] | Giotto [?] | 7 *no attr.* |
| A419a | Francesco Francia | | | |
| A342 | Franciabigio | | | |
| A292 | Gerolamo da Santacroce | | | |
| A83 | Domenico Ghirlandaio, attributed to | Masaccio | Masaccio | 22 Granacci, attribute▮ |
| A777 | Giorgione, attributed to | | | |
| A332 | Giotto, school of | | | |
| A882 | Giovanni Antonio da Pesaro | | | |
| A333 | Giovanni di Paolo | | | |
| A972 | Giovanni di Paolo | | | |
| A100 and A101 | Granacci | Granacci | Granacci | 23 Granacci |
| A20 | Anon. Italian, 1550–70 | | | 36 Federigo Zucchero ( |
| A503 | Leonardo da Vinci, studio of | | | |
| A790 | Leonardo da Vinci, studio of | | | |
| A713 | Leonardo da Vinci or Ambrogio de' Predis, copy after | | | |
| A721 | Licinio | | | |
| A81 | Filippo Lippi | Pesello Peselli | Pesello Peselli | 12 Filippo Lippi, attributed to |
| A141 | Anon. Lombard school, 1520–30 | — | — | — |
| A103 | Lorenzo di Credi | Lorenzo di Credi | Lorenzo di Credi | 26 Credi, school of |
| A736b | Mansueti, attributed to | | | |
| A793 | Maso da San Friano | | | |

| Guide | 1912 Guide | 1931 Guide | 1950 Catalogue | 1961 Catalogue |
|---|---|---|---|---|
| | | | | A886 Domenico Mancini (?) |
| | | 335 Anon. Ferrara–Bologna, school of | 26 Anon. Ferrarese or Bolognese school, early XVI cent. | 26 Anon. Ferrarese or Bolognese school, early XVI cent. |
| | | | 51 Lazzaro Bastiani (?), studio of | 51 Girolamo Mocetto (?) |
| | | | 134 Battista Dossi (?) | 133 Battista Dossi (?) |
| alian | Italian | 80 Florentine school | 329 Pietro di Giovanni di Ambrogi (?) | 329 Pietro di Giovanni di Ambrogi |
| | | 334 Florentine school | 268 Master of the Carrand Triptych (?) | 268 Master of the Carrand Triptych (?) |
| alian, XV cent. | Italian, XV cent. | 91 Tuscan school, XV cent. | 31 Anon. Florentine school, c. 1460 | 31 Anon. Florentine school, c. 1460 |
| | | 338 Raffaello de' Carli | 175 Raffaellino del Garbo | 175 Raffaellino del Garbo |
| lorentine school, ate XVI cent. | — | — | — | A70 Florentine school, XVI cent. |
| orentine school V cent. | Florentine school, XV cent. | 86 Florentine school and 87 | 162 Francesco dei and Franceschi 163 | 162 Francesco dei and Franceschi 163 |
| | | | — | A419(a) Francia |
| | | 342 Franciabigio, ascribed to | 164 Franciabigio | 164 Franciabigio |
| | | | 396 Gerolamo da Santacroce | 396 Gerolamo da Santa croce |
| lorentine school | Florentine school | 83 no attr. | 330 Pintoricchio | 330 Pintoricchio |
| | | | 177 Giorgione | 177 Giorgione (?) |
| | | 332 Giotto, Florentine school of, 1300–50 | 178 Giotto, follower of | 178 Giotto, follower of |
| | | | | A882 Giovanni Antonio da Pesaro |
| | | 333 Giovanni di Paolo | 179 Giovanni di Paolo | 179 Giovanni di Paolo |
| ranacci | Granacci | 100 Granacci and 101 | 181 Granacci | 181(a) Granacci and 181(b) |
| — | — | — | — | — |
| | | | 240 Leonardo da Vinci, copy after | 240 Leonardo da Vinci, copy after |
| | | | 239 Leonardo da Vinci (?) | 239 Leonardo da Vinci, formerly attributed to |
| | | | | A713 Ambrogio de' Predis, copy after |
| | | | 243 Licinio | 243 Licinio |
| lorentine school | Florentine school | 81 Filippo Lippi | 246 Filippo Lippi | 246 Filippo Lippi |
| — | — | — | 254 Bernardino Luini (?) | 254 Anon. North Italian school, early XVI cent. |
| redi, school of | Lorenzo di Credi | 103 Lorenzo di Credi | 118 Lorenzo di Credi | 118 Lorenzo di Credi |
| | | | — | — |
| | | | 391 Francesco Salviati (?) | 391 Maso da San Friano |

| 1977 Catalogue | | 1859 Guide | 1865 Guide | 1891 Catalogue |
|---|---|---|---|---|
| A676 and A677 | Master of the Dominican Effigies, ascribed to | | | |
| A520d | Master of Marradi | | | |
| A84 | Master of the S. Louis Altar-piece | Domenico Ghirlandaio | Domenico Ghirlandaio | 19 Domenico Ghirlanda |
| A300 | Master of San Martino alla Palma | | | |
| A99 | Master of Santo Spirito | Raphael, school of | Raphael, school of | 21 Domenico Ghirlanda school of |
| A290 and A291 | Altobello Melone | | | |
| A66c | Michelangelo, ascribed to | 2 Michelangelo | 2 Michelangelo | — |
| A504a | Michele di Ridolfo, studio of | | | |
| A724 | Bartolomeo Montagna | | | |
| A722 and A723 | Bartolomeo Montagna | | | |
| A874 | Bartolomeo Montagna | | | |
| A980 | Moretto da Brescia | | | |
| A446 | Giovanni Battista Moroni | | | |
| A1014 | Naldini | | | |
| A231 | Anon. Neapolitan school (?), 1400–20 | | *no attr.* | 17 Tuscan school, XV cent. |
| A96 and A97 | Nicola di Maestro Antonio d'Ancona | Giotto | Giotto | 4 Niccolò Alunno, attributed to |
| A74 | Orcagna, studio of | Taddeo Gaddi | Taddeo Gaddi | 3 Taddeo Gaddi |
| A300a and A300b | Orcagna, studio of | | | |
| A366 | Orcagna, studio of | | | |
| A938 | Lelio Orsi | | | |
| A88 | Gerolamo del Pacchia | Verrocchio | Verrocchio | — |
| A930 | Pacchiarotto | | | |
| A504 | Jacopo Palma | | | |
| A108 | Perugino, copy after | *no attr.* | *no attr.* | — |
| A348 | Pier Francesco Fiorentino | | | |
| A420 | Piero di Cosimo | | | |
| A400z | Pietro degli Ingannati, attributed to | | | |
| A303 | Pintoricchio | | | |
| A365 | Anon. Pisan school (?), 1310–25 | | | |
| A144 | Pordenone, copy after | — | — | — |
| A256 | Pulzone, copy after (?) | | | |

| ...ide | 1912 Guide | 1931 Guide | 1950 Catalogue | 1961 Catalogue |
|---|---|---|---|---|
| | | | 27 and 28 Anon. Florentine school, c. 1380 | 27 and 28 Master of the Dominican Effigies |
| ...enico Ghirlan-o, attributed to | Domenico Ghirlandaio, attributed to | 84 Florentine school | 374 Cosimo Rosselli | 374 Cosimo Rosselli |
| | | | 271 Master of San Martino alla Palma | 271 Master of San Martino alla Palma |
| ...enico Ghirlan-o, school of | Domenico Ghirlandaio, school of | 99 Florentine school | 17 Davide Ghirlandaio | 176 Davide Ghirlandaio |
| | Altobello Meloni | 290 and 291 Altobello Meloni | 273 and 274 Altobello Meloni | 273 and 274 Altobello Meloni |
| | Michelangelo | — | 278 Michelangelo | 278 Michelangelo |
| | | | — | — |
| | | | 284 Bartolomeo Montagna | 284 Bartolomeo Montagna |
| | | | 285 and 286 Bartolomeo Montagna | 285 and 286 Bartolomeo Montagna |
| | | | | A874 Bartolomeo Montagna |
| | | | 290 Giovanni Battista Moroni | 290 Giovanni Battista Moroni |
| ...an school, cent. | Tuscan school, XV cent. | 231 Tuscan school, 1350–1400 | 30 Anon. Florentine school, c. 1425 | 30 Anon. Florentine school, c. 1425 |
| ...an | Italian | 96 and 97 Marchigian school, 1450–1500 | 301 and 302 Nicola di Maestro Antonio d'Ancona | 301 and 302 Nicola di Maestro Antonio d'Ancona |
| ...an school | Tuscan school | 74 Tuscan school | 306 Andrea Orcagna | 306 Andrea Orcagna |
| — | — | — | — | A300(a) and (b) Orcagna, style of |
| | | 366 Florentine school | 29 Anon. Florentine school, c. 1425 | 29 Anon. Florentine school, c. 1425 |
| | | | | A938 Lelio Orsi |
| — | — | — | — | A88 Anon. Florentine school, XVI cent. |
| | | | | A930 Pacchiarotto |
| | | | 311 Palma Vecchio | 311 Palma Vecchio |
| — | — | — | — | — |
| — | — | — | — | A348 Pier Francesco Fiorentino, formerly attributed to |
| | | | 328 Piero di Cosimo | 328 Piero di Cosimo |
| ...oricchio | Pintoricchio | 303 Pintoricchio | 331 Pintoricchio | 331 Pintoricchio |
| | | 365 Tuscan school, c. 1300–25 | 34 Anon. Pisan school (?), c. 1315–25 | 34 Anon. Pisan school (?), c. 1315–25 |
| — | — | — | — | A144 Pordenone, formerly attributed to |
| — | — | — | — | A256 Anon. Florentine, XVI cent. |

| 1977 Catalogue | | 1859 Guide | 1865 Guide | 1891 Catalogue |
|---|---|---|---|---|
| A45 | Raphael, copy after | 19 Raphael, copy after, supposed to be the work of Julio Romano | 31 Raphael, copy after, supposed to be the work of Julio Romano | — |
| A59 | Raphael, copy after | 16 Raphael | 23 Raphael | — |
| A228 | Raphael, copy after | | Julio Romano | — |
| A76 | Sano di Pietro | Bernardo da Siena | Bernardo da Siena | 14 Sano di Pietro |
| A102 | Andrea del Sarto, formerly attributed to | Andrea del Sarto | Andrea del Sarto | 32 Andrea del Sarto |
| A939 | Sebastiano Secante il Vecchio attributed to | | | |
| A255 | Simone dei Crocifissi | | | |
| A817 | Andrea Solario | | | |
| A717 | Lambert Sustris | | | |
| A731 | Domenico Tintoretto | | | |
| A678a | Jacopo Tintoretto | | | |
| A720 | Jacopo Tintoretto, assisted by the studio | | | |
| A397 | Jacopo Tintoretto, copy after | | | |
| A226 | Titian, copy after | Titian, copy after | 33 Titian, copy after | — |
| A451c | Anon. Tuscan school, XIV cent. | | | |
| A79 | Uccello | Benozzo Gozzoli | Benozzo Gozzoli | 28 Benozzo Gozzoli |
| A82 | 'Utili' | Filippo Lippi | Filippo Lippi | 8 Filippo Lippi, sc |
| A696 | Andrea Vanni | | | |
| A991 | Vasari | | | |
| A293 | Anon. Venetian school (?), 1500–20 | | | |
| A94 and 95 | Anon. Veronese school, 1480–1500 | Masaccio | Masaccio | 10 Gentile Bellini and 11 |
| A512 | Anon. Veronese school, 1550–60 | | | |
| A863 | Paolo Veronese | | | |
| A377–82 | Paolo Veronese, follower of | | | |
| A142 | Paolo Veronese, copy after | — | — | 33 Veronese |
| A143 | Paolo Veronese, copy after | — | — | 35 Venetian school |
| A98 | Zoppo | *no attr.* | *no attr.* | 13 Zoppo |

| ...ide | 1912 Guide | 1931 Guide | 1950 Catalogue | 1961 Catalogue |
|---|---|---|---|---|
| | — | — | — | A45 Raphael, copy after |
| | — | — | — | A59 Raphael, copy after |
| | — | — | — | A228 Raphael, copy after |
| ...se school | Sienese school | 76 Sano di Pietro | 395 Sano di Pietro | 395 Sano di Pietro |
| ...ea del Sarto | Andrea del Sarto | 102 Andrea del Sarto, copy of (?) | — | A102 Andrea del Sarto, formerly attributed to |
| | | | | A939 Morto da Feltre (?) |
| | | | | A255 Simone dei Crocifissi |
| | | | 410* Andrea Solario | 410* Andrea Solario |
| | | | 400 Savoldo (?) | 400 Lambert Sustris |
| | | | 49 Jacopo Bassano (?) | 49 Domenico Tintoretto (?) |
| | | | 434 Jacopo Tintoretto | 434 Jacopo Tintoretto |
| | | | 433 Jacopo Tintoretto | 433 Jacopo Tintoretto |
| | | 397 Domenico Tintoretto | — | — |
| | — | — | — | A226 Titian, copy after |
| | | | — | — |
| ...llo, attributed | Uccello, attributed to | 79 Uccello | 442 Uccello | 442 Uccello |
| ...po Lippi | Filippo Lippi | 82 *no attr.* | 444 'Utili' (?) | 444 'Utili' (?) |
| | | | 447 Andrea Vanni | 447 Andrea Vanni |
| | — | — | — | A293 Venetian school, XVI cent. |
| ...th Italian school | North Italian school | 94 and 95 North Italian school | 35 and 36 Anon. Sienese school (?), c. 1480 | 35 and 36 Anon. Sienese school (?), c. 1480 |
| | | | 431 Pellegrino Tibaldi (?) | 431 Giovanni Demio (?) |
| | | | | A863 Paolo Veronese |
| | | 377–82 Paolo Veronese | 450–5 Paolo Veronese | 450–5 Paolo Veronese |
| ...nese, copy after | — | — | — | A142 Veronese, copy after |
| ...nese, copy after | — | — | — | A143 Veronese, copy after |
| ...o | Zoppo | 98 Zoppo | 483 Zoppo | 483 Zoppo |

# ADDENDUM

## ATTRIBUTED TO JACOPO BASSANO active 1534, died 1592

A1080 PORTRAIT OF AN UNKNOWN MAN WITH HIS SECRETARY
Canvas (relined). 128·5 × 103. **Pl. 16**

Condition: fair. The surface is rather dirty and the colours have darkened but the flesh tones are comparatively well preserved. The portrait appear: to have been cleaned prior to the Bassano exhibition in Venice in 1957.'
Collections: Sir Frederick Cook, 2nd Bt.,² and by descent to Sir Franci; Cook, 4th Bt., Doughty House, Richmond (Sotheby's, 25 June 1958. lot 3 repr. bt. Brod); H. M. Calmann.

Purchased 1975.

Exhibited: *Jacopo Bassano*, Venice, 1957 (Rittratti, No. 4).

Literature: B. Berenson, 1910, 215; 1932, 181; 1936, 155; T. Borenius *A Catalogue of the Paintings at Doughty House, Richmond and Elsewhere in the Collection of Sir Frederick Cook Bt. Visconde de Monserrate*, ed. H. Cook. i. Italian Schools (London, 1913), No. 184, p. 203 repr.; G. Fiocco, 'Ausstellung venezianisher kunst in München', *Zeitshrift für bildende Kunst, 6;* (1931–2), 158 repr.; W. Arslan, *I Bassano* (Bologna, 1931), pp. 123–4 repr.; S. Bettini, *L'arte di Jacopo Bassano* (Bologna, 1933), pp. 121 and 173 M .W. Brockwell, *Abridged Catalogue of the Pictures at Doughty House Richmond, Surrey in the collection of Sir Herbert Cook Bart.* (London, 1932) p. 50; R. Pallucchini, *La pittura veneziana del Cinquecento* ii. (Novara, 1944) p. xl repr.; R. Pallucchini, 'Commento alla mostra di Jacopo Bassano' *Arte veneta*, 11 (1957), 116; E. Arslan, *I Bassano*, i (Milan, 1960), 99 an( 174–5 repr.

Traditionally ascribed to Moretto and attributed by Berenson to Paol( Farinati, No. A 1080 was first published as a portrait by Jacopo Bassan( by the late Professor Fiocco, who drew Arslan's attention to the picture Arslan (1931 and 1960) accepted Fiocco's attribution to Jacopo Bassano suggesting in the first edition of his monograph a date of *c.* 1570, but ii the later edition modifying this date to one of 1562–8, close to the *S. Jerom;* in the Accademia, Venice. On both occasions Arslan described No. A 108(

as being one of Bassano's finest achievements of his middle period, but of the other writers only Professor Sergio Bettini and Professor Pietro Zampetti, in the catalogue of the Bassano exhibition, have so far whole-heartedly agreed with this attribution. Professor Rodolfo Pallucchini, who in an earlier publication (1944) did favour an attribution to Jacopo Bassano, preferred after the Bassano exhibition of 1957 to describe the hand simply as Veronese *c.* 1550. This last suggestion is first found in the official catalogue of the Cook collection where Tancred Borenius tentatively mentions the name of Domenico Brusasorci which, according to Pallucchini (1958), Fiocco himself had mentioned at some unspecified time. The variety of opinion is obviously the result of the portrait not being very well known and rarely being inspected at first hand by scholars.

The picture is a fine example of the type of double portrait evolved in the first place by Raphael, *Pope Leo X with Cardinals Giulio de' Medici and Luigi Rossi* (Uffizi), painted 1517–19, and developed by Titian, *Pope Paul III and his Grandsons* (Naples, Museo di Capodimonte).

REFERENCES: 1. Cf., e.g. the reproductions used by W. Arslan, *I Bassano* (Bologna, 1931), pl. XLV and again in *I Bassano*, ii (Milan, 1960), fig. 121, the source for which was a photograph by Anderson (No. 18510), and the illustration in the exhibition catalogue *Jacopo Bassano* (Venice, 1957), Ritratti, No. 4, p. 226. 2. An account book kept by Sir J. C. Robinson, who bought many of the pictures in the Cook collection, has recently been acquired by the Ashmolean Museum. It does not contain a reference to No. A 1080.

## GIOVANNI DAL PONTE active *c.* 1346–1369

Florentine school. His real name was Giovanni di Marco, called dal Ponte since he had a studio near S. Stefano a Ponte. He appears to have been a follower of Spinello Aretino. The only extant documented work is a series of frescoes in S. Trinita, Florence, but there are a large number of works ascribed to his hand, all of which are painted in a popular, although rather outmoded, style closely akin to that of the Master of the Bambino Vispo.

## ATTRIBUTED TO GIOVANNI DAL PONTE

A736C THE VIRGIN (pinnacle panel from an altar-piece). **Pl. 162**
Wood. 32·5 × 17·7

Condition: poor. The surface is dirty. The process of restoration was begun at an uncertain date, but was not carried through.

Presented by the daughters of J. R. Anderson, 1947.

A736d   S. JOHN THE EVANGELIST (pinnacle panel from an altar-piece)
Wood. 32·5 × 18·2

Condition: poor. The surface is dirty. The process of restoration was
begun at an uncertain date, but was not carried through.

Presented by the daughters of J. R. Anderson, 1947.

Both panels almost certainly once belonged to the same altar-piece and
most probably served as the pinnacles of the side panels, assuming that
the central element of the altar-piece was crowned by a pinnacle panel
showing *Christ on the Cross*. If this assumption is correct the original
altar-piece must have been quite large.

The attribution to Giovanni dal Ponte was first suggested by Professor
Sir Ellis Waterhouse, but to the compiler the types seem closer to those
of Neri di Bicci.

# INDEX TO RELIGIOUS SUBJECTS

# INDEX TO IDENTIFIABLE PORTRAITS

# INDEX TO PROFANE SUBJECTS

# INDEX OF PREVIOUS OWNERS

# NUMERICAL INDEX

# LIST OF ARTISTS REPRESENTED IN THE COLLECTION

Altichiero
Andrea di Bartolo
Andrea del Brescianino
Fra Angelico
Apollonio di Giovanni and Marco del Buono Giamberti
Anonymous Aretine School(?)
Bacchiacca
Barna di Siena
Bartolomeo degli Erri
Fra Bartolommeo
Marco Basaiti
Jacopo Bassano
Leandro Bassano
Giovanni Bellini
Bicci di Lorenzo
Bonifazio de'Pitati
Sandro Botticelli
Francesco Botticini
Agnolo Bronzino
Bartolomeo Caporali
Giovan Francesco Caroto
Baldassare Carrari
Naddo Ceccarelli
Anonymous Cremonese School
Carlo Crivelli
Vittorio Crivelli
Dosso Dossi
Anonymous Ferrarese School
Francesco Bianchi Ferrari
Camillo Filippi
Anonymous Florentine School (1420–1430)
Anonymous Florentine School (1430–1450)
Anonymous Florentine School (1450–1460)
Anonymous Florentine School (1490–1500)
Anonymous Florentine School (1580–1590)
Francesco de' Franceschi
Francesco Francia
Franciabigio
Gerolamo da Santacroce
Domenico Ghirlandaio
Giorgione
Studio of Giotto
Giovanni Antonio da Pesaro
Giovanni di Paolo
Giovanni dal Ponte (Addeneum)
Francesco Granacci
Anonymous Italian
Studio of Leonardo da Vinci
Bernardino Licinio
Fra Filippo Lippi

Anonymous Lombard School
Lorenzo di Credi
Giovanni Mansueti
Maso da San Friano
Master of the Dominican Effigies
Master of Marradi
Master of the S. Louis Altar-piece
Master of San Martino alla Palma
Master of Santo Spirito
Altobello Melone
Michelangelo Buonarroti
Michele di Ridolfo
Bartolomeo Montagna
Moretto da Brescia
Giovanni Battista Moroni
Giovanni Battista Naldini
Anonymous Neapolitan School(?)
Nicola di Maestro Antonio d'Ancona
Orcagna
Lelio Orsi
Gerolamo del Pacchia
Giacomo Pacchiarotto
Jacopo Palma
Pietro Perugino
Pier Francesco Fiorentino
Pietro degli Ingannati
Piero di Cosimo
Bernardino Pintoricchio
Anonymous Pisan School(?)
Pordenone
Scipione Pulzone (?)
Raphael
Sano di Pietro
Andrea del Sarto
Sebastiano Secante
Simone dei Crocifissi
Andrea Solario
Lambert Sustris
Domenico Tintoretto
Jacopo Tintoretto
Titian
Anonymous Tuscan School
Paolo Uccello
'Utili' (Biagio di Antonio da Firenze)
Andrea Vanni
Giorgio Vasari
Anonymous Venetian School(?)
Anonymous Veronese School (1480–1500)
Anonymous Veronese School (1550–1560)
Paolo Veronese
Marco Zoppo

1

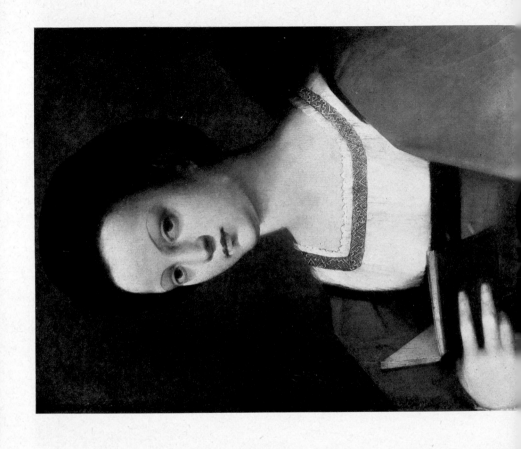

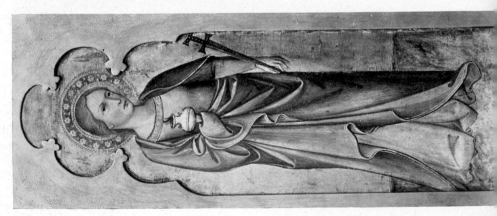

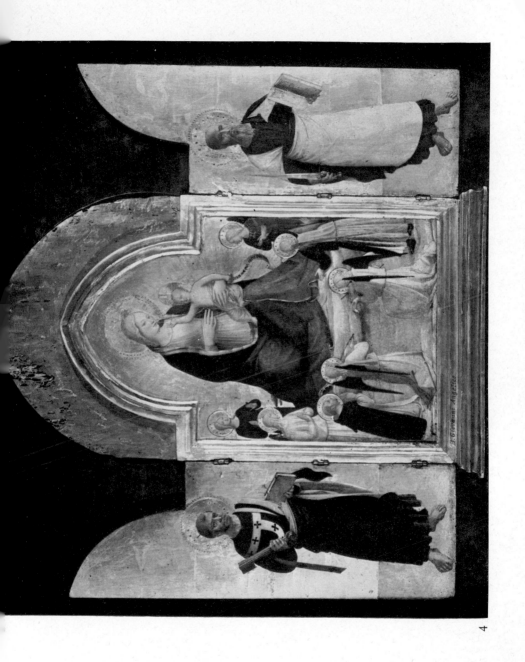

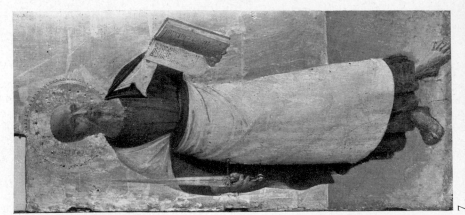

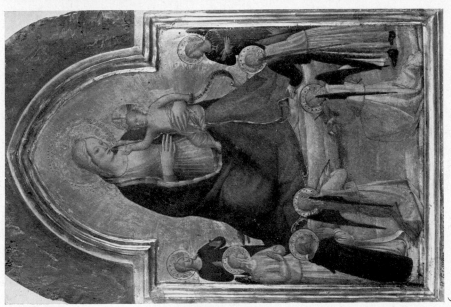

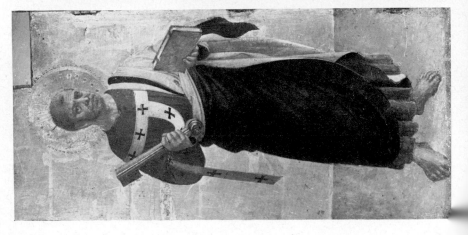

7

6

8

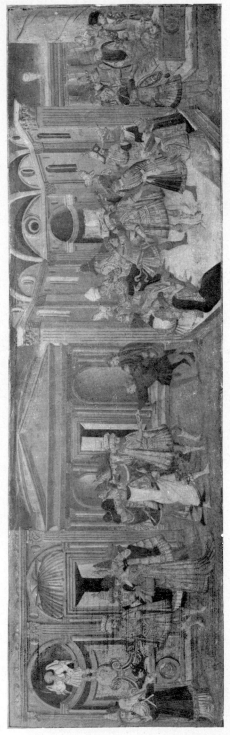

9

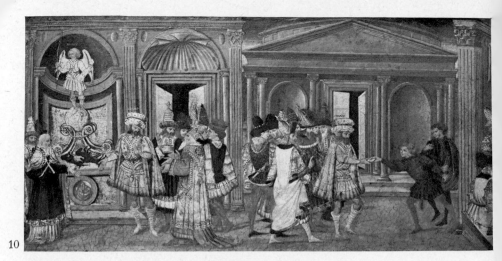

10

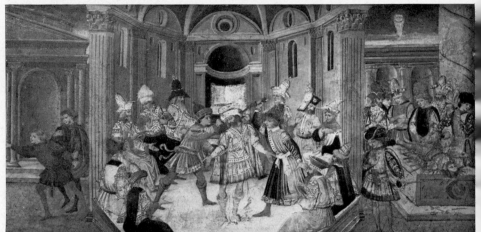

11

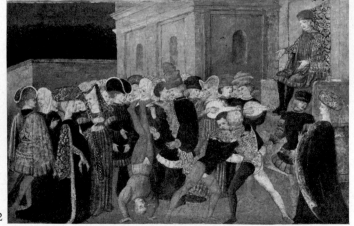

12

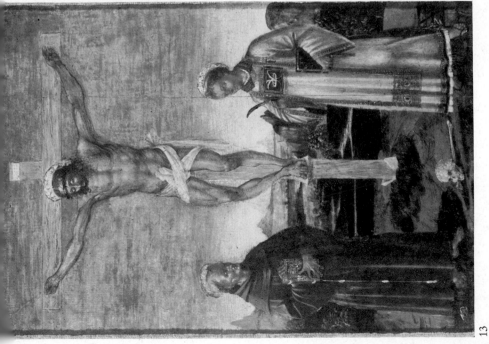

14

13

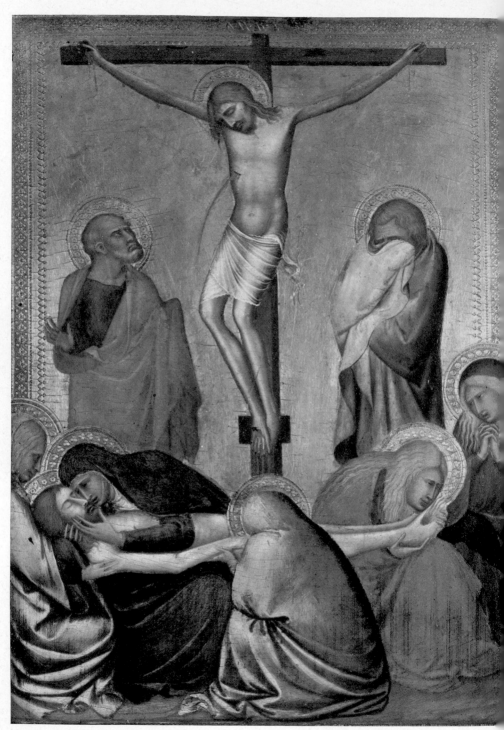

15

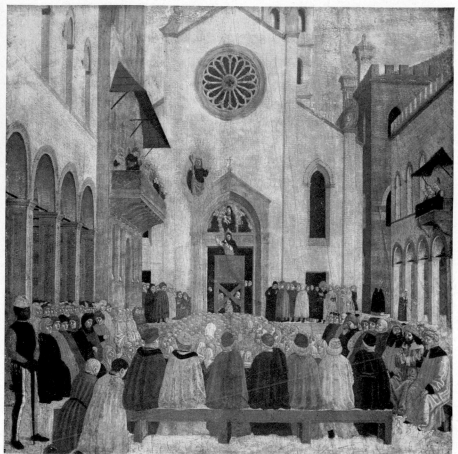

16

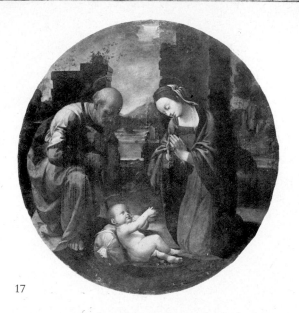

17

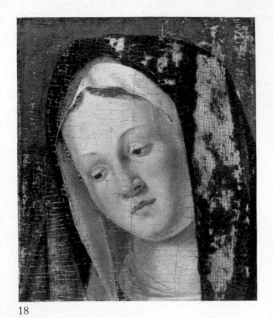

18

19

20

21

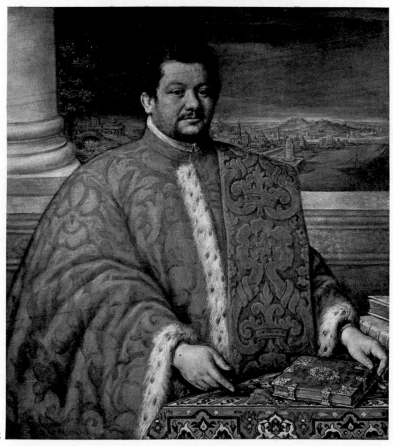

22

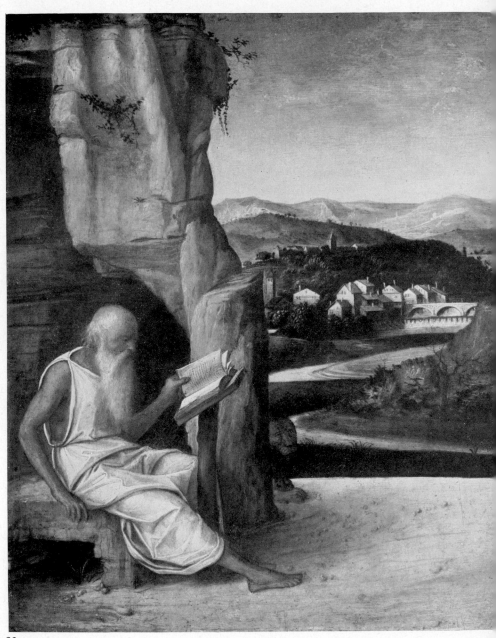

23

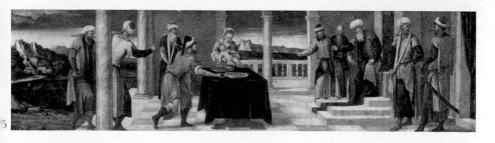

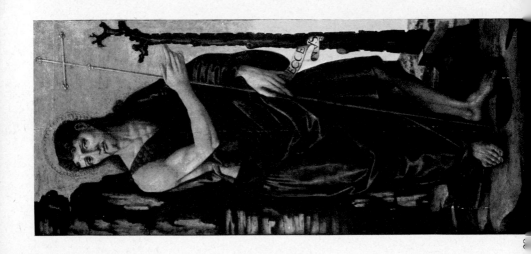

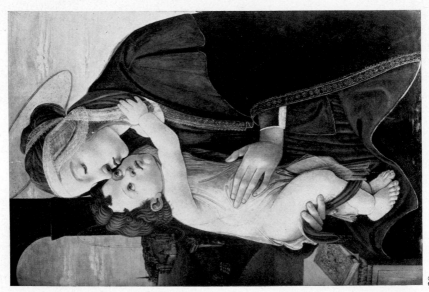

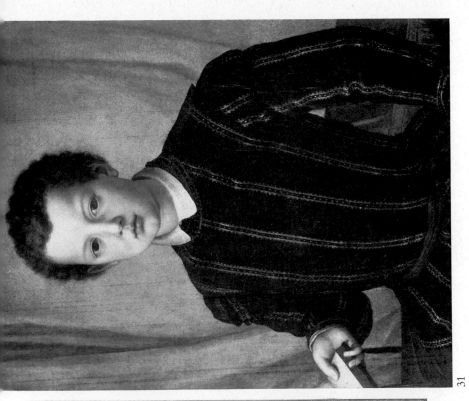

31

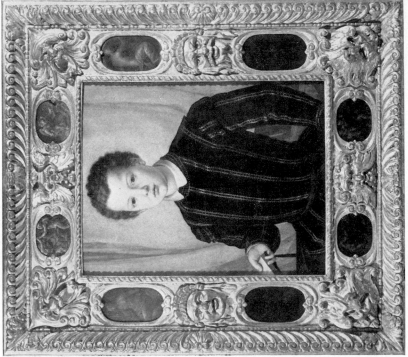

30

34

33

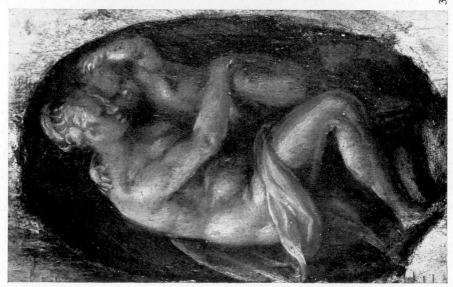

32

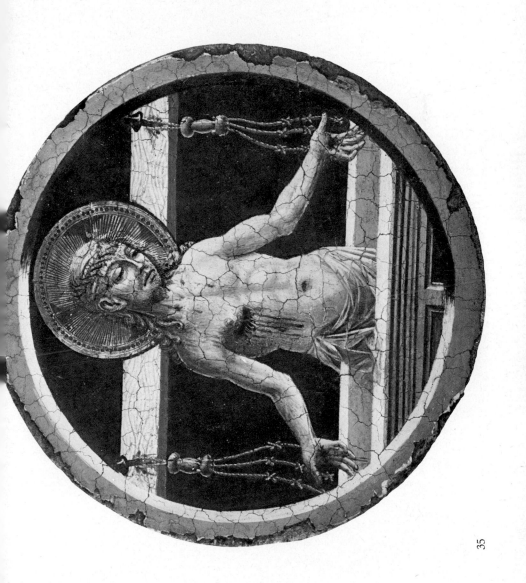

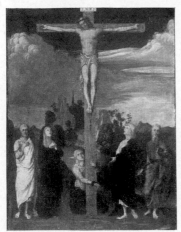

36

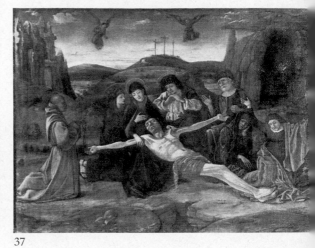

37

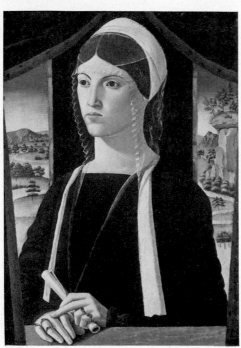

38

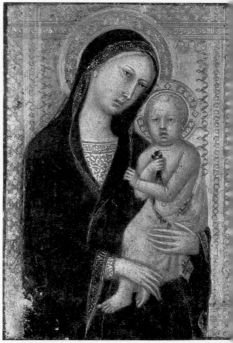

39

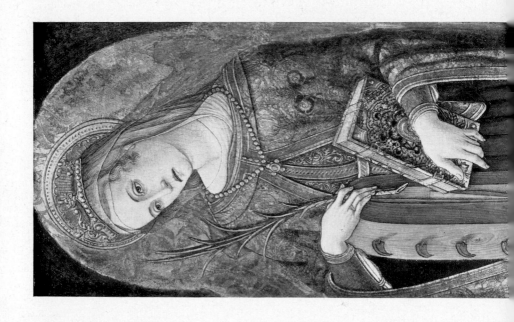

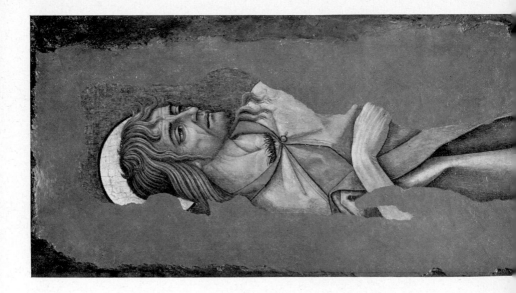

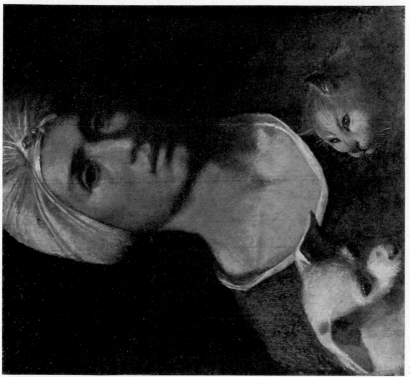

43

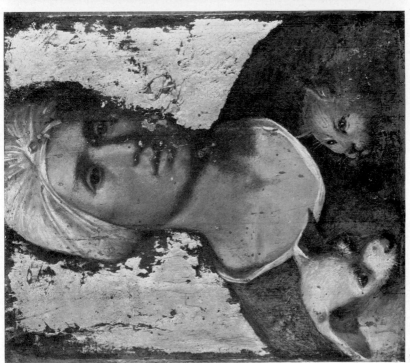

44

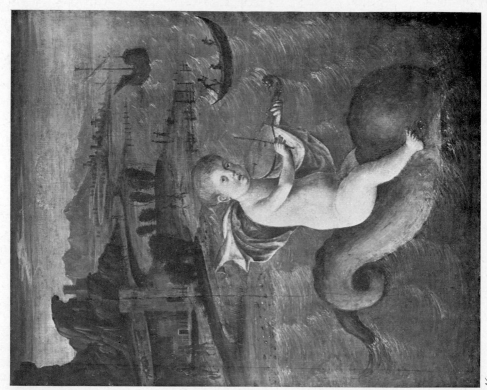

46

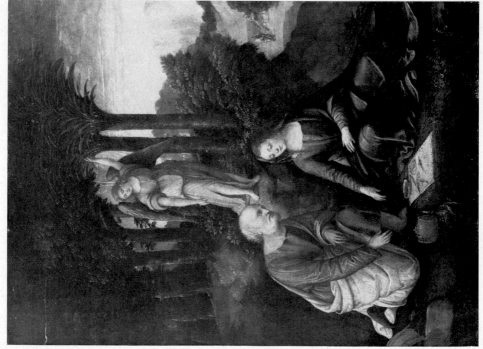

45

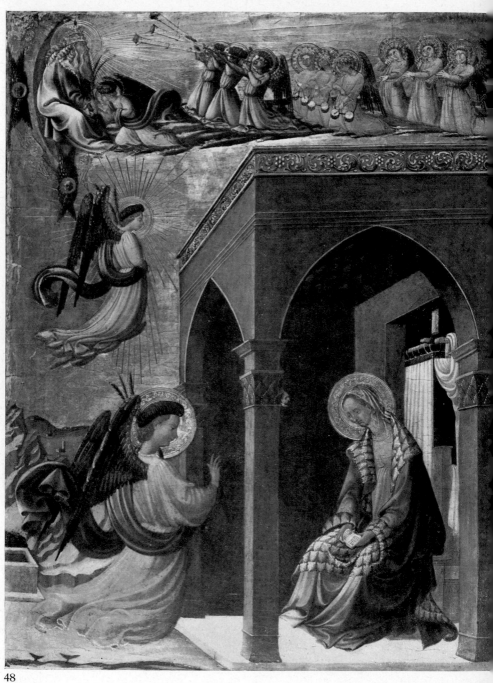

48

50

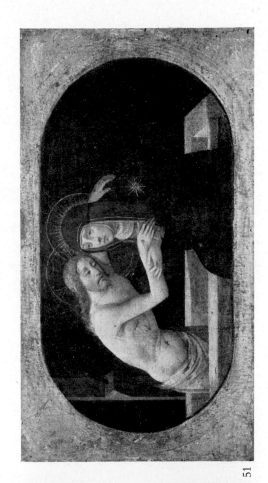

51

49

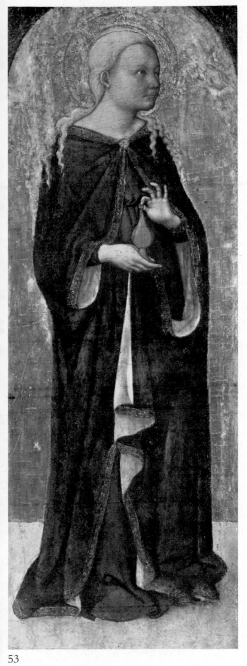

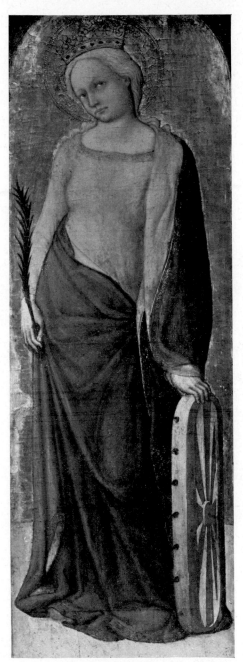

53                    54

55

56

57

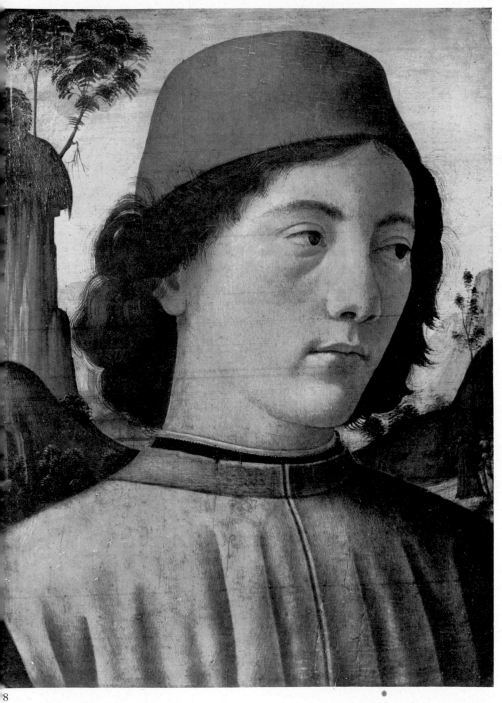

59

61

60

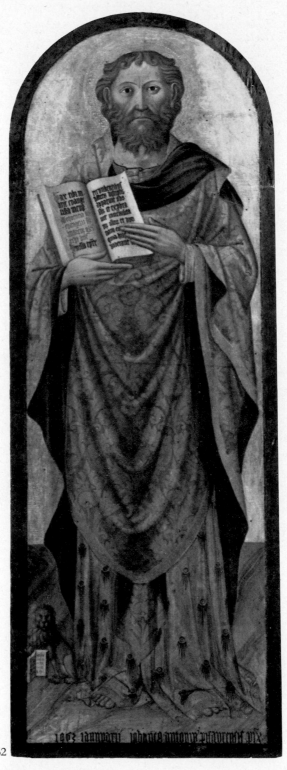

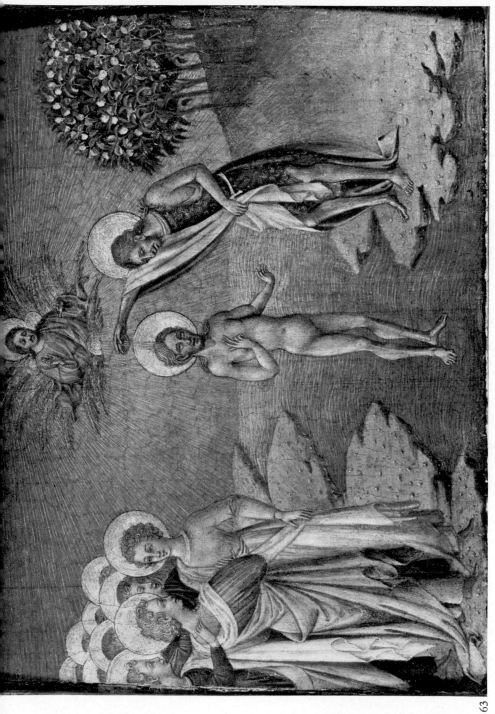

64

65

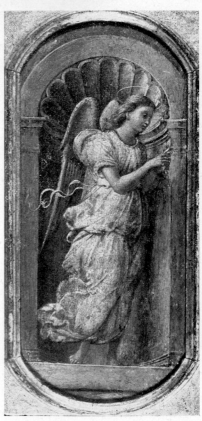

66

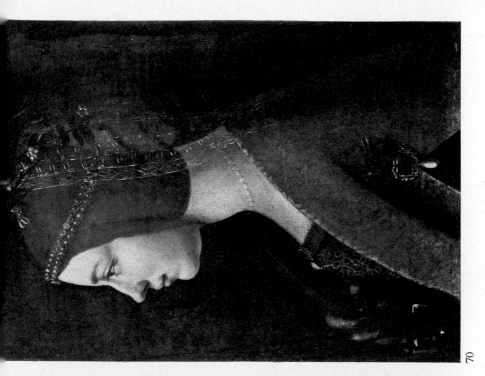

70

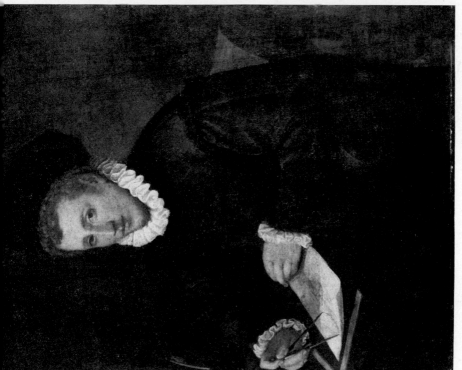

67

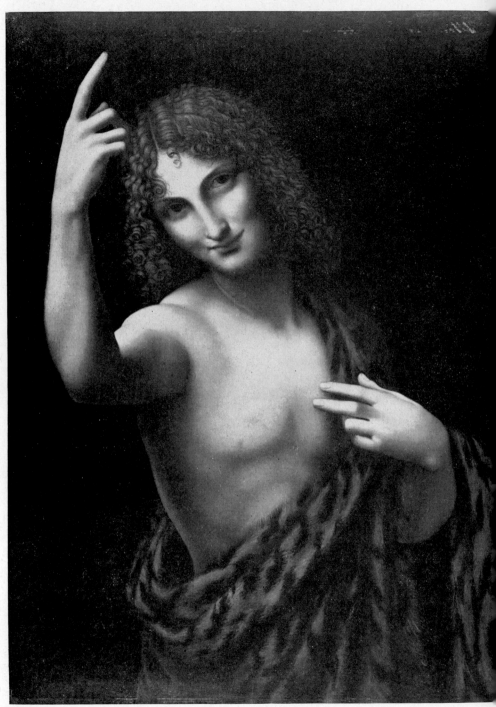

68

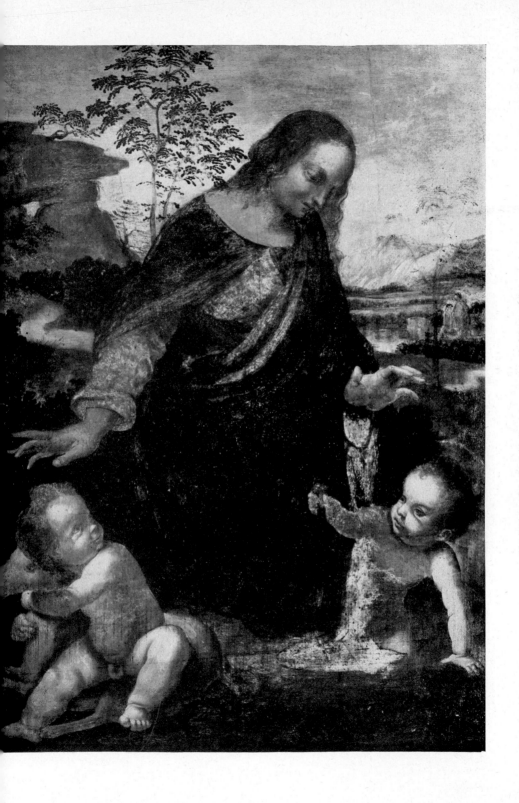

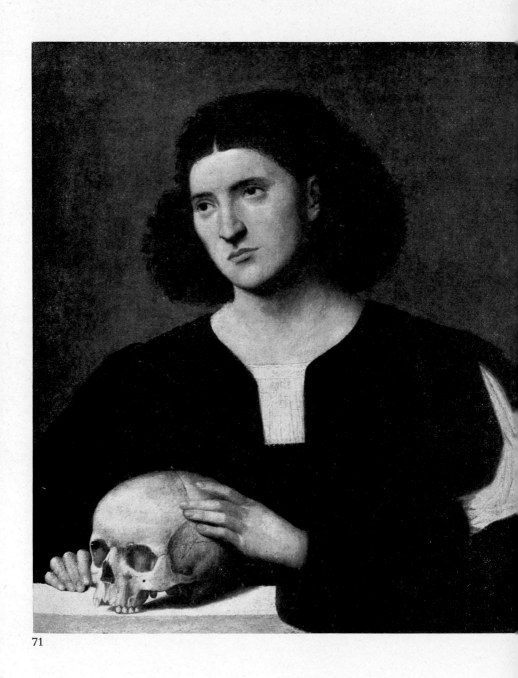

71

72

73

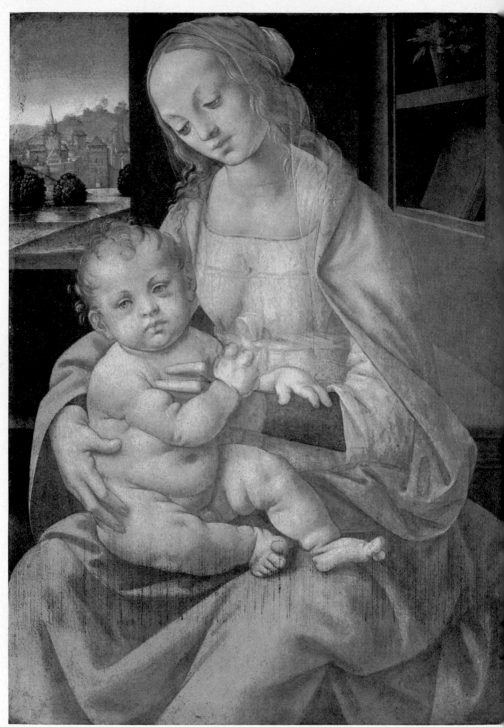

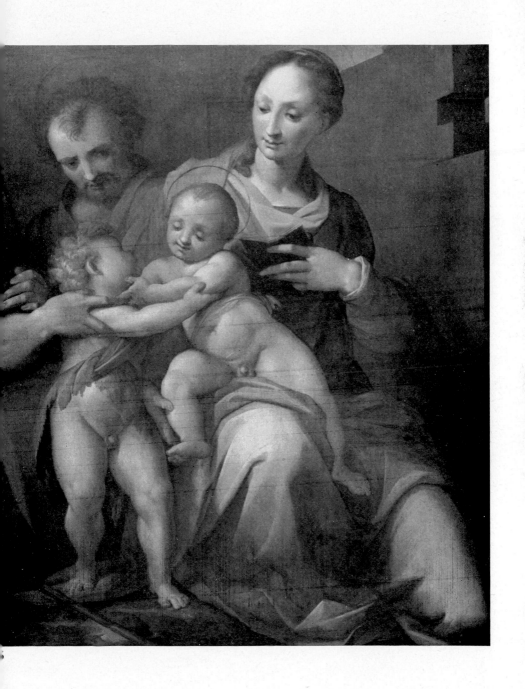

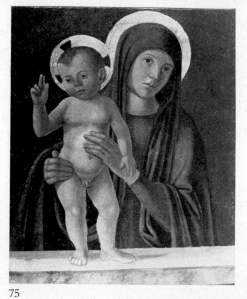

75

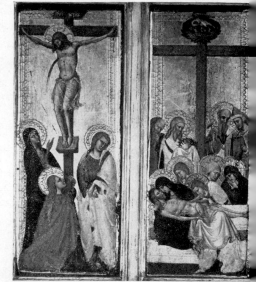

77

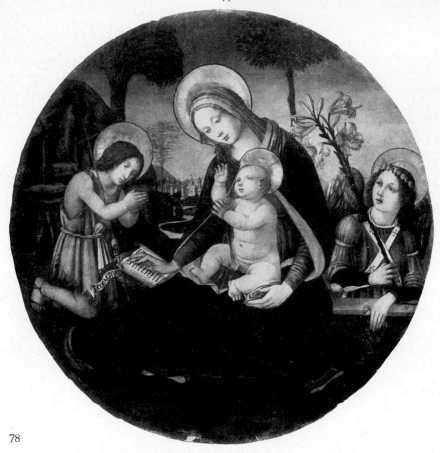

78

81

83

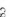

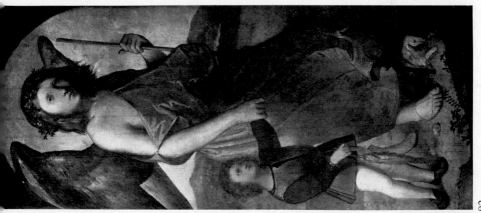

82

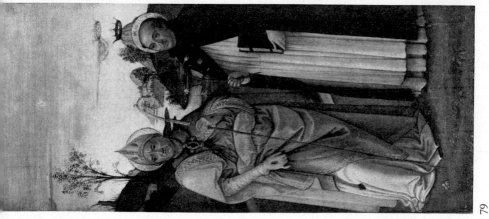

79

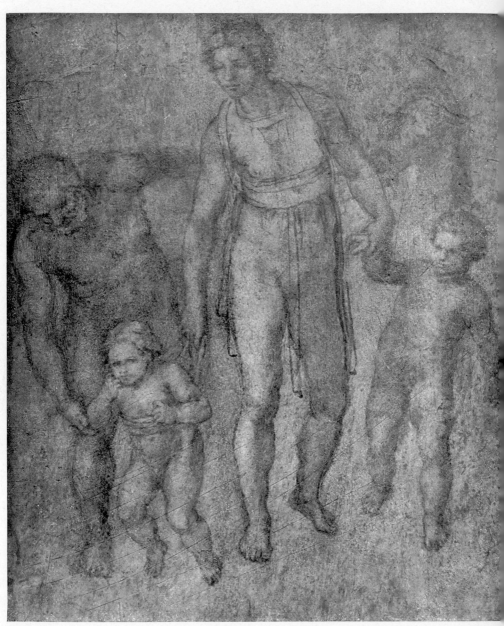

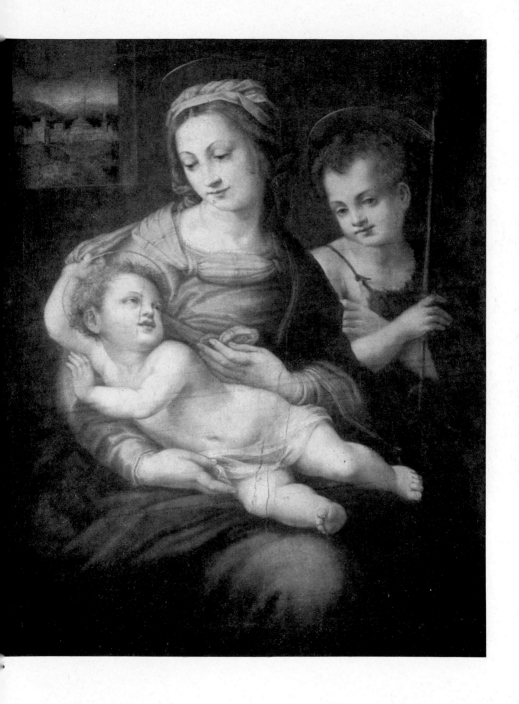

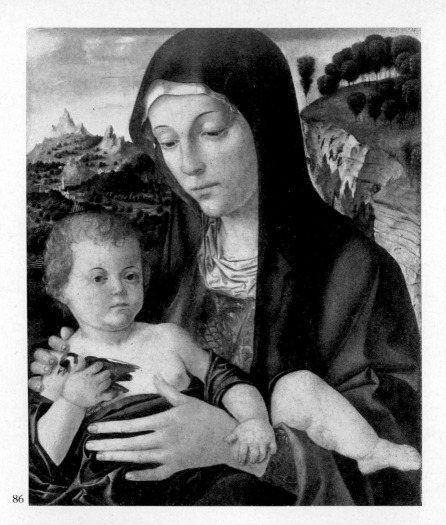

86

87

88

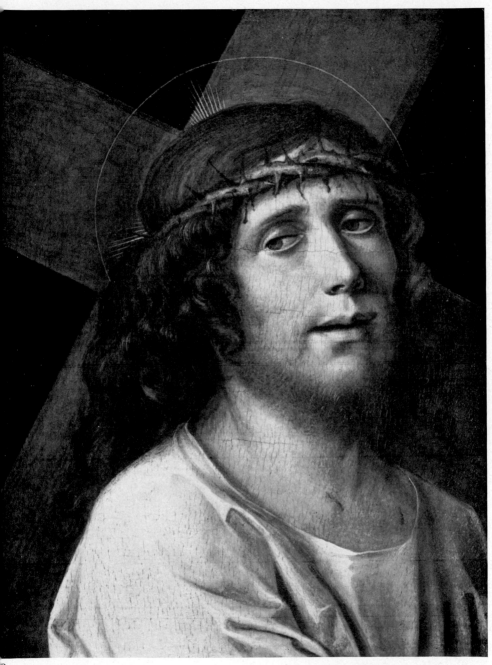

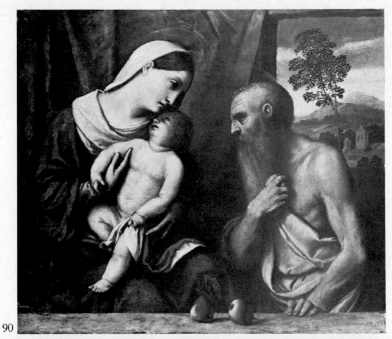

90

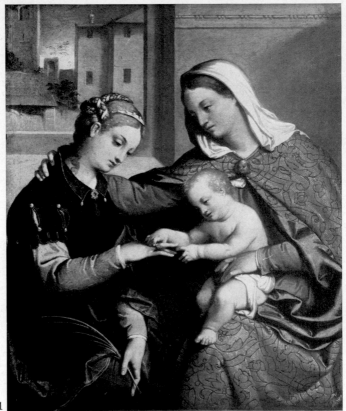

91

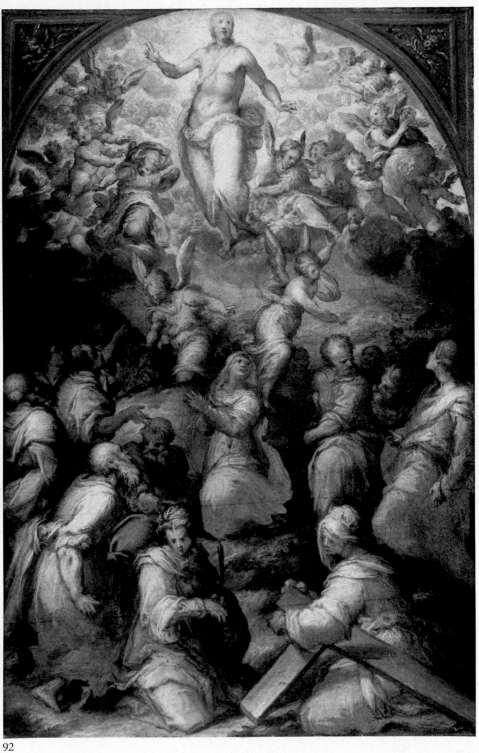

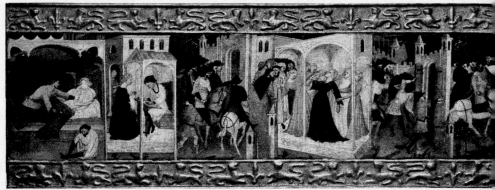

93

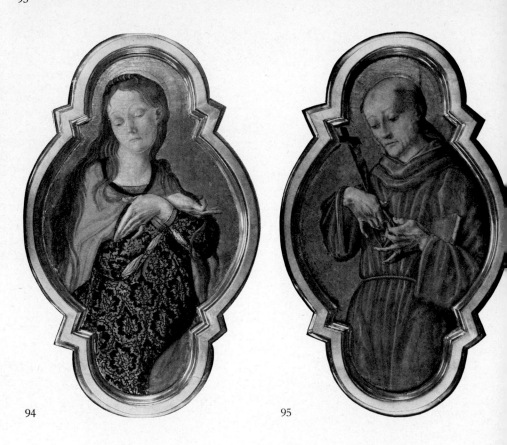

94                                                    95

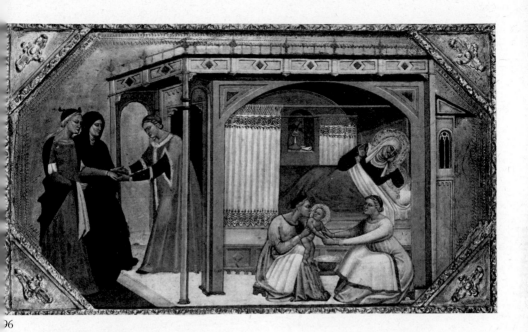

96

97

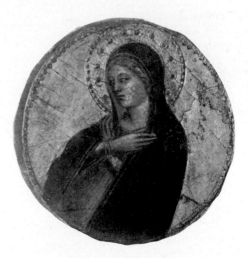

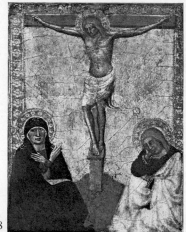

98

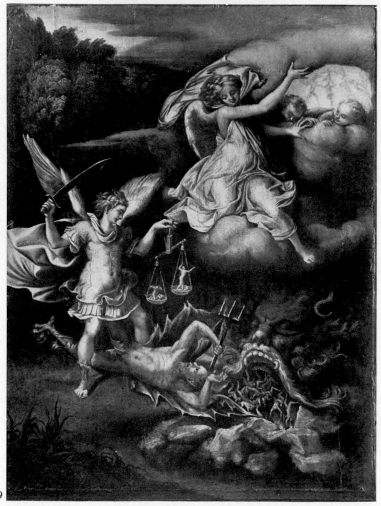

99

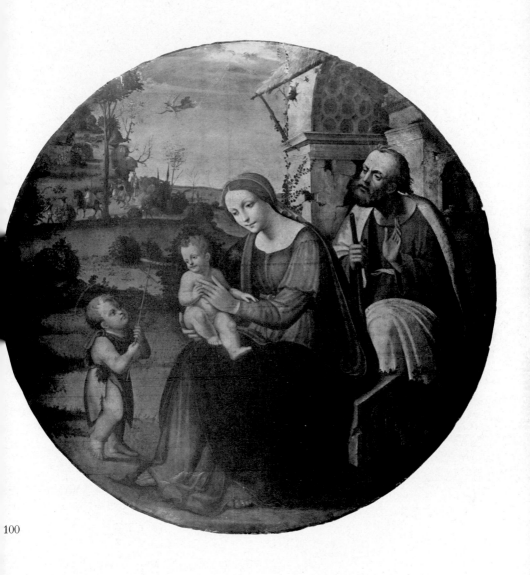

100

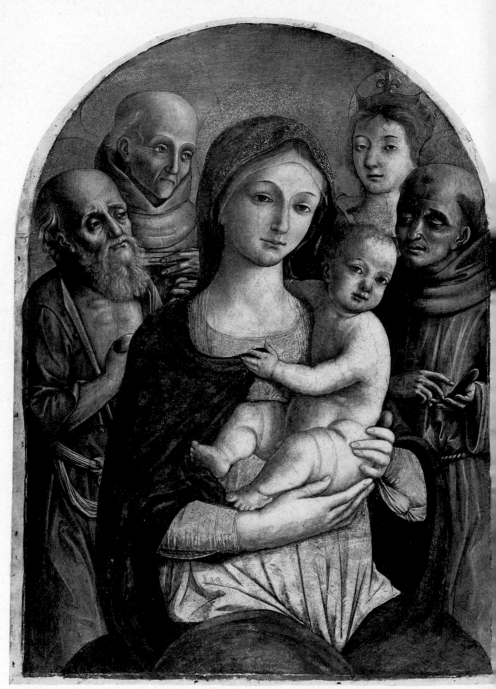

101

102

103

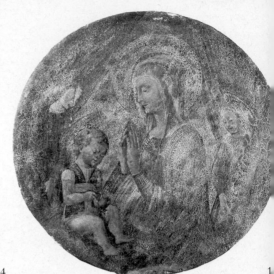

104

1

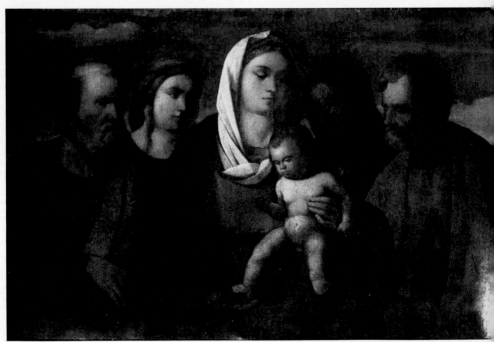

107

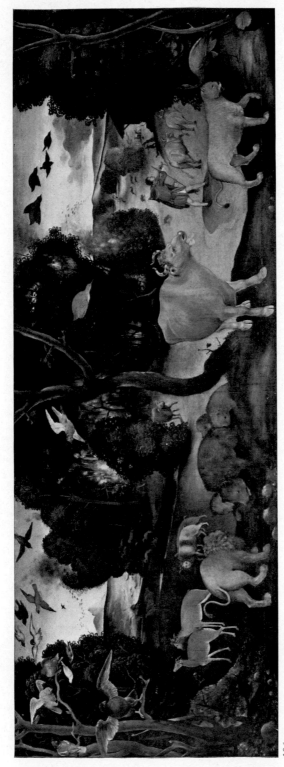

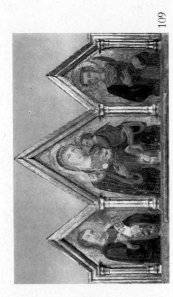

109

110

108

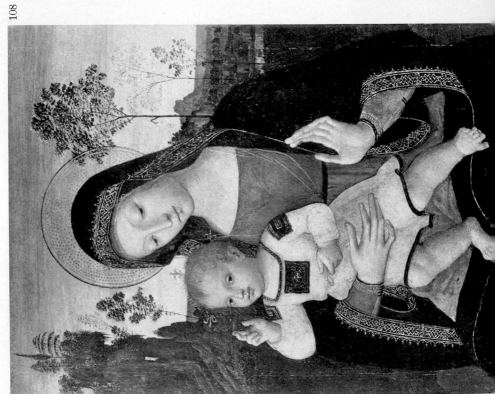

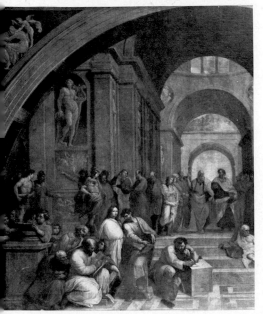

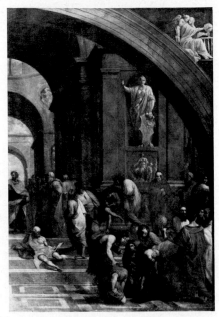

112

114

115

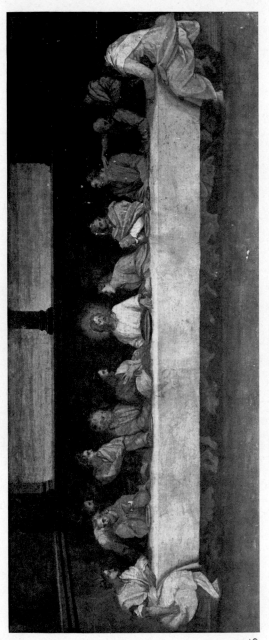

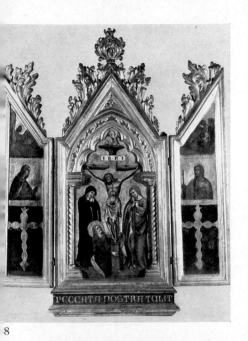

8

119

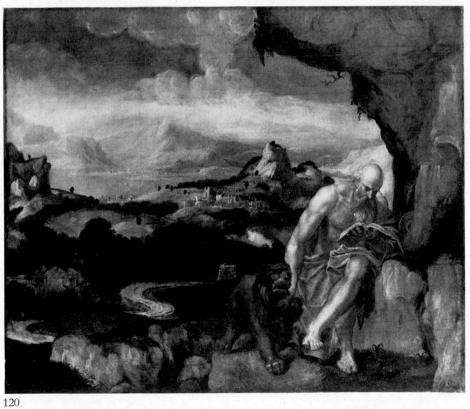

120

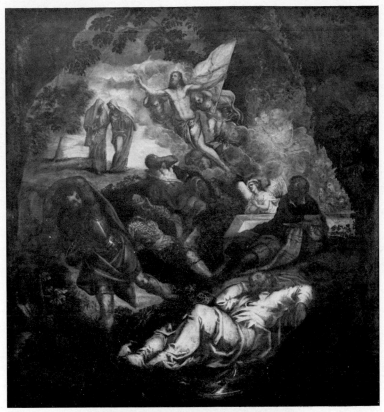

123

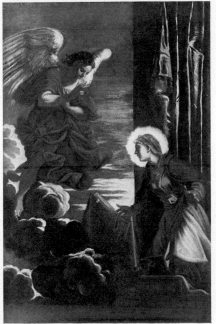

124

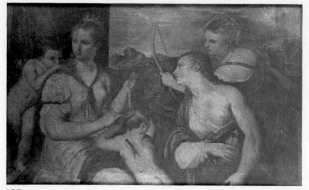

125

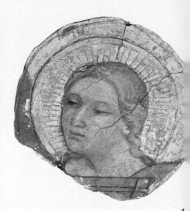

1

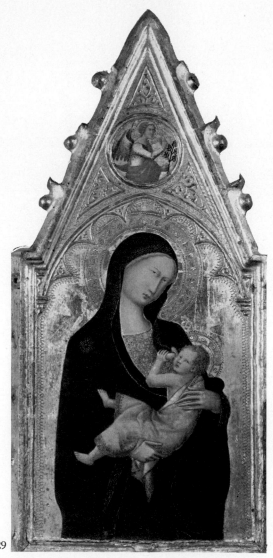

129

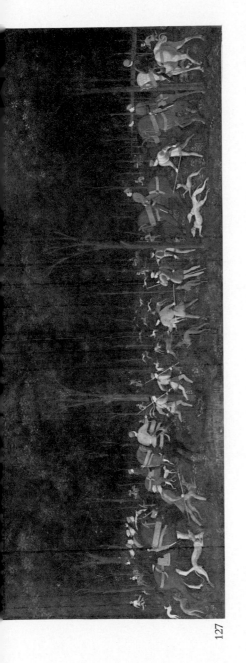

127

128

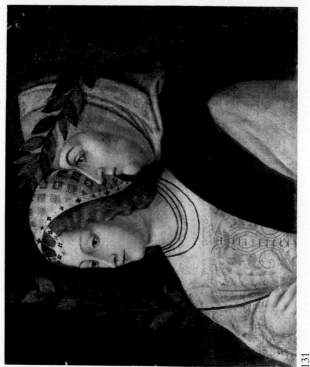

131

130

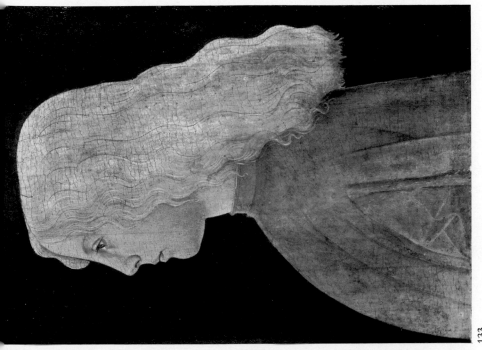

133

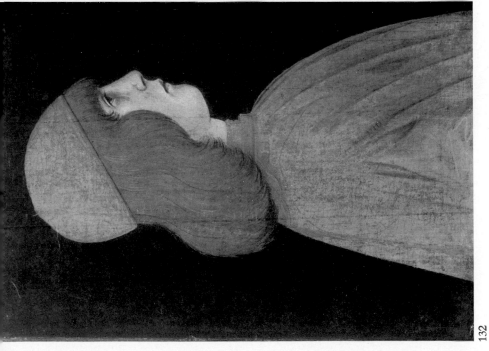

132

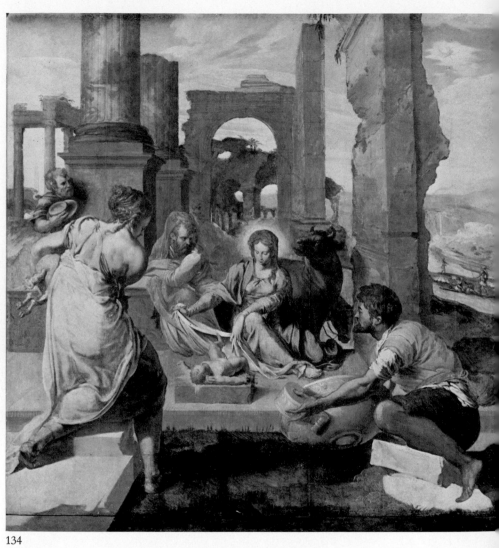

134

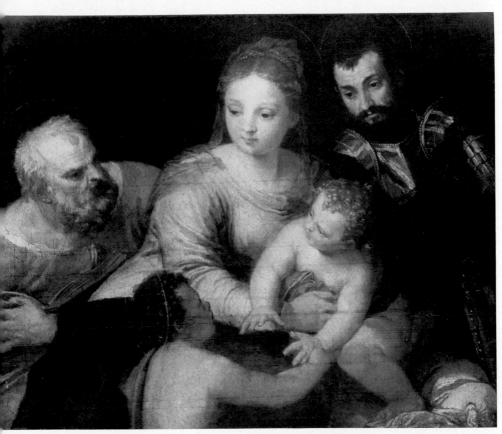

135

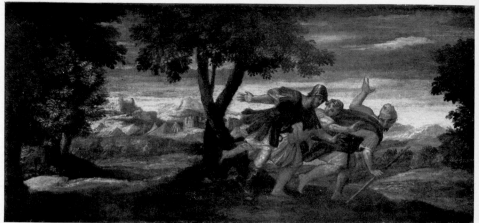

136

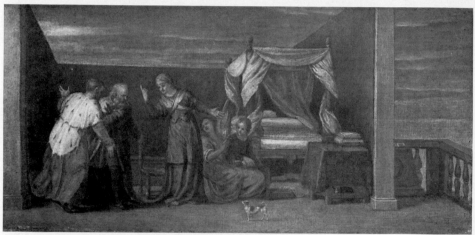

137

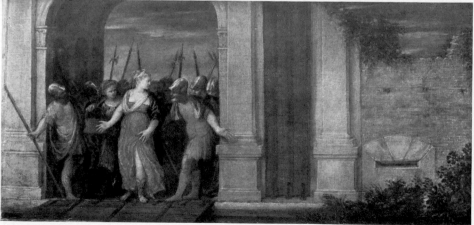

138

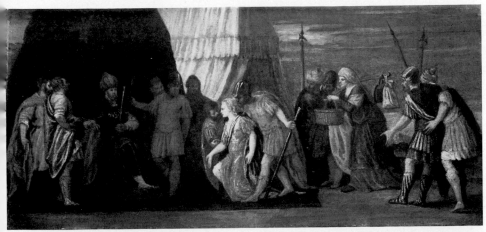

139

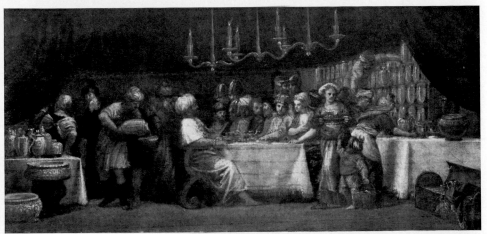

140

141

142

143

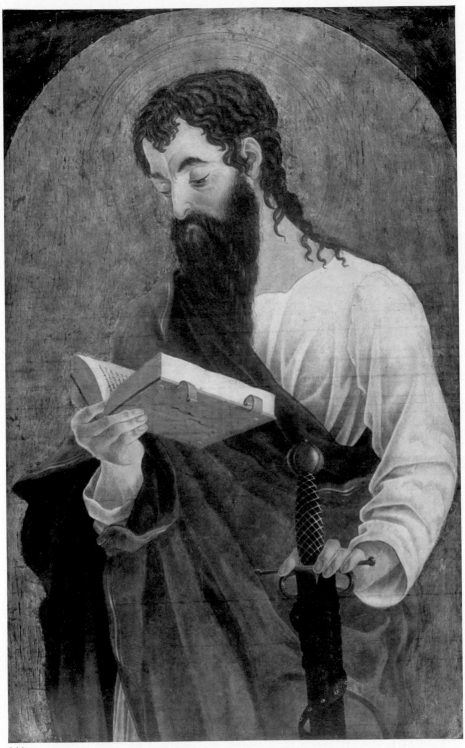

145

146

147

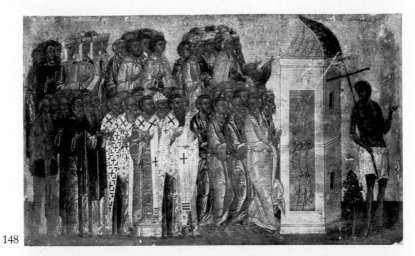

148

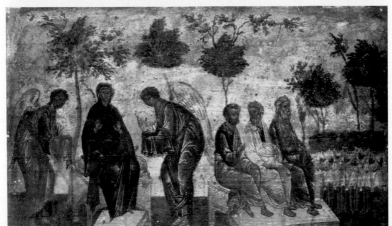

149

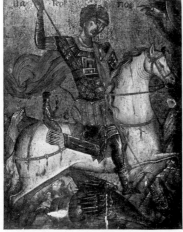

150

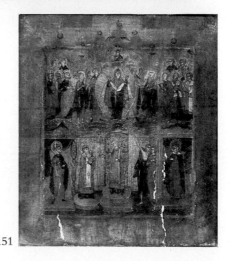

151

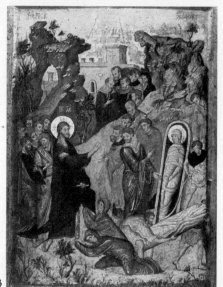

153

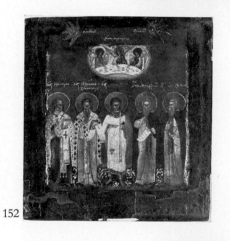

152

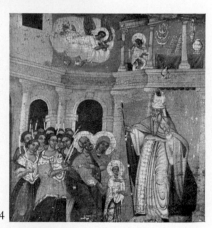

154

155

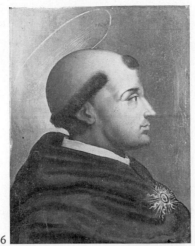

156

157

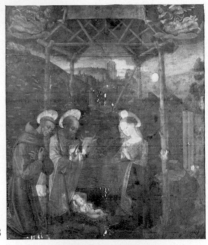

158

159

160

161

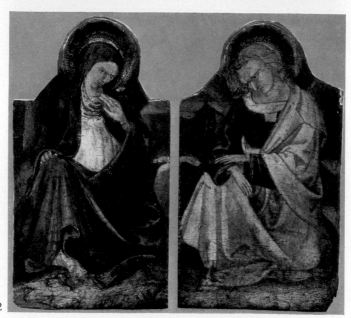

162